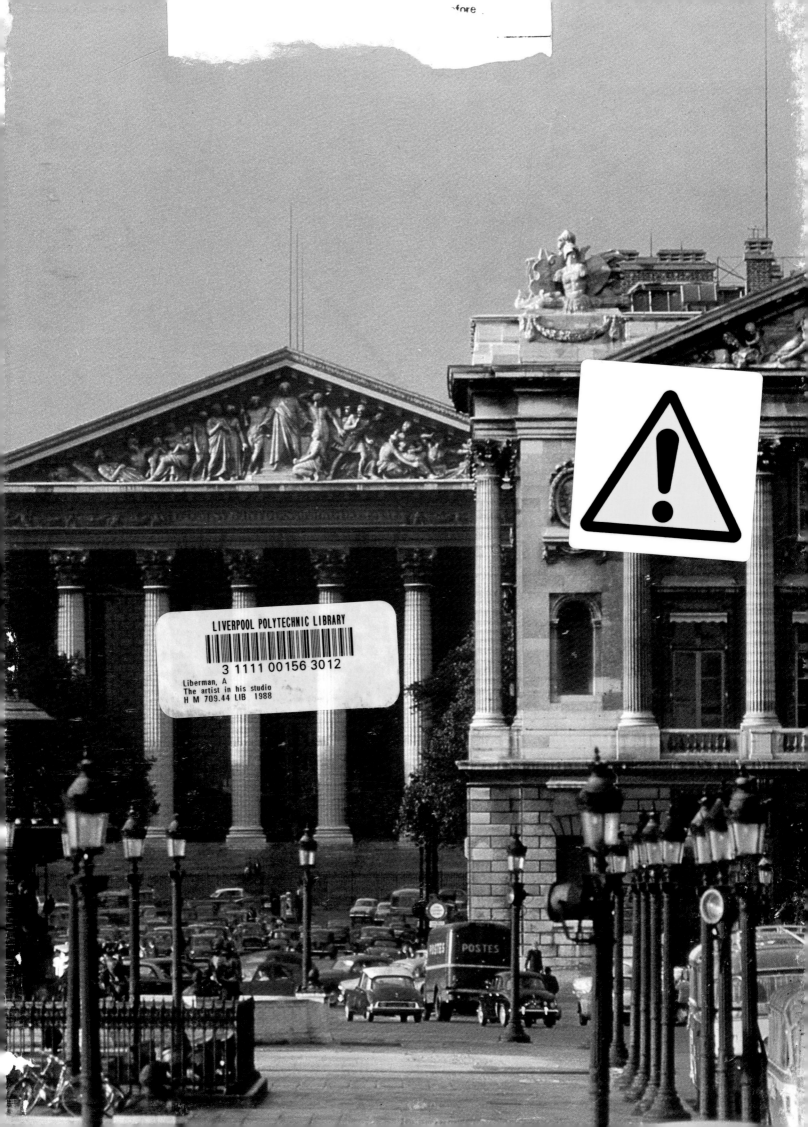

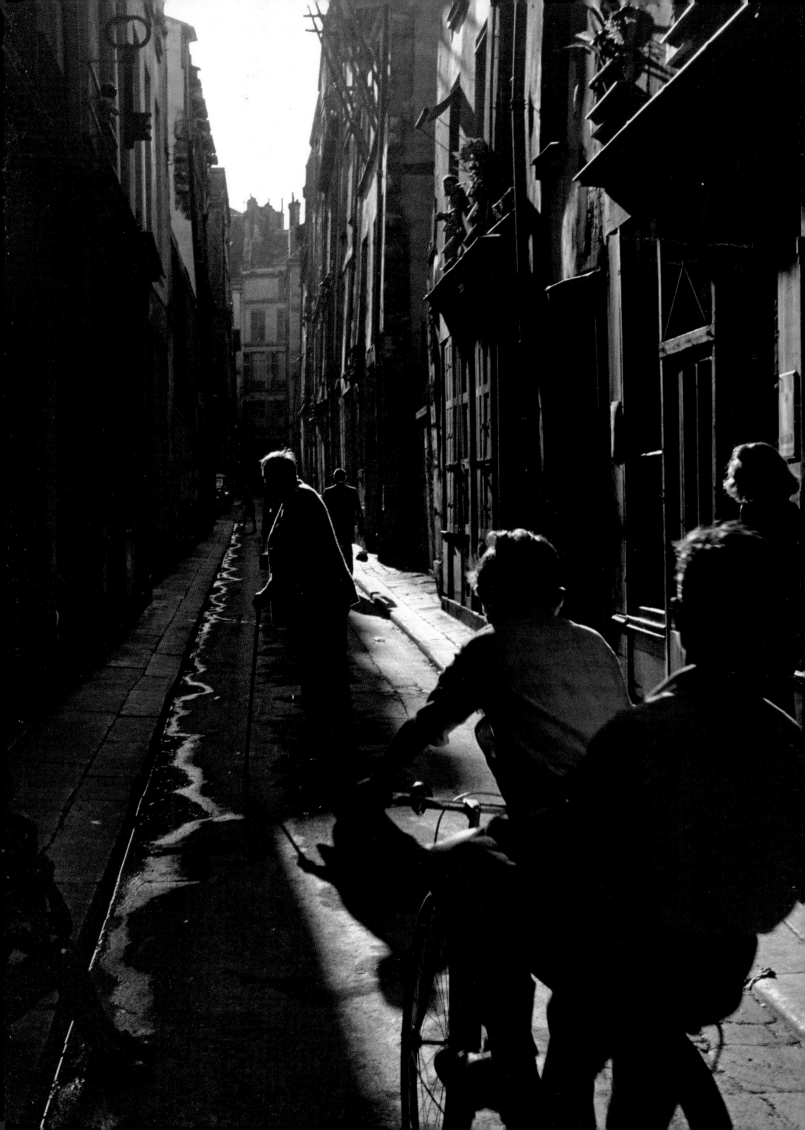

The Artist
In His Studio

Alexander Liberman

Thames and Hudson

Printed and bound in Italy by Amilcare Pizzi, S.p.A.

Front Endpaper: Paris: the architectural splendor of the Place de la Concorde.
Frontispiece: Paris: Michael Larionov leaving his studio on the rue Visconti. Racine and Balzac had each worked here, one of the oldest streets on the Left Bank.
Back endpaper: Paris: the rue des Grands-Augustins: at the upper right, the windows of Picasso's studio.

Contents

To my wife, Tatiana, a friend of many of these artists. She has inspired me and given me courage by her faith and love through the years.

Acknowledgments

For this new and expanded edition, twenty-eight years after the first one, I want to express my gratitude to S. I. Newhouse, Jr., for his active support and trust in *The Artist in His Studio*; to Harold Evans, whose enthusiasm encouraged me initially to create this new edition; to Edmund Winfield, who collaborated on the first edition and was again deeply and perceptively involved with the quality of the material; to Alessandro Franchini, for his great sense of style and design and a rare response to all visual needs; to Ellen Williams, for her remarkable, patient, and wise contribution to the difficult task of researching the art illustrations and particularly to the editing of the captions and new text.

It was a personal pleasure to work with Kari Bjelland; her sensitive help contributed immeasurably to the work.

Crosby Coughlin and Roger McCaffery were a great help. Special thanks for their insightful comments to Ruth Ansel, Mary Shanahan, my grandson Luke Gray, and particularly to Cleve Gray for his always thoughtful, knowing advice in the planning and selection.

Recognition must go to Bob Lehmann and to Jaye Shore for their devoted aid in many fields.

My deep appreciation to the editors at Random House: Joni Evans, whose brilliant suggestions helped vitally in the final working of the book; Sam Vaughan for his belief in the material and his stimulating, wise steering of its many aspects; Dennis Dwyer for his dedicated and perceptive attention to quality; and above all to Susan Ralston, whose great cultural experience and ceaseless striving for perfection made our collaboration a joy.

Introduction

During the Second World War, when France became a battlefield, I feared that many traces of a heroic epoch might vanish. Since the Renaissance in Italy, no country except France has seen such a continued flourishing of painting and sculpture. After the war, I decided to seek out those artists who had contributed most to this modern renaissance, the painters and sculptors who have been closely connected with the School of Paris. Many were still alive. These I visited. The remaining traces of those who were dead I sought out.

The more I explored, the more absorbed I became with the mystery of environment. Why should France have become the focal center of painting and sculpture at this particular time? What relationship exists between the paintings and the vision of reality that the artist has daily before his eyes? At no time have I believed that environment provides a complete explanation of art. I am sure, however, that it plays an important role. Further I cannot go, but I can offer to artists, historians, and other readers this record of how some of the greatest painters and sculptors of our time looked, lived, and worked. I have tried to reveal the core of their creative act, to show the creative process itself, and thereby to locate painting and sculpture within the mainstream of man's search for truth.

In books on art I found little factual information about artists' studios, methods of work, and tools. The books concentrate on either biography or aesthetics. Seldom has anyone described those details that are part of the creation of the work of art itself. One reason is that the studios of great painters are seldom preserved intact after their deaths; even if some are preserved, or made into museums, the "cleaning-up" usually destroys the link with the artists. However, with most studios I was fortunate; Cézanne's for instance, was still more or less as he had left it. I looked at the studios with the painter's interest in mind. Whenever I saw a significant detail that enhanced my knowledge of the artist and his method of work, I recorded it. To document the creative act I had to observe it without altering it by my presence. To gain the confidence of an artist, so that he could work as if I were not in the studio, took several years of patient visits.

Sometimes the artist himself is ignored while the spotlight focuses upon his work. Sometimes he dies or becomes very old before his work is recognized. I tried to catch expressions that seemed to have meaning in connection with temperament and creativity—especially those of artists such as Rouault, Kupka, and Villon, who had to wait until they were over seventy for recognition. About these men there has been relatively little recorded, in contrast with Picasso, more amply documented than any painter in history.

This book is not intended as a thorough, systematic study of modern art history or a compilation of biographical data. It is a series of impressions, essays in words and photographs. Some important artists are not represented because of the physical impossibility of including everyone, but I hope that through the ones who do appear the essential atmosphere of the epoch will show. The unequal space given to each artist is not meant in any way to diminish or increase his relative importance. In many instances this variance depended on the amount of available material, the amount of time I was given by the artist, and sometimes on my personal affinity with the man and his work. It is on this subjective plane that my book might be best approached. I hope that it will communicate some of my admiration for the men and women who have created the revolution of modern art.

After years spent visiting, talking to, and photographing these great artists, I am impressed most by their obsessive, unswerving dedication to creation. In the words of the poet, they are "a lifetime burning." Their dedication to art, like that of men to religious orders, is a self-imposed vow. These artists are the priests of a new religion—Art. Jacques Villon, the grand old master of modern art, at the age of eighty-four said to me in 1959, "Before starting to paint one should follow Cennini's advice and say a prayer." The long history of painting has come full cycle, for Cennino Cennini, in the fourteenth century, defined the chief virtues that a man taking up painting should have: "Therefore, you who love this accom-

plishment because of a refined disposition, which is the chief reason for your engaging in our art, begin by adorning yourselves with these vestments: love, reverence, obedience, and perseverance."

A.L., New York, 1960

It has been more than forty years since I began this project, almost thirty years since *The Artist in His Studio* was first published. In this new enlarged edition I have not altered the original texts as I did not want to weaken my first, still vivid impressions, but I have been able to expand on the artists on whom I had collected the most material. By giving more space to some, however, I was forced to eliminate others who are important, but about whom I had limited material. Some of the photographs have been taken since the publication of the first edition, and thanks to new printing techniques, a great number of pictures that were originally reproduced in black and white are now in color, which more truthfully reveals the essence of a moment in time.

I feel especially fortunate to have seen many of the artists in their old age, as sometimes this is a period of summation and a time of liberation, of freedom, of dealing with the essential. I was also fortunate to see some of the great studios before they were destroyed. Many years have gone by, but there have been few improvements in preserving the traces of the great masters. Brancusi's studio has been reconstructed at Beaubourg, but in a truncated version. Cézanne's studio at Aix has been repainted, rearranged, and made "interesting" for visitors, but the original disorder of the creative environment has disappeared. What is happening to Picasso's various studios? Who is interested in documenting them? What will happen to them in the future?

It was an extraordinary experience to meet and observe some of these exceptional creative beings. I thought of myself as a pursuer of a mysterious absolute, maybe of an unseen grail. The works of all the masters from this recent past have a special meaning today. They are part of the inescapable continuity of artistic inspiration in which each generation borrows from the one before.

When I first began this quest, I was a curious young painter trying to pierce the secret ways of the creative process, to discover how the great masters lived and worked, and to report this for future striving artists. The camera was the pretext to enter the privacy and stillness of their studios, witnessing, photographing, and documenting their involuntary mannerisms and, perhaps, their unwitting communications.

The days, months, years spent on this endeavor were among the most rewarding of my life. I came out of this soul-searching experience humbled by the knowledge of the difficulty of attaining a radiant goal despite the rejection that often greets the new. With their simple means, these men and women gave the world an immense joy—the indescribable power of Art is secreted in their creations, there for us to seek. I pray that the memory of what they achieved will last for eternity.

A.L., New York, 1988

The Artist In His Studio

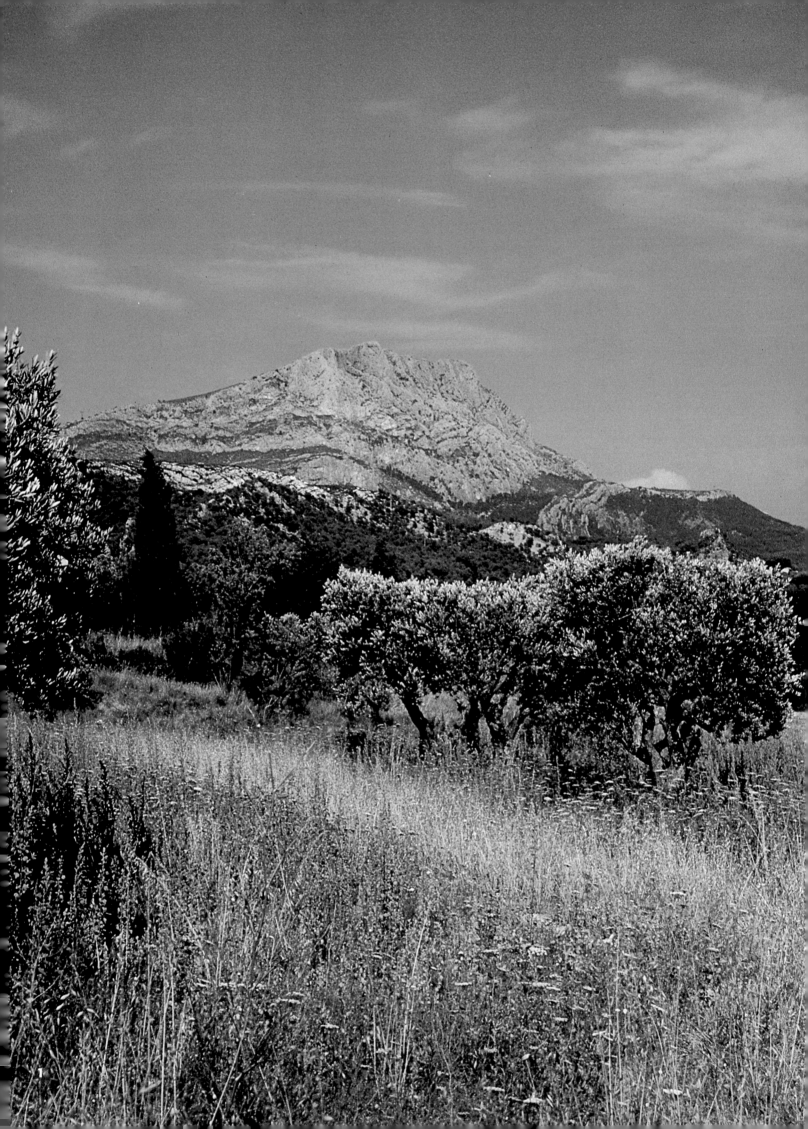

Cézanne

Paul Cézanne is the spiritual father of modern art. His pictorial lessons and discoveries are more than ever alive in the art of our time. He is the painters' painter. His personal struggle to reconcile the two realities of an artist's existence, the life of art and the life of man, provides an ideal study of the artist as a phenomenon of existence. Cézanne is an archetype for painters.

He was a rich man. He once said, "My father was a man of genius. He left me an income of twenty-five thousand francs." Thus Cézanne never had to worry about material existence. He could afford to live without having to sell his art. This independence was one of the great secrets of Cézanne's liberty, and he knew it well. Throughout his life his gratitude and admiration for his father never ceased.

For a long time the modern movements in art have been associated in the mind of the uninformed public with Bohemianism, revolution, disorder. Cézanne disproves this legend. A rich bourgeois, he lived a humble, methodical, solitary life. The house he built himself in Aix-en-Provence around 1902 is a somber shell that still stands today on the rechristened Avenue Paul Cézanne. I found little difference between the modest two-story building and its neighboring suburban houses when I visited in 1949; only the immense studio that occupies the whole second story distinguishes it. The house is still intact more than fifty years after Cézanne's death. By an accident of fate it was bought by a Provençal poet who lived in the lower rooms and did not touch the studio itself. Today Cézanne's beret, his cape, his paint boxes, his rosary, his palettes and bottles of turpentine, all the objects that surrounded him during his work are there as he left them, untouched, unmoved throughout the years.

Two tiny rooms, a dark dining room and a bedroom, open out onto the tile floor of the little entrance hall. Alongside the dining room is a dark kitchen in which one can barely move. The proportion of the three rooms is the minimum essential for a retired functionary. A minuscule staircase with a metal balustrade and a wooden ramp winds up in a slow curve to the second floor. In contrast to the dinginess and the smallness of the living quarters the studio is luminous, tall, high, and, as in many painters' houses, obviously the center, the principal room in the man's life. The studio is extremely orderly, with its meticulously kept filing cabinets, books, papers, and a long shelf on which Cézanne had arranged with method the objects that inspired him. The great height of this austere room is accentuated by a small crucifix hung close to the ceiling.

This is the studio of his old age, a dynamic old age in which Cézanne created some of his greatest masterpieces. His *Les Grandes Baigneuses*, now in Philadelphia, was finished in this room after seven years' work. The longevity of painters is striking. Cézanne died at sixty-seven, Matisse at eighty-five, Rouault at eighty-seven, Léger at seventy-four, Kupka at eighty-six, Kandinsky at seventy-eight; Villon is eighty-five, Picasso is seventy-nine. Such longevity contradicts the established legend that the artist destroys himself. The stimulus of creation seems to be favorable to the human system; perhaps boredom and lack of activity kill faster than the difficulties of creative living. In their old age all these painters have kept the spark of youth. Cézanne's friend, Gasquet, wrote that when he visited Mont Sainte-Victoire with Cézanne at sixty-five, he said, "This is like the first spring."

This studio, stark and sad, a room of anguish and torment, was also the shell of a hardened egotist. Cézanne sacrificed all personal human contacts to achieve his vision. Bitterly, indestructibly egotistical, he forced his wife to live apart from him and treated his friends indifferently. There is not a single comfortable or luxurious object in his house. All is centered around work. Like Picasso, the richest contemporary painter, Cézanne lived in ascetic, mystical surroundings, with painting as his sole luxury. Yet, like Braque, Cézanne had the means to materialize his conception of the ideal workroom. There is similarity between Braque, Picasso, and Cézanne in the uncluttered space of their working areas. There is space and grandeur in their studios; in the act of planning them, they preconceived

the immensity of their purpose. Cézanne's conception was vast; one can still see the slit knocked out on the wall of his studio through which his *Baigneuses*, too large to go through the doors or windows, was taken out.

By the far wall away from the crucifix is a stove with a long pipe to heat the immense studio. Gasquet recalls that one of Cézanne's greatest paintings, the *Old Woman with a Rosary*, which he did one year before his death, was found lying next to the stove, steam dripping down on it. Cézanne, seeking the summit of art, was often in despair with his own achievement. He slashed, threw, stamped on canvases, folded them to prop up a sideboard, tossed them out of windows. Vollard remembers once seeing a canvas hanging on a tree near his studio. This disregard for his creation, a mixture of pride and intense humility, was one of the conflicts of Cézanne's life. He knew his greatness.

Hanging on hooks in the farthest corner of his studio are a thick black woolen coat with a cape, his beret, another coat, a folding easel, a white parasol, and a canvas bag smeared with oil paint, all living souvenirs of his contacts with the outdoors. He had great physical energy and walked miles through the countryside to his motif. He identified himself and his canvas with his landscape, in the most literal sense of communicating with nature. His studio was a study into which he brought the riches that he collected outside, to write them down in color and line into the scientific journal which was his painting. "Everything is in art, especially theory developed and applied in contact with nature."

This artist was born in Aix and died in Aix; except for infrequent trips to Paris and visits with his friends, he seldom left his birthplace. It was the profound familiarity between his eye and his surroundings that permitted Cézanne to see the nature around him as though he were seeing into himself. One of the secrets that we attribute to genius may be merely acute observation. How often one says, looking at a painting, "What a genius this man is to have interpreted the shadow as blue!" But the fact is that, in a particular geographic location, the shadow actually is blue. If Cézanne had not been so deeply rooted in his Aix countryside and had not for over half a century observed its shadows, he might not have rendered them as precisely as he did. In old age Cézanne would allow himself the luxury of being driven in a fiacre to the subject he wanted to paint. He would stop the driver and say, "Look at these blues—look at these blues under the pine tree." And in the countryside of Aix, the blues that Cézanne was the first to see are there today for anyone to see.

Cézanne's unwillingness to travel, to change, is in striking contrast to the adventurous spirit of many artists. "My eyes are stuck to the point I look upon," he said. "I feel they would bleed if I tore them away." This fixity of vision and recognition of the infinite richness within small changes are revelations of Cézanne's method. There may be a link between Cézanne's power of concentration and (without intention of a pun) his concentric conception of vision. "It became concentric by looking and working," he said. He wanted to show nature composed of "the cylinder, the sphere, the cone." These forms are based on the circle, and this revolu-

tionary discovery is one of his profound contributions. To Leonardo da Vinci's statement, "The eye is the top of a pyramid," Cézanne might have answered, "The eye is the top of a cone." To Cézanne, a base was not linear but curvilinear. In his obsession with apples, with fruit, with his baroque-tormented arabesques of the human form, the future father of cubism tried to break that static linear volume into a flowing curvilinear rhythm.

His obsession with Mont Sainte-Victoire, the rock mountain that stands like a cathedral dominating the plain of Aix, involved much more than a pictorial problem. In contemplating this manifestation of nature, unspoiled by man, Cézanne sought more than a communion with the Creator, he wanted to be the hand and the eye of the Creator: "I want to paint," he said, "the virginity of the world." In seeking the secret rhythm underlying creation, Cézanne was seeking the universal, the eternal, the classic, for his was no expressionistic ego playing with accident. Cézanne is the great classicist. His heads tend toward one common basic shape, which is the underlying unity that he was striving to reveal. The exact shape of a particular head is but an accident; he sought the basic, universal form of the human head. The mountain, to his eye, was like minute life revealed through a microscope, the gigantic, visible revelations of nature's rhythms and structures. After this vision, Cézanne could see in a humble tablecloth a smaller symbol of the same life-pattern; the folds of a napkin in one of his still lifes have the grandeur of Mont Sainte-Victoire. The eye of the spectator travels and recognizes within the lines of any great still life, portrait, or landscape the eternal movement that it subconsciously seeks, and is satisfied. The painting possessed with the rhythms of nature itself becomes a part of creation, an object of nature.

Cézanne's great good fortune may have been that he remained on the outskirts of Aix, so deeply immersed in nature. Painters who live in cities seem gradually to accept the transitory as reality. City streets, cars, factories, theaters, momentarily hide the real aspects of nature from citydwellers. Anything man-made is not eternal. As Cézanne well understood, it is only in nature undefiled by man that eternal truth can be discovered. The artists of the cities are also frequently spoiled by money and success. It may be that the continuity of Cézanne's vision lay in his isolation, his lack of appreciation by the public of his time. He pursued art, regardless of recognized success. He may have occasionally craved the satisfaction of approval, but his proud nature revolted against his bourgeois-dominated age.

Cézanne carried his love of nature to the people who lived in nature. His friends were the gardeners, the farmers, the peasants; he helped them live, gave them money, painted their portraits. He fought bitterly against the narrow-minded middle class and, being close to the humble people of his native Aix, remained close to their basic tastes and understanding.

The peasants who were Cézanne's friends and models were also his link with the truth of nature. Just as the Mont

Sainte-Victoire remained undefiled by human hands, these simple people were unspoiled by false culture. From their rough, weathered faces, Cézanne could paint his human landscapes.

Hanging on the studio walls are cheap, bad reproductions of his favorite artists, El Greco, Tintoretto, Titian, Delacroix, Courbet. Cézanne wanted to redo the classics, "redo Poussin after nature." He did not discard the lessons of the past masters, but retaught these lessons to advance human vision a step further. A classicist, Cézanne did not break with tradition; he developed tradition within the spirit of his time. All artists whose influence has been lasting have based their work on an idea, a philosophical concept. Renaissance art was above all an intellectual revolution based on the discovery of humanism; the impressionists found their sources in the optical revolution of Chevreul. In Cézanne's life, as in his work, he sought method. He once said of Rodin, "What he lacks is a cult, a system, a faith."

On a long, high shelf stand the objects he used so many times in his still lifes: Puget's *Amour*, the *écorché*, the straw-bound bottle, the vases, the bowls. In their carefully preserved accumulation these everyday objects are the standards of comparison with his works. The measure of his departure from these objects reveals his theories. Cézanne's acceptance of the reality of nature, of man, of the objects that surrounded him was part of the naturalistic revolution of the early twentieth century. Nature, naturalism are essentials in Cézanne's work. He is one of the greatest modern painters because he taught artists to portray their own time, to avoid an outdated mythology, and to create their own myth.

The ceiling of the studio is white, the doors pale gray, the walls slate-gray. The floor of natural unvarnished wood, gray with age, adds a warmer shade to the monochromatic room. Almost all the colors that surrounded Cézanne were gray—part of his need of subtle, unviolent color within which he could see all modulations. "Gray alone reigns in nature," he said, "but it's frightfully difficult to catch." No one saw more colors in a gray than Cézanne. And the dark gray walls of his studio are the neutral background against which his eye translated the many hues of his inner vision. This great colorist also loved to paint on a gray day.

"Light is a thing that cannot be reproduced," he said, "but must be represented by something else—by color. I was pleased with myself when I discovered that." This interchangeability of light and color is similar to the modern notion of charges of energy. When Cézanne said, "The painter is above all an optic," he meant that the artist vibrates under the energy impulse of color and translates the charge onto the canvas.

Two tall bottles stand on a shelf still half-filled with turpentine, darkened with age, reminders of Cézanne's mediums. He thinned his paints more than any other painter, trying to reduce density of color for a less material but more important use. Cézanne's method prefigured the research of contemporary painting. Before him color was looked upon as the property of the object painted, as part of its substance. The orange of an orange belonged to the orange itself. But Cézanne with his translucent, transparent tones tried to put

into his water colors and his oils a light from behind; his white canvas or white paper charges his thin film of color with an inner glow. The uncovered areas of his canvases are his affirmation that the canvas is the light behind color.

On a piece of glass Cézanne mixed his colors, often adding gray—no pure colors but a swirling, subtle mixture of subdued tints. From this impromptu palette one can judge the energy, the impulsiveness of the painter at the moment of creation. On this palette he was free to let his hand move with undisciplined passion. In this freedom he found a release before again disciplining his passion into the methodic, systematic strokes that are the substance of his painting. Passion, mysticism, discipline, anguish are still felt in this room whose occupant died fifty-four years ago. It remains charged with the intense radiation that his energy infused into all he touched. For Braque, who said, "I like the rule that corrects emotion," Cézanne is the Gospel. His whole life was the rule that corrected emotion. From all accounts, there was a constant struggle in Cézanne between his passionate, romantic nature and his conception of art. Somewhere inside he was an expressionist with a constant desire to pour out his feelings in violent images. Only his admiration for classical art and his high conception of the artist's mission could discipline him. This struggle led Cézanne to the high summits of classical art, in which his ego was vanquished, but not without the struggle needed for great creation. The artist suffers, strives, but the work of art is pure, serene, calm, and eternal. Cézanne's apples and portraits have the eternal repose that fulfills our need of permanence. The solidity of Mont Sainte-Victoire, encased in an atmosphere formed of the same molecules as the mountain, conveys that satisfaction of permanence.

Cézanne had the infinite patience to build a system which would translate what he saw. Painting had suffered under improvisation, under so-called inspiration, and compared with music and writing it had relatively no laws. Cézanne created the most demanding and rigorous pictorial system devised by man.

Attached to a small wooden rosary are a crucifix and a small skull. These are links with one of Cézanne's favorite painters, El Greco, in whose portraits of prelates and saints there is often a skull, symbolizing the presence of death. Cézanne's Catholic mysticism drove him into the solitary meditation of a monk. His was the freedom of the iconoclast to break with tradition, but to break with tradition he had to be very familiar with that with which he broke. The cheap reproductions of past masters in his studio were his links with the past. Cézanne also had the means, in the early materialistic twentieth century, to meditate in a self-made monastery. He could afford the luxury of living like a hermit, afford to resist violently all interruptions, all attempts of dealers to put the hand on him.

It is only in a life of peace and silence that one can see clearly, that one can even attempt what Cézanne attempted: a vision of the overall pattern of creation. Cézanne's vision was close to that of another mystic, Spinoza, who wrote, "God and

the universal laws of structure and operation are one and the same reality." Cézanne's answer to a friend who asked him if he believed was "If I did not believe I could not paint." And he once said of a sculptor, "He makes admirable pieces, but he does not see the whole." This vision of the whole belongs only to genius. It is said that Mozart could visualize his music as though it were a painting, could see the whole in one moment of time while other composers conceived their work within the passage of time. The whole is another form of harmony, which is the planned relationship of various parts, and to see the plan one must have a perspective, a distance of vision so that he is not lost in detail. Cézanne, who said, "Nature to me is very complex," needed the perspective given by meditation and faith to unravel the complexity of sensation.

Several skulls lying on shelves are evidence of Cézanne's need for permanency. As God's creation has permanency, as the human skull remains behind as a reminder of life, so painting needs that solid structure that will preserve it through time. This demand for structure, this bone of Cézanne's vision, is similar to Plato's system of ideas. Cézanne admired Plato, who over his academy placed the inscription, "Let no man ignorant of geometry enter here." Cézanne wrote, "God always geometrizes."

The security based on number is one of the reasons for music's emergence as a major art. And Cézanne's greatness lies in this seeking for universal law and permanent rhythm through number. In his search for solidity, for the perception of universal harmony, he was conscious of musical ends. "To paint," he said, "is not to copy slavishly the object...it is to seize harmony between several correspondences, then to transpose them into a scale of one's own and to develop them, following a new and original logic." So he used the harmonic principles of music, trying to establish for the art of painting the structural security and solidity that is particular to music. When Cézanne said, "I will have to repaint this whole portrait if I put in one accidental stroke," he was a musician afraid of a false note.

The concept of "idea" has changed in our modern world. When artists speak of ideas today they do not use the word in a Platonic or Cézannian sense but in a literary sense. No one hated literary painting more than Cézanne. For Cézanne storytelling was not the way to great and universal painting. For him to tend toward an idea was to tend toward the ideal, the essence of a thing. "Nature for us is revealed more in depth than in surface," he said. His ideal was so great, his purpose so immense, that if he sometimes deprecated his own achievement it was not, as many thought, because he was afraid he lacked talent; it was his feeling of unworthiness before his Creator.

The garden outside his house, with its geranium pots and olive trees, still stands beside the quiet lane leading down to the city of Aix, which so long ignored him. Mont Sainte-Victoire still stands. The eternal nature, from which the accidental spark that was Cézanne has disappeared, remains eternal. But his paintings remain engraved in memory like a revelation of the truth about ourselves that we knew but did not face. And one of those noble silver olive trees must have been his friend, of whom he said to Gasquet, "It's a living human, it knows all of my life and gives me wonderful advice. I would like to be buried at its feet." It is said that Cézanne often came out to speak to the tree and embrace it.

Notes on the Illustrations

Paul Cézanne, 1839–1906. Born: France.
Photographs taken in 1949.

1. A view of Mont Sainte-Victoire, one of Cézanne's most constant themes, from the outskirts of Aix-en-Provence. The magnificent architecture of the rocks obsessed the painter, who was preoccupied with the mystery of nature's relation to art.
2. Cézanne, Self-Portrait, circa 1875. Musée d'Orsay, Paris.
3. This is the room where modern art was born, one of the holy places of painting: the last studio Cézanne built for himself, in 1902, on the Chemin des Lauves near Aix. Here, shortly before his death, he felt the first glow of world recognition. Here he painted his masterpiece, Les Grandes Baigneuses ("The Large Bathers"), over several years. When finished, it was so large that an opening had to be made in a wall to remove it. On the left hang his coats, capes, berets, and painting satchel. On the long shelf above are many objects Cézanne used in his still-lifes; in the foreground, the table on which he made his arrangements. The wooden mannequin reminds us how difficult it was for him to get models to pose in the nude. The walls retain the original rich gray that Cézanne interpreted with infinite subtlety in his paintings — grays achieved through many colors.
4. Skulls on a shelf beside charcoal sticks. Cézanne used a skull in several of his paintings as a reminder of life's underlying structure and man's mortality.
5. On the shelf, elements for still-lifes with a plaster cast of Puget's Putto.
6. Cézanne, The Large Bathers, 1898–1905. Philadelphia Museum of Art.

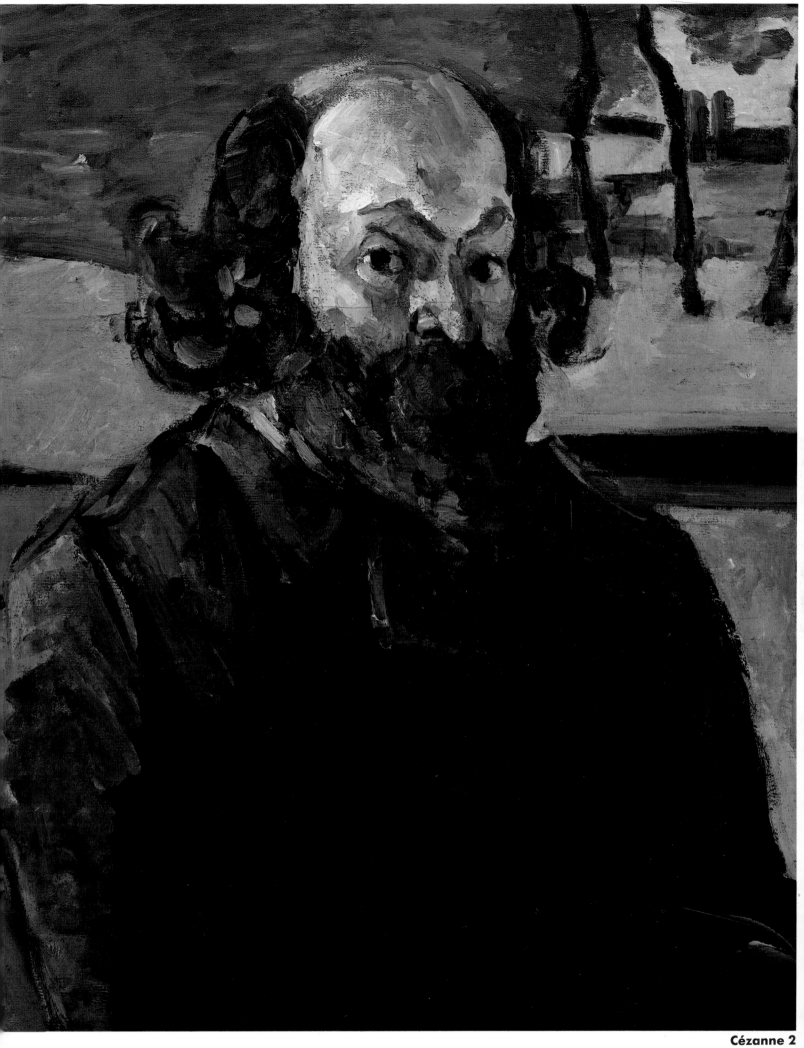

Cézanne 2

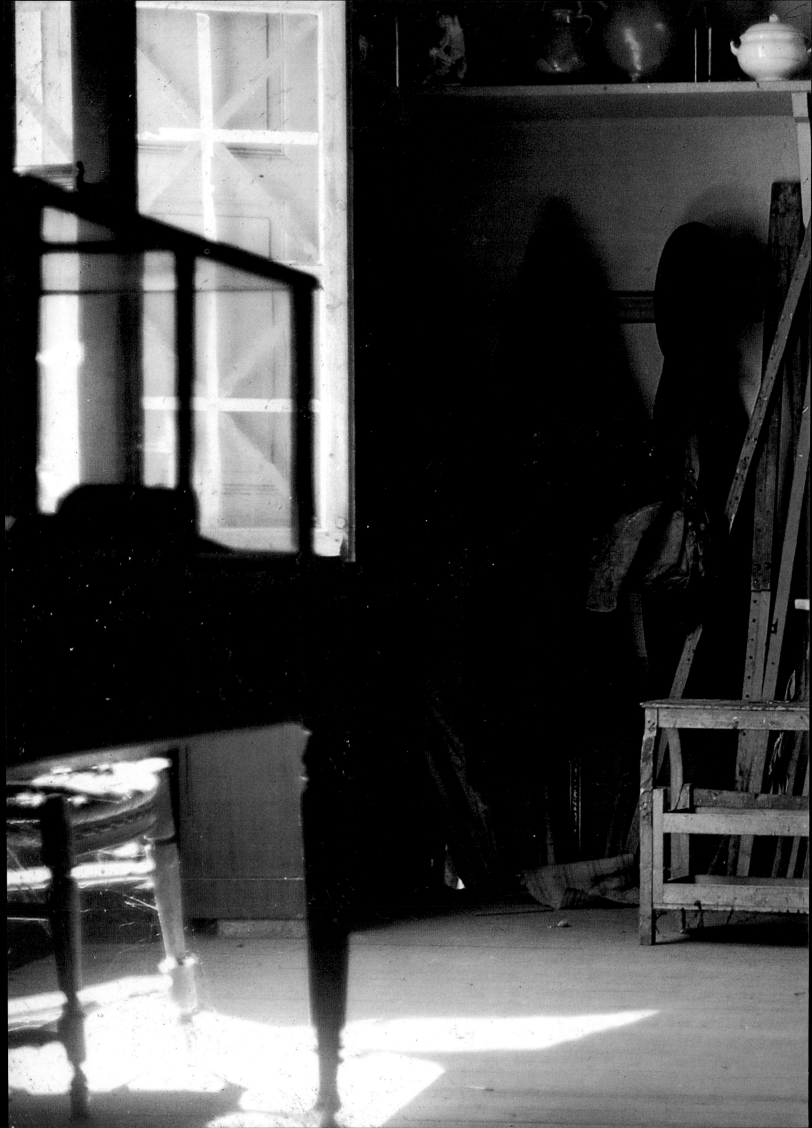

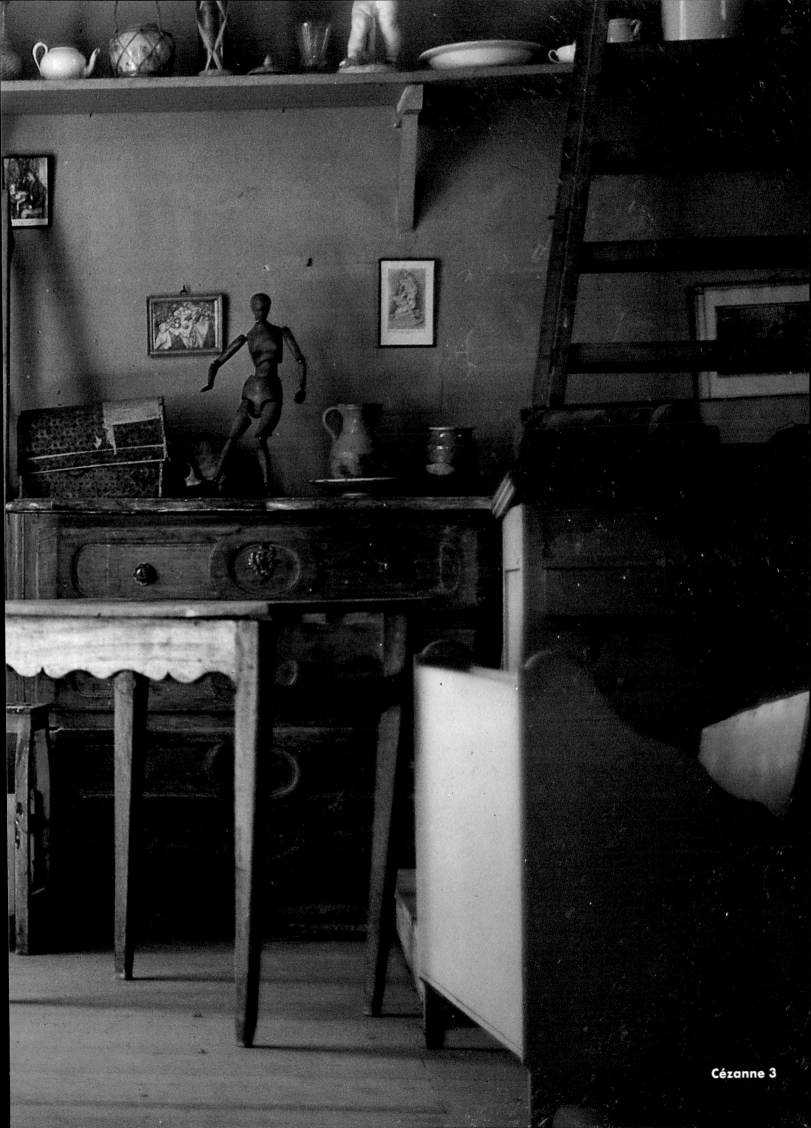

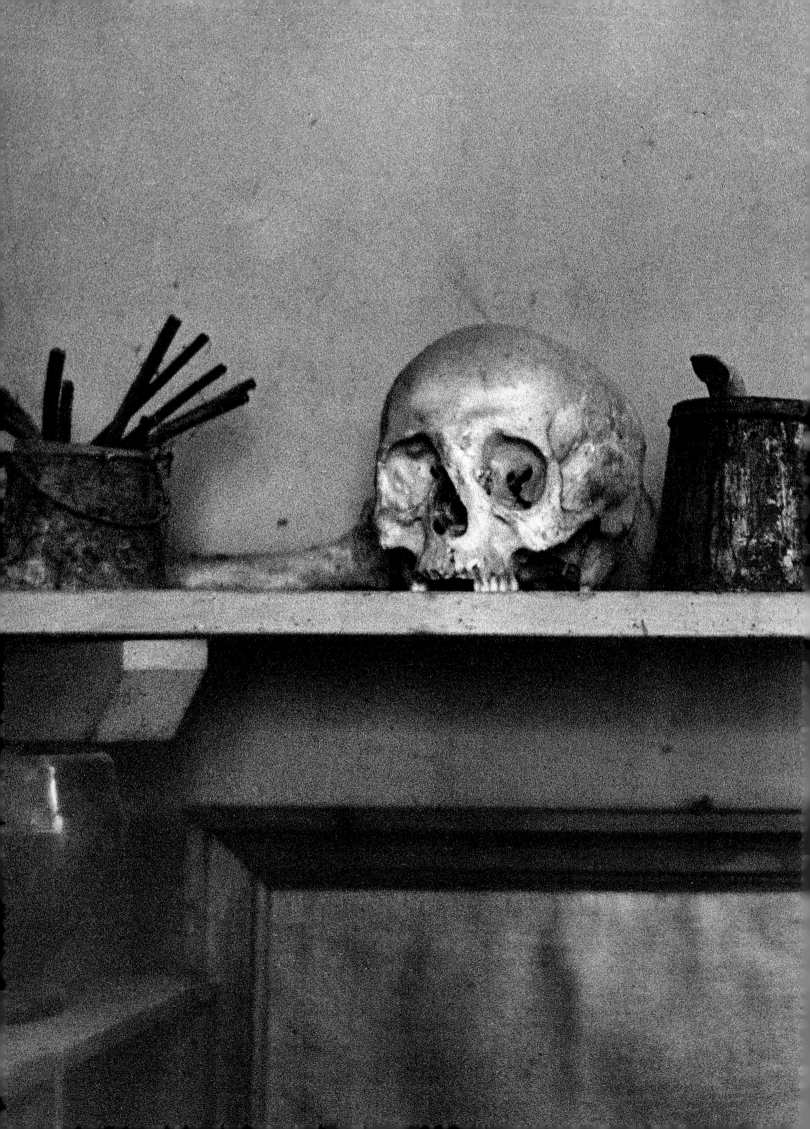

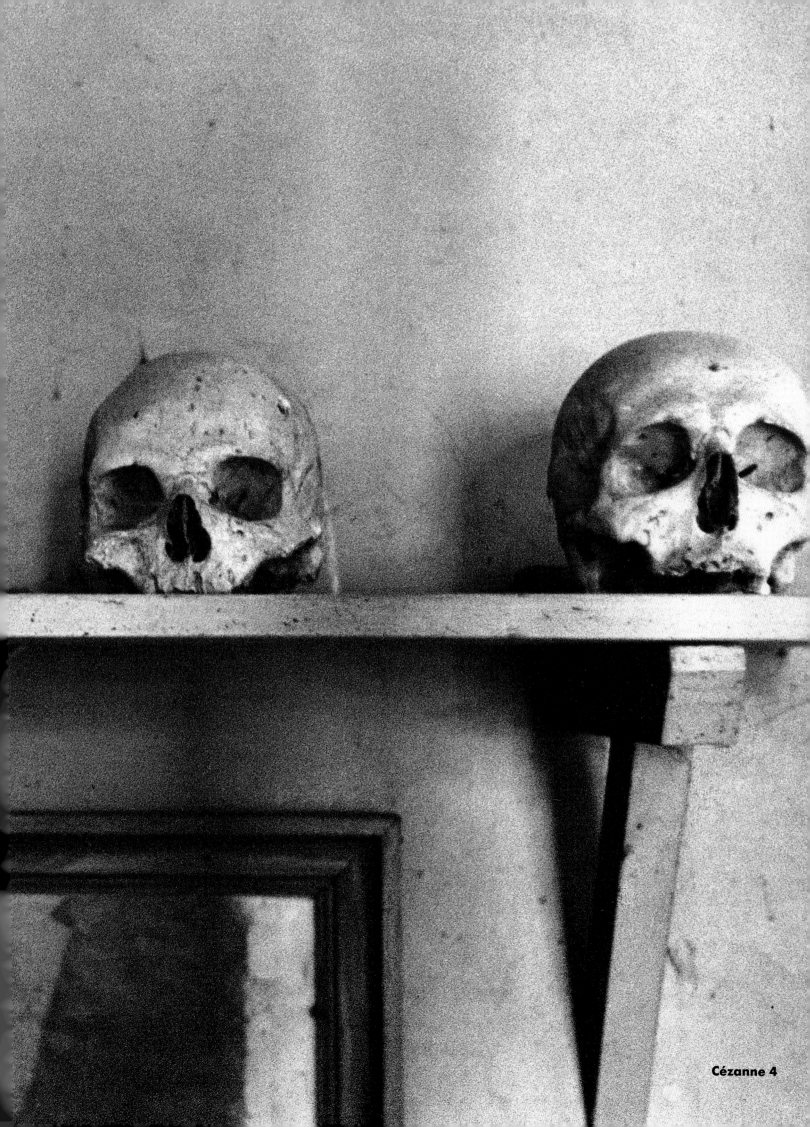

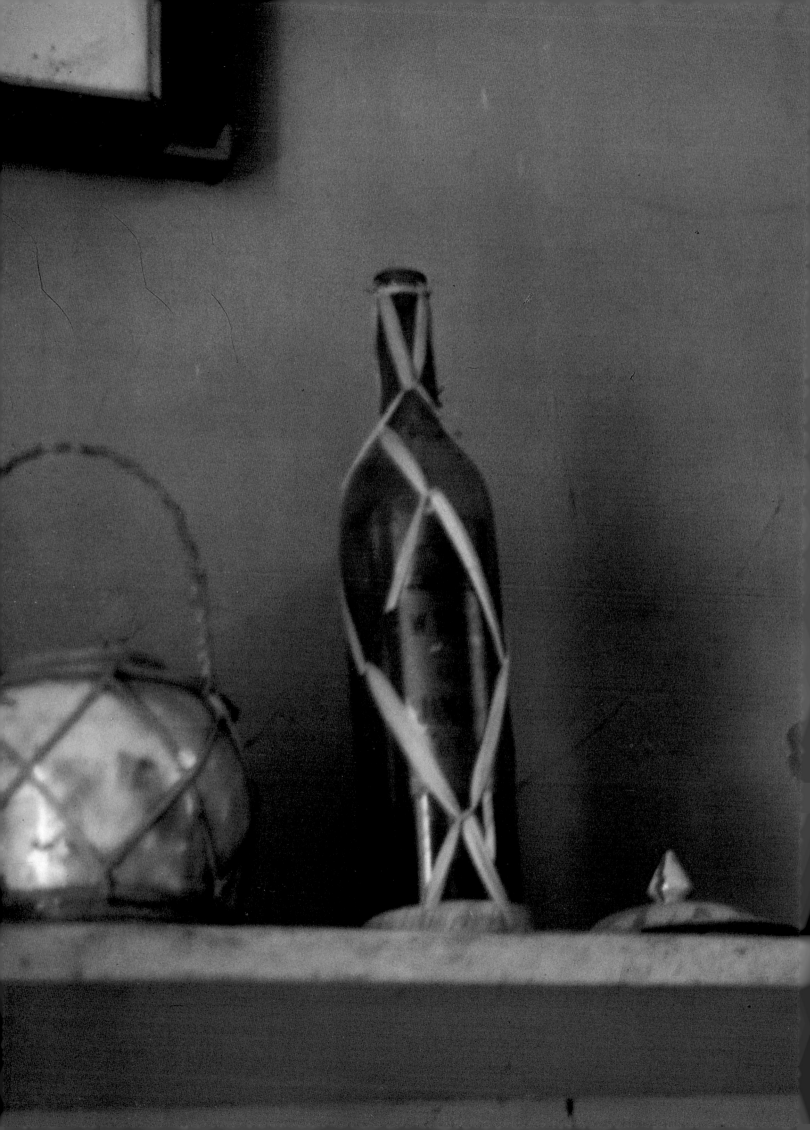

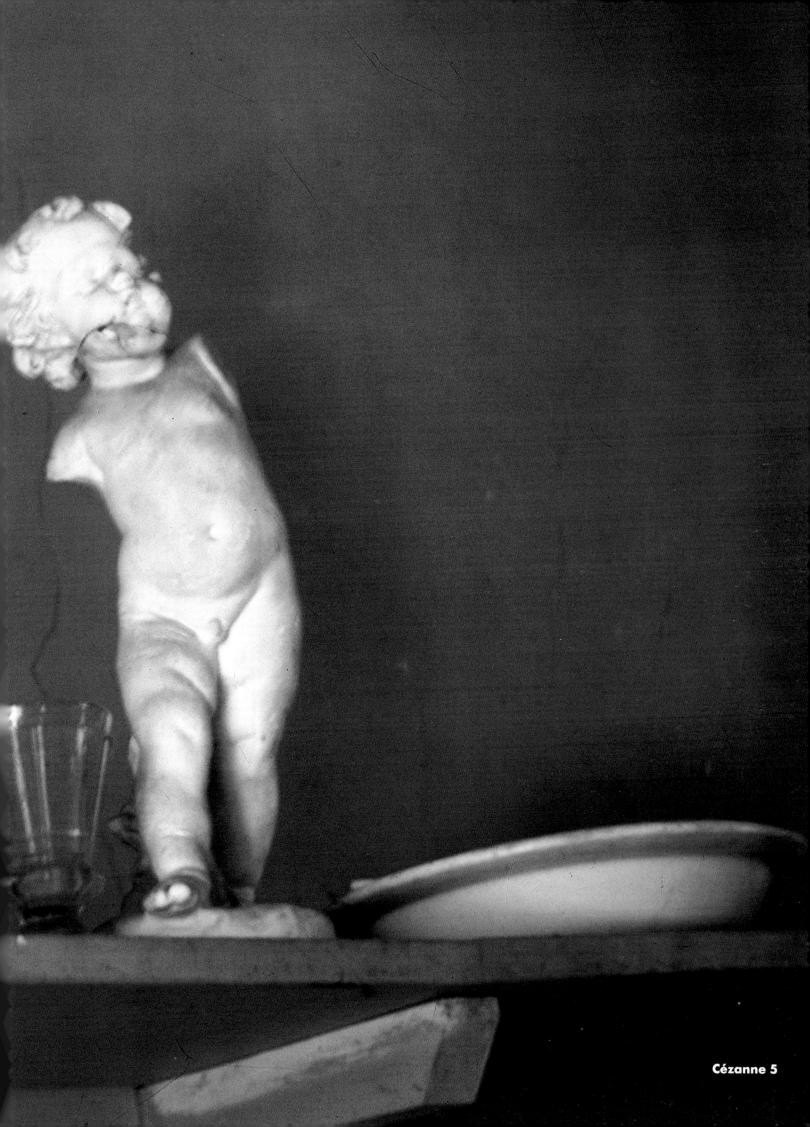

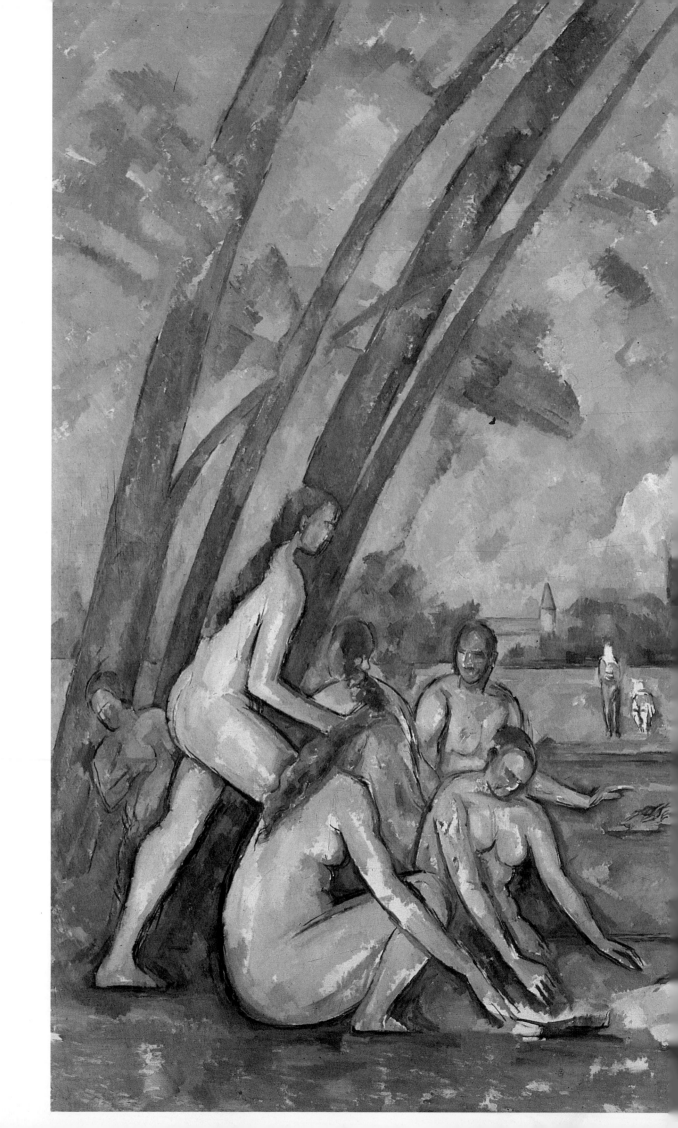

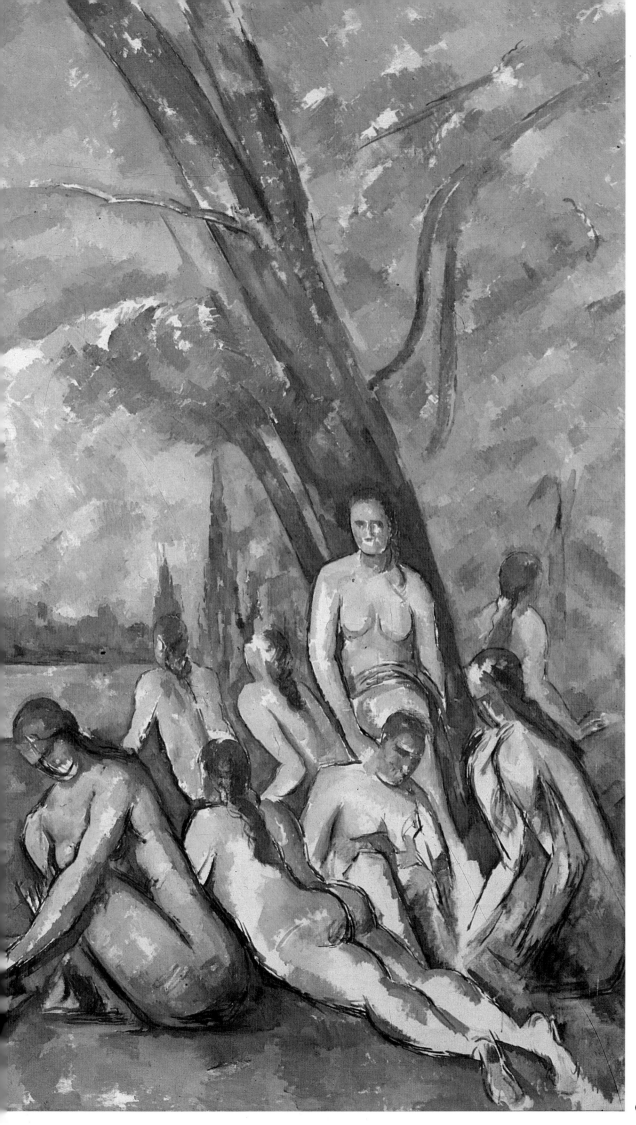

Cézanne 6

Monet

I n 1883 Claude Monet settled in Giverny, a small village on the river Epte, seventy kilometers from Paris; and here, until his death in 1926 at the age of eighty-six, the true founder of impressionism lived and worked in comfort and seclusion.

The image of Monet that the world remembers is the one of him, in the Giverny gardens, in the blue coat and trousers of a gardener, a large hat shielding his eyes from the sun. His piercing eyes peer from this shade like those of a hunter, protected by the leafy shadow, observing his prey. Below the dark, deep shadow across his face, the white patriarchal beard gleamed whiter.

Monet's house and studio have been lovingly preserved by his son, Michel, who lives nearby. Actually living on the place is Monet's stepson, a small, alert old man with a long white beard, who, dressed in the blue overalls of a head gardener, walked with me through the blue-shaded gravel paths. Twenty-eight years after Claude Monet's death, the descendants of the flowers that watched him were surrounding this man, who looked like a materialization of Monet. The white beard created the illusion of time standing still; it was the mysterious, unexpected visual accent that suddenly, like the tuning of an orchestra, gives the right note, synchronizes our sensations, focuses them in the proper channel in order that we may fully experience. The white of the beard, when struck by the sun against the background orgy of violent colors, was a rest, a pause like an uncovered area of a painting through which the pure white of the canvas shows.

A long, low two-storied structure, Monet's house reminded me of the gaily painted railway stations of small French summer resorts. The vivid emerald-green paint of the windows intensified the complementary red paint of the brickwork; large bands of white underscored the banal architecture, the gay colors integrating the building into the tapestry of the garden.

That vast garden of Giverny became his outdoor studio. The Monet garden is a symbol of an era—a moment in history when peace seemed eternal, prosperity guaranteed by science

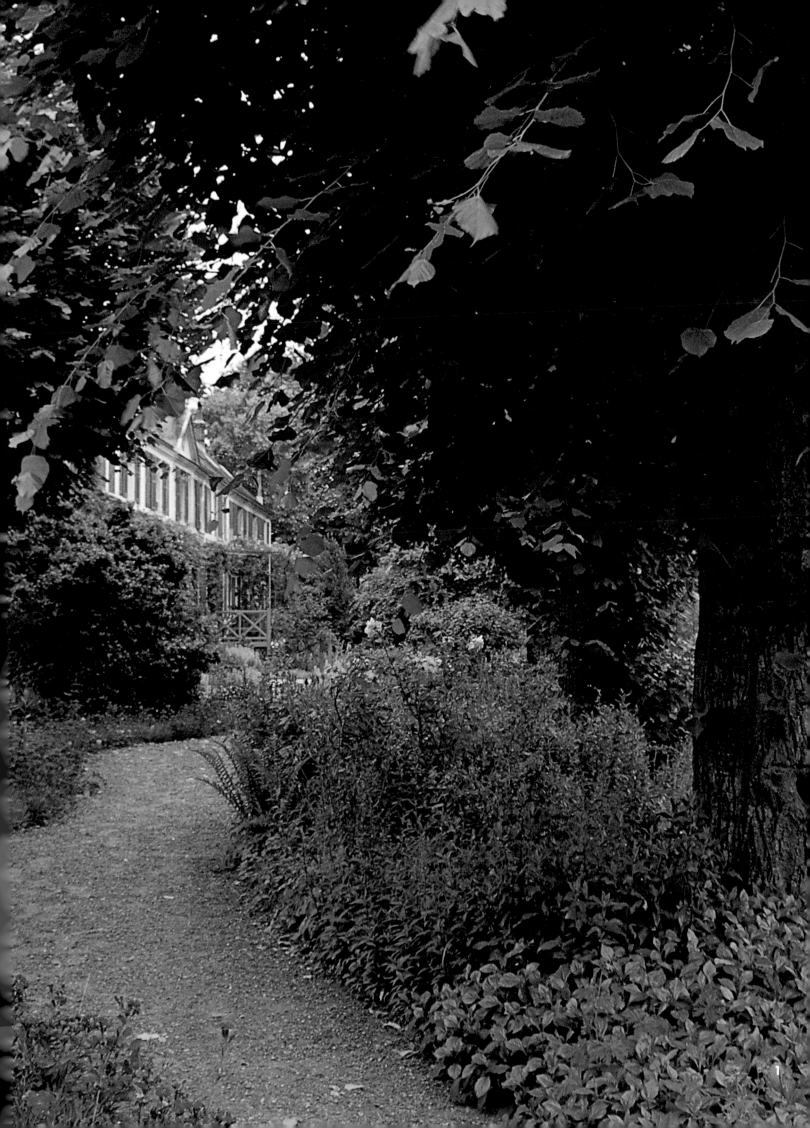

and progress. The early struggles of impressionism were over; Monet, the successful artist, could literally live in his own impressionistic landscape. Here, "nature imitated art." The carefully planted trees, the long *allées*, created depths and perspectives.

But the true meaning of this garden was in the flowers. On that summer day the intense colors of the flowers forced me to stop as though pushed back by their tangible color radiations. The air seemed full of color waves; I blinked, the brief darkness a necessary relief. A step forward seemed possible only under the cover of that momentary darkness. The buzzing of insects underscored the waves of visual sound. In this laboratory of sensual pleasures the colors and sounds entrapped us.

The flowers were planted with apparent carelessness, irregular masses of yellow floating next to patches of climbing pinks and reds in a sea of green. Proust, who used Monet as the model for the painter Elstir in his *Remembrance of Things Past*, had written of Monet's garden: "a garden of hues and colors more than flowers; a garden that is less the old flower garden but a color garden."

Of color Monet said, "When you go out to paint, try to forget what objects you have before you, a tree, a house, a field, or whatever. Merely think, here is a little square of blue, here an oblong of pink, here a streak of yellow, and paint it just as it looks to you, the exact color and shape, until it gives you your own naïve impression of the scene before you."

This vast estate was like a giant nursery in which plants, trees, flowers were but the fertilizer for that mysterious growth, painting. Scattered, independent studio buildings were hothouses in which the slow creative germination of inspiration could take place. The original visual inspiration born outdoors was brought back to the glass studio, where, like a seedling, it would grow hidden from the real world until, full grown, it was a painting.

After we left the brilliance of the outdoors, the enormous studio was dark and austere. The immense panoramic water-lily canvases, leaning against the walls, glowed against the grayness. Covering the well of the narrow staircase leading to his room were hundreds of Japanese woodcuts, their blue dominants vibrating against the acid pink of tall fireweed at the entrance door.

We walked from the studio over to the house. Inside and intact were traces of a comfortable bourgeois life. The all-yellow dining room, its walls densely hung with more Japanese prints, was a place of enjoyment. Monet's stepson said, "Nothing was ever spicy enough for him." The blue-aquamarine-green accents of the evenly spaced prints spotted the chrome-yellow walls like an iridescent collection of rare butterflies.

In the salon were photographs, *bibelots*, and the quiet dignity of rooms formally arranged, but not truly inhabited. For in this house life was obviously elsewhere. Monet paintings hung in several rows on the walls, their watery greenness made more intense by the green reflections of the emerald shutters. On tables were blocks of crystal and pale Japanese

prints and, like offerings in an ancestor cult, freshly cut flowers, placed by his sons in the many vases scattered around the dark room.

The center of the house, with a few steps leading to the small iron-grilled door, was the axis for the principal *allée* of the garden. A series of iron arches encased that *allée* in a flowered grip. Those arches, now partly uncovered, poked their rusty skeletons through the masses of climbing roses; metal, rust, flowers, a curious funereal association, with yet a suggestion of a country fair in the naïve humor of these triumphant arches.

To enter Monet's most private garden with its extraordinary Oriental water-lily pond, we had to cross the railroad tracks that cut through his meditative, tender, and flowered landscape. Those tracks sliced through the two garden worlds of Claude Monet—the French impressionist garden and the Buddhist water-lily pond.

Around the pond the all-pervading green gave a monochromatic sensation. This one-color dominant allowed him a visual rest and a concentration on deeper values. His pond was the culmination of Monet's lifetime interest in Japanese art.

Oriental art, which gave a direct impetus to Monet and impressionism, can be fully understood only through the knowledge of Zen. Truth cannot be understood, it must be felt. Each one must seek it for himself and find it himself; nothing can be taught. One of the fundamentals of Zen is that it is impossible to describe in words that which it is most important to say.

Tao is the way of nature, the universal order; the Oriental artist seeks it in contact with nature, and that is why landscapes are a favorite theme. Occidentals make a great mistake if, in the art of China and Japan, they see an impressionistic study of mountains and lakes. The Oriental artist, in a state of meditation, expresses through familiar visible symbols, such as mountains and waterfalls, a deeper truth.

Since symbols are abstractions, the seemingly realistic art of the Orient is actually an abstract painting in which the symbols used have the appearance of reality. The waterfall stands for a "symbol of continuous movement, a symbol of the world in which elements constantly change, but form remains unchanged."

To practice Tao is to live according to nature, to accept it as the all-pervading force of the universe. Man must comply with it and not seek to dominate it. Humility of man, humility of nature are essential for a harmonious existence. Water, which always seeks the low places, is a visual symbol of this belief. Water always held a fascination for Monet. In its transparent liquid density he saw a tangible materialization of that invisible air that bathed the nature he painted. Water became a liquid air. The ever-changing states of water, like a flexible optical system, helped Monet and his colleagues to see the structure of light.

It was to be Monet's destiny to investigate deeply some of the major preoccupations of contemporary art: the Orient, light, color, and abstraction. The great reevaluation of Claude Monet, taking place today, is due to his prescience. Toward

the end of his life, blinded by cataracts, Monet, the great visionary of light, was again as desperate as in the heroic days of impressionism.

People sometimes forget how impressionism came about. Claude Monet, who became the undisputed leader of the new movement, was born in Paris, the son of a grocer. His childhood was spent in Le Havre, the great French Channel port. At sixteen he drew caricatures with such success that one of them was noticed at a frame-dealer's by the painter Eugène Boudin. He initiated the young Monet, making him a disciple of his faith that art needs nature and that the studio must be abandoned for the direct contact with the living light of the outdoors.

Monet became part of a group of artists who regularly came to the Channel beaches to paint—Boudin, Jongkind. The seascapes that they painted were studies of space, color, and light—a realistic attempt to render the until then unpainted atmosphere. This air, this ether that bathes all nature, was here rendered more visible by the presence of water.

The two years of military service that Monet spent at the age of twenty in North Africa were to play a decisive role in his perceptions; like Eugène Delacroix, the great colorist, he had found in the light and color of Africa the answer to his thirst for new visual sensations. Monet said, "The impressions of light and color that I received there were not to classify themselves until later; they contained the germ of my future researches."

After an illness he returned to France, where he met, and through the years became inseparable from, all the men who were to become his companions in the struggle for a new art—Manet, Renoir, Degas, Pissarro, Sisley, Cézanne. These men, under the influences of Delacroix's color and Courbet's realism and Corot's vision of nature, led the revolt against academic art with its dirty-brown imitation of old masters.

At the 1867 Paris World's Fair they came in contact with Japanese art. This vision of the world with its conception and techniques of art, new to the artists of France, had a deep lasting effect on all the Occidental artists. The Japanese engravings were to have the same revolutionary effect on the creative thinking of the impressionists as Negro sculpture had later on the cubists.

In 1874 Monet exhibited a painting, *Impression, Sunrise*. The academic critics seized on his word and from then on "impressionism" as a derogatory label clung to Monet and his friends. To be an impressionist one had to have strength of character, for this new art was ridiculed and insulted. At one time Monet, desperately poor, thought of suicide, but his courage returned. Eventually he had the acclaim of those who had earlier condemned his work. Finally rich, he bought his house in Giverny.

He lived long enough there to feel again out of fashion. His last years were saddened by the lack of understanding that surrounded his final creative research, the great series of *Nymphéas* or water lilies. In these paintings, the creative fire, before dying out, gave forth a final spark, igniting the imagination of future generations. They were a symbolic transmission of the flame in the creative relay race that is life.

Around 1900, when Monet started building his Giverny pond and garden, there was a profound revolution in thought. Henri Bergson, the great French philosopher, who died in 1941, led the revolt against materialism and related time and life in his "creative evolution." Einstein brought out his thought-shattering concepts of relativity based on a new use of light as a constant of the universe. The notion of time as an imperative of life suddenly took on new importance in man's consciousness. Marcel Proust tried in literature to recapture time already past. The camera and the cinema were changing man's vision, giving him the means to record and capture segments of time. In a curious way the impressionists previsioned the coming change.

Maybe painting should be reevaluated and considered as one of the major thought processes of humanity. The artist may through intuition see certain truths and unknowingly express them on a canvas; he may well be ahead of the scientists, writers, and philosophers of his time. Even the greatest scientists admit that in scientific discovery there is a part of intuition, of creative inspiration; they too are artists. The painters who discovered the visual properties of light changed the vision of the world and opened the eyes of scientists.

Einstein's conclusion that matter and energy are interchangeable terms curiously paralleled Monet's and the impressionists' research. These painters had for many years disintegrated on their canvases the tangible vision of nature; they were not painting the solidity, the substance of matter, but, by transcribing the color sensations that reached their eyes, unwittingly were making energy notations. For light is energy; color is a variation of light's energy.

Monet tried to "fix his sensations," the fleeting imprint on his eye. The painters of the period became living sensitized films, competing with the camera in the recording of nature. Light became the principal and unique subject of painting. Theirs was a daring gesture. They opened the door to all modern art. Once the apparent unity of visible nature was dislocated, light broken up into color components, once the questioning mind was focused onto that which had never been questioned, man's vision of the world could never again be the same.

Out of the impressionistic dogma of light split up into its components on the canvas and optically recomposed in the spectator's mind came the necessity to apply paint differently. The spectator, confronted by the seemingly loose, deliberately unprecise brushstrokes of Monet, by his transitory impressions of time fleeting on the surface of reality, has to contribute his share of participation. A painting never again would look photographically finished on the canvas; the ending had to be supplied by those who saw it. The demand for totally realistic art is an acknowledgment of mental laziness, a refusal of effort, and in the end a debasement of art and of the individual.

The Gestalt theory of perception had around 1910 discovered that the human mind tends to the act of closure; an unfinished, a suggested, circle looks to us still like a circle. The "unfinished," the incompletely defined canvases of Mo-

net are the incompleted aspects of reality that still look to us like reality, and more so than the exact portrayal of nature by the realists. Even the great representational painters always left in their art an escape for the imagination; Rembrandt's escape hatch lay in the miracle of illuminated form losing itself in shadow.

Through the interstices between the rough brushstrokes of the impressionists, mystery could be sensed. For the painter seemed to say: This is all that can be portrayed, the rest cannot be portrayed. To define form completely, to describe all, "to finish," is to die.

The great painters knew that great secret and had the strength not to paint it. A Chinese sage said:

The greatest perfection must appear imperfect,
Then it will be infinite in its effect.

One discovers how much a brushstroke is a true expression of the artist by studying the earliest works of the great painters. In a corner of one of these canvases there is always an area, seemingly unimportant, where a few brushstrokes become through the years the silent witnesses of the artist's inescapable nature. When, fifty or sixty years later, in the full possession of his creative means, the artist paints a picture, the small original pattern of brushstrokes, like a seed planted in fertile soil, has multiplied, and the whole new canvas bears a profound resemblance to the original imprint of personality.

The brush is but the extension of the artist's eye; as the needle of a seismograph shows the slightest tremors of the earth, so the brush-needle shows on the canvas the slightest tremors of the artist's emotions. To free his eye, to purify his vision, Monet attempted to disconnect his mind. Paul Valéry defines vision: "To see is to forget the names of the things one sees." Monet tried to connect in an inspired automatism the eye directly to the hand of the painter.

He painted with the suppleness of an artist who wanted a deep union with nature; his brushstrokes, his calligraphy, were a pliant reflection of his vision. In fact, Monet wrote, "I have no other wish than a close fusion with nature, and I desire no other fate than (according to Goethe's precept) to have worked and lived in harmony with her laws."

As an impressionist, Monet was always conscious of time. Vollard told this story to Degas: "Listen, Monsieur Degas…one day in Varengeville I saw a small car arrive in a cloud of dust. Monet gets out, looks at the sun, consults his watch, and says, 'I am half an hour late; I will come back tomorrow.'" Monet would choose a subject, then paint it for days, months, years under every hourly changing aspect of light, the succession of views creating a giant cinematographic color film. He returned at precise hours of the day, to be sure to see the subject under identical conditions, then put that canvas away to work on another that corresponded to the changing light. Time guided him when he started his series of paintings of cathedrals, of haystacks, and of water lilies. The need for series expresses an artist's knowledge that nothing can be wholly perceived and expressed in one experience.

Just as the Japanese *makimonos*, horizontal landscapes with figures painted on long rolls of silk, preceded our cinema in the unreeling of time, so Monet often changed the shape of conventional canvases into long, narrow rectangular canvases which cannot be comprehended in one all-embracing view. One has to read them as one reads a line of text. In his masterpiece, the immense panoramic panels of water lilies, now in the Paris Orangerie Museum, he envelops the spectator, who becomes immersed in the *Nymphéas*.

If it were possible to record on film in chronological order all the paintings created by an artist during his lifetime, the whole creative life, when unreeled, would give us a life capsule. An artist's life is a succession of creative moments, each one marking a chronological development; his works of art become the exterior signs of inner growth. The painters themselves, when they date their paintings, mark the significant and inspired moments of their creative lives. To capture and record time a painter paints; paintings become the inscriptions on the memory of the world.

Cézanne's series of apples, his series of the Mont Sainte-Victoire, Monet's water lilies, cathedrals, and haystacks are the images of man's creative motion flowing around a fixed point of interest, nature. That fixed point rallies the scattered senses, intensifies the creative urge by channeling its drive. This withdrawal from all-surrounding life, with the exception of the particle through which revelation is sought, is a painter's meditation. The creating of art is the revelation of oneself through oneself. This sense of being part of a celestial and earthly harmony creates an urge to express it. This perception of the infinite, through creative meditation, is the inspiration of the artist.

Notes on the Illustrations

Claude Monet, 1840-1926. Born: France.
Photographs taken in 1954.

1. An alley in the garden looking toward Monet's house and the small living room-studio on the left.
2. A corner of Monet's yellow dining room hung with his favorite Japanese prints, a great influence on his art.
3. Monet's oriental water lily pond. The water lily, nymphea, or lotus flower, is sacred to the Buddhists, a symbol of the deliverance of the soul through knowledge. Here in the lotus garden Monet, from 1899 until his death in 1926, pursued his great visual meditation in paint, the Nympheas *series.*
4. A view of Monet's small studio-living room in the house. On the walls, some of the master's paintings; the steps to the right lead to the dining room.
5. In a former studio, apart from the house, stand some of the last paintings of the Nympheas *series.*
6. Close-up of a water lily, the focus of his study of light and water.
7. Close-up of brush strokes in one of Monet's Nympheas. *Here is the artist's handwriting transcribing the mysterious fusion of flower, sky, and water.*

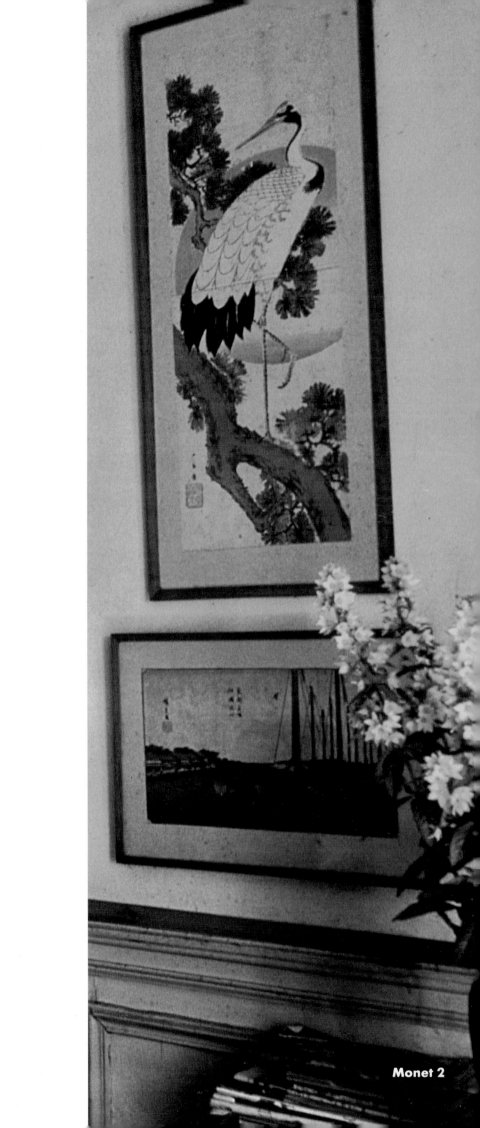

Monet 2

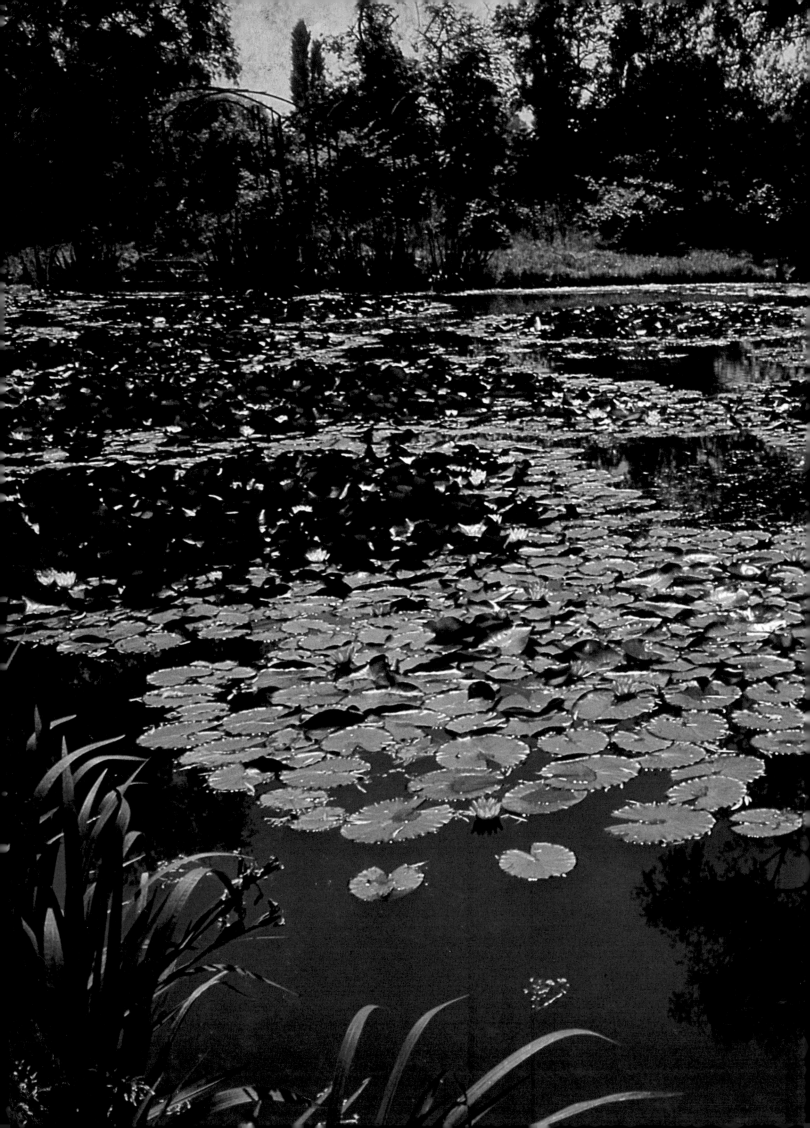

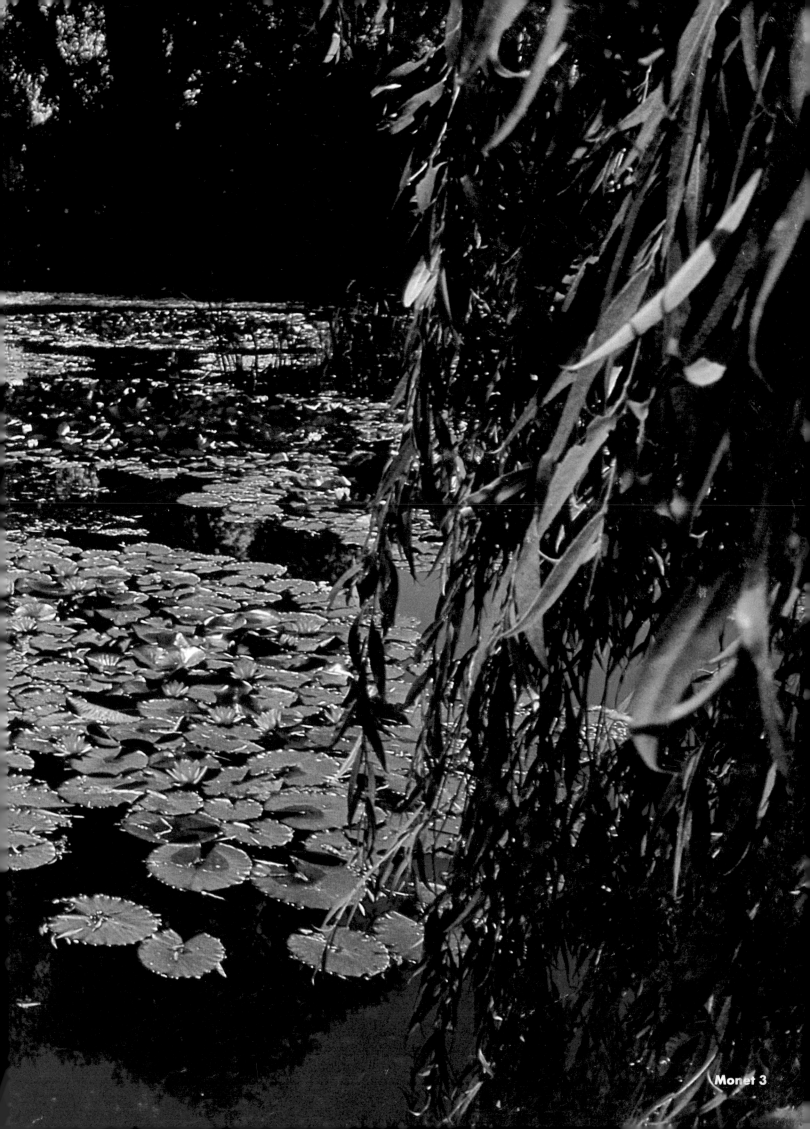
Monet 3

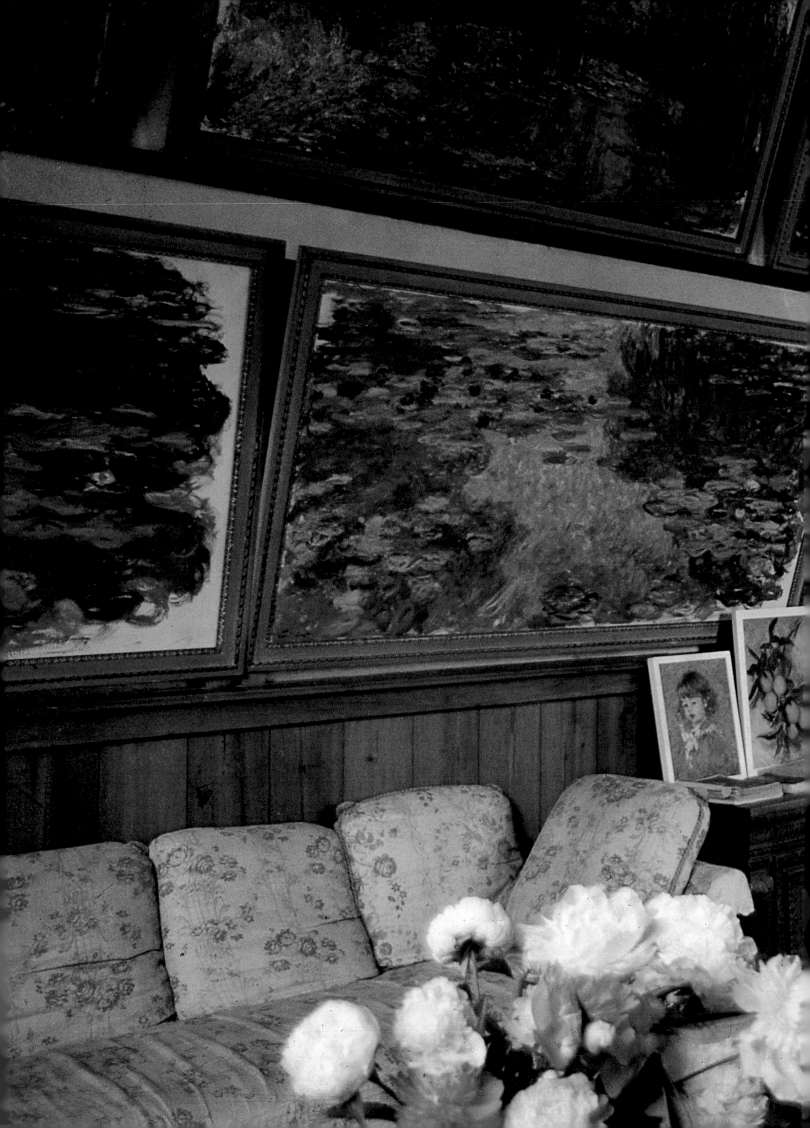

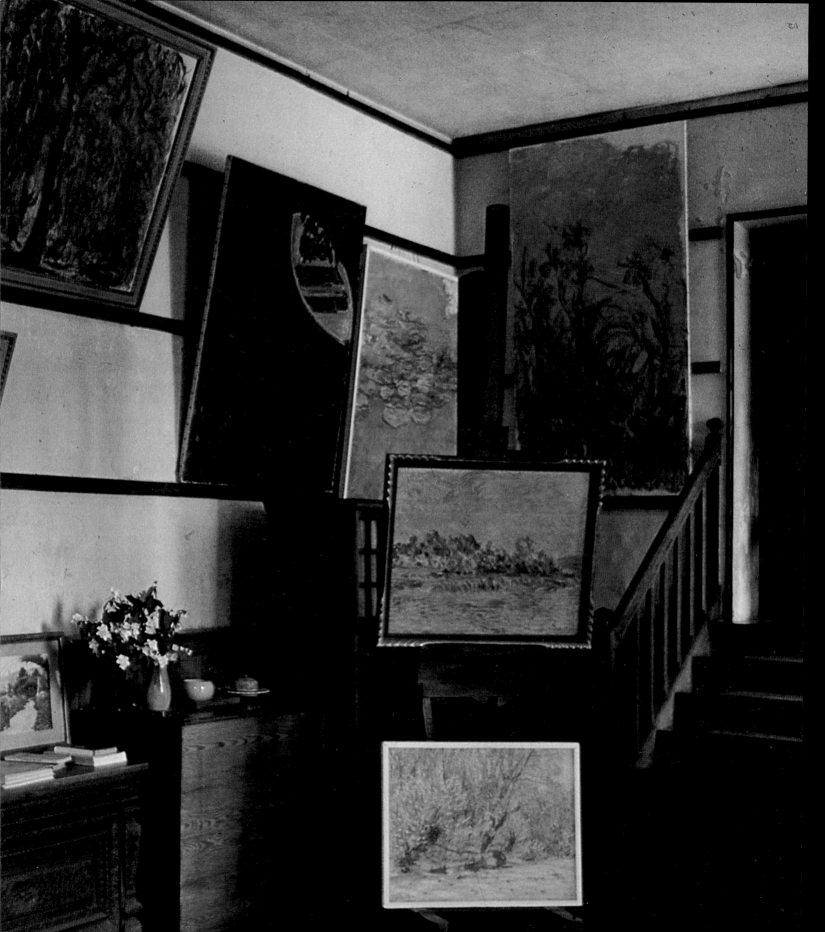

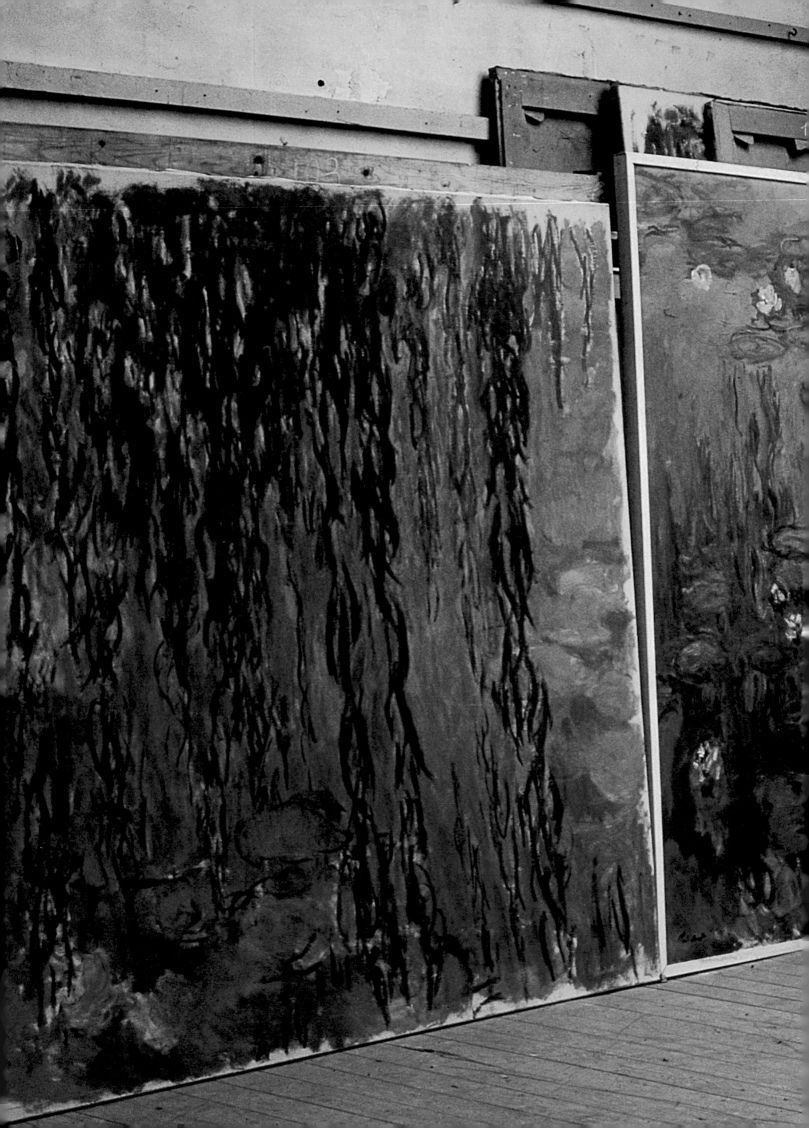

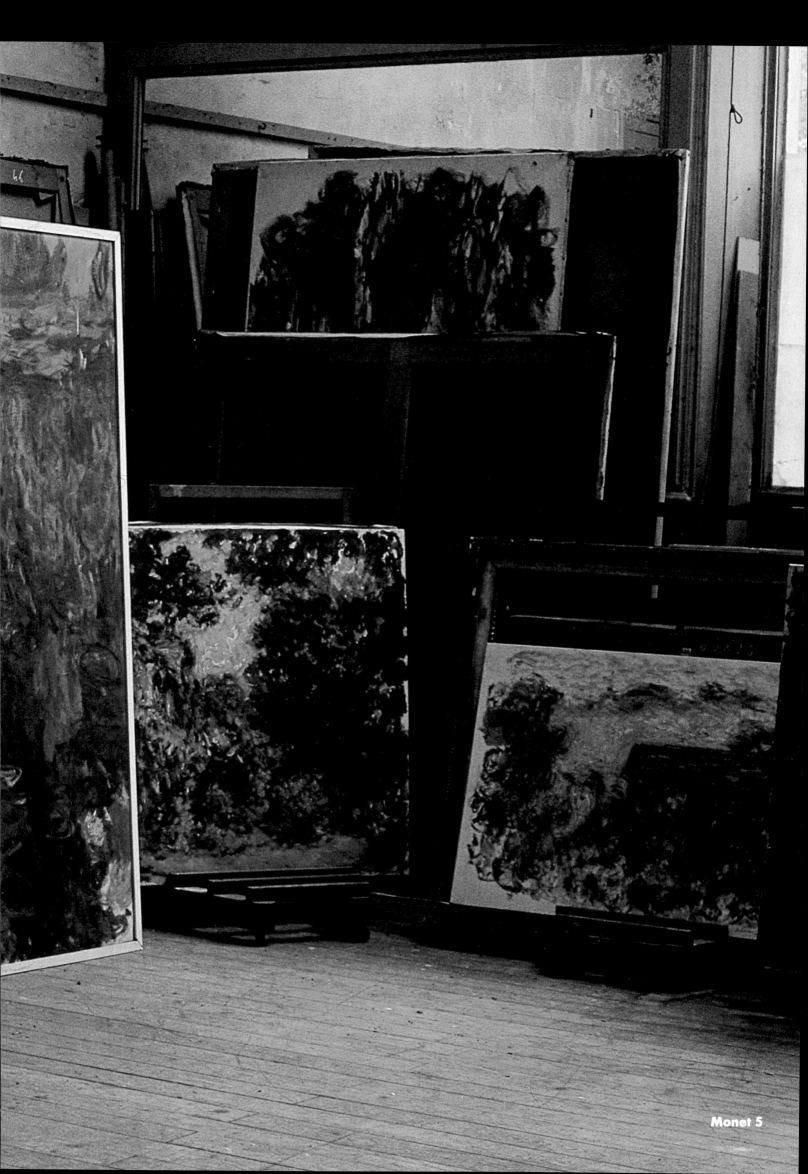

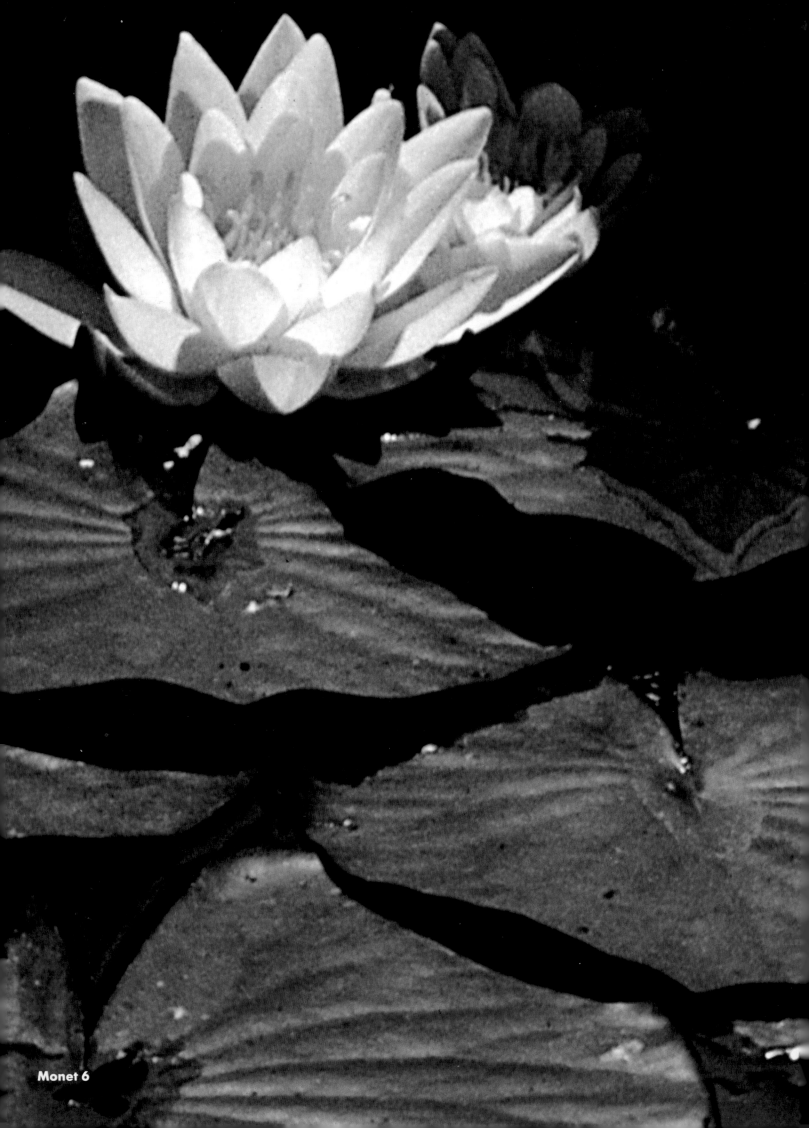

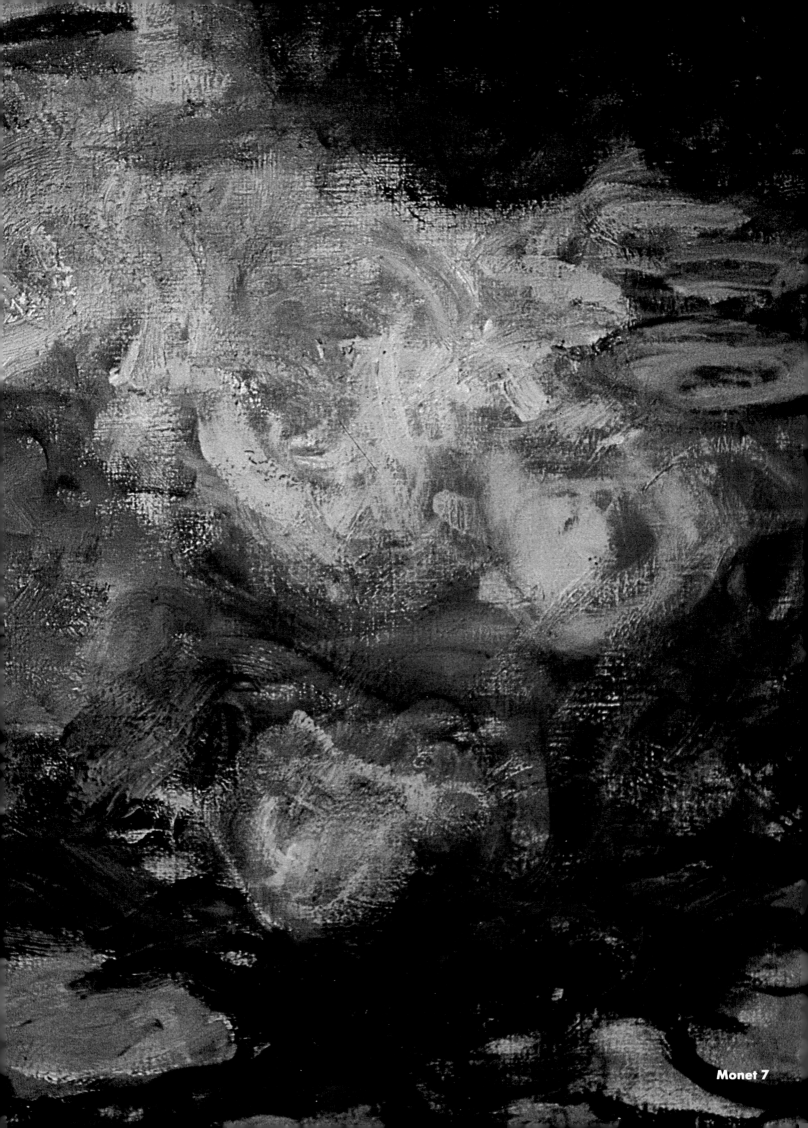

Monet 7

Renoir

Les Collettes, Auguste Renoir's villa in Cagnes on the French Riviera, is the tangible trace left of the master's way of life. His studio, once a glass construction in the garden, was so badly damaged by a bomb in the last war that it had to be destroyed. The villa is a large one with terraces, regal in comparison with the simple dwellings of most artists. The nineteenth-century bourgeois elegance and formality of its interior remind one of the artistic conventions with which Renoir had to break.

Along the main drive up to the entrance of the villa, palm trees add their stylization of form to that of several Renoir sculptures. The magnificent century-old olive trees that Renoir painted so many times are like human bodies writhing in space, bathed by the scintillating reflections of sunlight through their silvery leaves. When the mist rises from the sea and softens the blinding Mediterranean light, the subtlest hues of color become intensified. If one stops to meditate in this landscape, the vision of Renoir emerges. His search, a classical one of the artist, was to incorporate man into nature, for nature, however beautiful, does not give a sense of total fulfillment without a fusion by the artist of the human with the inhuman.

Renoir moved to Cagnes in 1903 and died there in 1919 at the age of seventy-eight. Toward the end of his life he suffered severely from rheumatism and had to be wheeled about in a chair. His arms, however, were not crippled, and he painted with brushes tied to his pain-knotted hands. It was during this time at Cagnes that he developed the grand style of his late period. Freed from the doubts of youth, freed from the need of scholarly discipline, he invented a new intensity of form and color. He had reached the knowledge that "Regularity, order, desire for perfection (which is always false perfection) destroy art.... Irregularity is the basis of all art." This freeing of a painter's vision is the moment of revelation that some great painters reach in their long lives. Renoir was one of the fortunate geniuses who live long enough to begin to see what they search all their lives to see.

Notes on the Illustrations

Auguste Renoir, 1841–1919. Born: France.
Photographs taken in 1957.

1. The living room of Les Collettes. Toward the end of his life Renoir, because of acute rheumatism, had to spend more and more time in the South. Here, in this house, he lived a calm, organized, elegant bourgeois existence. In the dining room, many simple wooden chairs around a vast table recall the children and grandchildren who animated the quiet of his final retreat.

2. The olive trees and luxurious vegetation that surround Renoir's house in Cagnes-sur-Mer on the French Riviera. This is the vision of nature from which he drew his last inspirations. Renoir is, above all, the painter of the human form, but like the great masters of the past, he attempted the union of body and flesh with the elemental forces of nature, made possible by the miracle of light.

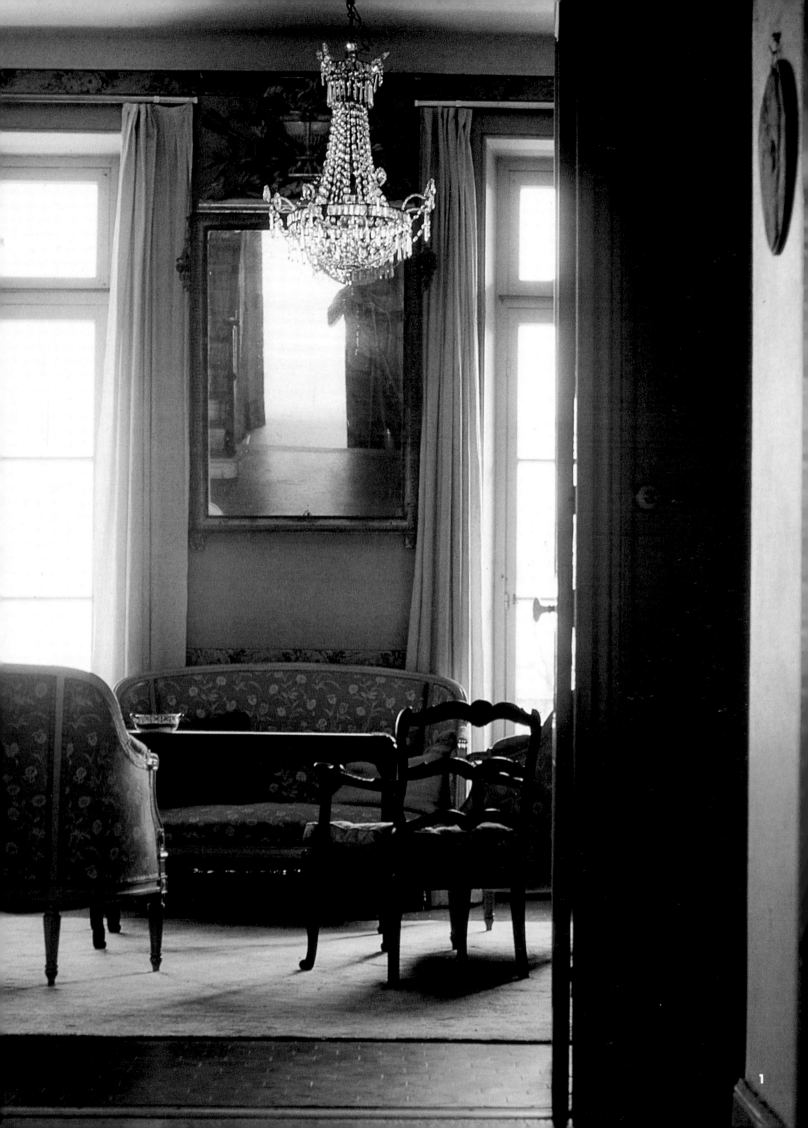

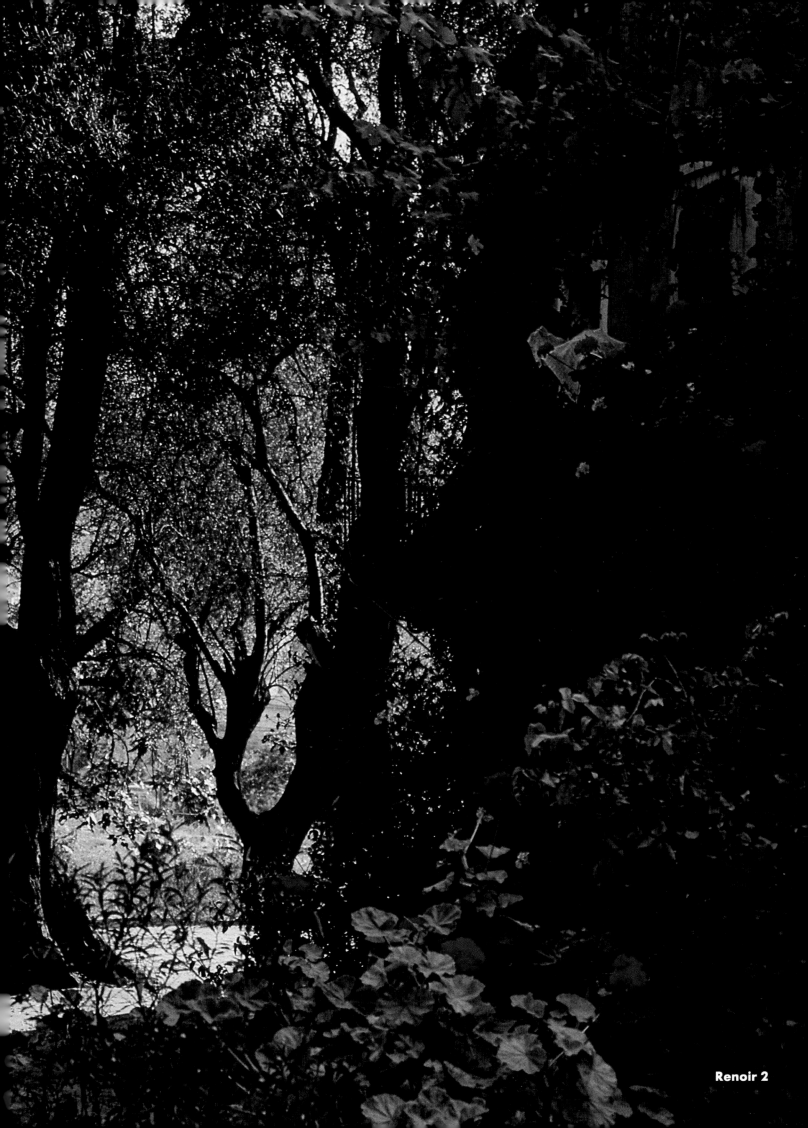

Renoir 2

Bonnard

Cézanne once said, "I could keep myself busy for months without moving from one spot, just by leaning now to the right, now to the left." Pierre Bonnard found worlds to paint in the personal, intimate world that surrounded him. His most radiant canvases were painted in the small, modest villa that stands in Le Cannet on top of a high hill dominating Cannes on the Mediterranean. There Pierre Bonnard lived from 1925 until his death in 1947.

When I went to Le Cannet in the middle of the summer, there were complete quiet and very little movement on the steeply winding avenues. In the haze, the red tile roofs of the carpetlike city below Bonnard's house combined with bright geraniums in a glimmering visual pattern. The pink walls of his villa were faded by sun and rain. A beautiful garden surrounded it, dense and thick; patterns of trees, shrubs, flowers, bushes intermingled, pierced with windowlike openings through which the eye escaped into a panorama of sky, mountains, sea, and distant Cannes.

On a clothes rack in the entrance hall hung the soft beach hat Bonnard loved to wear, the kind of hat a French bourgeois wore to the seashore in 1900. In its limp, amorphic shape one sensed the love of ease of the man who wore it. In the dining room that opened out onto a garden terrace still stood an immense table covered with a thick dull-red felt cloth, scattered with empty fruit baskets and jars. This red felt cloth was the singing accent in many of the Bonnard paintings.

I walked up one flight to his simple bedroom with its little open washbasin. The walls were pale blue; a narrow dust-gray bed stood next to the small window. Pale, worn remnants of clothing were still in their place—the formless sweaters and jackets of an elderly gentleman. Across the narrow hall there was a boudoir, and, beyond, Madame Bonnard's bedroom, where a yellow-painted wooden terrace opened out onto the trunks of palm trees and the immense blue of the Mediterranean. A torn Japanese print decorated the wall of the boudoir, a remnant of the late nineteenth century, when the Japanese influence was beginning to be felt.

His bedroom communicated with a bathroom, perhaps the most arresting room in Bonnard's house. For it was this simple white and blue tiled room with its antiquated gas water heater, illuminated by intense sunlight and an immense, luminous view, which gave him the background for many of the paintings of his greatest nudes. A white bathrobe hung in soft folds on one wall.

Not far from that room was his studio, the smallest studio of any great modern painter, a most impractical and uncomfortable workroom. In this already cramped area a tall platform had been erected. On it stood a couch, a work table, an armchair.

Bonnard used to tack to the walls the canvases on which he was working—several paintings would hang side by side. He worked on two or three at the same time, returning to add an accent after many days or even months. A slow accumulation of sensation was both Bonnard's life and method; he never knew where any canvas would stop. He cut off the canvas whenever he felt his emotional needs were satisfied.

There was no haste in the execution of his art. The brush seems to have meandered over the canvas as if the painter had time to pause and enjoy, and sensuously, caressingly describe.

On the wall above his shelves, right in the middle of his working area, he had neatly arranged and clearly exposed his inner admirations: Delacroix, Picasso, Vermeer, Monet, Seurat, Gauguin, classical Greek sculpture, and even a preferred Bonnard hung in a rich mixture of black and white and color reproductions. Three cheap colored postcards of the Midi gave life to a map of Cannes. Above it hung the strangest souvenirs of all—silver chocolate wrappings neatly pinned into various sizes and shapes. Glowing next to this museum, the crumpled, glistening tinfoil was a constant reminder of the master of all art, light. On some of the tinfoil there was a stamped pattern. It seemed to hold light captive. All his life Bonnard was fascinated by pattern.

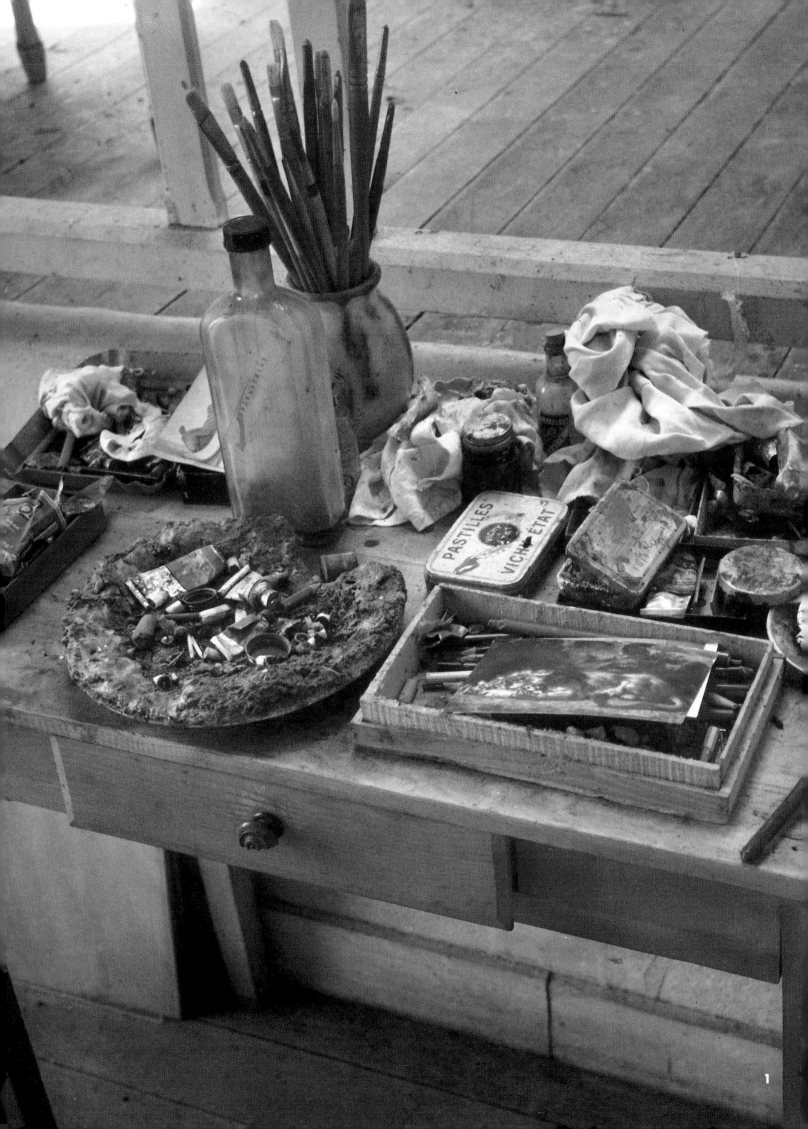

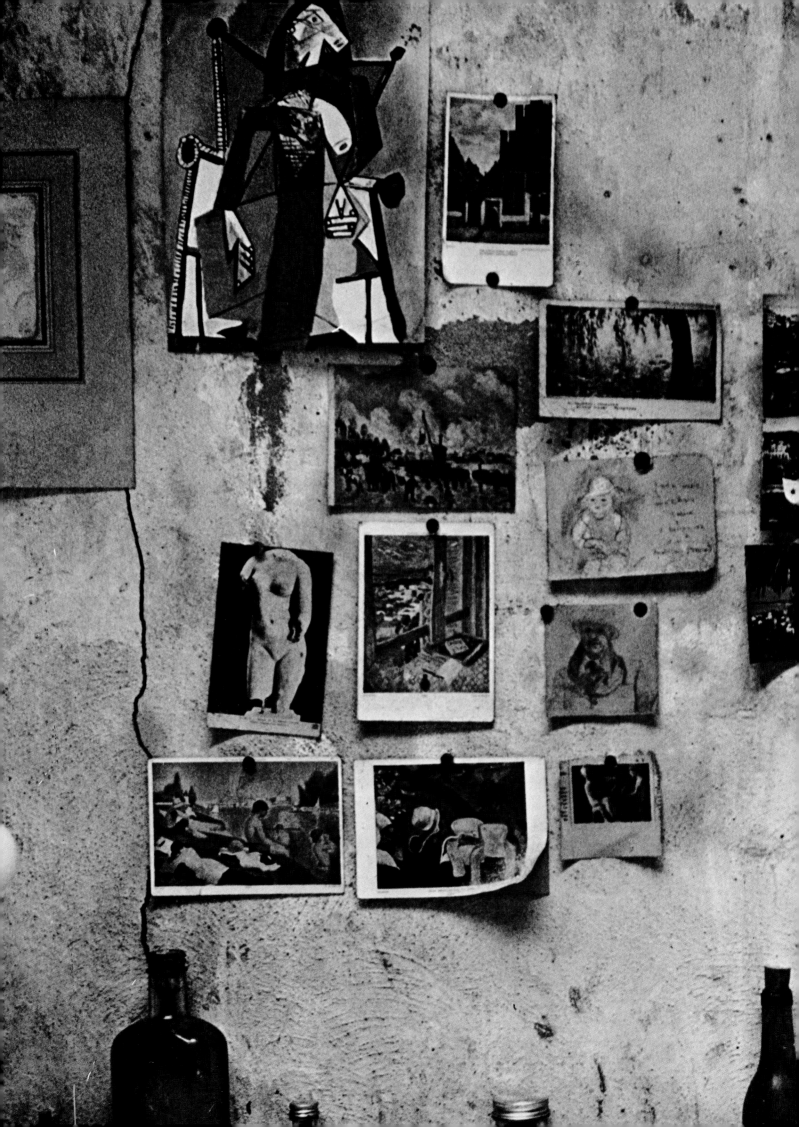

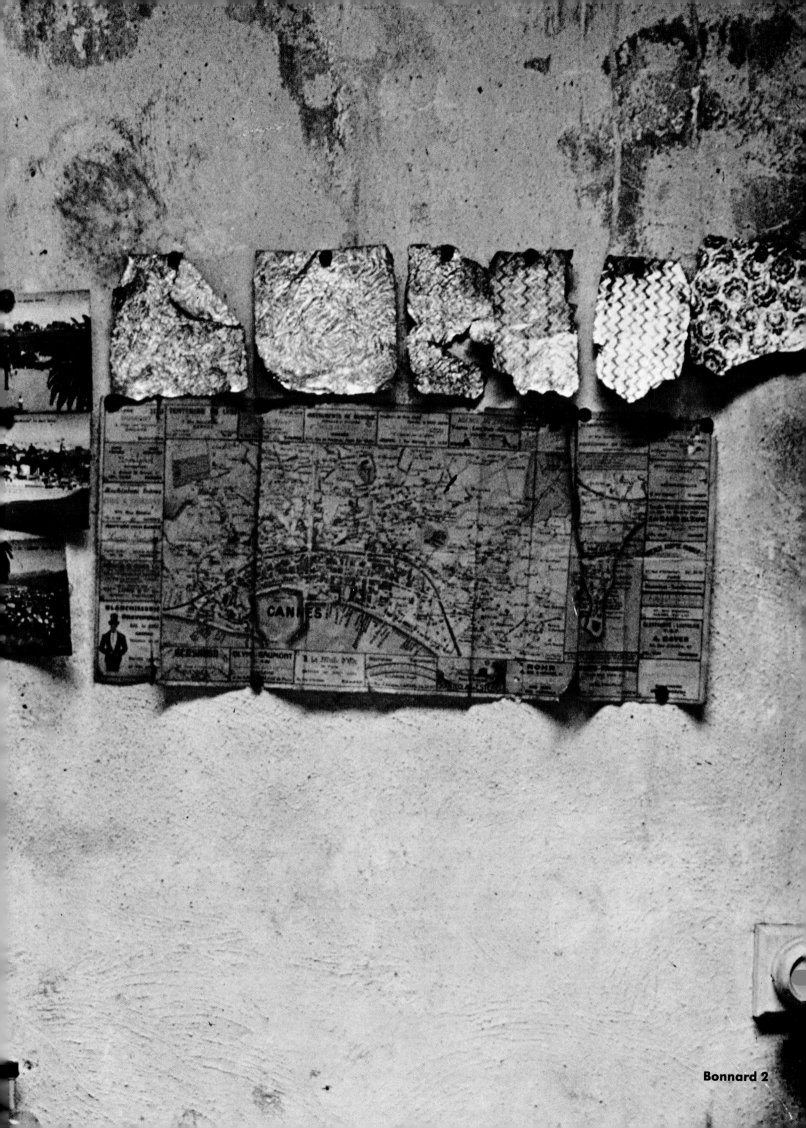

Bonnard 2

The repeated forms of the wallpapers, the checkered tablecloths, the designs in fabrics of women's dresses, the patterns of leaves and flowers created a visual pattern that, like rhythm in music, gave a beat against which melody could sing. But pattern had another purpose: like a beat repeated or an incantation, it fascinated and hypnotized. A spell was cast on the spectator; one was snared and then one entered Bonnard's world. To achieve the true play of light, diamonds are cut; to keep light glowing on a canvas, Bonnard used many-faceted patterns that cut the surfaces of his paintings.

His art is a magnification of the modest. It was within his bourgeois surroundings that some of the most triumphant affirmations of the beauty of everyday existence were created. The dining room, the kitchen, the bath were stages for the observation of the everyday behavior of human beings, and his people live and behave in his paintings as though unobserved.

"Bonnard, one must beautify," said Renoir to his friend. There is the secret of art's universal appeal. Bonnard covered reality with his emotions, which he expressed through the infinite richness of his color. His was the same desire to adorn the object of one's love and admiration that made the primitives put precious stones and gold into religious paintings.

Out of his small gray, cell-like studio Bonnard's lyrical outburst of color was the triumphant song of a man in love, in love with art, in love with painting. Bonnard's art is a serenade of a man in love with life.

Bonnard was extremely timid. His simple and withdrawing nature never gave rise to the bold, egotistical aspirations of Cézanne or of most artists. He did not see himself as the founder of any school, never envisioned himself as another God re-creating his own universe in competition with the Creator. Nature dominated him because of his extreme susceptibility to the slightest pressure of impression. He once said he would rather keep flowers in a room separate from his studio while he was painting them so that they would not become overbearing. Antoinette, the woman who was his housekeeper for twenty years and who still kept the villa, said to me, "He liked my bouquets but he would never paint them right away....He let the flowers wilt and then he started painting; he said that way they would have more presence."

A cautious approach, a bourgeois prudence, was Bonnard's way of life. Antoinette recalled how economical he was. He insisted on going over every detail of his household's accounts. The drawers of his desk were still filled with numerous receipts, laundry and electric bills, neat little notebooks in which he made lists of his expenses. He had studied first for the position of small *fonctionnaire* in the government recording office which keeps track of births, deaths, and marriages; later he studied law. But by the time Bonnard was twenty-one he had abandoned his legal studies, and, fairly soon, in turn, the Ecole des Beaux-Arts. Academic teaching was not for him. He preferred to study painting on his own.

He met Vuillard and Maurice Denis and the group of young painters who called themselves the *nabis*, after the Hebrew word for prophets. They were inspired by Gauguin, who preached of "the artist's right to dare everything," and were also influenced by Redon. Through Gauguin, Bonnard came under the influence of Japanese art and Japanese philosophy; he retained not only the graphic lessons but also the moral ones. From Zen Buddhism and other sources of Oriental thought, with which, like Redon, Bonnard seemed to have an inner rapport, he learned that the hard, the resistant is, in the end, vanquished by the soft, the pliant, much as a rock is eroded by water.

The *nabis* explored new painting techniques in order to express more fully their personal feelings. They were, above all, painters for whom a painting was, "essentially a flat surface covered with colors arranged in a certain order."

Cézanne's great discovery was that it was up to color to interpret light. Bonnard followed and enlarged on this theory; but where Cézanne's color is based on strict logic, on a severe and determined relationship to form, Bonnard's color is related to the senses. As Debussy broke rules of harmony to please his ear, so Bonnard broke rules of color to please his eye.

Like great musicians who have a perfect ear, Bonnard composed with a perfect eye. In his art the color shape of a given area on a canvas is dictated not by the representation of an object in reality, but by the satisfaction of an eye-hunger for a certain color.

In his stressing of color and his abandonment of line, Bonnard is one of the greatest realists. For in nature there is no outline, only color and form. Line is an invention of the artist, a tool to convey his meaning. Bonnard used the interrelationship of massive areas of color to convey his meaning. His vision is the physical vision and not an intellectual translation of vision.

The impressionists painted in direct contact with nature; they transcribed literally what they saw. Bonnard made notation sketches, then painted from memory in the peace of his studio. From the distortions of memory comes the personal and original vision. His cropping of subject matter, the layout in the frame of his canvas, the scale of his subject matter, the intensity of his color were seldom ruled by logic or laws of perspective but obeyed the laws of his inner feelings as experienced through recollection.

In Proust, his contemporary, each minute, infinitely unimportant observation, acquires significance through addition of facts and in the final picture fits in as a necessary, indispensable element; so in a Bonnard painting the smallest accent of light, the slightest touch of the brush, becomes indispensable to the final image of reality. This is a process of emotional accretion; and for the spectator the time spent by the eye in unraveling the accumulated tangle of colors, forms, and light becomes an experience of seemingly endless pleasure. This element of time enjoyment in a painting is one of the greatest strengths of Bonnard's art.

And just as Proust coated the facts of everyday life with the endlessly subtle texture of the variations of his sensibility, so Bonnard coated his environment with the infinite subtlety of his color sensibility and the intricacy of his patterns.

Bonnard used memory as Proust did; he painted all from memory, trying to recapture through tender recall the first inspiration, the first seduction, the first spark of love. Time for its own sake was not what Proust really sought. Time was a means, like a ladder descending into the depth of the past, a means to recapture the real object of his search, love.

In his essay "On Love," Stendhal compared the process of love to a crystallization: "In the salt mines of Salzburg a bough stripped of its leaves by winter is thrown into the depths of the disused workings; two or three months later it is pulled out again, covered with brilliant crystals; even the tiniest twigs, no bigger than a tomtit's claw, are spangled with a vast number of shimmering, glittering diamonds, so that the original bough is no longer recognizable.

"I call crystallization that process of the mind which discovers fresh perfections in its beloved at every turn of events."

In love Stendhal never underestimated the visual process. We have two visions: one exterior, the other interior; one the vision of the eye, the other the vision of the mind or imagination.

The diamond crystals that transform the dead branch into an incandescent radiance need, in order to act fully on the beholder, the help of our two visions. Through imagination we adorn the glittering bough with unseen, unsuspected qualities, real only to our inner vision. Through the eye we receive the miracle of light glancing off the surfaces of the many-faceted crystals, breaking in prismatic beams through the crystalline formations, each new penetration and reflection seeming to add velocity and momentum to the original sunbeam before it strikes our eyes.

Bonnard took the reality and plunged it into the deep recesses of his mind, and there, through the accretion of sensation, through a literal falling in love with his subject, he endowed it with a new life. On the canvas a crystallization took place; each brushstroke added particles of paint that, like the crystals on the bough, made each object painted an idealization of nature through light, and each painting an act of love.

The tenderness of his art does not make Bonnard a weak artist. It is as if his weakness reached such monumental proportions that it became strength. A Bonnard canvas is like a minute section of an impressionist painting enlarged X times. This physical magnification gives scale and grandeur, but it is also an emotional increase. His painting is a poster of the subtle; it shouts in a soft voice; it advertises privacy. He had retained from his early days, when he painted posters, the ability to dramatize the essentials. Later in his art the essentials became the hitherto unadvertised, the never before violently expressed moments of intimate tenderness.

Bonnard, in his rare comments on art, often used the word "seduction," and it is a key word in describing his art.

For seduction is an emotional attraction, an unreasoning surrender to an impulse to admire, to find beauty, to possess; in fact, seduction is the first instant in the process of love.

For centuries a symbol of love in painting has been woman. And just as there are many aspects of love, there are many ways of portraying woman. Woman is present in almost all Bonnard paintings: either she is directly represented, a portrait or a nude; or she is glimpsed from the corner of the eye, present but seemingly absent in a family scene; or, as in the interiors or still lifes, her hand is felt in the arrangement of things. She is the mother nature of the interior, rearranging the nature that is her home.

Bonnard's art is a sublimation, a distillation. When he painted nudes, they were never the portrayal of flesh for its own sake. He painted a nude as chastely as if it were a flower.

This uninhibited intimacy with all that is beautiful and joy-giving is the key and fascination of Bonnard's art. When he painted the privacy of life, the everyday casual clutter, he was describing the core of family life.

This is what life with love looks like. The original crystals of seduction become everyday objects of the home, laden with emotional associations. The coffeepot, the plate, the tablecloth become under his brush, as the *madeleine* under Proust's tongue, the sentimental, memory-evoking talismans.

For Bonnard, woman and her portrayal, was one of the essentials of his art. But where most painters used the nude for a decorative, sensuous effect, Bonnard invented a new vision of the female body. Each painting is an addition of knowledge that slowly, delicately, chastely brings us into a private world.

For the backgrounds of many of his nudes, he chose the bath, for this was the ultimate vision of privacy, the one place where in our civilization human beings are really natural, for they are unobserved, not on the defensive. For Degas, a woman washing was critically observed. The opinion of the artist is present in his art. For Bonnard, there was a tender acceptance and no criticism.

His women wash, bathe, and move as if unobserved in that supreme, defenseless moment when all shame disappears because, through love, confidence and trust are born. His women know that they are loved and that the painter, like a lover, will adorn them in whatever instant he sees them with the all-embellishing magic of his crystallization. Bonnard expressed the peace, the trust, that reigns in the home. So happy and intimate and close had been his life with Madame Bonnard, the model of many of his canvases, that when she died in 1940 he could not bear his solitude. This need for the presence of love is the indispensable climate for a serene creation. Only the human beings who have known the true meaning of a love mutually shared can express true joy. When we look at a Bonnard canvas its secret power is that healthy knowledge, that certitude that love can and does exist, and that man can find happiness and joy through love.

The austere simplicity of Bonnard's life, the bare whitewashed studio, like a monk's cell, and the gentleness of his art, the tender originality of his color, and his all-enriching vision bring to mind the life and work of another painter of joy, Fra Angelico. The Florentine monk centuries earlier had entranced the world with his ineffable visions. The rigid monastic discipline, the strict laws of Catholic dogma not only

did not prevent, but, on the contrary, stimulated the creative outlet; his art brimmed full with pure visual happiness. So Bonnard, centuries later, sheltered and concentrating his vision on the intimate, private world around him, invested it with magic richness.

Bonnard had that lucid moment of clear vision, that closeness to the reality around him, that faith, that wonder at the light-drenched revelation of the beauty of life, that same worship and sense of kinship that made the Poor Man of Assisi, Saint Francis, exclaim, "My brother Sun."

Notes on the Illustrations

Pierre Bonnard, 1867–1947. Born: France.
Photographs taken in 1955.

1. A corner of Bonnard's studio in his small villa at Le Cannet behind Cannes, where he lived and painted from 1925 until his death in 1947. The studio, compared with those of other painters, is incredibly small, but here Bonnard was able to paint some of his largest canvases. On the table, his brushes and paints just as he left them. Lying among used rags and tubes is a color postcard of Delacroix's Lion.
2. The art Bonnard admired most. This wall in his studio is one of the most revealing documents of a great painter's inner thoughts that I have ever seen. It is like a small altar to the gods of his life, the presences he wanted near him. Reproductions of works by Picasso, Vermeer, Monet, Seurat, Gauguin, Greek sculptors, and Bonnard himself, hang next to a map of Cannes and some chromo postcards. The crinkled chocolate papers neatly pinned and preserved enabled him to study the effects of light, one of his lifelong preoccupations.
3. The bathroom of the villa at Le Cannet. Bonnard explored the intimacy of life further than any of his contemporaries. Dreary everyday reality was transformed by his art into an object of admiration and beauty. The folds of his bathrobe, as he left it, have the nobility of medieval sculpture.
4. Bonnard, Nude in Bathtub c. 1941–46. Oil on canvas, 48" X 59½" (121.9 cm X 151.1 cm). The Carnegie Museum of Art Pittsburgh. Acquired through the generosity of the Sarah Mellon Scaife family, 1970.

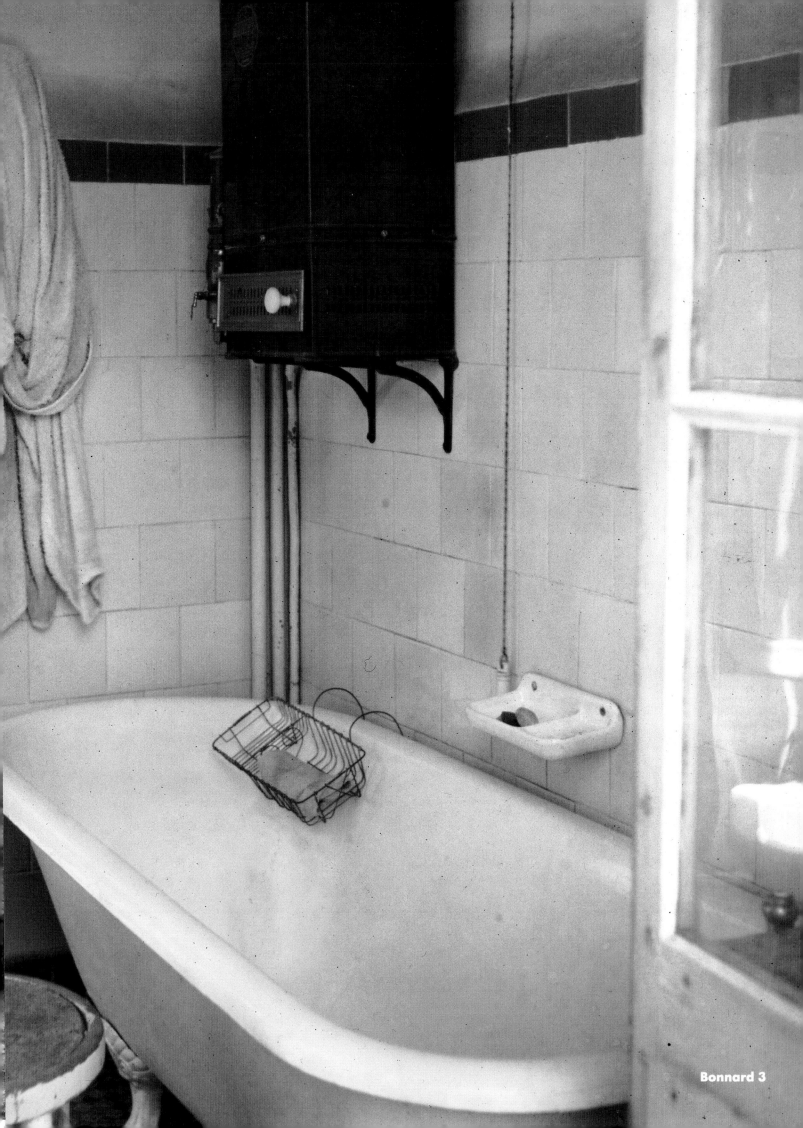

Bonnard 3

Matisse

The case of Matisse is extraordinary. At seventy-one, an age when most people feel they have completed their life's work, he was stricken by disease. Until his death in 1954, he lived in a permanent state of convalescence. Yet, a miracle of willpower, he forced into his last fourteen years a splendid succession of achievements.

"Imagine an artist who would be spiritually in a permanent state of convalescence," Baudelaire wrote in his essay on Constantin Guys. "Convalescence is like a descent into childhood. The convalescent, like a child, enjoys to the limit the ability to be intensely interested in things....The child sees everything as new....Genius is but childhood recovered at will."

During the years of his illness Matisse never revealed a morbid thought in his work. The more he suffered, the more he withdrew from active life, the more he dared in his art. He did not confine himself to any single period or style. He evolved. And this capacity to evolve, to adapt oneself to change, is the gift of the child as well as of the artist.

Many great artists have led very long lives. Perhaps old age offers an opportunity to throw off the yoke of adulthood and, in a new yet final childhood, reinherit the unbridled creative wonder of youth. Matisse, in his old age, worked with the vitality of youth and the wisdom and knowledge of age.

In his last works, in his *papiers découpés*, in his paintings, in his book illustrations, in his chapel at Vence, he risked more than ever before. This was the courage of an old man, a genius who knew that he would soon die and who had everything to gain in exploring the preoccupations of his whole life—color and line.

After the Second World War, when I first visited Matisse in Paris, he lived on the Boulevard Montparnasse, a few hundred yards from the intersection of Boulevard Raspail. Between two wars Montparnasse had triumphed over Montmartre; nearby were the great meeting places, the cafés of La Rotonde, La Coupole, and Le Dôme.

A small self-service elevator took me to the sixth floor of a modern apartment house. When I was admitted I entered a

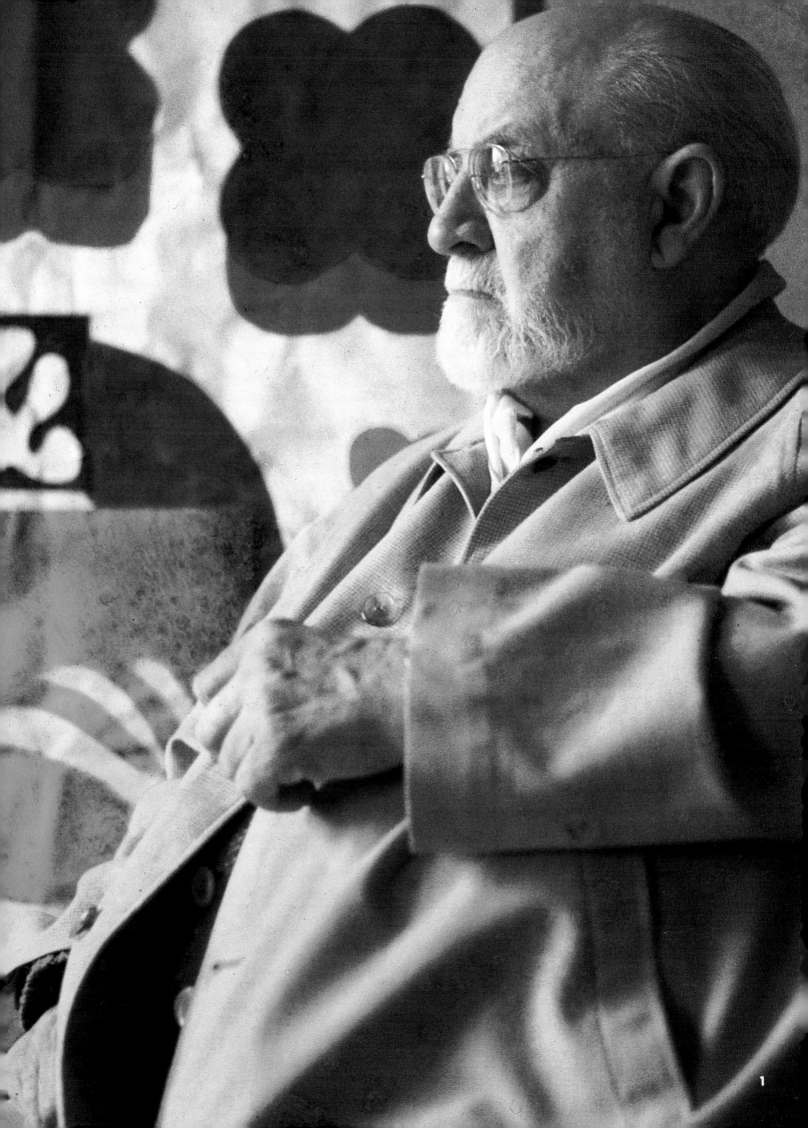

long hall with several glass doors covered by curtains. In the studio, the living room of a conventional apartment, the light was so intense that the metal shutters had been drawn. A sensuous backdrop of many nudes dominated the room. In one corner stood a classical Greek torso of a woman, in another a large Polynesian polychrome figure, and near the windows were his own sculptures, dark, shiny bronzes silhouetted against the light. On a chest of drawers rested many books. I noticed John Dewey's *Art as Experience*, and volumes on Cézanne, El Greco, the drawings of Leonardo da Vinci, and Chinese calligraphy. Hanging on the walls were Matisse's most recent canvases, vigorous, vital, and young. The room vibrated with the charge of color. Next to this intensely luminous studio was Matisse's bedroom, a smaller, darker room into which he could withdraw. Then, when refreshed, he would return to the light.

Wherever he was, life was reduced to one purpose—Matisse's creativeness. Everything was so arranged that his slightest desire, his slightest urge for expression, could be easily set into action. Illness became a justified excuse for eliminating all unnecessary activity. To protect him, as many of the problems of life as possible were solved in advance. How many creative people have yearned for fate to force them to concentrate upon only the problems they want to solve?

His protective shield from disturbances and interruptions of daily life was Madame Lydia Delectorskaya. A slight, blond, thin-lipped Russian woman, she was his nurse, housekeeper, secretary, companion, and model. With deep respect and obedience to the master, she satisfied his least desire with quiet efficiency. As I looked around the living room, she entered and announced that I could visit Matisse.

In the semidarkness of his bedroom I saw walls covered with drawings, studies in line, in bold black ink, of nudes and faces, and still lifes. Then, as I grew accustomed to the dark, I distinguished an old man lying in bed. He was extremely pale. The sheets, his face, his pajamas, the covering on the bed, all seemed bathed in the same yellow-white grayish mist.

This impression of softness was pierced by the sharp accents of light hitting the rims of his metal spectacles, hitting the thistles of hair that were his beard. The white beard, neatly clipped in a circular shape, gave an extra dimension to the face. The bald head and the round lenses of his glasses continued the circular movement. Only the perpendicular and the horizontal of the nose and mouth relieved the curvilinear mask.

His was no ordinary beard. It had been trimmed and shaped with a profound knowledge of form. It was more than a beard; it was a form fashioned in relation to other forms. As a smile appeared, the bristles moved and intelligent eyes showed behind the rims of his glasses. Those eyes were haunting. Small in relation to the enlarged features of the face, they were magnetic in their grip. They penetrated, even intimidated. They were the eyes of a bird. As very old people sometimes do, he viewed with discernment all outside manifestations—a knowing, questioning, quizzical appraisal.

In a voice that was low and soft he greeted me.

Because I wanted to photograph him, he got out of bed. I returned to the living room. He entered, impeccably dressed in brown trousers and a loose beige jacket. He sat down in an armchair, his legs assuming, as they crossed, the pose for a formal portrait. There was an extraordinary grandeur in his bearing. He sat like a king, patient and purposely severe. Of all the painters I have seen, Matisse was by far the most awesome; physically and emotionally he kept his distance. Later Madame Lydia said, "He hates to see himself smiling in a picture." Somehow, his voice seemed weak in contrast to the monumental stature of his appearance. As he posed I said that he reminded me of a Venetian portrait. "Yes," he said with a smile, "I'm an old *sbire revêche*" (literally, a severe myrmidon).

But aloofness and reserve seemed a self-imposed discipline on a tender, emotional nature. In him intelligence, culture, and wisdom blended with caustic French irony and doubt. Not self-doubt—there was none of that—but a doubt or *méfiance* of everything outside of himself. He was steady and precise, demanding that each term be carefully defined. The precision and logic of French education were perceptible in his speech. His scientific analysis of light, his careful movement of pieces of paper, his numerous preparatory sketches, were cautious steps before any definite or final commitment.

When, because of illness, it became difficult for him to move or to stand before an easel, he solved these problems in an intelligent and systematic way. For instance, he had sheets of paper painted to match his colors. By cutting and pasting these papers he created striking designs, collages, or, exactly, *papiers découpés*.

Matisse, unlike the cubists, did not use collage as an end in itself. It was a method to facilitate his experiments. Earlier cubist collages by Braque and Picasso are predominantly brown and gray; Matisse—in his own words—"sculpted with color." With scissors he cut paper in the way that a sculptor with his chisel cuts into stone. On a colored background, these papers were rearranged many times, held with pins until he was satisfied with the design, then secured with glue. These bold compositions came closer to abstraction than any of his other works. Here were Matisse the sculptor and Matisse the painter wedded in a new medium.

In retrospect, *papiers découpés* may well be his greatest contribution to twentieth-century art. As experiments they are in step with modern research in pure color in art, in electronics, in films. Matisse said, "The future of art is in light." His play with color sensations was bolder than that of any artist before him.

His experiments led him one logical step further, to the deeper problem of light itself. Now he could sculpt with color through light. In the stained-glass windows of the chapel at Vence he culminated a lifetime of research in color and light.

To test his theories, he transformed his immense apartment in Cimiez, above Nice, into a scale model of the future chapel. The windows were high, the ceilings lofty. From the ornate balcony, so familiar in Matisse's early Riviera paint-

ings, he could see the tops of palm trees swishing in the summer breeze. Beyond lay the roofs of Nice, then the scintillating blue sea. This view, however, was no longer the principal source of his inspiration.

Pasted on a white wall was an imaginary window, a window created out of colored paper. One of the actual windows of the room was half covered by the same pattern in samples of colored glass. As the room could be darkened, Matisse was able to put sheets of white paper in front of the stained glass to work out his theory of complementary light. In balancing primary colors, blue and yellow, with green, he found that the resulting light created within the white box of the chapel would be rose violet. Matisse was attempting to advance beyond painting, by imprinting on the senses of the spectator colors that did not exist in reality but only in the mind.

In another room at Cimiez, his "drawing research center," the ceiling, the walls, everything was white, the whole room bathed in light. Across one wall was stretched a large sheet of loosely pinned paper on which he had drawn in charcoal the Virgin and Child. Standing briefly during his working hours, with a piece of charcoal attached to a long stick, he drew with one hand, as he had drawn earlier in 1931 the figures of *The Dance* in the great collection of the Barnes Foundation in Merion, Pennsylvania. The sureness of his hand and of his conception was incredible, the reward of constant practice. For Matisse, obsessed with line, this was the apotheosis of a whole lifetime of draftsmanship.

The drawing was the most glorious I had ever seen. Its unexpected scale, twenty by thirty feet, made one physically penetrate into it. Usually sketches for murals are small notations, and one has to imagine them in their actual size. Here, instead, hung a sketch that was both a project and a finished work of art. The Virgin, at that stage, was in a robe made of stars; the sky behind her was studded with stars that looked like the petals of flowers. The head of the Child was another breast on the Mother's body. Resplendent, splendid, the drawing was a chant of intellectual fervor expressed through the artist's inventiveness.

Opposite was another immense mural, equally large, representing the Stations of the Cross. The Stations were still in a tentative state, faintly indicated in light charcoal. Many of the lines had been erased. The unnecessary eliminated, emotion was reduced to the essential moment. This series of drawings of Christ's agony were the only manifestation of suffering that I have ever seen in any of Matisse's work. He would portray tragedy only in the presence of God; never did he expose his emotions to the art buyers of the world. Proud, civilized, and sensitive, he wanted his art to celebrate his faith that a profound life could be a happy life. More than any other modern painter, Matisse expressed that particularly French appreciation of *joie de vivre*.

As an intelligent Frenchman, Matisse tried to discipline his sensuousness into order, into form. He had a classical desire to restrain the emotions. His was the world of the highest senses, a world of *jouissance*, of pleasure stronger than enjoyment. In his art, the seemingly superficial, pretty side of life is raised to another level. He made the pretty beautiful, conferring nobility on charm.

Naturally, woman was his principal subject; he surrounded her with ornaments—fruits, flowers, plumes, birds, rare fabrics—all to enhance seduction. She is the promise of happiness—as Baudelaire wrote, "a divinity, a star, who presides at all the conceptions of the male brain." The image of the artist as a lover creating himself the object of his love contributes to the art of Matisse a male vigor.

One must read Baudelaire, for his influence on the thinking of French artists in general and on Matisse in particular was profound. The poet of intellectual escape, he was able to transform visions into sensual form. *Luxe, Calme, et Volupté*, the title of one of Matisse's great compositions, was taken from Baudelaire's poem, "L'Invitation au Voyage." In every cultivated Frenchman there is a longing for liberation, a desire to break the conventions of the *bourgeoisie*. Baudelaire's invitation to discovery is the key to the quest of the artist. And, with escape, with adventure, there is usually the association of love.

The exotic spell of the Orient has awakened many writers, poets, painters to new visual stimulations. Ingres with his odalisques and *Bain Turc* brought the voluptuous Orient to conventional France. Then Delacroix, the master of color, was transformed by his experiences in North Africa. Nearly a century later, Matisse followed Delacroix's footsteps, and in Matisse's art the rich influence of Mohammedan or Islamic art found its fullest flowering. The nineteenth century had been stamped by the revelations of Ingres and Delacroix. The twentieth saw Matisse take possession of the Afro-Islamic motif. So strong was Matisse's hold that few artists dared touch his domain. Only after his death could the odalisque and the Moorish interior be approached by other painters.

In his long life Matisse had perhaps traveled more than any other great painter. North Africa, America, Russia, Tahiti, Spain, Germany, England, Italy, Scandinavia, Holland, many other places came under the scrutiny of his hungry eyes.

As one reads Matisse's extraordinarily perceptive biography by Alfred H. Barr, Jr., one is struck by the sequences of dates, places, and events which seem to fit into a unique pattern. They offer clues to a perhaps insufficiently stressed aspect of the thinking of a great artist. Is it possible to find a unifying thread that, unknown to Matisse himself, was the secret motivation of his creative life? Man has the power of synthesis, of welding together the lessons of centuries of diverse cultures. From this unity the genius can spring forth to new and as yet unexplained visions.

As early as 1905 Matisse worked in Collioure, ten miles from the border of Spain, and, as late as 1492, a Moorish stronghold. Matisse went to Africa for the first time in 1906, and we know that in Berlin in 1910 the great Islamic exhibition created a lasting impression on him.

What, briefly, in Mohammedan art played such a powerful role in Matisse's life? The origin is in Persia, from where it wandered far into India, China, and Europe. Centuries later,

under the stimulation of Byzantine and Islamic art, memory images of Persian art, dormant in the deep subconscious of European cultures, were reactivated. The impact and the enthusiasm with which the Islamic influences were received was in reality the joy of recognition. Perhaps not enough has yet been said about the role Islamic culture has played in European art. And, in the twentieth century, it is important to remember that Mohammed, in his fear of idolatry, forbade the representation of the human form. Thus for centuries Mohammedan art relied on pattern and ornament, in one word, abstraction, for its principal inspiration.

Here we touch on the fascinating adventure of modern art. What had seemed for so long a freak of destiny, the fact that advanced French painting was first understood by faraway Russians, can perhaps be explained by the influence of Islam.

The discovery of abstract art is generally attributed to Kandinsky, a Russian of Siberian origin. The culture of Russia has been forever branded by the visual splendor of Christian Byzantium and of Mohammedan Islam. Byzantine ornament and Islamic abstraction are imprinted on Russian cultural memory. With this in mind, it may seem less surprising that Shchukin, the Russian merchant, was the first great patron of Matisse. He found instinctively in Matisse's art a resonance with this yearning for Oriental splendor.

The same Russians who discovered Matisse discovered also Picasso, who received Islamic influences through his native Spain. Before him Cézanne, the father of modern art—again first appreciated by Russian collectors—surely had been subtly inoculated with the abstract precepts of Islam. His native Aix lay close to Spain. North Africa was just across the Mediterranean. And, through his admiration for El Greco, some of the tragic mystery of Islam may also have penetrated his sensitivity.

To the eyes of the Russians, the rich and vibrant color patterns of Matisse brought emotional satisfaction. His sun-drenched canvases were like glowing suns. They were windows to the south.

Matisse was the first *fauve*, maybe because he was the first to understand the lesson of the southern sun, the lesson of Cézanne, that form is at its maximum when color is at its maximum. Matisse knew that the sun, the source of light, can be transcribed in painting only through the equivalence of color. It is impossible to match its brightness, but through the vividness of hue our eyes can receive a stimulation similar, if not equal, to intense illumination. To intensity of color, Matisse added the power of line. He made color inseparable from line. In his art, line is the fluid frontier of color sensation.

Matisse himself found in sun-conditioned Islamic' thought the nourishment for his inspiration. In early Moslem ornaments, the twist of the tendrils of the vine is the main source of inspiration. This symbolic unfolding, this groping search of the vine was used by the Arab scribes in their rounded script. Matisse, in his yearning to express the power of life, repeatedly used the curvilinear shapes of leaves and the sinuous forms of female bodies to stress the unity of nature. The line that delineates his nudes, the line that describes objects and their interrelationships, is the line that ties all together, to allow the spectator to comprehend in one swoop the undulating unity of the universe. The rubber plant leaves that Matisse scissored out of colored papers rejoin in their basic shapes the shapes of his nudes. Nature is one. As in Cézanne's paintings of bathers there is no division between man and his surroundings. Nature is seen as an inseparable whole.

For Matisse, the Mohammedan emphasis on calligraphic as opposed to representational images became a source of fascinating study. When he created his great book of *papiers découpés, Jazz*, he wrote out in longhand the whole text. In the same way, a few years later, he also transcribed in his own hand the poems of Charles d'Orléans, another example of his effort to restore to written images their long abandoned prestige.

Arabic writing, like Chinese and Japanese calligraphy, expresses more than just the meaning of words. The flowing rhythmic scripts seem to imitate the basic rhythms of life. In his greatest canvases, Matisse tried to express through the movement of the nude human body rhythms that are also the signs of the beat of life. His famous composition, *The Dance*, first commissioned by Shchukin and reinterpreted in the Barnes murals, offers in its vital arabesques a graphic translation of rhythm through the movement of the body.

Rhythm, beat, life were essential to Matisse. His vitality is expressed through the visual exuberance, the ornamental richness of his art. For Matisse the decorative was not the superfluous, but the abundance of life's creativity. In his paintings the flowered shawls, the patterned tiles, the flowered wallpapers assume the value of symbols of the artist's energy.

He believed in lavishing the gift of the artist. The eye loses itself quickly in the infinite repetition of patterns, just as the eye, when contemplating the uncountable multitude of stars, leads the mind to a notion of infinity. This pleasurable, even hypnotic, power of ornament has been knowingly used by Matisse, who in his art sought to give a sensation of rest, of peace. He said, "What I dream of is an art of balance, of purity and serenity devoid of trouble and depressing subject matter. An art which might be for every mental worker, be he businessman or writer, like an appeasing influence, like a mental soother, something like a good armchair in which to rest from physical fatigue." A Matisse painting is like a *riad*, a visual oasis and a glimpse of paradise on earth. It is not a coincidence that the North African house was turned toward an inner garden, the *riad*, in which man could seek joy and repose.

When Matisse through the magic of his art created the momentary but incessantly recurrent sensation of joy and beauty, he was allowing us to escape reality. His ability to entice us from everyday life, as if under a charmed spell, reveals much about himself. His travels, his need for the transformation of reality— even by the use of disguise—his yearning for the exotic, his search for beauty were the ambitious and silent

cries of a great artist who undauntedly believed in the grandeur of a beauty that he instinctively knew he could reveal through his art. And when, toward the end of his life, he built a chapel, he sought to create the image of his ideal place, where man could be cleansed by his surroundings, and then, when visually purified, could come before God unsullied.

The chapel at Vence, with its tiles, with its green and yellow and blue stained-glass windows that make one believe that a sunlit garden is surrounding the pure white walls, is a spiritual *riad*. The door to the confessional, fabulously chiseled from wood and rubbed with white, is like the rarest ornament of a mosque. The black line drawings on the white tile walls are the calligraphy of Matisse's faith. This chapel is his testament. In its color, light, and line, Matisse's lifelong quest for a place of rest and peace is combined in a final daring masterpiece. The unity that he achieved, the peace that he found, were again the tangible expression of his fervent belief in the unity of the world. To this chapel he brought the experience of many cultures. This final unification of all creative faiths was Matisse's supreme homage to the creator of all.

Notes on the Illustrations

Henri Matisse, 1869–1954. Born: France.
Photographs taken in 1949 and 1951.

1. Henri Matisse, Paris, 1949.
2. Sculptures on the windowsill of the Paris studio-apartment overlooking Boulevard du Montparnasse. The window and the balcony are important visual motifs in many of Matisse's paintings.
3. Matisse, Piano Lesson, *1916. Oil on canvas, 8' 1/2" X 6' 11 3/4" (245.1 cm X 212.7 cm). Collection, The Museum of Modern Art, New York. Mrs. Simon Guggenheim Fund.*
4. In the Paris living room, a Polynesian sculpture, an early Matisse landscape, his cut-out design for a stained-glass window, and a black and white aquatint (a study for the altar cloth of the Vence chapel) that had just returned from the printer.
5. In the Paris apartment, a painting and a plate ready for etching. On the commode, art books and a sculpture, Jeanette I, *1910.*
6. In the Paris studio-living room, a brightly colored couch; on the wall, Gray Nude, *1929; by the window, the bronze* Jeanette IV.
7. In the Nice studio, the original plaster of the 1907 Reclining Nude *against the fabulous backdrop of Matisse's own painted tiles, exotic fabric, and Japanese pottery. These were early sources of inspiration for Matisse and represent his ever-present need for the stimulation of visual patterns.*
8. Matisse, The Necklace, *1950. Brush and ink, 20 7/8" X 16 1/8" (52.8 cm X 40.7 cm). Collection, The Museum of Modern Art, New York. The Joan and Lester Avnet Collection.*
9. Matisse's hand drawing.

10. In a vitrine in Nice, a Bukuba headmask from Africa.
11. One of Matisse's many palettes. He placed his colors in clearly defined areas so they would remain pure.
12. In the entrance of his apartment in Nice, a color postcard of Cézanne's Mont Sainte-Victoire *next to a giant plaster cast of an Egyptian sculpture.*
13. In the Cimiez apartment above Nice, Matisse's work table as it looked when he was planning the Vence chapel: a charcoal sketch for the Stations of the Cross; a charcoal study of a head; a scaled doll of a Dominican nun dressed in the black and white of her order. On the cardboard model of the chapel Matisse previsioned the finished effects of his orchestration of light, line, space, and architecture. In the background, the tall, narrow yellow, green, and blue paper cutouts that prefigured the stained-glass.
14. The Vence chapel is Matisse's masterpiece, his message to the artists of the future; line is used as a stenography of communication; color is used separately from form and line. A view of the altar with the altar cloth, candle-holders, and crucifix—all designed by Matisse. On the right, the levitating image of St. Dominic, the patron saint of the nuns' order in a glory of color reflections from the stained glass windows.
15. Detail of the Stations of the Cross painted in black on white glazed tile.
16. A detail of the finished yellow, green, and blue stained-glass windows of the Vence chapel. Their skyward patterns create a mysterious all-pervading glow.
17. Henri Matisse caught in a rare smiling mood.
18. Matisse, "The Sword Swallower," from the Jazz series, 1943-46, Musée National d'Art Moderne, Paris.

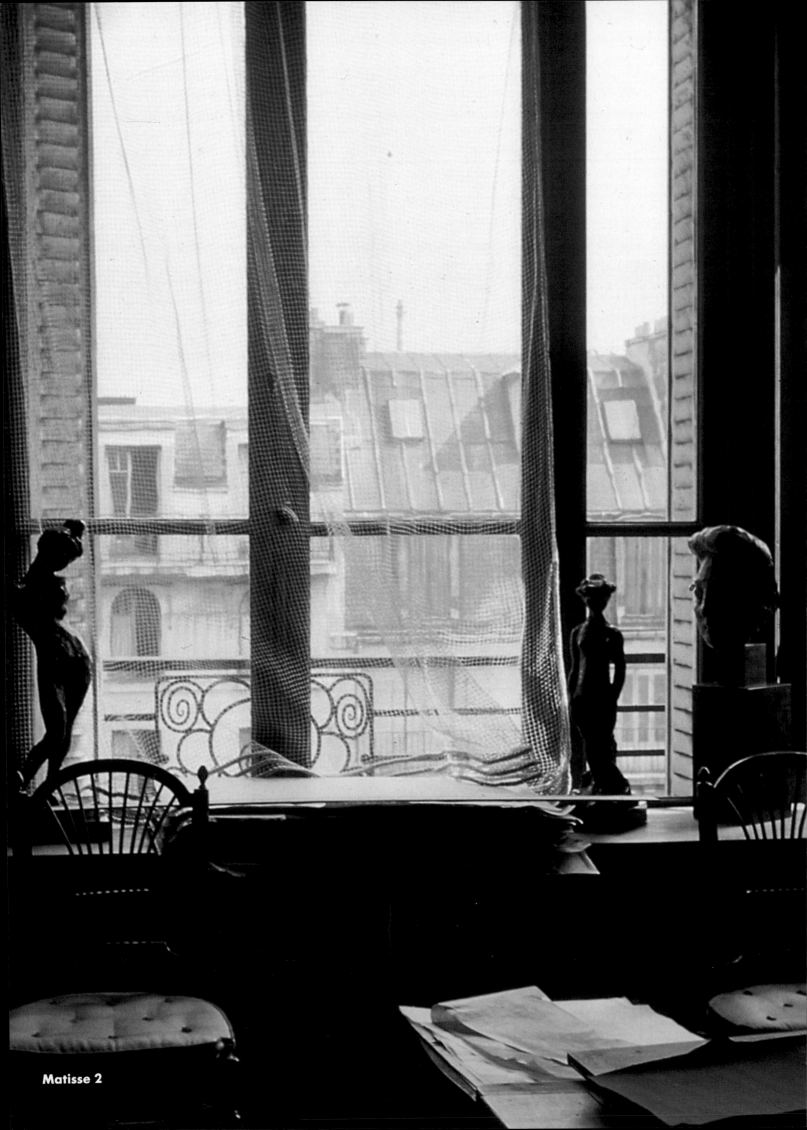

Matisse 2

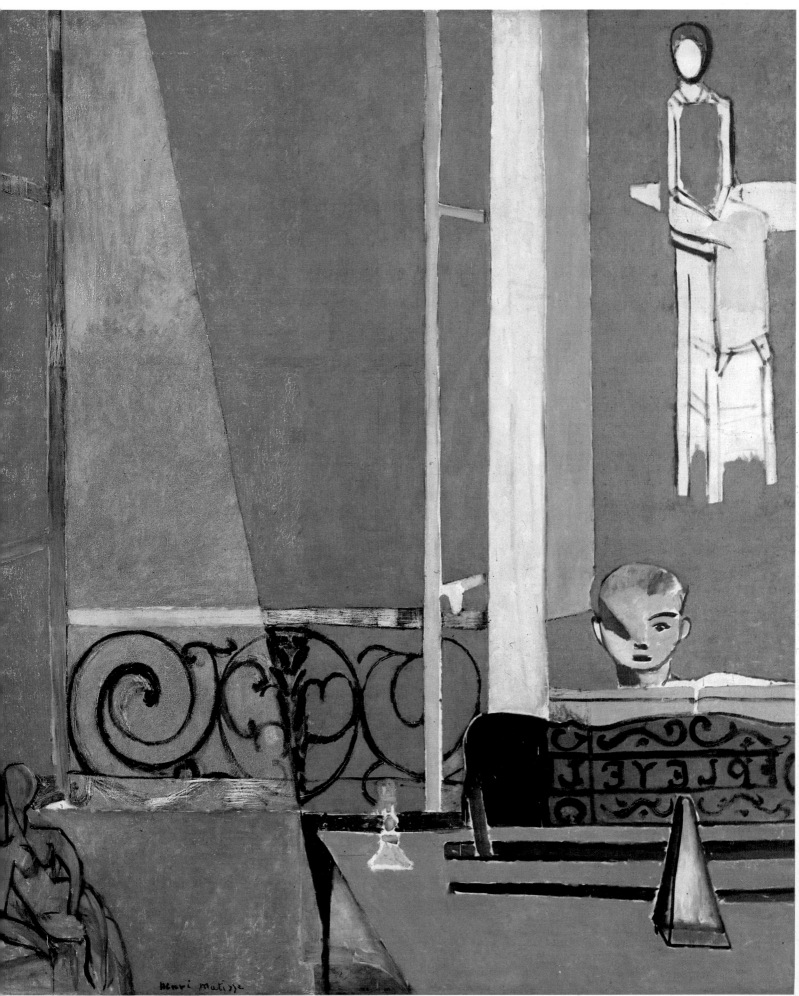

Henri Matisse

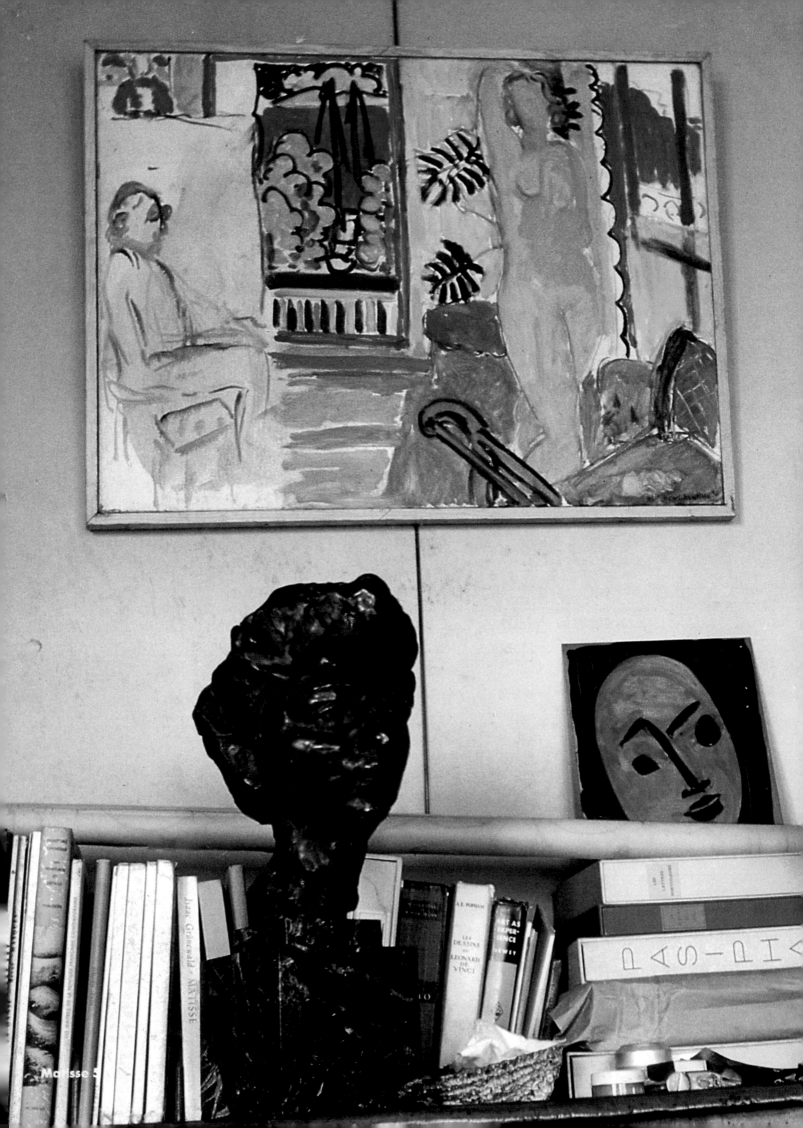

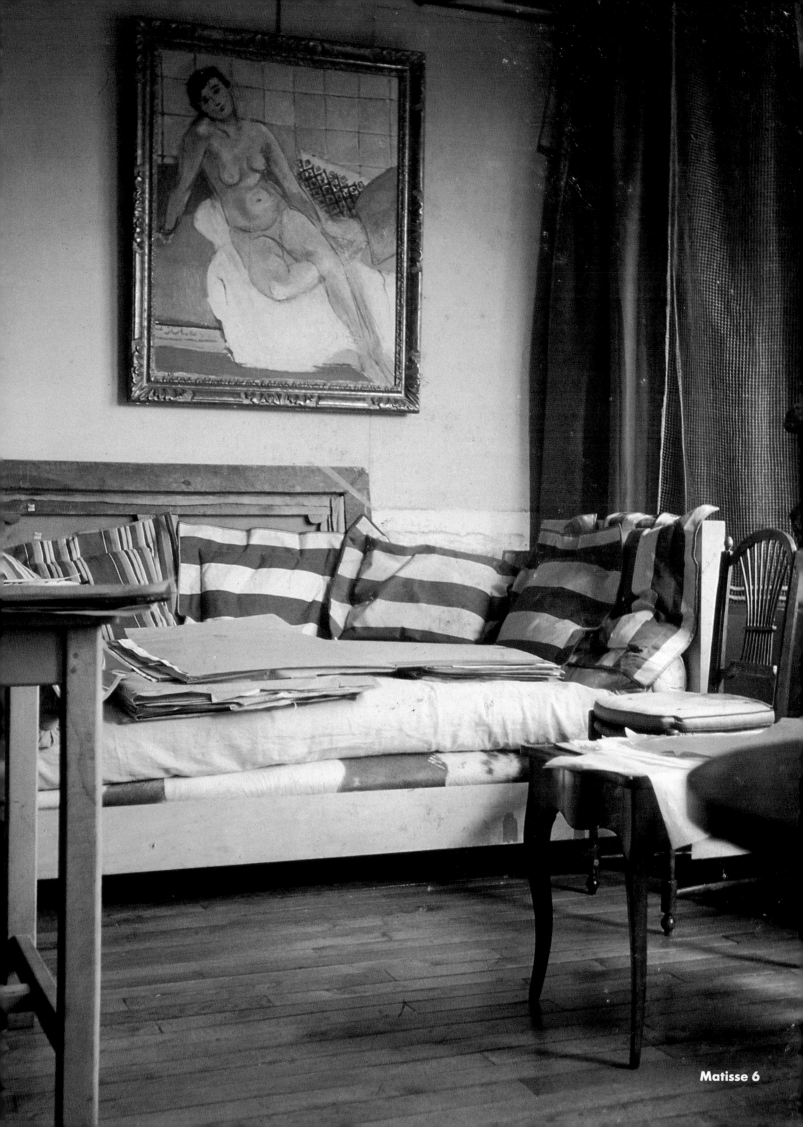

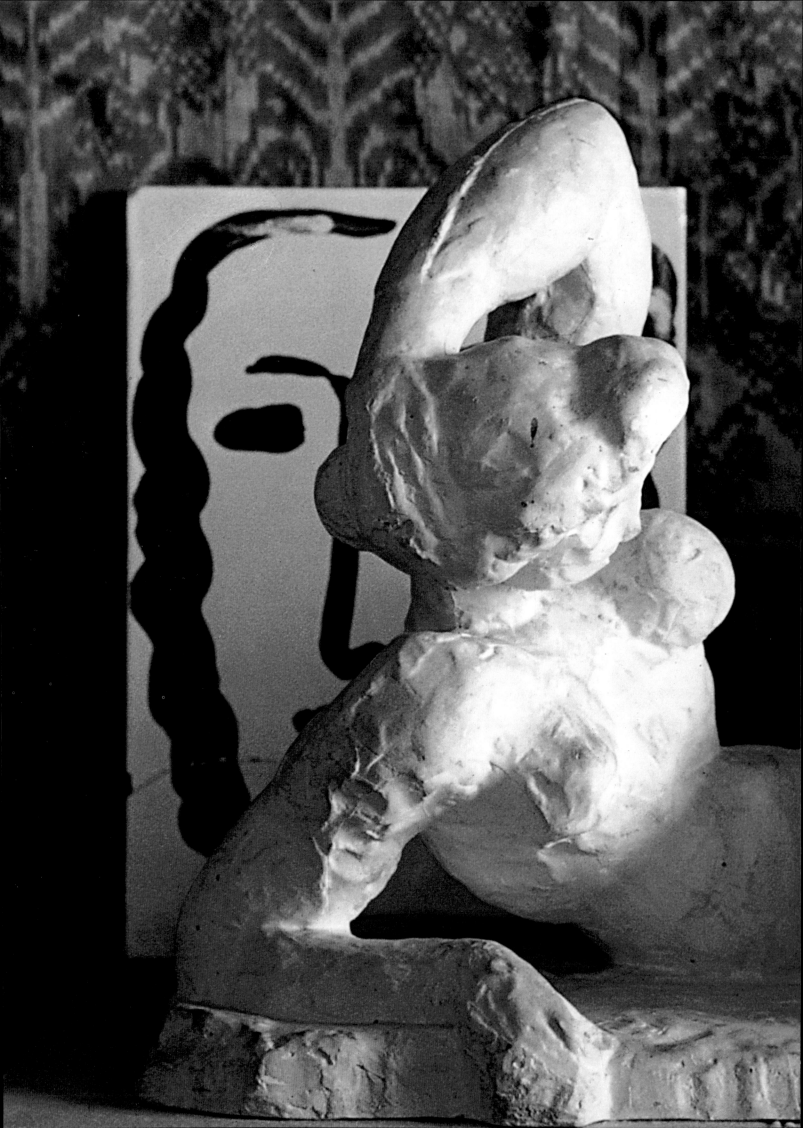

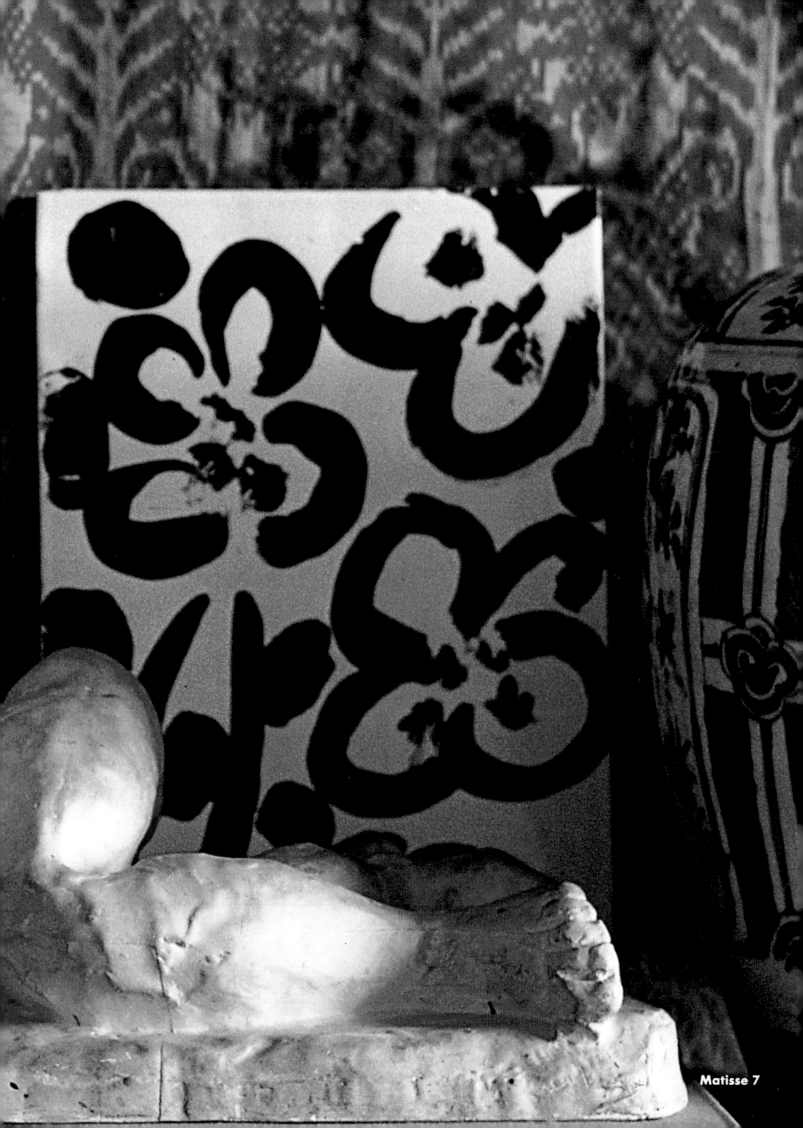

Matisse 7

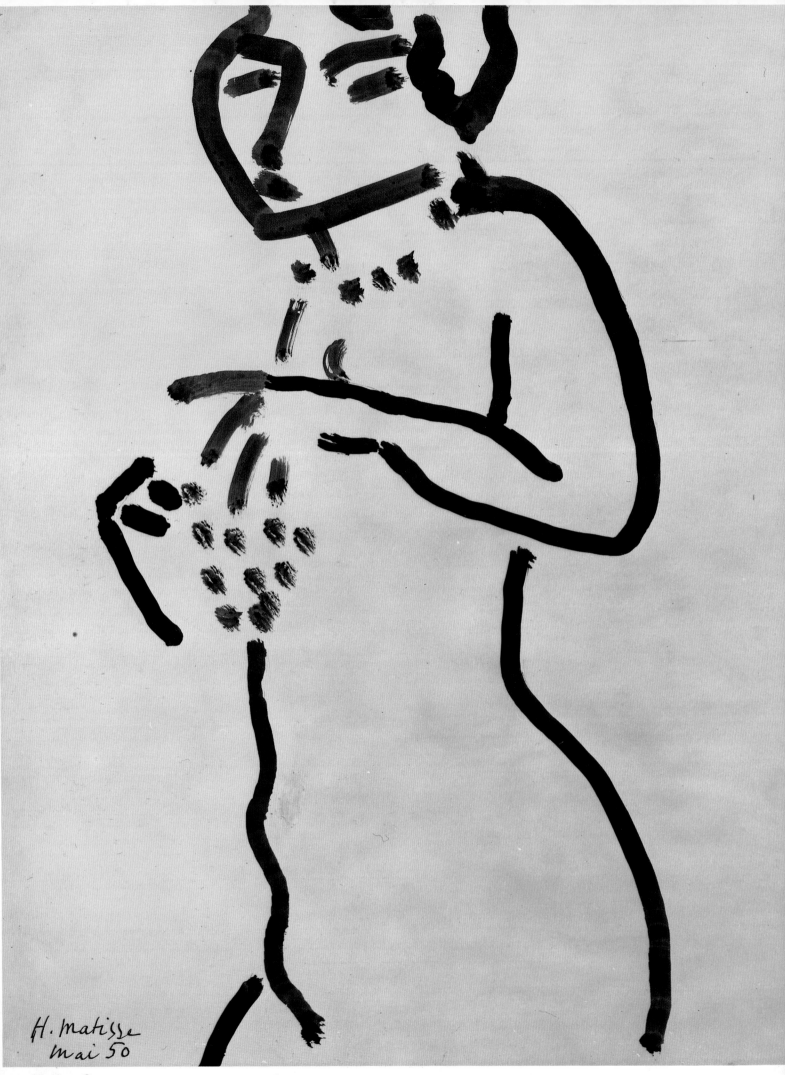

H. Matisse
mai 50

Matisse 8

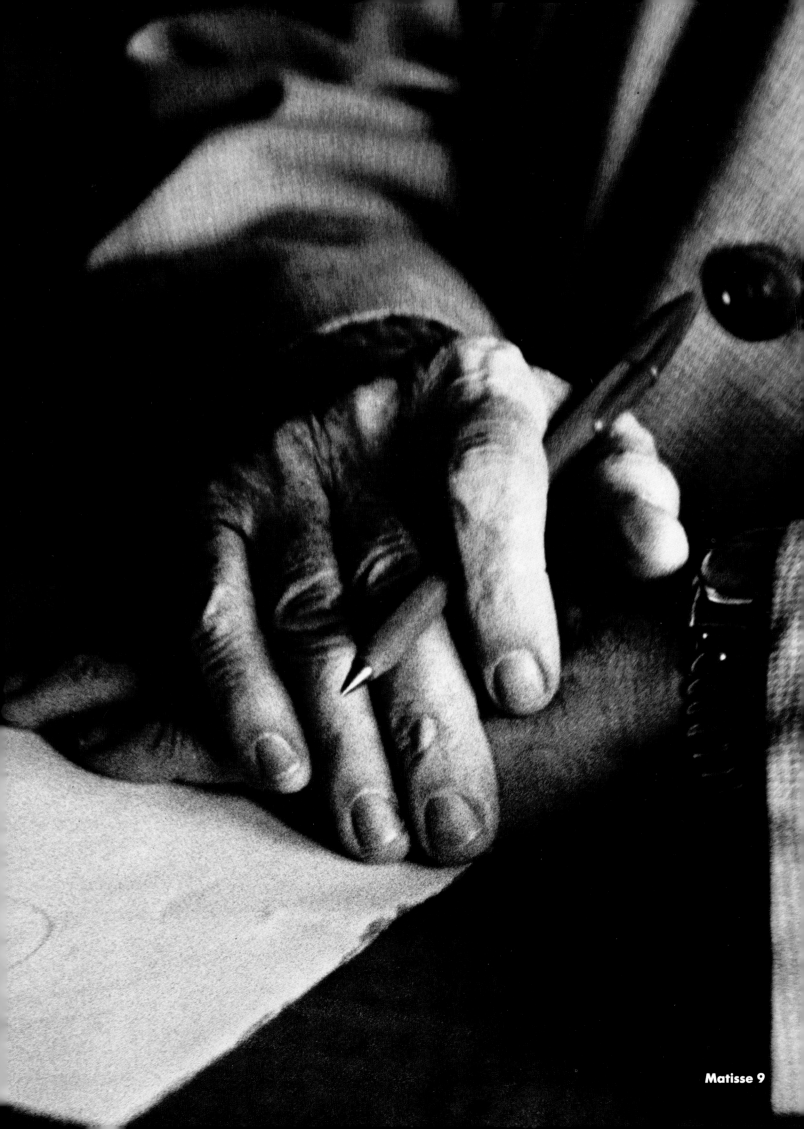

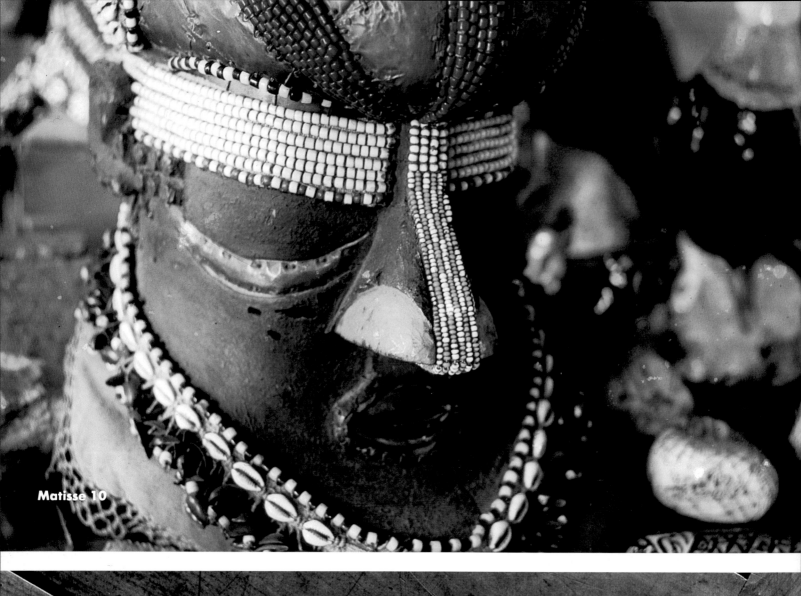

Matisse 10

Matisse 11

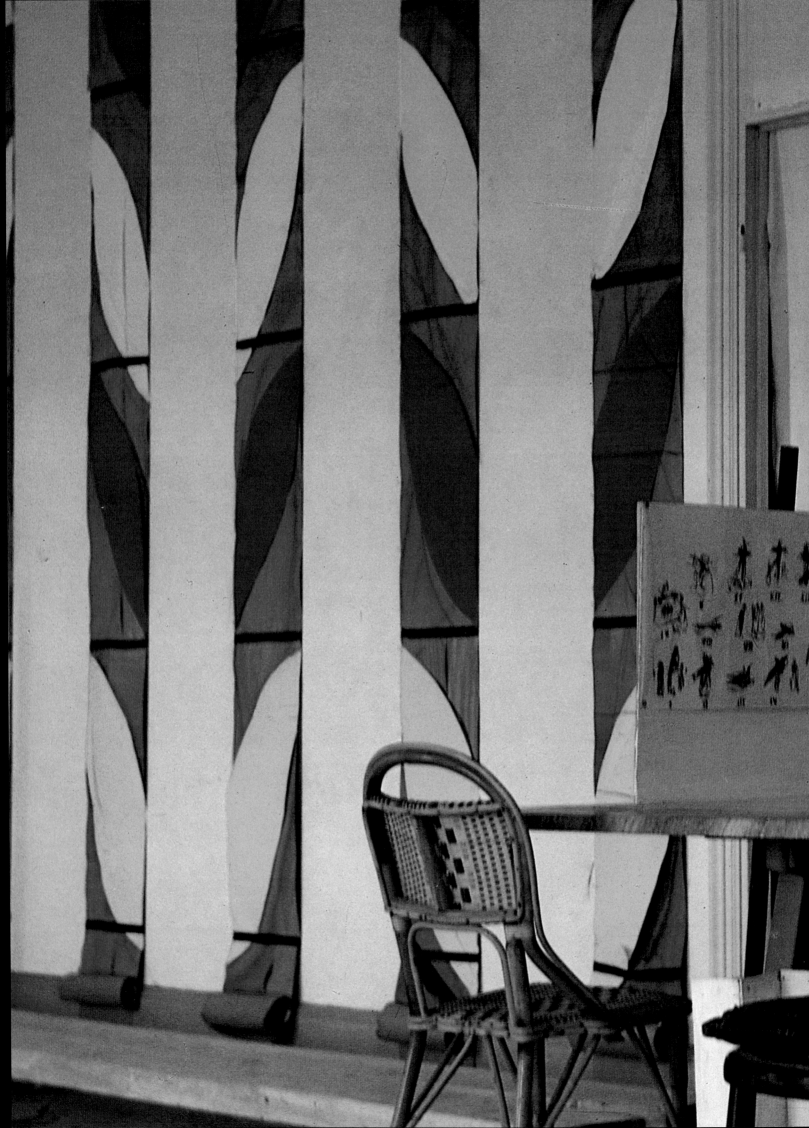

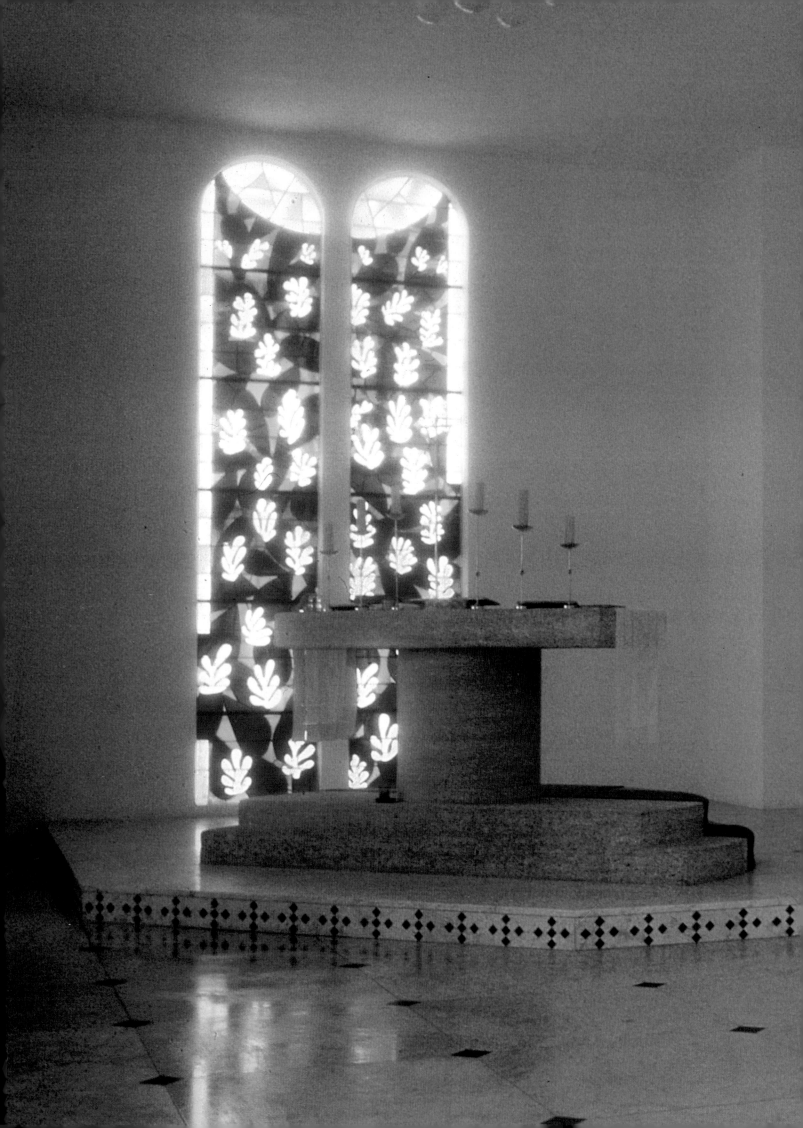

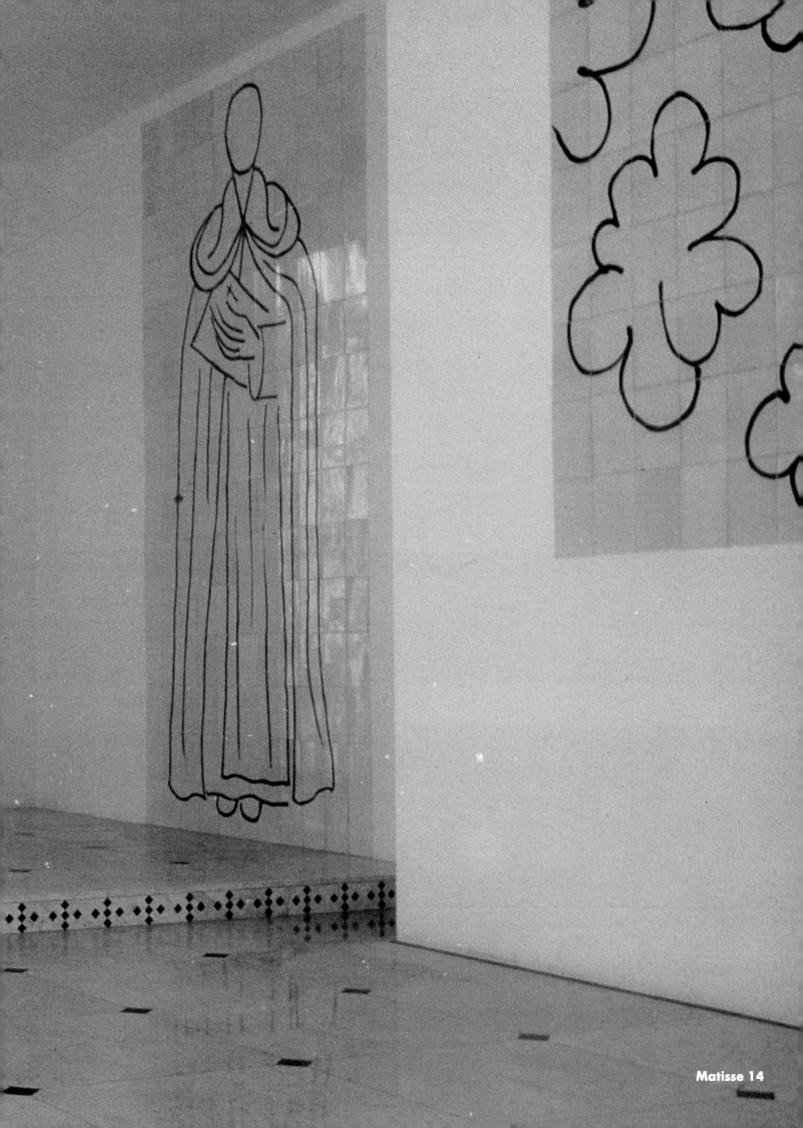

Matisse 16

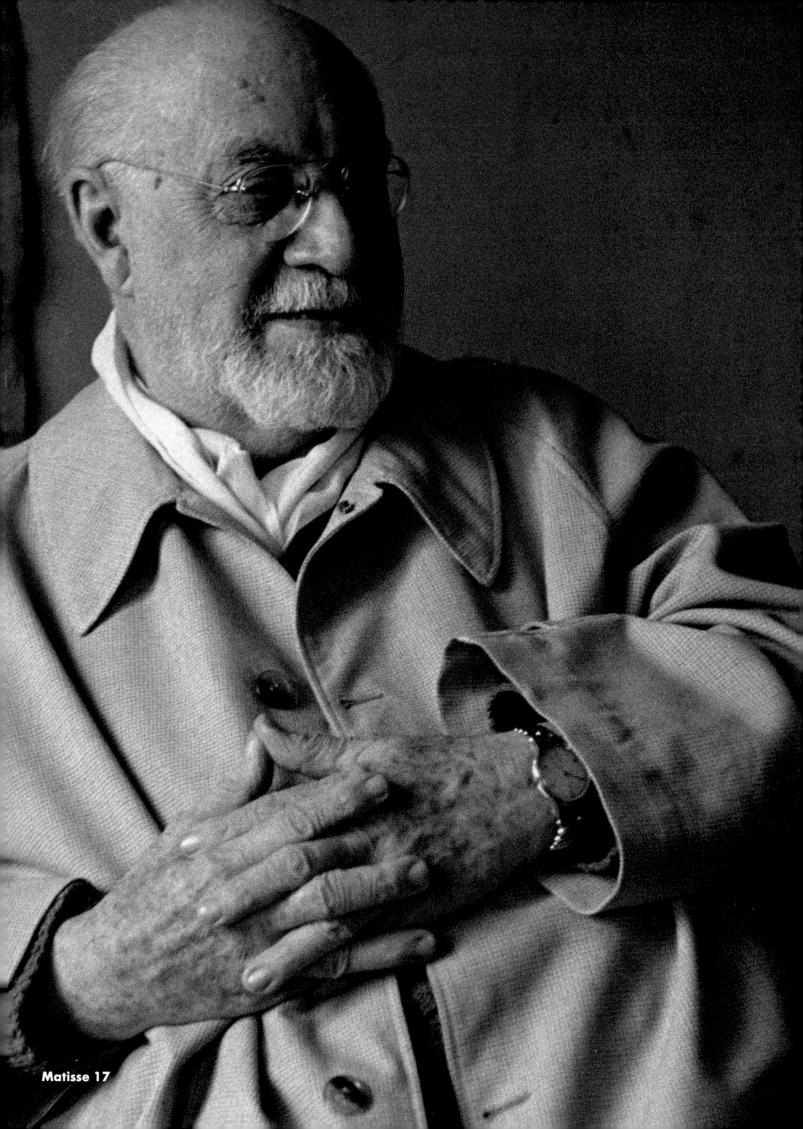

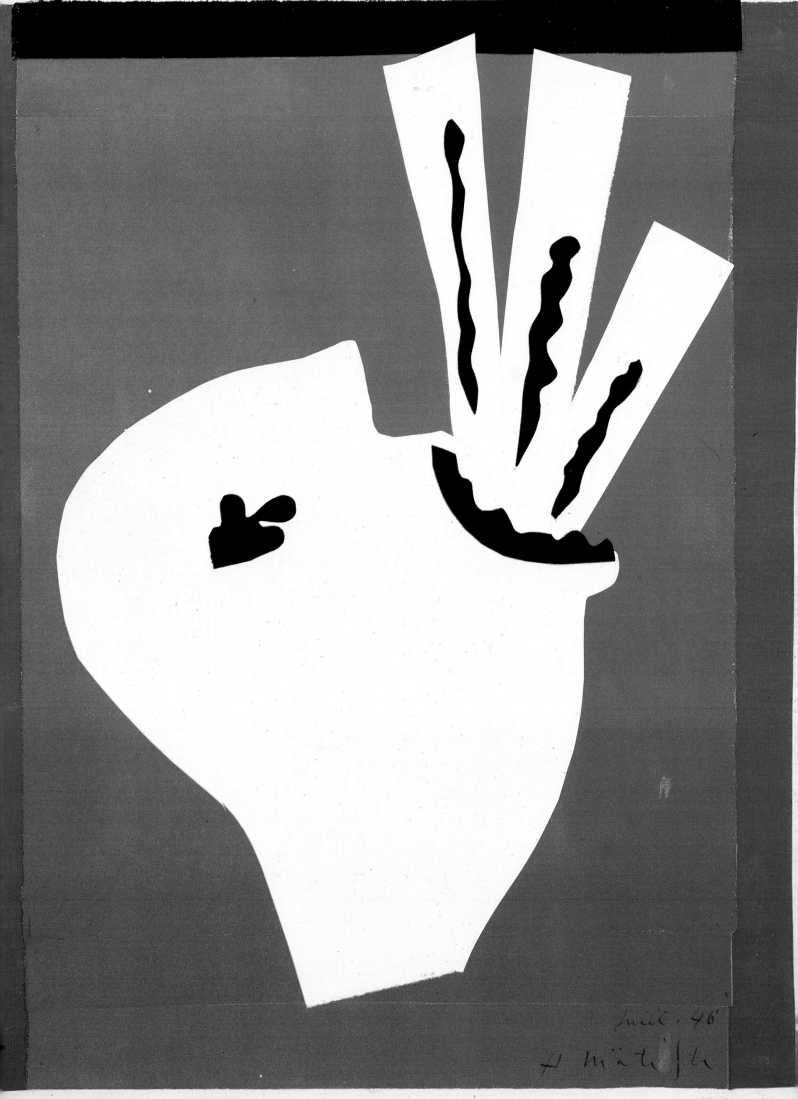

juill. 46

H. Matisse

Rouault

In the doorway of a dimly lit living room appeared a man with an extraordinary lunar face. His complexion was pale, his stare fixed, with eyelids blinking quickly over large pale blue eyes. There were yellow streaks on his eyelids, as though while painting he had rubbed his eyes, smearing some yellow pigment. The wrinkles on his face were thin, like the lines on a sensitive young hand. The wide mouth with its thick lips covered a row of widely spaced, protruding yellow teeth. He was dressed in a light bluish-gray suit, a stiff white collar, and a large-knotted tie fixed with a ceremonial pin. And, in the intimacy of his own home, he wore a hat, a formal gray Homburg. This was "Monsieur Rouault," the master on an official appearance.

At the threshold of the room Georges Rouault stopped and stood still, as if enjoying the effect of his entrance. His daughter produced a stenotyping machine and hid in a corner to take down every word her father was about to say. Her straight hair, parted in the middle, was pulled tight. Her face, slightly tilted to one side, bore the wan smile of a woman used to being browbeaten.

The living-room furniture was dark, Gothic. In an enormous cupboard opposite a sideboard open shelves displayed decorated porcelain plates. Near the window were a lectern, a wooden eagle with wings outstretched, an armchair worthy of an archbishop. The dark wood, the scale of the objects, crowded the small conventional room. The window, hung with lace curtains, opened onto the extraordinary cacophony of a station square. Milling in front of the Gare de Lyon, the busiest railway station in Paris, were hundreds of taxis, buses, bicycles, porters, trucks.

Rouault moved slowly. He sat down and began a monologue addressed mostly to himself. My questions, like a tap, released a long stream of recollection. He had much to tell, but age jumbled the chronology in his memory. It was extraordinary to be in the presence of someone who spoke of Degas, of Cézanne, and of Renoir—as his contemporaries: "I looked at Cézanne's canvas and said…"; "Cézanne said to me…" Elaborate recollections followed; he played the record

Rouault 2

of his memory regardless of his audience.

He was often bitter. He said that for many years Ambroise Vollard, the famous art dealer, used him as his secret advisor. He seldom bought a painting without consulting Rouault. Rouault felt he was the art director behind the scenes, and this unacknowledged role had left its scar. At a time when Rouault's own art was not sufficiently appreciated, he found himself employed to evaluate other people's productions. Vollard also kept him working day and night on illustrations, with no time for life. He was always kept busy changing, correcting, never ready. He seemed bitter that the Germans and the Russians and the Americans had appreciated his art and discovered him before his own compatriots. He was bitter that success had come so late in his life—to late for him to enjoy. Only when Rouault was over seventy could he afford to go to Venice.

"You know," he said, "I have never got on with officials...they have cared little for me. They've let me be in my little nook. And now that I'm half dead they have tried to come and fetch me.

"Isn't that so, Isabelle?" He turned to his daughter. "They waited until I was old and feeble to propose me for a seat in the Institute. You can guess I sent them away with their tails between their legs, eh? They've waited for me to be nearly dead to come to fetch me."

Funny, agile gestures of his hands illustrated his stories and reminded me of the accents and mimicry of a Punch-and-Judy show. He acted out a role. His stylized movements performed a carefully rehearsed pantomime. He lowered his head and raised his arms when sadness was his mood. He raised his head and stretched his arms wide for joy. To display cunning he scratched and curled his body.

An understanding of the theatrical gesture is a key to Rouault's art as well as his conversation. Many artists have this gift for mimicry, which is part of the ability to observe and, after having observed, to draw. The artist must be able to imitate, to project himself inside whatever he wants to draw. This is why Rouault drew with such ferocity and understanding and humor the soldier, the prostitute, the judge, the lawyer; he could act out all parts in his own *commedia dell'arte*. He was both its actor and playwright.

Present in all of his stories and gestures was laughter, violent, cruel, and sardonic. When the thick lips of his wide mouth stretched into a grin, his yellow teeth protruded. When he looked over the photographs of himself he chose the one of himself laughing violently, making a strong gesture with his hand.

"I am fed up with always seeming sad and tragic," he said. "I am not. I like a good laughing picture of myself."

Rouault liked to laugh. But it was a satirical, Rabelaisian laugh. This mystic, this man who had been all his life preoccupied with religion, had the rough humor of a country priest. And in Rouault one understood how close laughter is to tragedy.

Rouault never outlived the 1900s. In his talk he tangled

turn-of-the-century political intrigues with his admiration for Albert Besnard, a French *pompier* academician, his admiration for his Beaux-Arts teacher Gustave Moreau, his admiration for everything in a past era. He never mentioned any contemporary artist except Matisse.

Of all the twentieth-century painters, Matisse was Rouault's oldest friend. Although the two men—both ill—did not see each other often, their friendship remained. The link between them was Gustave Moreau, under whom they had studied at the Beaux-Arts. Moreau, who painted mythological scenes in the style of the 1890s—pictures of Salomé in luminous glazes and small jewel-like touches of color—was preoccupied with texture, sensuousness, the voluptuous richness of precious stones. His lessons are still felt in both Matisse's and Rouault's work. And his students, these two geniuses, met toward the end of their lives in the same preoccupation with religion, the same interest in the stained-glass medium.

There seemed to be no contact between Rouault and his surroundings. Considered one of the leaders of the modern school, he took a stand against everything modern. He believed that since the days of his early manhood people had forgotten how to draw, how to paint. He felt that too many of his contemporaries had been bypassed and not sufficiently appreciated.

"All these youngsters think they can build on emptiness," he said. "Nothing emerges from nothing. You must be humble and not think that you know. Everything must be begun again…and I who have waited until seventy to go to Italy!"

While Rouault talked, I looked at his feet. Although carefully and so formally attired, he wore felt bedroom slippers. This was a telltale evidence that he lived an old man's life and perhaps was more of an invalid than he appeared. He gave the impression of an animal in a cage. One felt that Rouault was suffocating and lacked the vigor, because of age, to break his chains, and that whatever energy remained he poured into his violent canvases. The sad house, the sad, dull apartment, were out of scale with the giant's soul. As he talked, some of his gestures reminded me of Michelangelo's prophets. There were flashes of extraordinary grandeur in his speech and gesture that contradicted the pettiness of what he said.

But old as he was, he remained master of his house. One felt a fear of disturbing the great old man in the manner in which his daughter spoke to him. As I left, Mademoiselle Rouault grasped my hand and said, "Thank you for your discretion." Modesty, withdrawal seemed to be the keynote of that disciplined life in which a tormented, violent human being poured his passion into painting. It was striking that in the presence of a great religious painter never were the words "God" or "religion" or "faith" mentioned. Religion seemed to be a deeply hidden inner self in Rouault which he revealed only through his art.

Some years later I returned for a second visit with Rouault. I stood again in the dark living room. It was impossible to see his studio. Few had ever been allowed in it, or to see him "cook" at his painting. This time, through the white doors, appeared a white ghost. Rouault was dressed all in white—a white surgeon's coat tied with a simple belt, a white surgeon's cap on his head. This was his working costume. And he wore eyeglasses rimmed with plastic—incongruously modern in the medieval setting of his apartment.

In his right hand he held a huge, curved, carefully scraped palette, the traditional palette of the Beaux-Arts student, a bottle of turpentine, an inexplicable aluminum funnel, a jar with a few brushes. Much thinner than before, he looked younger and more ethereal. With the same absent-minded grandeur in his manner he started again on his stream of recollections. However, there were less fire, fewer gestures when he spoke. His daughter brought in one of his latest paintings; it was an exciting, dynamic canvas charged with every ounce of energy that remained in Rouault's body. The canvas was yellow-green. The scraped paint on Rouault's palette was yellow-green. This was the light that Rouault saw in his old age, the same light that seemed to surround Matisse in the Vence windows. Was there a mysterious relationship between these men's old age and their desire for the warmth of sun color?

In many of Rouault's late canvases a sun or a moon is the source of all light, a golden haze which spills over from the canvas onto the frame. It is more than just the light that concerns every painter. There is a mysticism in the light, as though the preoccupation with light had led this man away from this planet into another world. Rouault and Matisse seemed to have gone beyond the material on this planet. They went beyond matter to the source of all life and of all painting, this thing we call "sun" and beyond which is God. Rouault and Matisse reached their mysticism not through form but through light.

In the golden radiance which bathes his last works, Rouault seemed to have glimpsed the light of the Promised Land—that short, stocky, great man with the clown's face and the gestures of a prophet, with the sad mouth and the blinking eyes, who stood high above the turmoil of the street, oblivious to its whistles, klaxons, shouts, and crowds.

Notes on the Illustrations

George Rouault, 1871–1958. Born: France.
Photographs taken in 1950, 1953, 1956.

1. Rouault, in his Paris apartment, next to one of his paintings of clowns.
2. A group of religious sculptures and a painted crucifix in the studio.
3. Rouault entering his studio two years before his death in 1958, dressed in a surgeon's uniform and carrying his artist's tools. He said of his torn, twisted paint tubes, "I assassinate them."
4. A painted plate, one of Rouault's many experiments.
5. Rouault carried away by his vision.

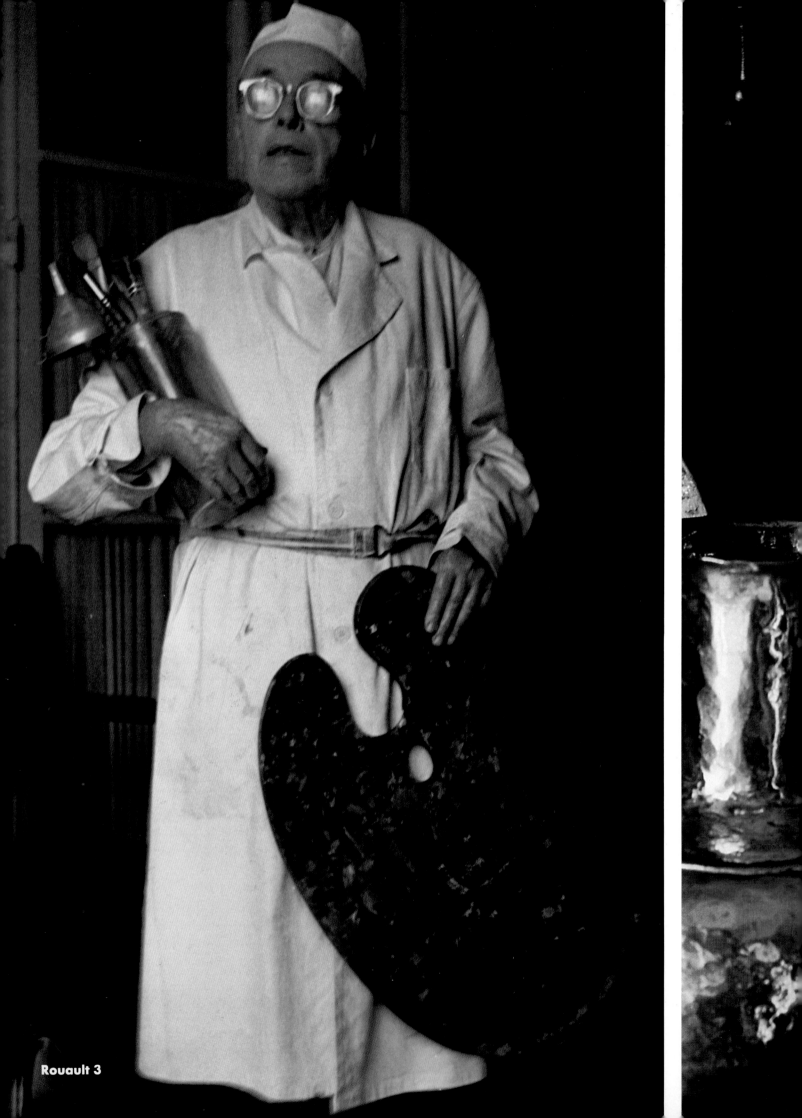

Rouault 3

Rouault 4

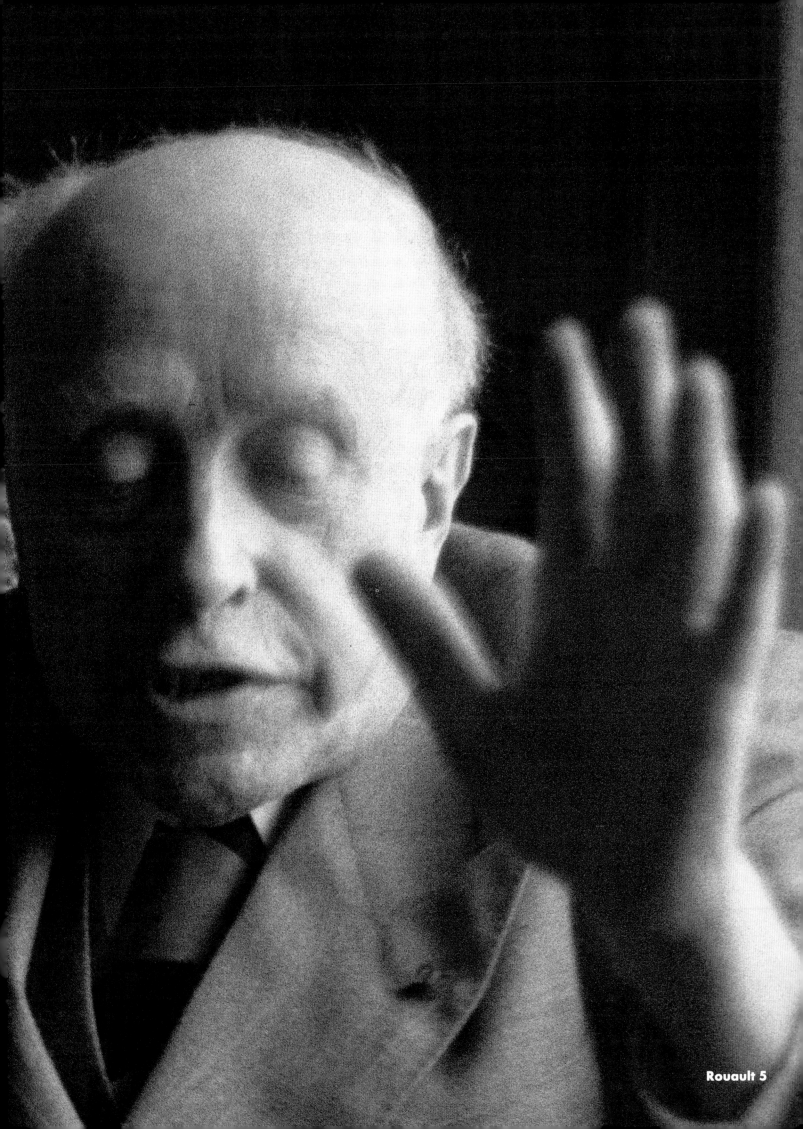

Utrillo

Under the Second Empire, when it was fashionable to live on the outskirts of Paris, the rich new society of Napoleon III built large villas in the suburbs of Chatou and Le Vésinet. Today these estates with their parks and gardens have been broken up into small lots, with one- or two-story houses that bear such pathetic names as "Çamsuffit," or "Good enough for me." This suburb, where Maurice Utrillo lived, is sadder than the poorest workers' districts. Its avenues are bricked in by walls. One rings several times before being admitted through the forbidding iron doors barring these houses from the outside world.

I visited Utrillo in 1949. From the outside, his villa, with its high walls of gray cement, was indistinguishable from its equally drab neighbors. But after ringing at the gate, I was somewhat surprised to have the door opened by a butler-gardener in a blue apron. At the end of a meticulously cropped lawn dotted with pseudoclassical statues, bird cages, and pergolas, stood a gay pink villa with orange sunshades, a house one would expect to see only under the bright Mediterranean sun.

Madame Utrillo, who is also an artist and paints under the name of Lucie Vallore, came out of the villa. She is short and stocky, with a square peasant face. She wears no makeup; her mouth is wide and mobile. She talked incessantly.

Madame reclined in a deck chair in the shade of a pergola and spoke of ambassadors, authors, princes, and Hollywood stars. "We were invited to go to the wedding of Rita Hayworth," she said. "Rita is a great friend. I ordered my husband a blue suit so that he would look more like a master." She spoke mostly about herself, Lucie Vallore, the painter. It was difficult to find out about Maurice Utrillo. She gave the impression of a monologist occupying the stage because the principal had been delayed or unable to perform.

After interminable chatter we walked toward the house. The red-orange shades were half drawn over the large glass doors of the dining room. Suddenly a ravaged face appeared from behind the glass, an elongated face with deep furrows and large dark pockets under downcast eyes. The face re-

mained immobile for a few instants, its glance averted, all the more tragic in its gay frame of sunlit pink walls and orange shades. It remained motionless, as if waiting for an incentive to move. The gardener-butler rushed up to open the door. A tall, stooped man with a thin streak of gray hair over his balding forehead shuffled slowly into the glare of the sunlight.

Utrillo wore blue painter's trousers, an Eisenhower jacket, a shirt with a stud but no tie; his feet were clad in the familiar checked-felt slippers of French concierges. His wife seemed to have dressed him for the occasion, but his clothes were too small for him. The sleeves of his shirt hung limply over his small, lean hands. His thumbs were folded inside his clenched fists.

An academic statue of a classically draped woman holding a palette in her hand stood in the garden. This Muse of Painting, probably left over from some imposing Beaux-Arts monument, was surrounded by rows of little red begonias and a minuscule, toylike green fence. Utrillo looked at the goddess of his household as though he were seeing it for the first time. He shuffled toward the statue, examined it with curiosity and surprise, shuffled away, bewildered. Madame Utrillo followed behind her husband and turned him in whatever direction she saw fit, saying, as to a child, "Answer the gentleman, turn and smile; the gentleman wants to take your picture." He responded with monosyllabic sounds.

A haunting tragedy was painted on Utrillo's physical self. The ever-averted eyes, the downcast face, the drooping sadness of his frame cried out for help. This man gave the impression that he did not enjoy life and wanted no part of it, that he had relinquished any control. One did not even feel his presence in his own home. Madame dominated the household.

The villa was overcrowded with fantastic baroque furniture—huge eighteenth-century side tables, consoles, chandeliers, grand pianos covered with inscribed photographs of celebrities. Hanging on the walls of the main living room were small Utrillos, the typical scenes of Paris that he had painted all his life.

The adjoining room, a library, was like a small oasis of filial love. Here there were no Utrillos, only paintings and drawings by his mother, Suzanne Valadon. Neither were there any of his paintings in his own bedroom, a boudoir-like room decorated in an exclusively feminine, rich, and contemporary manner, all crystal and satin. The walls were adorned with Madame Utrillo's paintings.

Madame walked around her husband, asking, "Darling, don't you think I'm talented? Don't you like my work? Tell the man," she prodded, "what you think of my work. Don't you think I have made progress?" Utrillo emerged from his dreamlike silence to answer, "Yes, yes, oh yes." He bought his peace, his right to live his way by agreeing. But she wanted more than obedience; she needed approval and asked for proofs of love. These manifestations are scattered all over the house. On a palette that he gave her as a wedding-anniversary present he had inscribed, "To my good darling Lucie, her Maurice Utrillo—Thursday, 25th of August, 1938."

His own studio, at the end of a narrow black corridor, was a very small room, about eight by ten feet, with a tiny window. It could have been a maid's room. A small easel held a canvas on which he was working—the familiar houses, a *moulin*. Human beings, more important than in his early work, were represented in naïve, childish bottle shapes. Next to the easel was a collection of postcards, one of his great sources of inspiration. A small decorator's table supported his palette. This palette was revealing. On its rectangular wooden surface rose a high pile of white pigment. Four or five colors were neatly aligned at one corner in small dabs. There were a rag, many palette knives—and brushes; one suddenly understood that this was not just a painter's palette: to this man who had spent his life painting walls, houses, and churches made of stone and plaster, the palette was a plasterer's trowel. The mass of white was not just paint pigment but plaster and cement that he applied like a mason to his canvas.

What is the mysterious power of Utrillo's art? Why do his seemingly naïve landscapes haunt the onlooker? Unlike the true primitive who straightforwardly states his spontaneous vision, Utrillo hid under a guise of innocence his real tragedy and suffering. This ability to combine charm and ugliness, to coat suffering with the illusion of serenity creates the poetic sensation particular to his art. The impersonality of his scenes, the severe discipline that architecture (his favorite theme) imposed on his emotions, brought his art to the brink of greatness, to the classic universality of the artist who has dominated his ego.

"For the Greatest the Fool is the pencil more Blest
And when they are drunk they always paint best."
—William Blake

Utrillo was an alcoholic. One might have expected from him an expressionistic, tormented vision, but his best paintings have the solidity of stone. Where Cézanne sensed that one had to discover structure in the universe, Utrillo, with the simpler approach of a less intellectual artist, groped for structure and found it in his subject matter—buildings. This search for structure and solidity as a refuge for a reeling mind led him toward great art. His suffering and striving, his struggle with himself, also led Utrillo to God.

The dangerous quietness of Utrillo's manner, and the curious twisted smile that occasionally pierced his face reminded me of Rouault, another painter-mystic. Religion is both in the background and on the surface of Rouault's art. In Utrillo it is a more subconscious layer that has exposed itself in his obsession for painting churches. Rouault, who seldom painted architecture, expressed his religion through the human form. Utrillo, who always avoided the direct portrayal of the human form, expressed his religion in the buildings of faith. One was preoccupied with the human aspects of faith, the other with the stones of churches. But the distorted faces of Rouault and the leprous walls of Utrillo's houses are both aspects of the human tragedy.

An ordinary chest of dark wood in Utrillo's studio held a large collection of religious objects. There was no aesthetic choice in their selection; they belonged to the sentimental

nineteenth-century religious art of Saint-Sulpice. They were objects of faith on its simplest level: yellow plaster statuettes of St. Vincent and St. Theresa, a statue of Utrillo's patron saint, Joan of Arc, holding her sword in a rapture of prayer. Behind this chromo art stood some graver objects of faith, a few black medieval crucifixes, as though a deeper mysticism buttressed Utrillo's every day religion. The window of the studio opened on a small gray cement building with geraniums in front of the door. This was his private chapel, where he spent many hours of his day in prayer.

In the humility of Utrillo's art, the innocence of his vision, the humbleness of his subject matter, the modesty of his aesthetic approach, he is never the artist rivaling or substituting himself for the Creator. He touches the spectator and brings out sympathy and love. This is the painted suffering of a sinner seeking redemption. Utrillo was hurt by the cruelty of the human race which too often finds pleasure in tormenting the sick and the feeble. He found shelter from their laughs and pranks in the shuttered houses that he painted. And the love that he had to express and could not give to humanity he gave to God's nature.

Notes on the Illustrations

Maurice Utrillo, 1883–1955. Born: France.
Photographs taken in 1949.

1. Maurice Utrillo with his wife, the painter Lucie Vallore, in the garden of their house in the Vesinet — Utrillo absent, lost in his dream. His wife was to him nurse, manager, and loving tyrant. The house, La Bonne Lucie, is named after her.
2. Utrillo, L'Impasse Cottin, 1911 (detail). Musée National d'Art Moderne, Paris.

Derain

To understand French landscape one must visit the Ile-de-France, that region northwest of Paris where small villages nestle in gently rolling hills covered with fruit trees and flowers. The human scale of the land, the humbleness of the steeple of every village church evoke another age.

The highway cuts through the peaceful summer landscape, and I arrived in the village of Chambourcy. In one of the narrow cobbled streets was Derain's house. The high walls that surrounded it were typical of the French hope of privacy. But this is not the poor suburb of Utrillo's Vésinet. This is a nobler countryside, and Derain seemed like the lord of the village. Violent barking answered my ring at the metal gate. A vicious dog ran toward me; visitors were discouraged.

In the small tree-shaded courtyard was the classic façade of a traditional French *petit château*. The doors and windows were high, and the horizontal rows of small square window-panes rose like small multiple ladders. In this old-world atmosphere my eye was attracted to a discordant object—the chrome and black intricacies of a modern racing car. The contrast of the quiet, sleepy village, the old stones of the house, the badly paved yard with its chickens and barking dogs, and this twentieth-century automotive monster was a key to Derain.

He came out to greet me, tall and massive. His face had the impassivity of a Roman emperor's bust. His weight and frame prevented undignified movement. There was something majestic in his bearing. There was a slowness and sureness about him, and with it a great humanity. Also a certain shyness seemed a protective barrier between him and the outside world.

On the ground floor there was a large studio, probably the old living room of the house. Here Derain kept his printing presses and piles of books and references, and here he worked on his etchings and lithographs. This was really a storeroom. The tiled floor of the large covered veranda was strewn with drying fruit, rose petals, and canvases by Derain.

The veranda with its tall rusty shutters opened on the

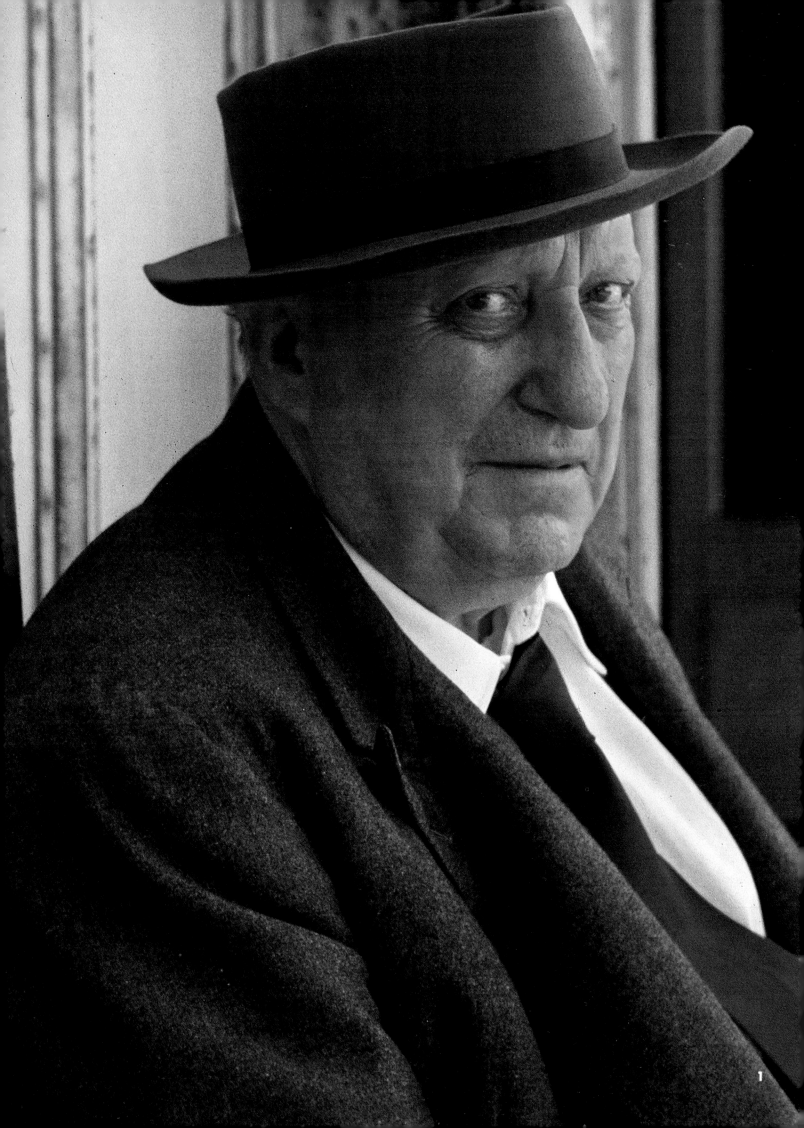

1

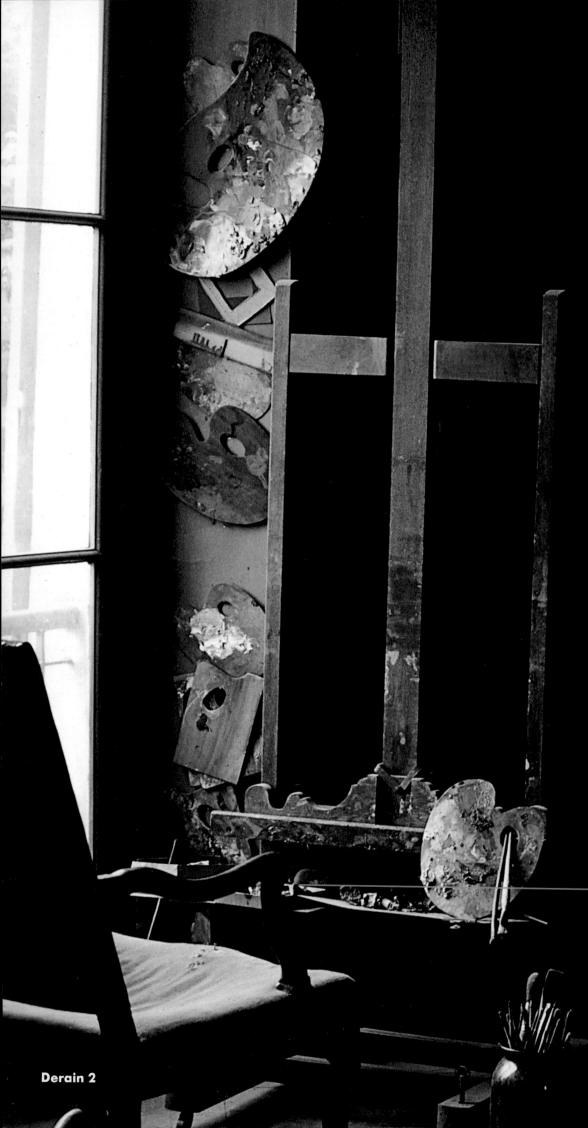

Derain 2

garden. This unfurnished terrace was also used as a storage for canvases. The unkempt lawn grew high with weeds and grass. The tall man who was showing me around seemed lonely amid surroundings that spoke of past glory. As in many others painters' homes, there were no ornaments in the living part of the house, just the bare necessities, and sometimes even these were absent. There was no need to keep up face, or to live a conventional life with each room having its appointed purpose. That was not the important thing in Derain's life; his work and his mood came first.

He wanted to take me down to his other studio, built down a slope at the end of the garden. Although the distance was only about three hundred yards, we got into a tiny car which seemed like a toy in the hands of this gigantic child. We drove down to the little studio—a modern one, neatly and practically built. Here, surrounded by tall trees, far from the conventional house, Derain was in his element. It was mostly filled with sculptures—cut-out pieces of metal—with hieratic, religious, or pagan themes.

Derain wore a worker's cap. As he sat by his worktable with the knives, pincers, chisels, and hammers, the metal, brass, and copper forms, he looked like a mechanic. He himself was the link between the cap, the tools, the metal, and the Bugatti. When I asked to photograph him, Derain became self-conscious. He kept asking advice: "Should I put on a blue jacket or gray? Which one will make me look thinner?" At first I felt a distance and a difficulty of communication, but gradually I found him one of the most charming human beings I have ever been in contact with. There were simplicity, ease, and naturalness, as well as an intense and subtle dignity in his bearing.

For a moment Derain sat down and placed his hand against his chest. The massiveness of his head, the thick, strong hands, the slow, curving volume of his body gave monumentality to the living Derain. There was grandiloquence in his manner. He reminded me of the great actors of the Comédie-Française. He had a true feeling for theatricality and drama. Seated and posed for a camera, he had a plastic understanding of what a pose should be. I expected him to recite in measured Alexandrines, that chant polished by the French tradition, some ode to nature.

Giacometti had often told me how highly all artists regarded Derain; how they respected his intelligence, and how he was always in the front of aesthetic research. When we dined one evening I was surprised to hear Derain say, "Art must not be intelligent; art is a *jouissance*, an enjoyment."

As I looked at Derain sitting next to his early *fauve* portrait, I thought of his sad life; there was a certain bitterness in his smile and expression. His had not been the easy path to art. He had been one of the wildest of the *fauves*; he had also journeyed with Picasso to the threshold of cubism. His early paintings were highly prized; but he had willfully turned away and struggled to re-create a classical tradition against all the egotism and expressionism that was flourishing among his fellow artists. This singlehanded reaction was difficult. Derain, like a dictator, felt that he had the power and

strength to lead the way; but the currents against which he fought have flourished and have attracted more and more followers. Derain, instead of gathering masses of young artists to his banner, found himself alone, more or less forgotten and, sometimes, even derided. There have been few Derain exhibitions. Indeed there have been few Derain books. This giant of art sat alone broodingly, stubbornly believing that he was right and all others wrong.

We returned to the house and then went upstairs to another studio. This must have been the old master bedroom with its fireplace, low ceiling, and doors that opened on a balcony. In this seemingly everyday room there was an incredible clutter—paintings, sculptures by Derain, sculptures from other countries and ages, Negro masks, medieval figures, Romanesque sculpture, playing cards, a fabulous accumulation of inspirational objects so intimately mixed that one could not distinguish between them and Derain's own creations. There were humorous portraits of children, prankish heads of men and women, funny caricatures, and by a window with a very strong cross light a still life was in progress. Like Braque, Derain drew in chalk over his oil paint.

All the while, I sensed a mind beating at the artist. As a *fauve* he had been one of the most powerful and dynamic painters of our day. Then, lashed by his discipline, he forced his talents and obediently painted in a classical, seemingly impersonal manner. If the ego was hateful, here was a demonstration of how to tame it. There was intense grandeur in this conflict, in these paintings, and in this man. But Derain felt that the art which was universal and had for centuries survived the passing fancies had some eternal laws. He works under the classical belief that the ugly is the human and the beautiful is the eternal and universal.

Notes on the Illustrations

André Derain, 1880–1954. Born: France.
Photographs taken in 1952.

1. Derain at seventy-two, a hard-living, haughty man of the world, with a 1904 self-portrait painted fifty years earlier, during his fauve *period.*
2. Derain's small painting studio in the Chambourcy house itself. There were several others for sculpture.
3. Derain, Landscape by the Sea, Côtes d'Azur, near Agay, *1905. Courtesy National Gallery of Canada, Ottawa.*

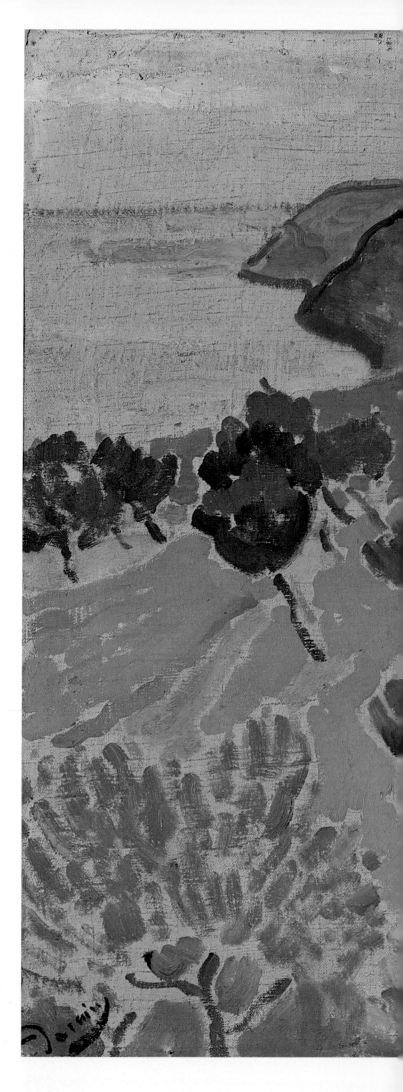

Derain 3

Vlaminck

In 1908 Ambroise Vollard, the French art dealer who made of his trade an art, called Maurice de Vlaminck, "the man with the red scarf." He wrote, "a big and rugged fellow; he looked like a militant anarchist with the red scarf tied around his neck." Fifty-four years later, Vlaminck stood in the doorway of his house in Normandy, a red scarf arrogantly tied around his powerful neck. The scarf was a stubborn link with his past when, in the early 1900s, he worked in a factory. An artist, he wanted desperately to belong to the people.

When I met him he wore the tweed jacket, the yellow shirt, the porkpie hat that seem the attributes of a city landowner visiting his farms over a weekend rather than the truly rural natural elegance of a man who belonged to the countryside around him.

La Tourillière, Vlaminck's house, is an old country seat with a carefully raked driveway bounding carefully cropped low hedges of box. Nature is gradually smothering the one-storied house; one could barely distinguish the architecture through the twining, climbing grip of exuberant wisteria.

Maurice de Vlaminck had lived in this *gentilhommière* since 1925. Over thirty years seems long by man's time, but nature needs infinitely longer to weld man into her creation. In this low, earth-hugging house he withdrew from the agitation of city life, seeking an immersion in nature. The half-door of the house, a carry-over from its peasant days when man and beast shared the same roof, half barred Vlaminck from sight, imprisoning his animal bulk.

In the mass of aged flesh, the eyes, though small, seemed enormous. As I looked at him, the bigness of the man, the coarseness of his features disintegrated; I became conscious of a tangible emanation from his eyes. Often artists speak of the tactile sense, of touching with the eyes the visible reality. Vlaminck's eyes were an invisible tactile extension that, like antennae, groped and touched the world around him. His blue pupils appeared to cover the whole eyeball with a metallic glint; the steely indifference of the stare enclosed in the scalelike lids had a brontosaurian grandeur. The pushing-away sensation that came from his eyes was in his whole manner; he resented and pushed away the outside world; his first words were gruff, question-resisting answers. In his hostility was the interplay of wounded sensitivity and self-sufficient pride. He exaggerated his surliness; having willfully withdrawn from civilization, he hated its intrusion and at the same time wanted to be loved despite it.

Born in 1876 in Paris, he was the son of a Flemish father and French mother. Three years later the family moved to Chatou, now a suburb of Paris. His parents were musicians, who paid little attention to their son's education, but they saw that he learned to play the violin. On his school report card his teacher wrote: "Bad pupil, irascible, generous, impetuous."

In 1899, after three years in the army, he returned to Chatou and painting, earning a living by giving music lessons or even playing the violin in a gypsy restaurant orchestra. That same year he met André Derain; it was the turning point of his life. They were both physical giants; both athletes, both painters, and both lived in Chatou, a small town on the Seine. There they saw the gray bridges, the green islands, and that mysterious fauna of French rivers, the red-topped barges, the fishing boats, the bathing establishments. Colors were enriched and blended by the watery haze and rendered more acute by the sensation-intensifying cacophony of river sounds.

The same Seine that, at Argenteuil upstream, opened the eyes of impressionists to color became in Chatou the initiator of the inspired young men experimenting with ex-plosive color. Derain, Vlaminck were to be the founders and only members of the "School of Chatou." In 1901, at the first great Van Gogh exhibition, Derain introduced his friend Vlaminck to Henri Matisse. Later Matisse came to see Derain and Vlaminck at work in their rickety riverside Chatou studio.

The discovery of Van Gogh was the great revelation of Vlaminck's life. He said, "I love Van Gogh more than my father." He felt a kinship of blood and spirit, but, above all, the violence of Van Gogh's transcription of emotion corre-

Vlaminck 2

Vlaminck 3

sponded to his own pent-up creative energy. He was given an outlet, a means of relieving inner pressure. This key that opened his soul was color. Van Gogh wrote, "Instead of trying to render exactly what I have before my eyes, I use color more arbitrarily in order to express myself strongly."

Fauves or "wild beasts" was the mocking name given to the group of artists who, with Matisse, Derain, Vlaminck at their head, exhibited in the Paris Salon of 1905. They believed in the use of bold, violent, unshaded color, often squeezed out directly from the tube onto the canvas. "*Fauves*," "impressionists," "cubists" were derisive labels, but time and success made the jokes misfire. The "sticks of dynamite," as Derain called the tubes of color, were triumphantly hurled into the face of the hostile world.

In this struggle mutually stimulating friendships were born, the curious spiritual associations of artistic teams pursuing the same goal. The tandems of Vlaminck-Derain, Derain-Matisse, Braque-Picasso were following the patterns of Gauguin-Van Gogh, of Monet-Renoir, of Pissarro-Cézanne. It seems as though man is afraid to climb unscaled peaks alone and needs a human teammate.

The search for who is first is alien to the artist. Matisse, Derain, Vlaminck, Braque, Picasso were enthusiastically creating side by side, discovering, giving to each other and eventually to the world, knowing that love of life feeds on generosity. It is all the more pitiful to find the great artists separated by art classifiers, dealers, and collectors. The struggle to establish rights of discovery is a mockery of creative purity, a money-minded belief in some universal patent office of art. Who was the first *fauve*? Vlaminck maintains that Matisse came to watch him and Derain paint their wild canvases in Chatou. Matisse's admirers brandish dates, proofs to the contrary. Who first "discovered" Negro sculpture and art? Vlaminck and his friends maintain that he was first. He saw an idol in a bar, showed it to Derain, who showed it to Picasso, who et cetera, et cetera. Others credit Picasso or Matisse.

The public has been misled into believing that art is an invention, a creation from nothing by a solitary genius working in a vacuum. Art, like life, which it reflects, is a continuity. The discovery of Japan stimulated impressionism. The enormous Easter Island heads, the hieratic art of Africa, existed for centuries but needed the right time and the right place to emerge and exert their power. Like a virus, such things lie dormant in the artistic bloodstream until a sudden change or shock, or weakening of other creative forces that have kept them subdued, permit their emergence into the collective consciousness.

Derain once said of Vlaminck, "Of us all he is the true painter." No one can take away from Vlaminck his greatness. The length of one's life does not always correspond to one's creative span. Some great artists have produced little; some died young; others, like Vlaminck, lived longer than the changing tastes of the world.

It has become fashionable to attribute greatness only to certain periods of an artist's creative evolution. Through these arbitrary decisions whole segments of inspired research are ignored. There are so few truly great painters who have dedicated their lives to the search that it would seem that the recognition given to their "great" moments would at least warrant a respectful, sympathetic viewing to whatever new avenues they explore. Vlaminck, Derain are branded as *fauves*; only their *fauve* paintings are sought; but their *fauve* period lasted only six or seven years in life spans of over seventy years. In 1908 both abandoned pure color, partly because they had come under the influence of Cézanne. Vlaminck said, "I suffered when I reached the maximum of intensity and was limited by the blue and red of paint manufacturers."

The striking parallelism of destiny in the lives of Vlaminck and Derain continued from adolescence into old age. Although Derain died only in 1954, at seventy-four, after an automobile accident, he, like his friend Vlaminck, had withdrawn into a haughty, wounded retreat. They, who had been the instigators, the creators of some of the most vital surges of contemporary painting, through a slow inner evolution felt that constant change and innovation might not necessarily be the purpose of painting. They were painters first, and with the same courage that spurred them in their early adventures they resolutely turned their backs on success —withdrew physically and mentally into a contemplation of what to them was true life, life as revealed through nature.

The dark, brooding landscapes that Vlaminck painted in his last thirty years are against the art current of the time. For Vlaminck the mind is the enemy of feeling, and his long life has been a logical pursuit of that "unspoiled eye" of the primitive. The Negro sculptures were a reaffirmation of permanent essentials.

The proofs of his passion for Negro art still hung in his studio-living room, a dark, large room. This accumulation of masks, figures, heads, helmets, weapons, animals, made the house look like a warrior's trophy room. The black, brown, yellow colors of wood, contrasting with the sickly yellow of ivory and the cold north light breaking in thin bluish-gray slivers on the rough-hewn facets, seemed to create a crystal of light around each dark object.

Vlaminck sat down in a dark red leather armchair, his weight pressing hard on the tired springs. I had a momentary image of a man drowning in fatigue, in old age, gasping for a last breath of air.

In answer to a question he held up two books, *Landscapes and People* and *Portraits Before Death*. "I have nothing to say; all you want to know is written here." He was a writer; he had published a dozen books—from romantic novels to vitriolic pamphlets.

He stood up, went toward the corner near the long, low window, and sat down on a high stool by a tall easel completely splattered with paint. "This easel that you see here is forty years old. I had it in Montparnasse." A curved palette hung on the easel, a large opaque area of black submerging the few bright colors.

Reminiscences started flowing; he forgot his forbidding act. His impulsive nature reassured, the process of communication started. Words crowded the mouth of this solitary man. Nothing could stop him now; his hoarse voice coming out of the hunched, resonant frame filled the room with a continuous rasping.

"Toward 1900 I shared a studio with Derain...the rent was ten francs a month...even so we didn't pay our rent. We used to burn the wooden chairs to keep warm. The portrait that you see here, I painted it in those days to pay the rent...ten francs...now, it's worth two million." His mind jumped from subject to subject as a word, a sound, pressed an inner button and released memories.

Lautrec: "He had the intelligence of a hunchback." Vlaminck goes to the movies but protests against their portrayal of artists: "Lautrec loved women and he was never embittered by his deformity."

Utrillo: "The film on Utrillo was equally false. They made him look like some idiot from the Renault factory. That isn't Utrillo. He is out of Dostoevski. There is a little of Alyosha in him."

Rouault: "He's a madman, too. His is a mystical folly. I have letters, poems of Rouault...completely crazy. For Rouault, Christ was a rebel."

Vuillard: "Don't like him. A Vuillard smells of cats and musty interiors. Bonnard has much in common with Vuillard, but Bonnard is an honest guy. He's a little master, like the little Dutch masters, who paint interiors with women darning socks and naked babies' bottoms....Bonnard's on the level. But he is a *petit bourgeois* who does not rise above his epoch. Like Proust...it does not go beyond his epoch. It becomes old-fashioned, like fashion that becomes unfashionable, like skirt lengths.

"A man who surpassed his epoch, and how, Van Gogh!

"I don't like artists, especially painters. I prefer writers. Literature is my 'Violon d'Ingres.'

"I work fast...I am not a Braque who makes tapestry. I never retouch a painting...it's better to start afresh on a new one; otherwise one gets lost.

"There is too much calculation in modern art. Me, I've never been able to add. I stand for the painting of feeling."

Vlaminck stood up, suddenly alert, momentarily rejuvenated, wound up by his own thoughts. Behind the easel were stacked many recent canvases: landscapes, seascapes, flowers. He put on his hat, as if the sight of his work made him think of the outdoors. He was alert, precise, and quick in the cumbersome process of stacking, pulling out, showing, putting away again his work.

As he leaned a landscape against a chair he said, "Today we see the world through the road. The gasoline pump has replaced the Virgin in its alcove by the road. One day we went one hundred kilometers to Deauville for dinner. Coming back I saw the gasoline pump illuminated by the headlights of my car. It's in that light that I wanted to paint it, in the beams of light from my headlights. I went back three times to see that gasoline pump."

His whole life had been this struggle for the direct transmission of the artist's personal vision to the spectator. In his youth he thought color could do it; in his later years, form; but his final belief was that the surest means is through sentiment. The emotion experienced in common with others is the truest way for the artist to be understood.

In an interview in 1925 he said, "In art, theories are as useful as a doctor's prescription; one must be sick to believe in them."

He paused, tired by the long conversation. The sun had set; the shadows deepened in the already somber studio. The twilight accentuated the chiaroscuro on his face. The light and shade, the ochers and the browns accented by blacks and whites, irresistibly drew one to think of Rembrandt.

Rembrandt in his old age studied himself, painted himself. The image of his old age is the image of man's suffering, but also of man's faith and humanity. Van Gogh sought in his many self-portraits the secret of himself. Memory is haunted by the questioning eyes of the painters looking at themselves in the mirror, looking into us as if we were mirrors that could answer their questions.

Vlaminck, the misanthrope, had not painted himself since his youth. But a painting, any painting, even a Vlaminck landscape, is in reality an artist's self-portrait. It is an indirect question asked of us; its reflection mirrored in our eyes may give the hoped-for answer. We look at a painting, but through his painting the artist looks into us. When he creates, he does not know the inner reason for his work. But the motive, the creative impulse, is the quest, the need, the yearning for love. Art even in its most popular forms seeks participation, understanding, and only dares hope for love. The thousands of paintings hanging on the walls of the world are thousands of living eyes looking into us. As we walk amongst them we run an emotional gauntlet. These demanding eyes beg the gift of ourselves.

All artists, all creators, painters, writers, musicians, sculptors, poets have made the gift of themselves. The creative act is an act of giving. Like a bridge thrown across a void, it allows passage from one shore to the other. Without pure, disinterested love, without the giving and receiving from the heart, there is no art. For a painter the true meaning of painting is in the act of painting. Vlaminck painted until he died. Van Gogh, his spiritual father, wrote to his brother, "In a painter's life death may not be the greatest difficulty."

Notes on the Illustrations

Maurice de Vlaminck, 1876–1958. Born: France. Photographs taken in 1954.

1. Maurice de Vlaminck at seventy-eight. A former fauve, *a solitary and forbidding man, Vlaminck lived at Rueil-la-Gadelière in Normandy for years in retirement from the agitation of city life.*
2. Vlaminck in his studio-living room.
3. Figures from the Baule tribe, from Vlaminck's collection of African sculpture.

Dufy

Raoul Dufy was a master draftsman. His drawing was the bone of his art. Even his use of color was in terms of drawing. His method of direct, uncorrected statement conferred on his work an apparent spontaneity that was the fruit of years of training. He was the most charming of the *fauves*, expressing his inner violence through the staccato of his strokes.

His studio was in Montmartre. Through the high windows he could see children playing in the cobbled street. Dufy always put on his glasses to paint, and his rounded features took on the pained expression of an old child concentrating. He was seventy-five when I last saw him, and he still worked swiftly, with a few sure strokes, but there were long pauses of doubt and contemplation. The gay, bright final result of his art hid from the world the pain of a sick man and the torment of his creation.

Notes on the Illustrations

Raoul Dufy, 1877–1953. Born: France.
Photographs taken in 1952.

1. In Paris, Raoul Dufy painting at his easel, 1952.
2. Dufy, Open Window, Nice, 1928. Oil on canvas,
25 ½" × 21 ¼" (64.8 cm × 54.1 cm). Art Institute of Chicago.
The Joseph Winterbotham Collection, 1937.166.
3. In his studio, Dufy kept this model of a sailboat,
a souvenir of his childhood spent in the great seaport of
Le Havre. On the easel, one of his regatta paintings. The
scintillation of the sails and flags against the blues of
the sea and sky was a favorite theme of this great colorist.
Ever present is a classical sculpture.

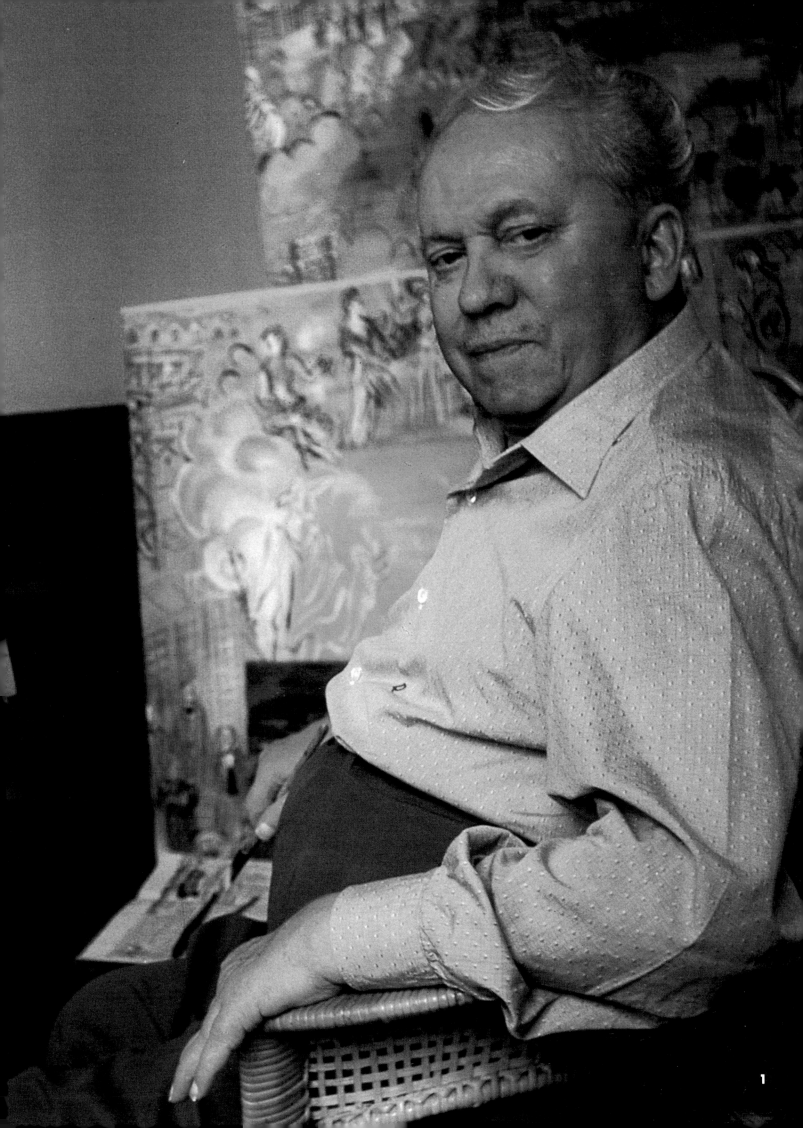

Dufy 2

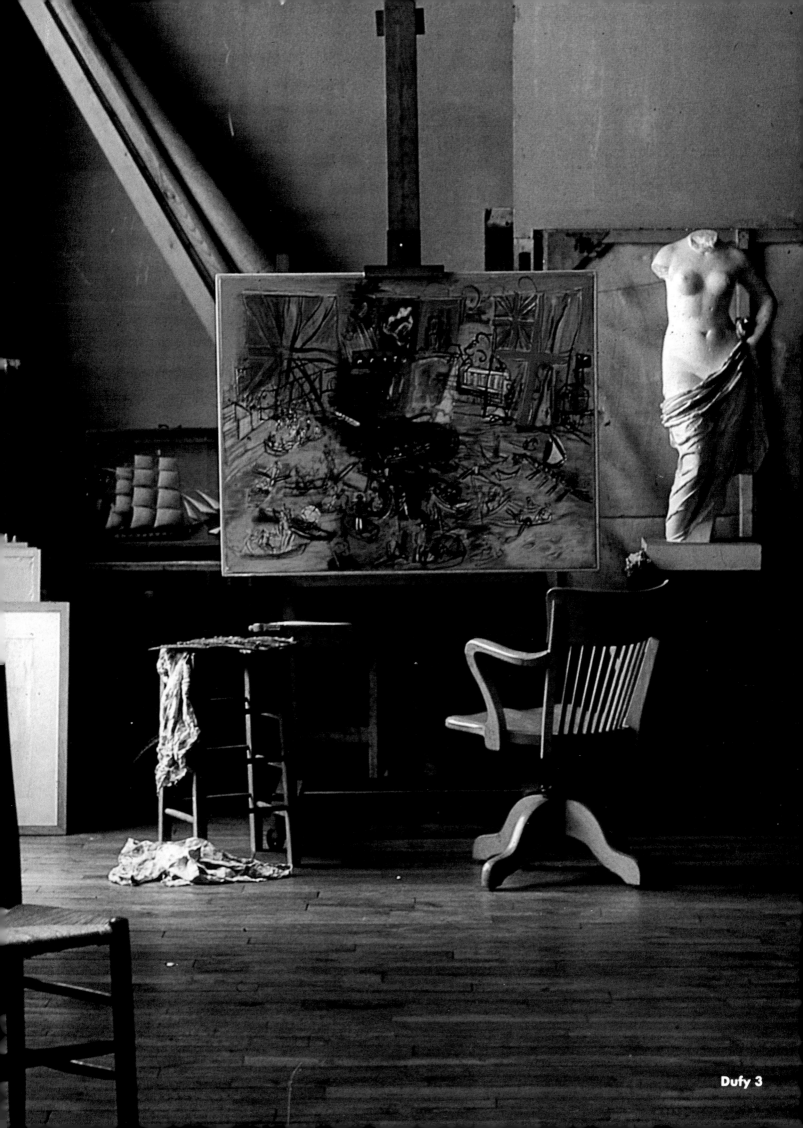

Dufy 3

Van Dongen

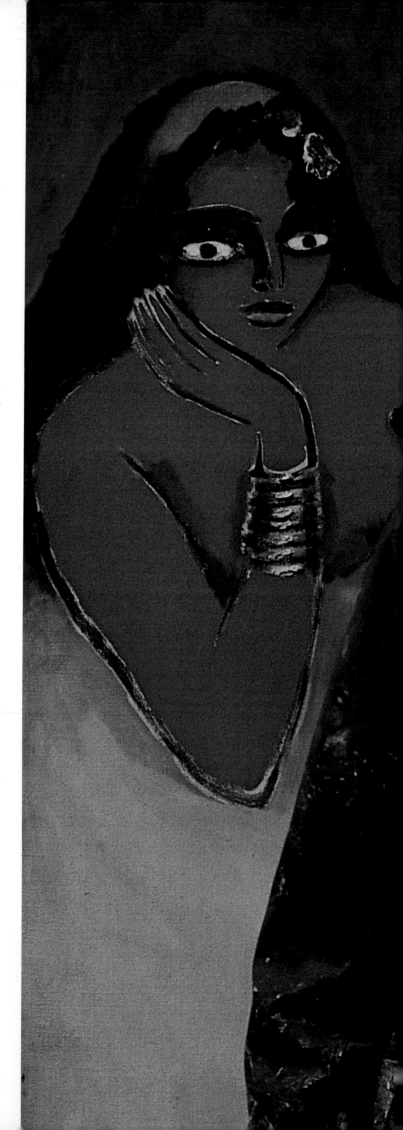

One of the first great *fauves*, Kees van Dongen found in the violence of color the means of expressing his vitality. As a youth he was so strong that he worked as a porter in the Paris Halles. Later in life he has known the debilitating and dangerous success of a painter of celebrities. The who's who of Paris between the World Wars were his models.

His Paris studio with its sculpted decor is of another era. It is so large, so sad and lavish that it made me think of a ballroom on some giant transatlantic liner as it sailed on its last crossing. Imaginary portraits of first-class patrons were its passengers. Kees van Dongen, his beret at a rakish angle, his white beard jauntily trimmed, was in command on the imaginary deck of the studio floor. He seemed a Dutch sea captain, experienced, powerful, the last master of a luxury cruise.

Notes on the Illustrations

Kees van Dongen, 1877–1968. Born: Netherlands. Photographs taken in 1959.

1. Van Dongen with his palette in 1959.
2. Van Dongen surrounded himself with art objects from many cultures. I noticed several Egyptian sculptures, a Buddha, and Chinese vases. His easel and palettes are set up in the center of the vast studio. Several mirrors placed about the studio allowed him to see his models from a great distance.

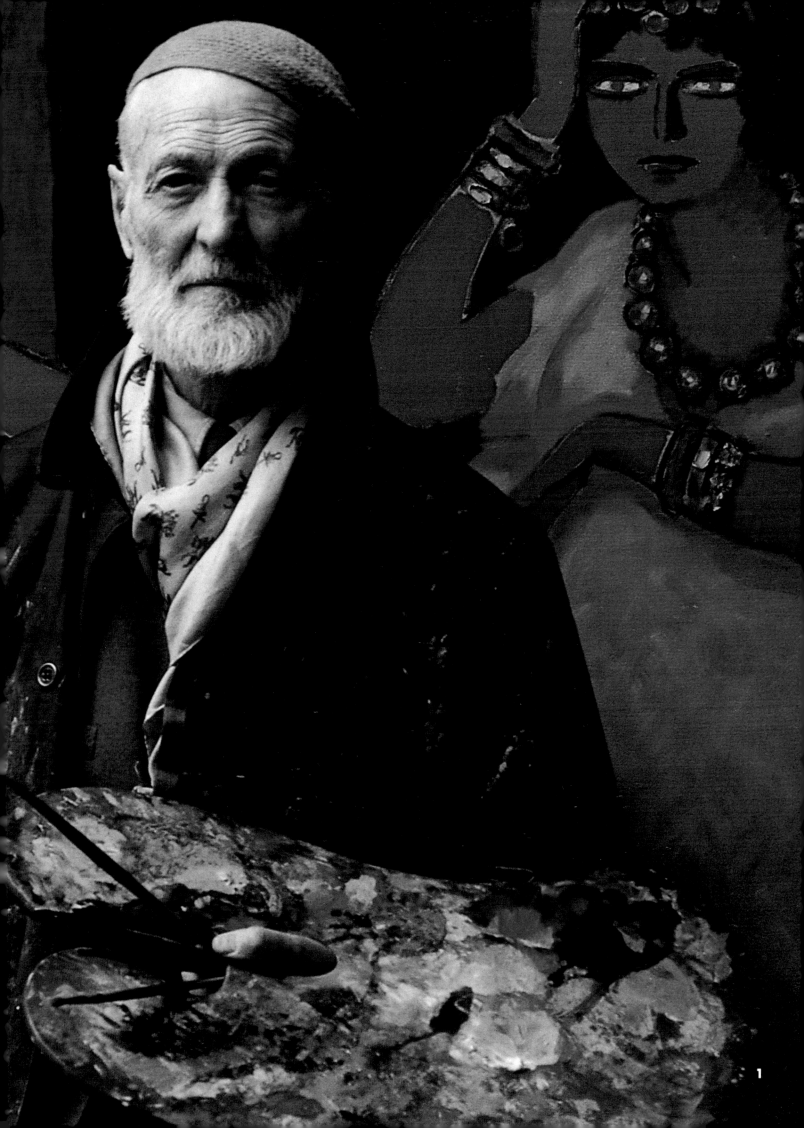

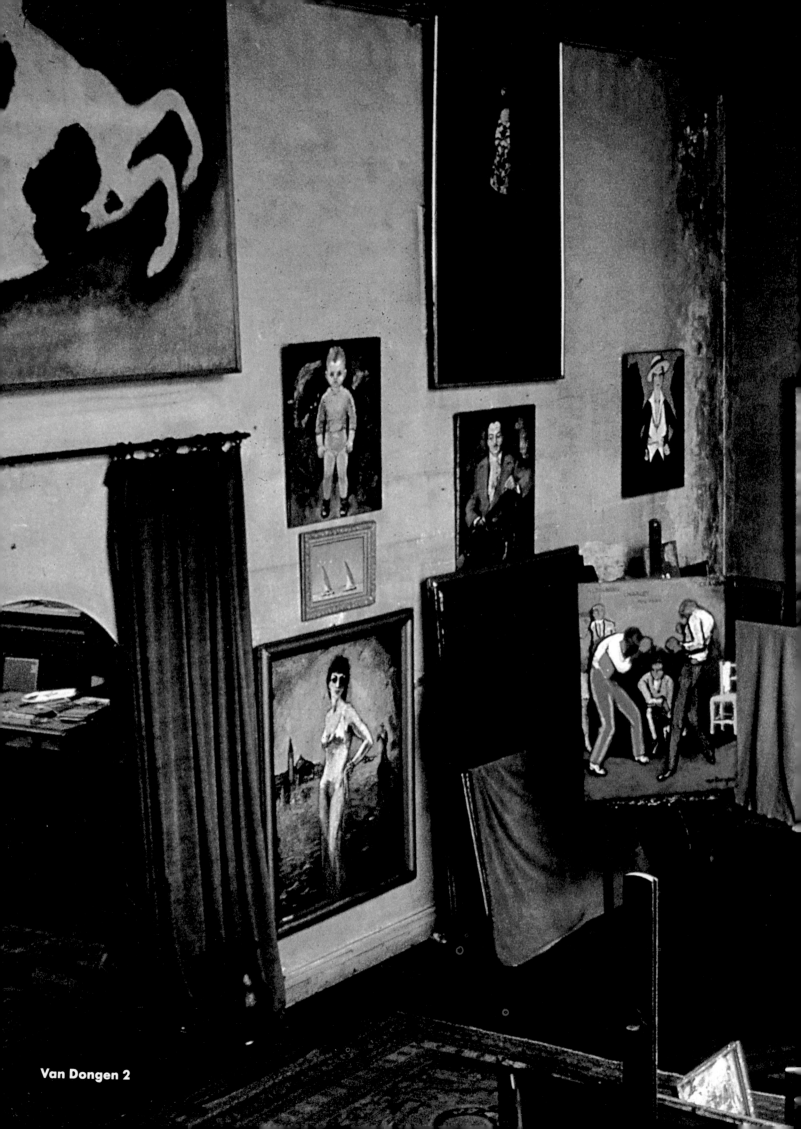

Van Dongen 2

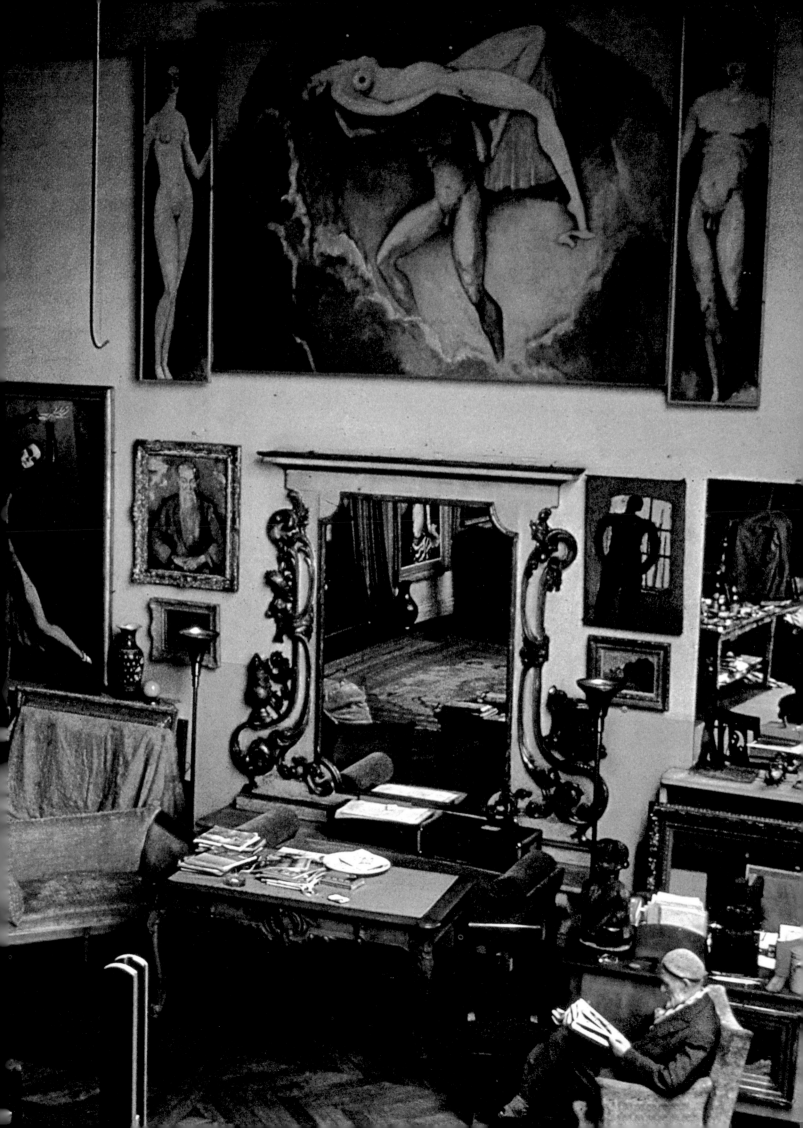

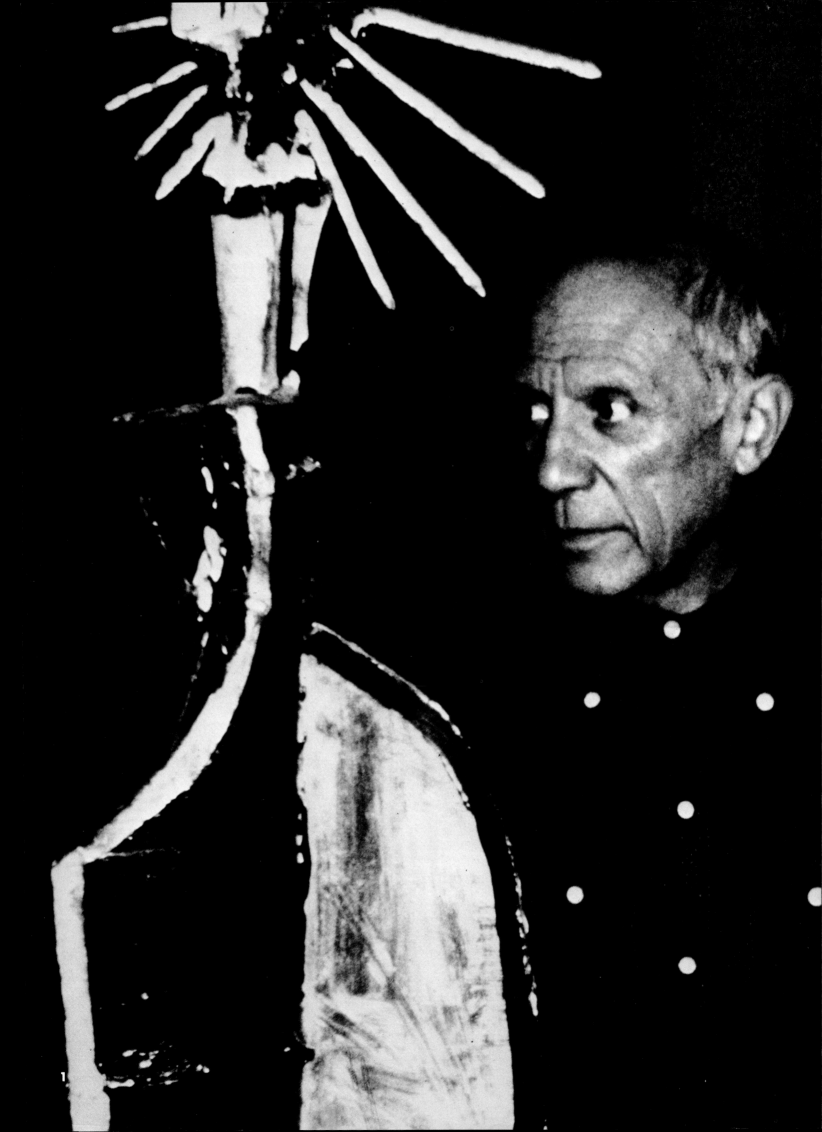

Picasso

"I am going up to Montmartre," Picasso said after luncheon in Golfe-Juan. He meant, of course, up to Vallauris, where he lived from 1945 to 1955, but the slip or willful change of name revealed the inner link with his heroic, creative youth in Paris and the vital importance that Vallauris, the quiet little hill town on the French Riviera, has played in his life.

On the Mediterranean coast he is close to his Spain. He can attend bullfights in Nîmes, and his Spanish friends can easily visit him. The rocky coastline, the olive oil in the food, the silver light reflected from the shimmering leaves of the olive trees, the intense shadows on the cubelike houses, are necessary to his creative life. In the South he finds that intense contrast of light on dry landscape which has caused almost all Spanish artists' preoccupation with the extremes of light and shadow, forcing them to attain the maximum expression in black and white. In this violent visual contrast is the secret of the Spanish genius for drawing and painting. It is as though the clear, dry southern air forces a clear, precise vision, even of death. The conflict of light and shadow, of black and white, is the conflict of life and death. Spanish art from the sadistic dismemberings of Goya's *Disasters of War* to the iridescent putrefaction of El Greco's *Burial of Count de Orgaz* to the agonizing last gasps of Picasso's *Guernica* has sought to make the idea of death a pictorial reality. In *Disasters of War* and in *Guernica* only black and white could express the artists' indignation at man's inhumanity and death.

The Vallauris villa, high in the hills, is a yellow two-storied house that could have been the house of a local doctor or notary. During the summer, hydrangeas help to give the semblance of a well-kept garden. One day when Albert Skira, the Swiss art publisher, and I went there, we walked around the house with its shuttered windows to the back entrance and the kitchen. Two women were busily cleaning. On the shelves, mixed with cooking utensils and ordinary kitchen dishes, were a few Picasso plates. On the Moresque tiles of the studio-living-room floor stood many paintings; on the walls,

souvenirs of bullfights, photographs. A large bookshelf was loaded with objects—books, gifts, mementos, sketches, and photographs, a storehouse of visual impressions, the same unbelievable clutter that is in Picasso's Paris studio.

One of the women told us to go on into the bedroom where Picasso was resting. In the semidarkness of that shuttered room he reminded me of a figure from his own classical period, a virile god of mythology, his torso covered with gray-white hair. His dark round eyes are so intense that you do not see anything else in his face except the two black piercing dots that hypnotize and hold you. The penetration of his eyes is prodigious. His body, old but strongly muscled, is the body of a prehistoric man. His neck is short and bull-like, his skull deep and large. His head seems large in relation to the rest of his body. In his seventies he still conveys an impact of primitive strength. He seems incessantly hunting to fix his visual prey, as the cave artist fixed his prey on the walls of Altamira. His eyes are constantly searching form, dimension, and movement. All of his gestures are precise and incisive. A pencil in his hand becomes a scalpel ready to cut the space before him.

In the middle of the small white room stood a big brass double bed and, near it, a heavily pearl-encrusted Spanish chest, the only piece of luxurious furniture. A three-paneled modern dressing mirror covered one whole wall. Over the top frame of that immense mirror were *banderillas* of red, green, yellow, blue. The ceiling held a bare bulb. Above the fireplace hung two heads by the Douanier Rousseau, along with portraits by Picasso of his children, and an enlarged photograph of Picasso's head, plus a small half-hidden photograph of Françoise, his wife, from whom he is now separated. The rest of the room was incredibly cluttered with newspapers, magazines, and letters, all piled high, unopened, waiting to be thrown out. Picasso, who always wants to answer letters, puts them aside to answer in the evening, then comes home tired, says, "I'm too exhausted, there are too many of them," and throws them into the wastepaper basket.

When Picasso saw us, he said, "Oh, today is a bad day to see me." He was expecting some Spanish visitors. He decided to get up and dress—in a polka-dotted blue shirt and wide, baggy shorts. With his extremely large head, this short, stocky man seemed like a young boy dressed in his father's clothes. There was a feeling of youth and at the same time of age: his hair very white, his face wrinkled, and his voice curiously soft and unsure as he asked questions and listened to their answers. But his dark eyes wandered. It was hard to understand in those eyes his changes of mood. One had to rely on his voice and on the extreme mobility of the wrinkles around his mouth. I was struck by his voice. He seemed to speak with such uncertainty, the thick Spanish accent coloring his French. Obviously a foreigner in France, where he has lived since 1904, he lapsed into Spanish with his servants, with his Spanish friends, with his son and daughter-in-law.

Everyone milled around. There were the two expected guests, who had arrived while Picasso dressed. They were from Nîmes, both Spaniards, one a picador, the other a bullfight promoter. (Picasso wanted to organize a bullfight at Vallauris.) They brought with them gaudy, wonderful Spanish bullfight posters for his selection. While talking to them about the coming *corrida*, Picasso became a Spanish peasant. We were joined by Madame Manolo, the wife of the Spanish sculptor. She has been a friend of Picasso's ever since his boyhood days in Barcelona. To him she seemed like a living letter from the past. There was also Paolo, Picasso's son by his first marriage. Paolo, until a few years ago, ran the household and acted as manager, chauffeur, and guard. With reddish hair, freckles, and heavy muscles, he is like a young healthy animal. When he smiled he exposed several gold teeth.

The whole crowd walked from room to room, talked of bullfighting, of memories of Barcelona; and Paolo, of the various domestic arrangements. Meanwhile the great man walked from one to the other, always with an expression of childish amazement and wonder. He seemed to be surprised at everything—delighted, pleasant, and anxious to put his guests at ease. Time seemed to be of no importance. People talked and sat around; there was no urgency about anything, no tension at all. Where would one eat? Well, time would tell. For the meantime there was conversation—not vital talk, just a sort of chatting, as though a group of peasants had met on a Sunday in a village square. Later, when we were ready to go out to eat, Skira put on a Tyrolean green hat. It amused Picasso so much that Skira gave it to him. He immediately put it on and looked at himself in the mirror delightedly. He has a need, a sort of childish desire, to take and to get inside other people's possessions. He likes to take, but he also likes to give and see people give. He put the hat on and never took it off until we got to the restaurant. This had made his day. The new toy he had received made possible a new transformation of himself.

A big table was set up at Tétou, a restaurant on the beach of Golfe-Juan. Everybody ordered bouillabaisse and lobsters. Tourists at other tables respectfully watched every move. One would get up from time to time and ask Picasso for an autograph; he was aware that he was watched and his concentration seemed more willful than in the relaxed atmosphere of his own villa. He ended his luncheon with vanilla ice cream and chocolate sauce. Paolo particularly amused him. Picasso likes clowns. He wanted to laugh. I felt as though he forced himself to laugh louder and stronger than others because deep in him he was extremely sad.

Around three-thirty he decided that he would take me to his studio, back in Vallauris. We drove up to a high wall with a gray weatherbeaten door covered with torn posters. Picasso took a large key from his pocket, opened the door, and we were inside an abandoned perfume factory. Several connecting buildings with big double hangar doors are Picasso's creative factory. It seems natural that this man, one of the most productive artists in the history of art, has to have a factory for his creative enterprise. In a corner building he opened a glass door. The first studio we entered was small and long, like a strange, narrow passage. At one end, next to the glass door, stood an easel surrounded with canvases. There is a

haunting resemblance between his Paris and Vallauris studios: they are both vast and dark.

Picasso works with very little of the painter's essential —light. The little there is comes through the window nearest his easel in a single, intense shaft of sunlight, its blinding brightness making everything around it darker. Sabartés, Picasso's lifelong friend and secretary, once said to me, "He does not need light....He has his own light from within."

The long tables were covered with cans of paint; shelves holding boxes of paint tubes, toy sculptures, his own sculptures; again, insistently present, an enlarged photograph of Picasso's head. On one table, mixed with the works of art, were thirty or forty blue boxes of Gitane cigarettes. He smokes incessantly.

Art is not a spontaneous creation; it needs either art or nature to thrive on. Picasso is surrounded by an unbelievable mass of visual stimulants. All the objects that have primed the pump of his creativeness are religiously preserved. For this man is a collector; he collects everything, everything that pleases, interests, or inspires him. "I never move anything in a studio. I always leave everything exactly as it is," he said.

Picasso, perhaps fearing that he will lose a source of inspiration, never allows anything to be thrown away. His houses, his studios show the accumulation of his long life. Picasso needs all the memorabilia, all the art and sculpture of the world to inspire him, but to produce he needs little. All has to be reduced to essentials as uncluttered as the inspirational sources were cluttered. His tools are a few brushes, a few squeezed tubes, some paint pots, a bottle or two of turpentine and oil, small tablets for palettes. "I use very little oil—mostly turpentine. I make my own small palettes out of plywood. I use boat paint—any kind they give me." This is all Picasso needs in order to create. The rest is in his mind.

The paintings on the easels were very different: one, a sad image of his children, as if their absence—they were in Paris with their mother—had drained his eye and mind of all joy. There were other paintings of his children, writing and drawing, starkly simplified in contrast to the realistic sweetness of his early portraits of children. In this period, with its opposite accents of green and mauve, of black and white, red and mauve, there is a sadness, like a deep minor key in a Mozart opera, the end of a chant. There are both a realization of age and an intense appreciation of youth.

Among these paintings was a carefully realistic canvas of a young girl in the manner of Cranach. On several other canvases there were stylizations and variations on the original head. On the main easel, the final image of the girl, with her hair in a ponytail, stood as material evidence of the immense filtering process leading to his artistic production.

He led me to a drawer and opened it. Inside were about forty pencil drawings of this girl, all heads, all drawn closer to his early Ingres period than anything he had done since. This then was the secret of his method—a completely penetrating, obsessive, realistic analysis of a thing seen. Only when it was at last fully known and possessed was he free to begin his experiments, slowly, progressively destroying the original form to arrive at the minimum of recognizable reality still sufficient to invoke in him the lingering image. After the first black and white realistic painting, he had painted twenty or thirty more canvases, each one abstracting a step further the original portrait; each one reducing to essentials, creating a new sign language that would still bring to the mind the image of the girl with her hair in a ponytail.

He had seized the original inspiration in the world about him, but after all the transformations only a faint yet indispensable trace of its prior existence in reality was left. His creation was no longer true to reality; it was true to a new reality of Picasso's vision. At the time of the final stroke, that moment when the truth of the artist's vision came alive on the canvas and defied death, Picasso was momentarily justified for all his striving. In such sublimation lies the purpose of art, the affirmation of the immortality of life through the inspired vision of the artist.

Creativity is the exteriorization of the life instinct, a sublimation of the sexual urge. The vitality of the artist is transmitted to his creation, which ignites a dormant spark of life in whomever is exposed to its radiation. As precious earths have emitted over generations their particles of charged mater, so masterpieces of art have survived centuries of ignorance, charged as they were with the artists' vital energy.

"You see this one," Picasso said, pointing to a study of another dark-haired girl. "I made three of her. In the third one I dominated her, and it is the best; in the others she dominated me." Somberly he added, "Women devour you!

"I have a horror of people who speak about the beautiful. What is the beautiful? One must speak of problems in painting!

"Paintings are but research and experiment. I never do a painting as a work of art. All of them are researches. I search constantly and there is a logical sequence in all this research. That is why I number them. It's an experiment in time. I number them and date them. Maybe one day someone will be grateful," he added laughingly.

"Rhythm is a perception of time. The repetition of the pattern of this wicker chair is a rhythm. The fatigue of one's hand as one draws is a perception of time.

"A painting doesn't exist—it cannot be a simple material object. A painting is a machine to print on the memory. A collector who buys it doesn't buy an object. He buys an intangible, and one day he wakes up with only a frame surrounding a space.

"For me each painting is a study. I say to myself, I am going one day to finish it, make a finished thing out of it. But as soon as I start to finish it, it becomes another painting, and I think I am going to redo it. Well, it is always something else in the end. If I retouch, I make a new painting."

Looking at one of his paintings, he said, "Accidents, try to change them—it's impossible. The accidental reveals man."

Just as his drawings in the drawer were all in black pencil, the original realistic painting was not in color, and the majority of the successive studies were in black and white. To

Picasso, form and line are all-important. He even said, "Color weakens." He sees fundamentally in black and white; he is not a colorist in the conventional sense but has the extra vision of a sculptor-draftsman. His great periods are predominantly monochromatic—the blue, the rose, the gray-brown of analytical cubism. Wherever he uses color, it is used to separate form and differentiate line. When I saw him, he was working with two colors at a time. On a small panel of raw plywood were pressed a dab of green, a dab of violet, and that was all; on a similar small panel, a large blob of white, a large blob of black, and that was all. These opposite extremes of color were the only ones in use, an economy of means to achieve the greatest possible contrast and richness.

"One must be able to cable a painting," he said.

Then after a moment's hesitation, he went on, "One can't cable a Rembrandt, but the archaics, the primitives, one can cable their art.

"Painting is really a way of life. I have a need to put things down on canvas or paper.

"I have an extraordinary memory. I remember practically all my paintings. The blue period was not a question of light or color. It was an inner necessity to paint like that."

"Cubism?" I asked.

"I saw that everything had been done. One had to break, to make one's revolution and start at zero. I made myself go toward the new movement. The problem is how to pass, to go around the object and give plastic expression to the result.

"The secret of many of my deformations—which many people do not understand—is that there is an interaction, an inter-effect, between the lines in a painting; one line attracts the other and at the point of maximum attraction the lines curve in toward the attracting point and form is altered.

"This change through attraction, that's what the collector never sees and will never understand in a painting," he said contemptuously. "And often one does a painting really for a corner of the canvas that no one looks at. One does a whole painting for one peach, and people think just the opposite—that that particular peach is but a detail."

He looked around him and said, "All this is my struggle to break with the two-dimensional aspect."

To break with the two-dimensional is not only an aesthetic problem. It corresponds to man's need to express a deeper dimension of his soul. Many great artists have revolted against their fate, against the restraints of society, or their inner compulsions. This breaking away is an affirmation of the artist's power. The revolt is a process of contradiction, the artist's choice between two opposites. If he feels the need to destroy that which he has just loved, this is compounded proof of the strength of his attraction.

The grotesque faces, the masks, the tortured monsters of Picasso, like those of Bosch and Goya, are not fantastic visions of another race but images of the artist's compassion and love of mankind. The ugly, the disgraced can be made beautiful by the artist, transformed as if by aesthetic magic. I thought, whatever monsters Picasso conjures up are not frightening, for they are but parodies of a thing loved. Parody, satire, and caricature are often devices to disguise excessive love, extremes to which one leans in order to balance excesses.

Near a tall stove stood some curious shapes of twisted tin, painted gray and then drawn over with black and white. They seemed to be attempts at creating a three-dimensional painting-sculpture. The thinness of the material, the angularity of the drawing, created as dry and pure an effect as that of the great cubist period. This seemed to be a new invention, a new game for this wizard of visual magic to play. He arranged the curious shapes with ease and with knowledge of the power of each interplay.

Picasso, like Michelangelo, seeks to give to painting the three-dimensional power of sculpture. When all Picasso's sculpture can be considered together, he will emerge as one of the greatest sculptors of our time.

In another room, with a higher ceiling than the others, was an immense scaffolding of fresh, raw pine going to the ceiling. This was where he worked on his great murals. In the middle of the workshop stood a weird relic, an enormous black limousine, a Hispano-Suiza, left from the 1920s. Picasso still uses it sometimes. This mechanical monster that he cannot discard is kept as a fetish. He went in and sat down alone in the back, crossed his legs, and for a moment or two was deep in thought, as if remembering the events and places that he had seen in this automobile.

As though locking up a compartment of his creative brain, he locked the studio door and led on tirelessly to another room, where, with another key, he opened the door, this time to an immense room, the largest in the whole factory, a studio crowded with sculpture. A little girl skipping rope was made out of wine baskets. In a corner, a perambulator, made of junk-pile discards, seemed to rock with the weight of a comic-strip baby. This man was playing, trying through play to recapture the innocence of childhood vision, trying through humor to bridge the gulf of years and purge himself of his sophistication. Picasso loves and needs to be near children. He was closest to them there in Vallauris. For his family, through the years a source of freshness and revelation, he has made countless toys, drawn cartoons, played visual games, painted their portraits, each experience enriching him and transferring to him some of the energy of youth.

His agile, playful mind needs such amusement. The sense of humor, the sense of theater, the childish delight in play are underlying qualities in many artists. Maybe one dares more under the excuse of play; the creative act becomes less pompous and self-conscious.

Above the sculpture studio are many small rooms. Over the fireplace of a small bedroom stood miniature furniture, chairs that would fit in the palm of a hand—his children's toys, and he could play with them too. On a peasant bed lay a book, *A Visit to the Louvre*, and next to the book, Picasso's sketchpad. On it he had drawn from memory, with incredible precision, *Le Déjeuner sur l'Herbe* by Manet and a portrait of Delacroix.

"Painting is a thing of intelligence," Picasso said. "One

sees it in Manet. One can see the intelligence in each of Manet's brushstrokes, and the action of intelligence is made visible in the film on Matisse when one watches Matisse draw, hesitate, then begin to express his thought with a sure stroke."

The exactness of the Louvre drawings in Picasso's sketchbook is proof of how accurately his hand re-creates the visions of his mind. He knows art by heart. He knows it, feels it, understands it, and can reproduce it better than anyone living now. He threw himself on the bed and, laughing, flipped through the pages of this recreation for his children of a trip through the Louvre, or a trip through the history of art.

"To fall back, to live on oneself, to withdraw is sterility. Communication with the exterior means fertility," he said.

"Success is dangerous. One begins to copy oneself, and to copy oneself is more dangerous than to copy others. It leads to sterility." Then, with a smile, he added, "To make oneself hated is more difficult than to make oneself loved."

An artist, as Malraux said of Goya, "discovers his genius the day he dares not to please." Picasso's break with his pleasing blue and pink periods, his caprice to reject successful periods too well mastered and to gamble for the domination of the yet unpossessed are the origin of his inventive greatness.

There are many great painters in the history of art, but few geniuses, few who, having mastered the material problems and techniques in a chosen medium, can transcend the limitations of the craft and from this dominance see beyond ordinary human vision. Picasso can. He is a modern Prometheus, a foreseer, a Titan of the arts. Like Prometheus chained to the mountain where each day a vulture came to tear out his liver, which each night grew again, Picasso is chained to his own greatness and each day his substance is torn out of him in the creative act. This is the ceaseless penalty of men of genius.

Picasso has seen the unseen and of his exploits into the darkness he has brought back proof. His visions do not evaporate like dreams in contact with light.

No wonder he prefers black and white to color. To him black and white are colors, the colors that shine in the two eternally opposed realms of existence, the realms of light and darkness. In a Picasso the intense black outlines and shadows are not the forms and shadows of objects in our everyday life but the color of things brought from the realm of darkness. The flat plane of the canvas is like the frontier between our world and the other. Forms emerge slowly from a Picasso, so that we begin to see them as objects surfacing from a great depth. When they pierce the flat surface of the picture plane, they are struck by the rays of our sun and take on the blinding white color of our reality. The black and white of Picasso are tangible proof that all has two sides, that the essence of things pertains to the two realms.

He led the way to another large hangarlike hall. In this rough plaster-walled room, with its high beamed ceiling like that of an old stable, were stacked against the walls hundreds of Picasso's paintings—large to small, all subjects, all periods.

Here this small, powerful man was storing up his accumulation of creation. Here he could come, look, and charge himself with his own vitality.

There is perhaps something of the curator about Picasso in relation to his own work. Each canvas had its year, month, and day written by Picasso in black paint on the back. Even his drawings, unlike most artists', carry a month, day, year under his signature. He is a collector collecting and cataloguing his own art, creating his own museum in his lifetime. He is even one of the rare painters who buy and collect the works of their contemporaries. In his Paris studio I remember seeing a large Balthus, a magnificent Matisse—*Still Life with Oranges*—and a Modigliani.

Picasso knew total poverty when, as a young man, he first came to Paris from Spain and starved. The habits of poverty are still present wherever he lives. Perhaps that is why he has bought and collected so much. It is a form of security. This search for security through the hoarding of one's own art may have a deeper reason.

The uprooted artist, living outside his own land, surrounds himself with a world of his own making. Most great artists of the past stayed close to their sources of inspiration. They could understand, explain, and portray them. They all benefited from the absence of easy travel and too-easy communication. Perhaps some nonrepresentational art can be partly explained by the lack of rapport between exiled artists and their new surroundings. The expatriate seeks by a private new vision to replace the lost one.

Picasso pulled out a fourth key. "There's a key for each studio," he said, smiling self-consciously. We went into a dark cavelike cellar, another storehouse. There was no light. We had to strike matches, and he finally opened a little porthole, a narrow beam of light blinding us momentarily. When my eyes became accustomed to the dimness, I saw shelves and shelves of pots, plates, vases, the work that he had been doing in the pottery, here assembled and stored. On the earth floor were baked bricks and curved tiles on which he had painted heads and nudes as beautiful as the early Etruscan and Pompeian masterpieces. The handling of earth itself, the mystery of color transmuted by fire are part of his continuous search for the secrets of timeless mediums.

In Paris he has a special glass vitrine holding his most precious relics. There his own small sculptures stand next to the dried skeleton of a bat, along with prehistoric, Etruscan, African, Eskimo sculptures, fetishes, coins, tokens, primitive idols, china figurines, fragments of bas-reliefs, bits of stone and metal, hammered, eroded, chiseled, chipped. In this miniature anthropological museum Picasso's own sculptures are indistinguishable from the rest of his collection. This small vitrine holds the product of centuries of human effort, like a giant test tube in which man's creative germ can be studied, man's ingenuity comprehended. And among these objects his own works find their place in the creative stream of humanity; they seem ageless and universal. He seems superstitiously afraid to touch these things, to disturb them, for fear that his work might be affected. They are the fetishes of

his creative life.

Here is no desire to break with the past. Although Picasso is the inventor of new visions, his break is only with the immediate artistic tastes, with the accepted academic schools of his own youth. In a deeper sense, he is a conservative and a traditionalist.

His is not a mind that reasons calmly. Picasso is a violent Spaniard, impetuously striving through his various mediums, painting, sculpture, drawings, lithography, etching, pottery, even writing, to ensnare the heretofore unseen images that will hold his generation hypnotized.

This man lives like a being possessed, a being obsessed with his mission. For a man with Picasso's compulsion a failure to continue to create is death, the living death that comes from self-despising. As Spain's Don Juan needed the constant reassurance of success through repeated possessions in order to preserve his own image, Picasso, to survive, to vanquish his inner fears, has to possess all creativeness. He dares to take creative adventure after creative adventure. His victory over death is his survival through repeated proofs of his own power.

There is anguish in the search which has led him to so many periods of style. He seems to have gone through life with haste, as though his span of life, though long, has seemed too short to him. He has plucked greedily right and left, hoping, by surrounding himself with art, to hold captive and prolong his own creative energy. And maybe in his comparisons of so many civilizations, so many modes of art, an eternal law has been made clear to him.

Picasso's art through the decades has seldom shown a constancy of style; his is a contradictory process of attack, then withdrawal, then attack again, each time advancing further than before on the path of artistic discovery. Some natures need a serene, reassuring, satisfied tempo to create in; others need the stimulus of opposites.

Picasso's inner structure is based on a continuous conflict of opposites. For certain hypersensitive artistic natures, contradiction is an overcompensation for emotional excess. It is a built-in stabilizing mechanism that, like a gyroscope, keeps an excessive nature on an even keel. Contradiction, like an alternating inner current, an oscillation of the mind between contrary and ever-present extremes, is the self-charging source of his creative energy.

Concerned with the unknown and the awesome, his art is seldom a purely joyful statement. But between his distorted, dark periods have appeared, like a recurrent leitmotiv, periods of infinite seduction, of playful, naïve charm.

As if to conform to his pattern of contrasts, in 1955 he left Vallauris and his dark studio to live in a gay sunlit villa called La Californie in Cannes. There the somber key of his late Vallauris period gave way to a sun-wrapped burst of color. In this luminosity he has executed infinite variations on Delacroix's *Femmes d'Alger*. Recently, in addition to the villa La Californie, he has purchased, near Aix-en-Provence, the Château de Vauvenargues, situated near Cézanne's Mont Sainte-Victoire.

Picasso's revolt is always against himself. He destroys the image of a face loved in order to free himself from the servitude imposed by love. He refuses to be the slave of his own admirations. He tries through a progressive stripping off to find the core of the thing loved, to reach his emotional freedom through exhaustive knowledge. Picasso's search for freedom, his craving for a classical detachment, is the hidden backbone of his art. But his attempt at disaffection is doomed, for the more he destroys, dissects, the deeper the final image will be stamped in him and in us. By making this striving visible, he has revealed the profound humanity of artistic pursuit. For Picasso, art is no longer a stern, impersonal set of canons, it is a revelation of the fallible in man. Art is a unifying, leveling force which brings all together in an understanding, compassionate vision. The artist's eye reveals a feeling heart, and through this chink in the aesthetic armor we are made part of the aesthetic experience. We are riveted as we stand before a Picasso by this visualization of an emotional tearing away. The remaining traces of reality in the "finished" canvas give us the measure of the distance that he has covered.

"I have a horror of something finished," he said. "Death is final. A revolver shot finishes off. The not completely achieved is life."

Yet Picasso in his creative life dares to risk death and takes chances as constantly as the matador does in the arena. Hemingway's great book, *Death in the Afternoon*, is a great help to the understanding of artistic creation, bullfights, Spain, art, and Picasso. In it Hemingway points out the importance of the Spanish word *suerte*, which, according to the dictionary, means: chance, hazard, lots, fortune, luck, good luck, haphazard, state, condition, fate, doom, destiny, kind, sort, species, manner, mode, way, skillful maneuver, trick, feat, juggle, and a piece of ground separated by a landmark. In the technical language of the *corrida*, *suerte* means either luck or any move which has rules for the manner of its execution. Picasso's paintings, drawings, and sculptures are his *suertes* of art. Each canvas is an arena in which he engages in aesthetic combat. Just as the bullfight has its inexorable laws, an individual work of art has its laws; the artist must perform within the framework.

He has the ability to see and appreciate the unexpected, as the matador must, when it appears before his hands and eyes. This ability to choose presupposes an experienced eye and mind. Here Picasso's knowledge of practically all that has been created through centuries of art is in immediate control. To select from the hundreds of thousands of lines that he has traced through his pictorial quest, he must compare, judge, choose, and retain only what goes beyond a previously seen pattern.

Picasso's prodigious memory of art serves him well; he is like a giant electronic computer into which the art data of the world has been fed; there it lies stored up until he calls upon it to sort out and eliminate visual duplications and produce an inspired result, all with unbelievable speed.

In the speed and abundance of his work Picasso is truly the artist of the twentieth century. He has understood its

tempo and much more. From the rapid frame-succession of the cinema and animated cartoon, he has learned the need of visual surprises, changes of pace, close-ups. He has made his entire creative process into a continuous film sequence; the dating and numbering of his works are permanent indications to posterity of the logical order of succession. His method of mass production, coupled with an incredible plastic inventiveness, admirably fits the definition of the beautiful as "that which gives the greatest number of ideas in the shortest space of time." This definition by the eighteenth-century philosopher Hemsterhuis has become the basis of advanced contemporary aesthetic research.

The notion of number and of speed brings out the role chance plays in creativity. Just as the throws of dice have to be infinitely multiplied in order to reveal the laws of chance, so the artist who casts his pictorial throw has to produce a great deal in order to have a chance at seeing his own pattern, his own inner law, that inescapable signature into which all he creatively throws out of himself will fall.

Picasso is never unclear; there is never any hesitancy in his art, just as in a bet there is no maybe, the decision must be final. His line is a definite opinion; the line he draws is his signature on the contract with chance.

There is no way out once the contract is made. Each decision and choice between colors or between lines is an intuitive selection based on an inspired belief that the gift of the artist is to choose correctly. One mistake, one wrong decision, and the structure is imperiled, the work of art collapses. The ability to win often, to triumph over apparent reason, to have faith in one's instinct, is a measure of an artist's genius.

Like most gamblers, Picasso is superstitious. He knows that his faith in the accidental, in the so-called laws of chance, is his best guarantee of continued creativity. A gambler, in spite of his faith, is unsure and needs to be confirmed, encouraged in all he does. That is why much more is involved in a gamble than the apparent stakes. All gamblers play for hidden and much higher stakes. They play for their very existence. Each decision, each toss of the coin, is heads or tails, light or darkness, life or death. This process of dying, then living is, like the creative process, a constant and vicarious rebirth, a reaffirmation to those who are caught in uncertainty.

There is no end in sight for Picasso; he must never finish gambling, he must never stop creating, for to finish would be an admission of defeat, a submission to death.

Picasso looked around the large cluttered studio and said sadly, "I am all alone. I do everything myself. No, no one helps me. I am all alone. It's too much for me!"

The enlarged photographs of Picasso's face that look down on his bed and on his easel are symbols of a self-examining personality. The large, noble, imperial head of Picasso, like a super-Picasso, watches over the small, aged man struggling in the creative immensity of his life. Like a stern image of his conscience, Picasso watches over Picasso, and Picasso has to account to Picasso. Few can stand the constant gaze of themselves upon themselves.

My visit to Picasso in Vallauris was in 1954. He was then in a tragic mood—his companion, Françoise Gilot, had just left him, taking with her their two children, Paloma and Claude. He seemed a sad, withered old man, but as always, like a phoenix about to be reborn from ashes, there was already a smoldering Picasso behind the depressed man. After a while, he took me into a barn and showed me a portrait of a beautiful woman with dark hair and burning eyes, seated like an odalisque. I knew then that his admiration of feminine beauty, his need for a woman's inspirational presence had not been extinguished.

Eleven years later, in 1965, I was taken by friends to Notre-Dame-de-Vie in Mougins, Picasso's new, and what would be his last, house. By then he had married Jacqueline Roque, the woman whose portrait he had shown me in the Vallauris barn. After he abandoned La Gauloise in Vallauris and La Californie in Cannes, his new home with Jacqueline in Mougins offered a calm retreat for the last years of his creative life.

Jacqueline was Picasso's guardian, preventing tourists, unwanted friends, people in general from penetrating the sanctuary. It was very difficult to gain access, but finally I was admitted through a room that had a characteristically cluttered appearance. As always, among the new work were examples of his earliest periods. Recent souvenirs and tribal fetishes hung next to a small head he had painted during his Negro period, early etchings, and a blue landscape. The very large studio was simply built with blocks of masonry over a scaffolding of steel girders, with the inside walls left unpainted. Here were two 1929 wire sculptures that Picasso brought with him wherever he went. Certain works he hung on to. They gave him strength and reassurance for the next jump forward. In this rough interior that probably reminded him of the unadorned factory of Vallauris, Picasso was able to create the monumental work of his last years.

Kahnweiler, the grand old man, who as a dealer had supported Picasso through many years, came with us that day. Also visiting were Picasso's friend, the poet Leiris, and from New York, the Saidenbergs, husband and wife dealers of his work, who all assembled on one side of the room. Jacqueline hovered over Picasso, who began to bring out the paintings. They seemed to discuss in whispers which to show or not to show. This was already a signal of her influence and power over him. As the paintings came out, he would prop them up in the middle of the studio and then sit back down with an anguished expression on his face. I have never seen an artist look at his work with such self-torturing critical appraisal. There was certainly no self-love, only the aesthetic doubts of a great man who was breaking into new pictorial territory.

He had been working for the last few years on a great series of the painter and his model. The artist was represented as an old bearded man, and the woman as a triumphant female animal. Out of these lithographs, illustrations, and hundreds of drawings had evolved a freer method of work. The paintings that were now before us really showed a new way to paint, as if free drawing had been put on canvas with paint and brush.

In this last period of his life, it seemed that Picasso was subconsciously absorbing all his own lessons and experiences from cubism to expressionism, and was now translating them into a new language of associations. There were no philosophical theories about color existing independently from form, or line dominating color. Here, line was color, color interplayed with color line; white spaces, the unfilled parts of the canvas, seemed like the framework of abandon to linear imagination, to spatial imagination. Some of the pictures were small. Sometimes he would repeat eight or ten variations of the same theme in many different techniques. But all these paintings were representational. They were always of human beings and, of course, Picasso never stopped working with allegorical subjects. This man of the Mediterranean continued the grand tradition of the artists of the south. For him, the nymphs and satyrs of the archaics and classics became an eternal yet modern subject.

Then we saw two tall, majestic figures painted in white and gray: musketeers, a subject that fascinated Picasso. "In these musketeers," he once said to his friend Zervos, "we may see ourselves. They sound the secret depths of men who, in their loneliness, their courage, their disappointments, find themselves bound by a common brotherhood, which means much to them, and means all the more when they come under stress of the terrible tensions involved in the search for something within themselves and their perpetual desire to be transformed." (This admirable thought is quoted by Jean Leymarie in his great book on Picasso.) But these words, with their tragic connotations, express the deeper feelings that have always been present whenever I met Picasso. As I looked at the small sad old man who was the giant of art in our time, I suddenly felt that in his expression of doubt there was the insecurity of a young painter looking at his work with a critical eye. This self-doubt, contradicted by a driven creative assurance, made Picasso surpass what he had done through the discovery of new, yet-unseen visual experiences—made him able to create beyond known limits.

His later works, like those of many great artists, have a daring unconscious disrespect for rules and conventions. Here, in the full freedom and splendor of his eighties and nineties, was a master unfettered—free to invent more and to open new directions for mankind's visual experience.

I came away moved by the exuberant fireworks of unceasing creativity, but also moved by the human interplay between not only the artist but also the man and the woman who loved and protected him.

Notes on the Illustrations

Pablo Picasso, 1881–1973. Born: Spain.
Photographs taken in 1949, 1953, 1954, and 1965.

1. Pablo Picasso in his Vallauris sculpture studio next to a detail of Bottle and Skull.
2. Picasso, Three Musicians, *1921 (summer). Oil on canvas, 45¾" X 32⅛" (116 cm X 81.4 cm). Collection, The Museum of Modern Art, New York. Mrs. Simon Guggenheim Fund.*
3. Picasso at play, using a painted pot as a mask.
4. The Vallauris studio before Picasso left it to live in Cannes. It shows the usual marks he put on his environment. On the easel, one of his many variations of his children, Claude and Paloma. Behind Picasso, one of the series of heads of Sylvette, and to the right, the ever-present photograph of Picasso watching Picasso.
5. Detail of Claude Painting, *by Picasso.*
6. Picasso in the act of painting.
7. The vast "Grands-Augustins" studio with the window that illuminated Picasso's easel. Many paintings stand finished and in progress. In the center, the small folding table for his paints and tools: the means of creation are held to a minimum.
8. Cabinets in Picasso's Paris studio contained his own sculpture next to the works of other ages. In the center, a bat skeleton.
9. Paris: In a bookcase, an unexpected wedding souvenir. Above, two small Picassos among jars, birds, and clay pipes.
10. On the lower floor of his Paris studio, a Picasso sand sculpture.
11. Children's toys, a matchbox with pins, and a candlestick used in many still-lifes.
12. Paris: In still another glass case, Picasso's long, whittled wood figures cast in bronze, next to casts of prehistoric sculptures.
13. Two Picasso clay figures next to a Benin African mask.
14. Paris: Next to reams of yet unused paper, a photographic enlargement of a Cranach and a marionette.
15. Vallauris: On a bookshelf, the first charcoal studies of his future wife, Jacqueline Roque.
16. Clay sculptures in a theater-set frame.
17. Paris: The entrance hall. Left, a Negro-period painting; right, a photograph of Ingres' La Grande Odalisque *and, in the center, a Picasso sculpture of fantastic flowers cast in bronze.*
18. Paris: Among the accumulated clutter of bottles, jars, an oil lamp, and frames are several small works by Picasso and a photograph of the artist's son Paolo.
19. Paris: An oil lamp, a sculpture by Picasso of his friends, and an imprint of a hand.
20. Picasso using his curious palette cut from plain wood, with just enough space for two opposite colors, white and black or violet and green. This was an invention of his to achieve the strictest economy of means.
21. In the Vallauris bedroom, in front of his brass bed, a revealing arrangement on the mantlepiece includes a

drawing of Françoise with child, a Picasso painting of his daughter Paloma, photographs of the artist, a Douanier Rousseau self-portrait, and a portrait of his wife— surrounded by the usual clutter.

22-23. The painter in his favorite elements—sun, sand and sea: the daily swim at the Golfe Juan beach.

24. Picasso in a rare exuberant laugh.

25. On a shelf in the Vallauris studio, toy dolls created to amuse his daughter Paloma, and a souvenir gondola on boxes of paints. Propped against the wall, two small paintings of Paloma and a mother playing with a child.

26. Picasso, Guitar, 1912 (early). Sheet metal and wire, $30\frac{1}{2}''$ X $13\frac{1}{8}''$ X $7\frac{5}{8}''$ (77.5 cm X 35 cm X 19.3 cm). Collection, The Museum of Modern Art, New York. Gift of the artist.

27. At Vallauris, a moment of past splendor recaptured. Picasso's Hispano-Suiza from the twenties was restored and once again used on great occasions such as attending the bullfights.

28. Picasso lying on his bed at Vallauris. With amazing precision, he sketched the cast of characters in Manet's Déjeuner sur l'Herbe.

29. On the windowsills of the Mougins studio, the two great 1929 wire sculptures with the glorious sunlit landscape of the Riviera in the background.

30. In the living room of his Mougins house, Notre-Dame-de-Vie, the usual accumulation of memorabilia, from watches to dried flowers, souvenirs of bullfights, early Negro-period paintings, later works, etchings, and many memories from Picasso's life. In the center, a 1906 self-portrait.

31. In the studio, Picasso stands between two giant paintings of guitarists from the mid-sixties.

32. Picasso with his wife, Jacqueline, in the Mougins studio, intensely and critically looking at his latest paintings as he showed them to Leiris, the poet, and several friendly dealers, including Daniel-Henry Kahnweiler. Picasso always scrutinized his work with deep misgivings and self-doubts. Jacqueline, here, as always, a reassuring presence.

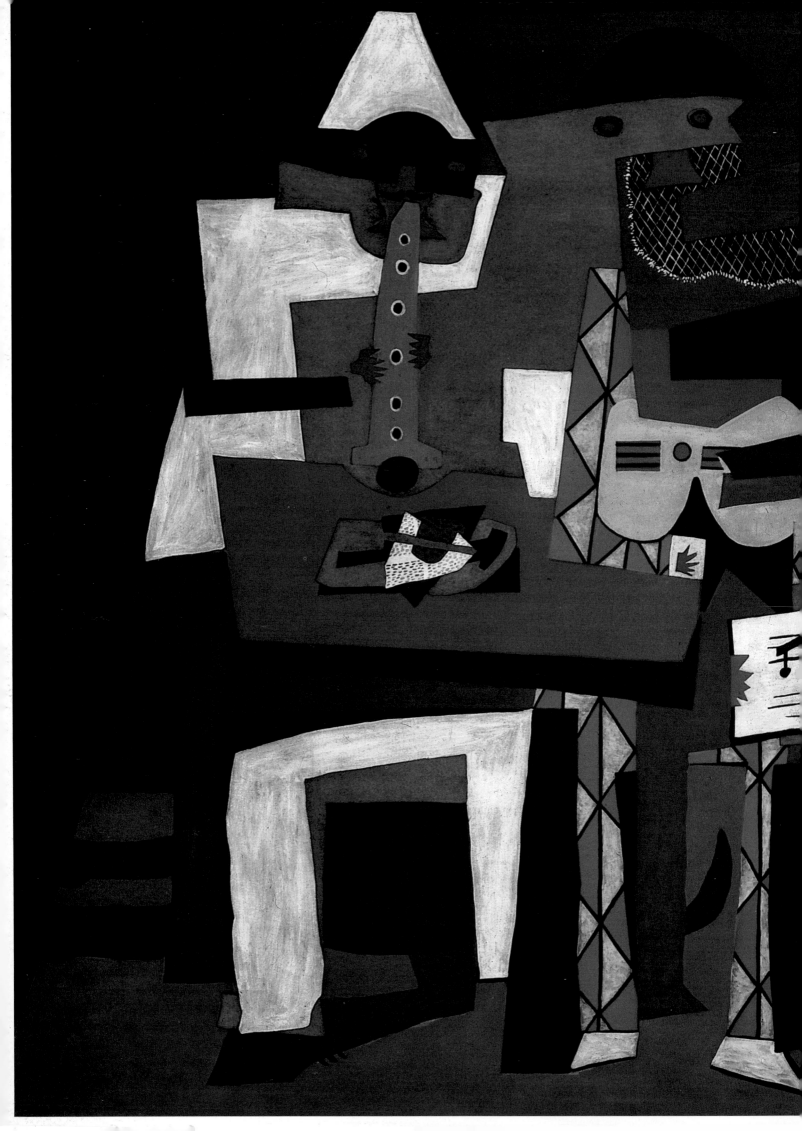

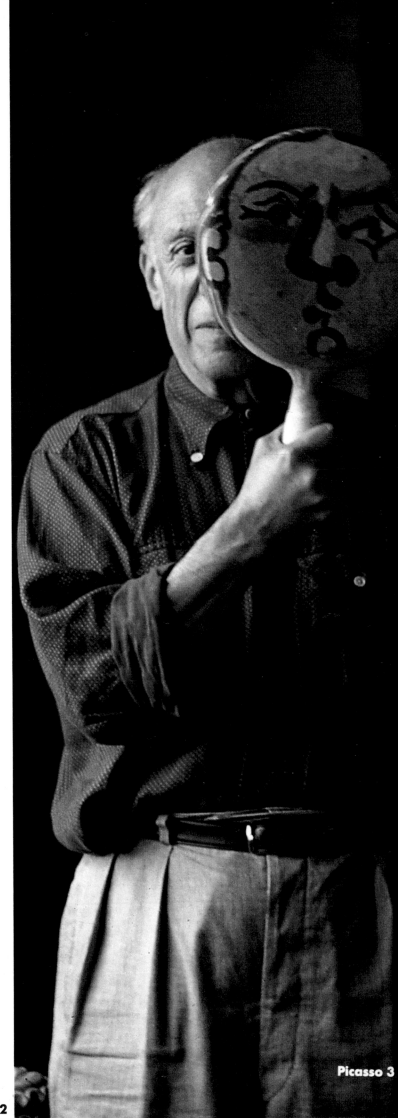

Picasso 3

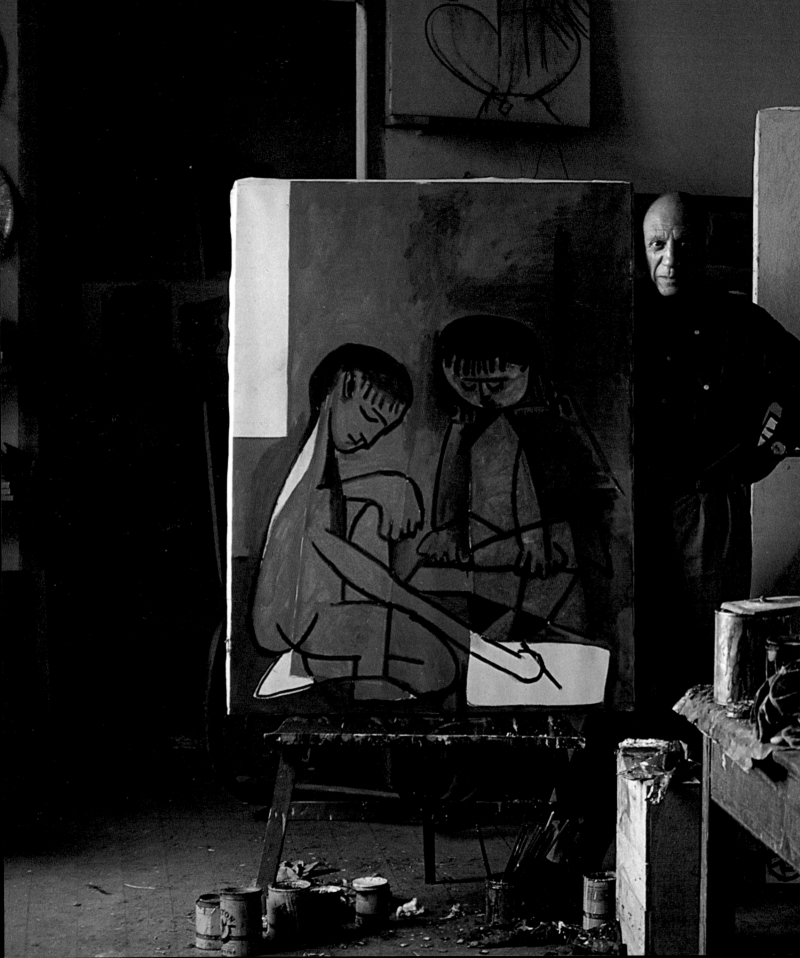

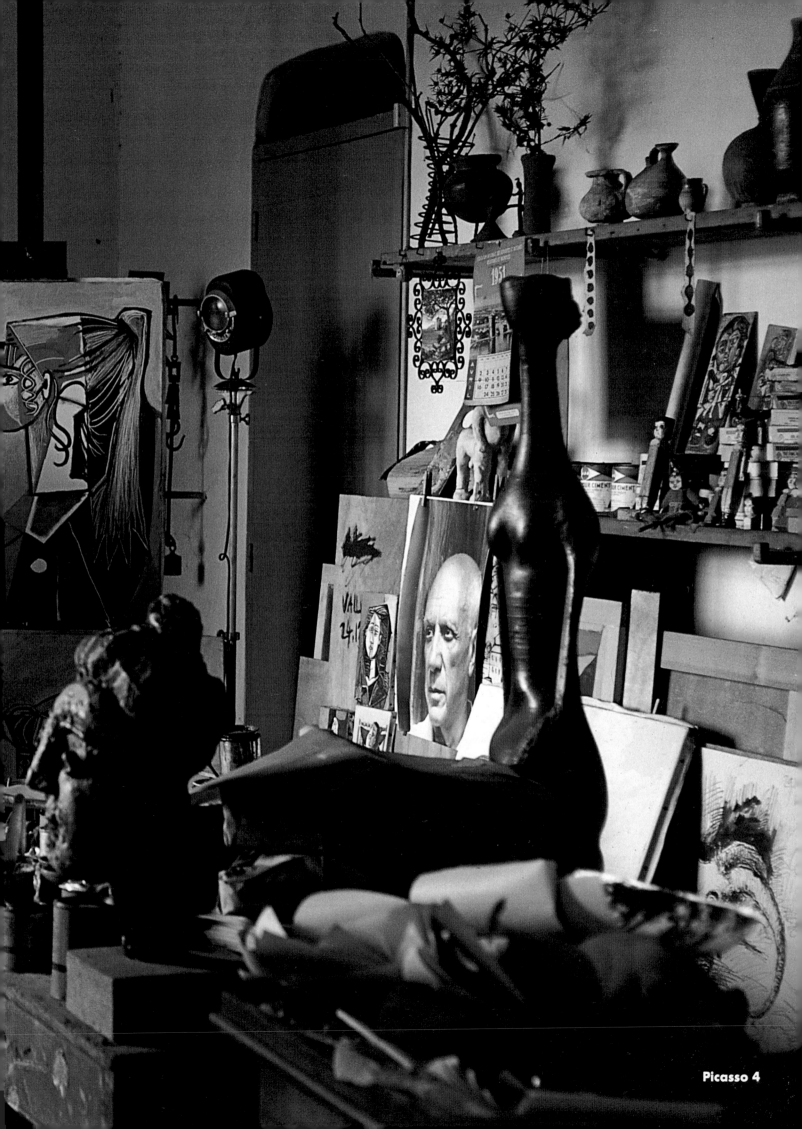

Picasso 5

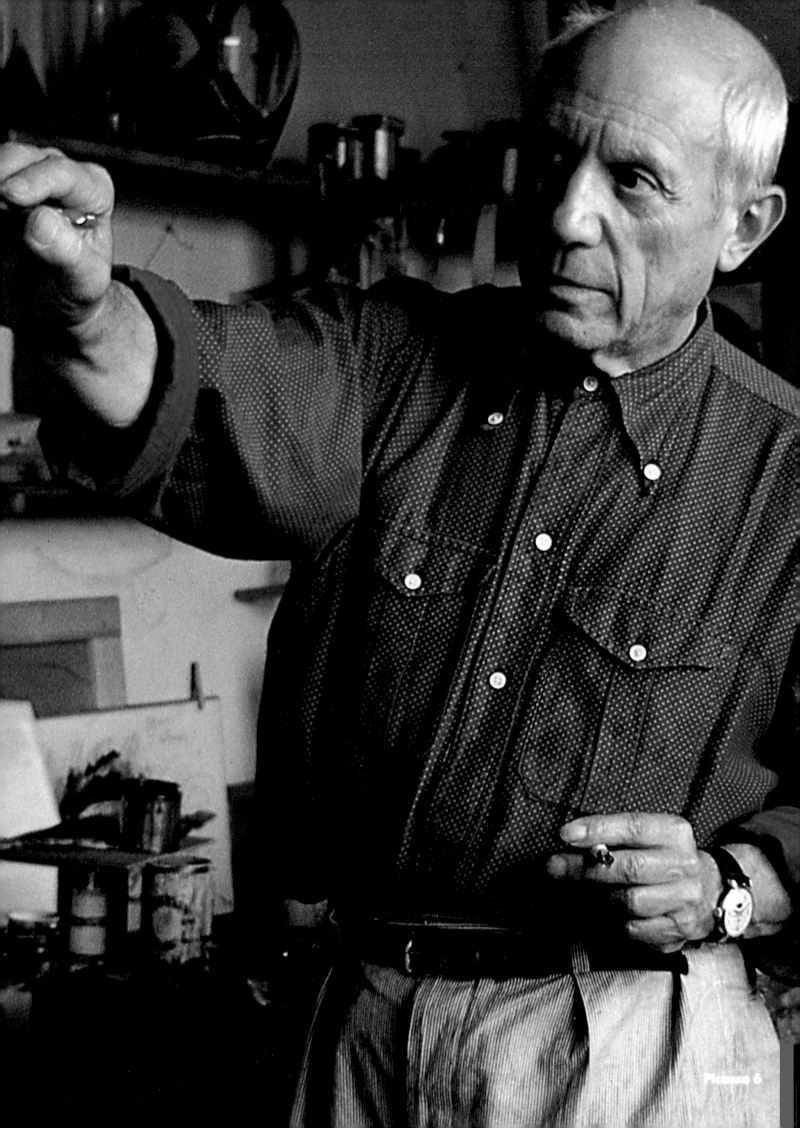
Picasso 6

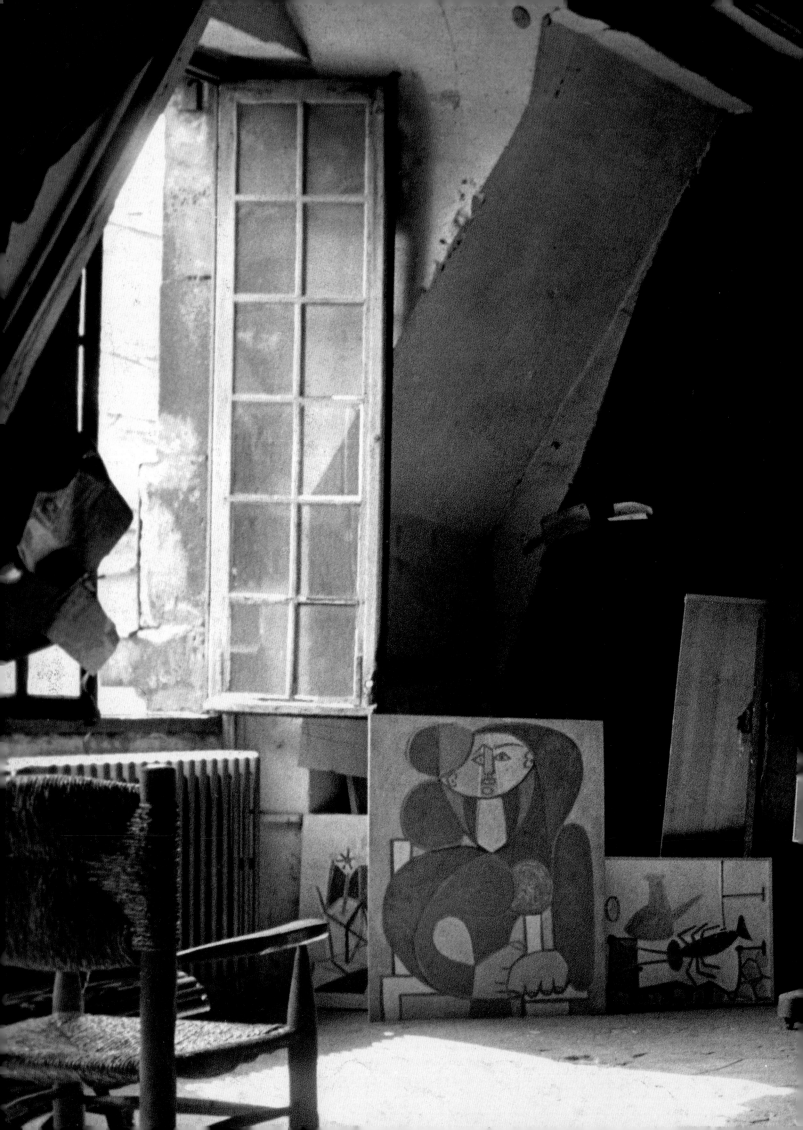

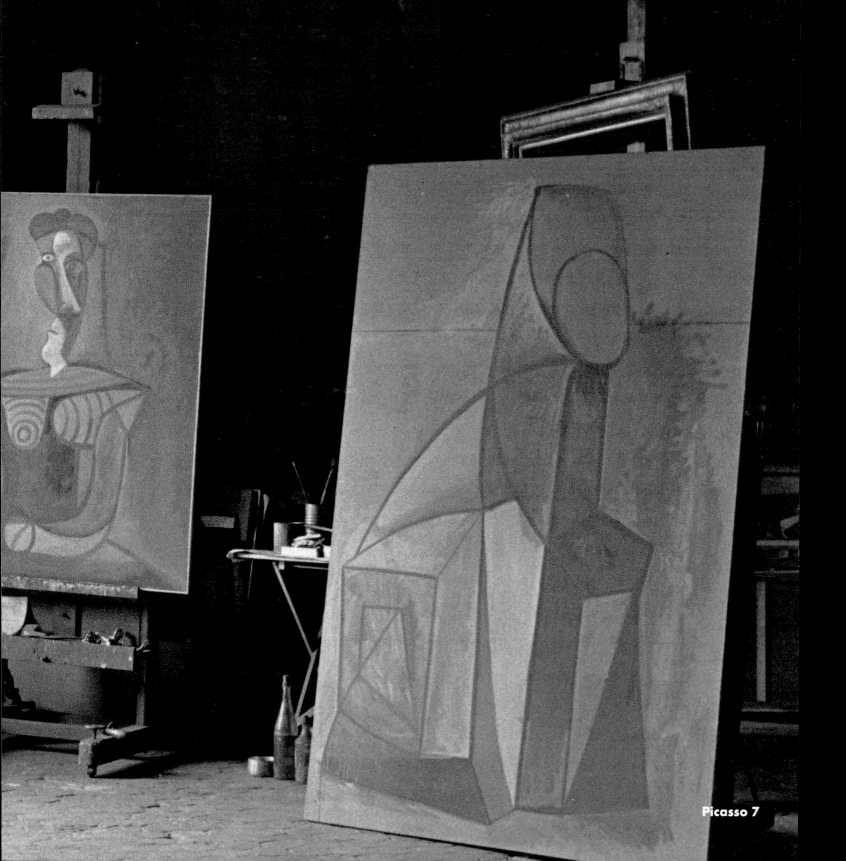

Picasso 7

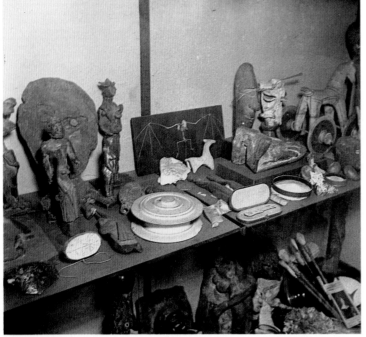

Picasso 8

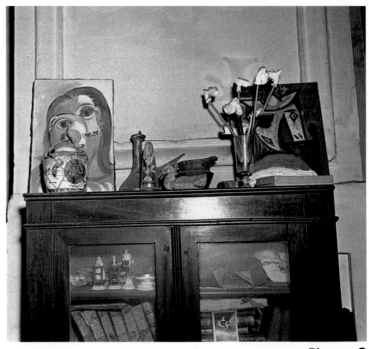

Picasso 9

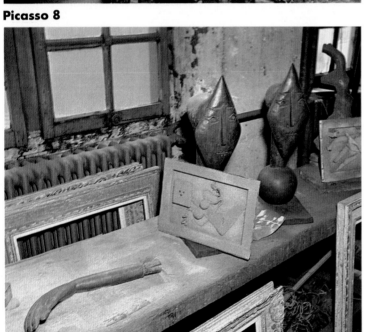

Picasso 10

Picasso 11

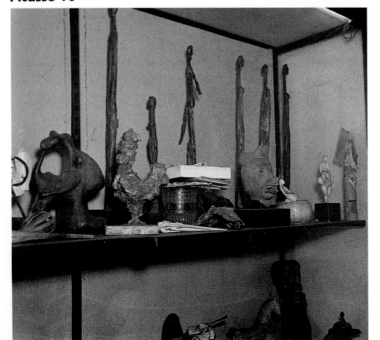

Picasso 12

Picasso 13

Picasso 14

Picasso 15

Picasso 16

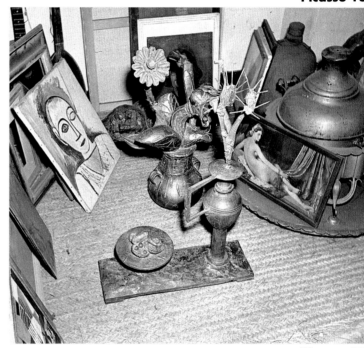

Picasso 17

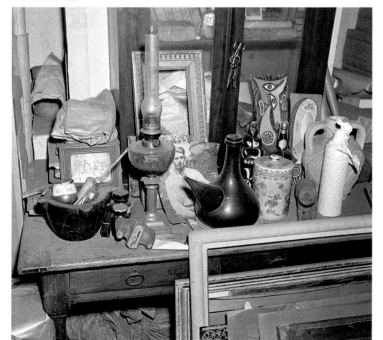

Picasso 18

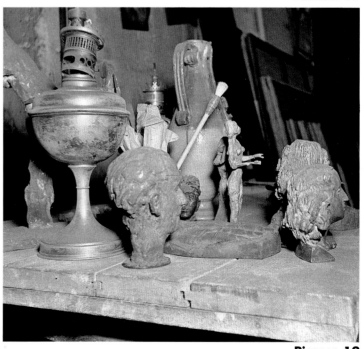

Picasso 19

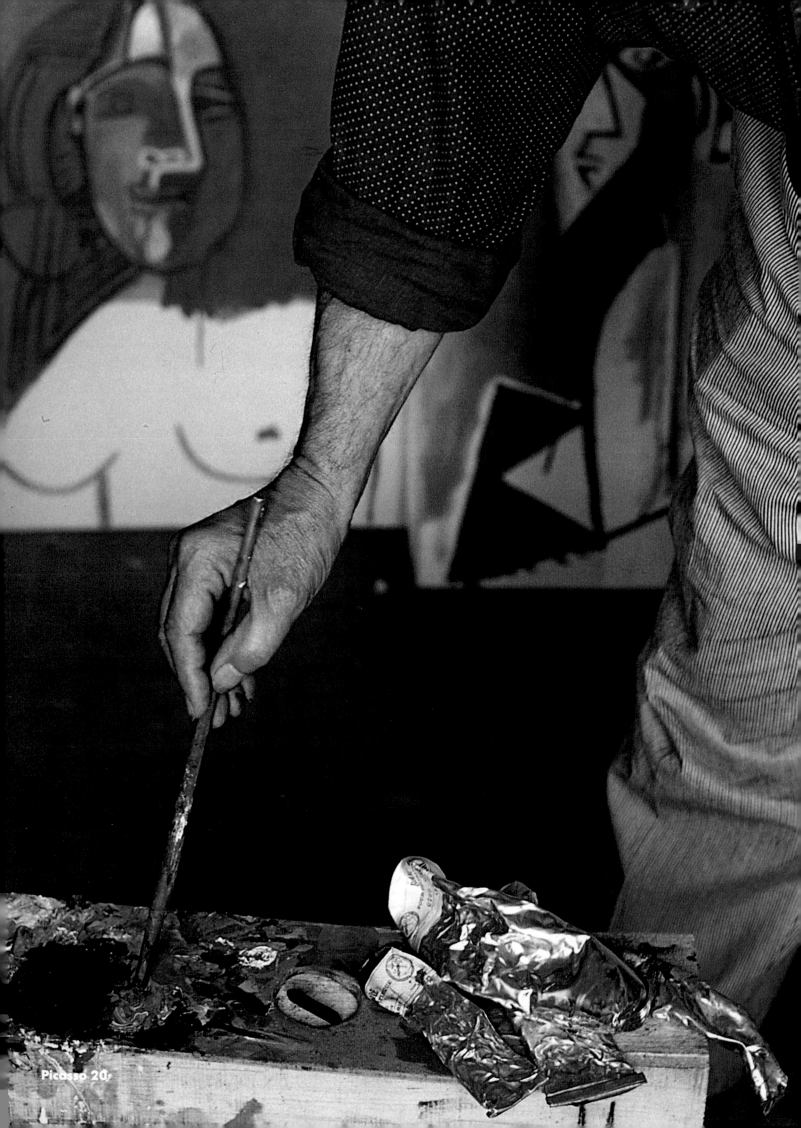

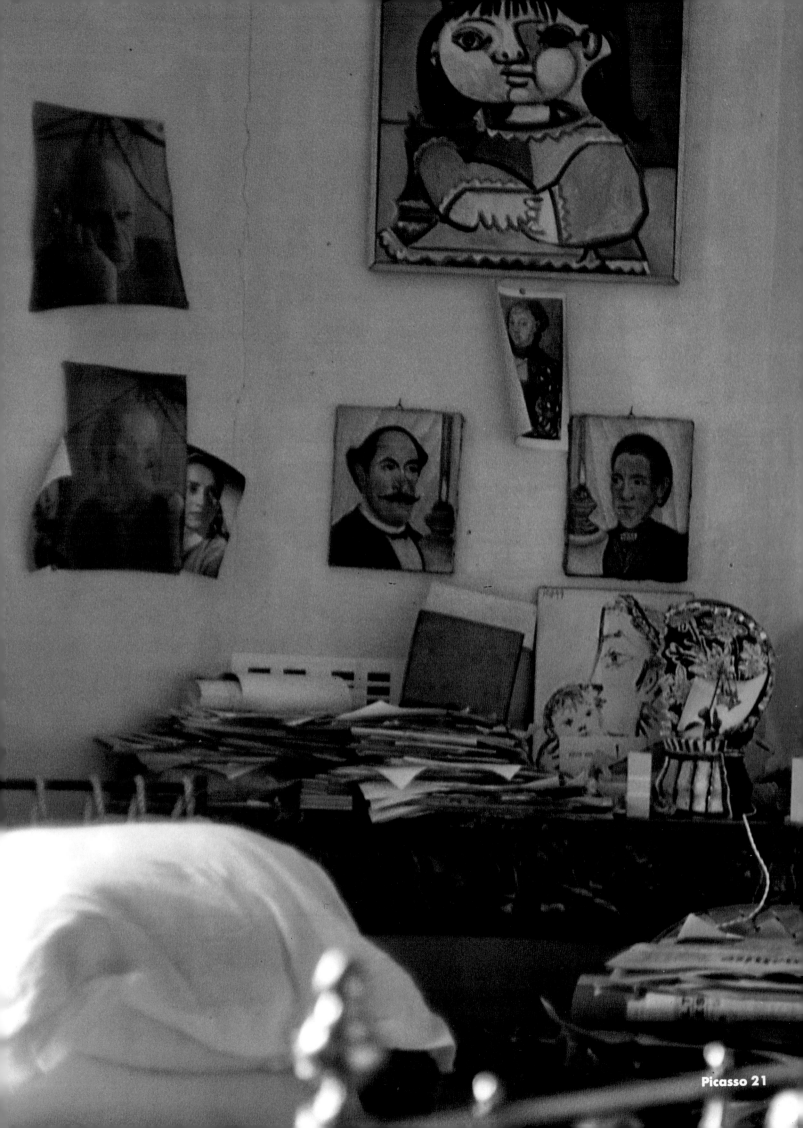

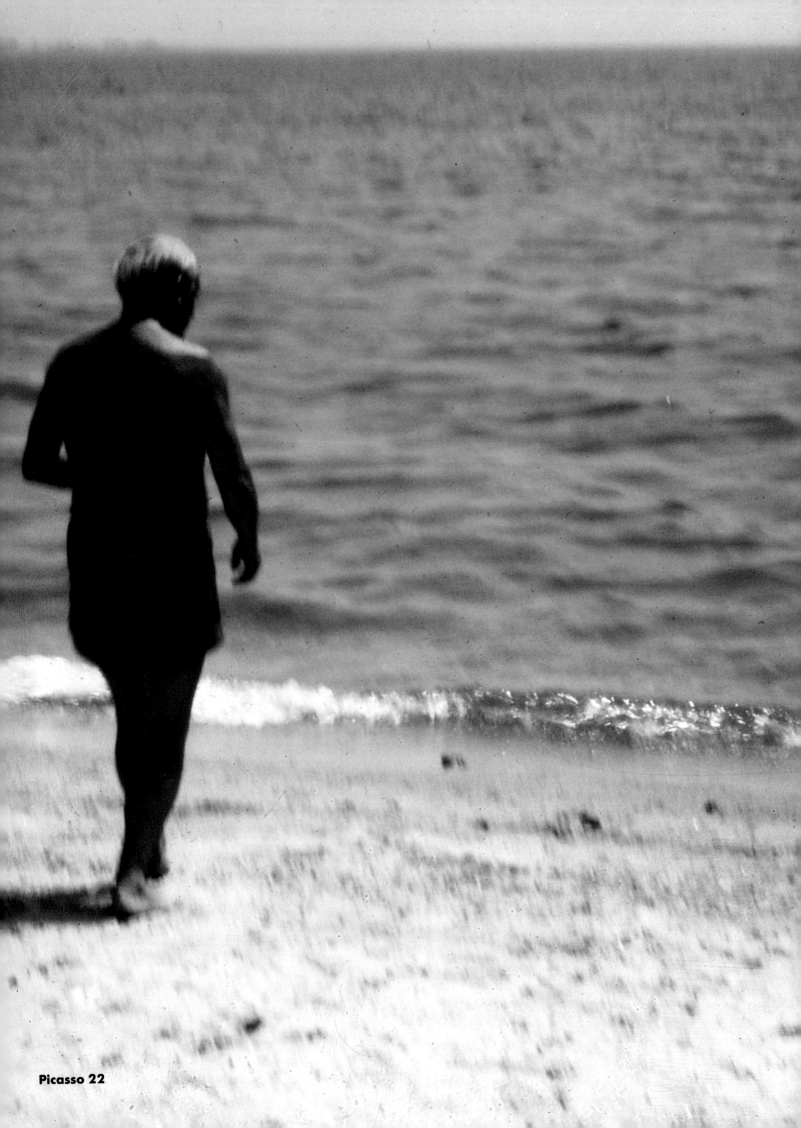

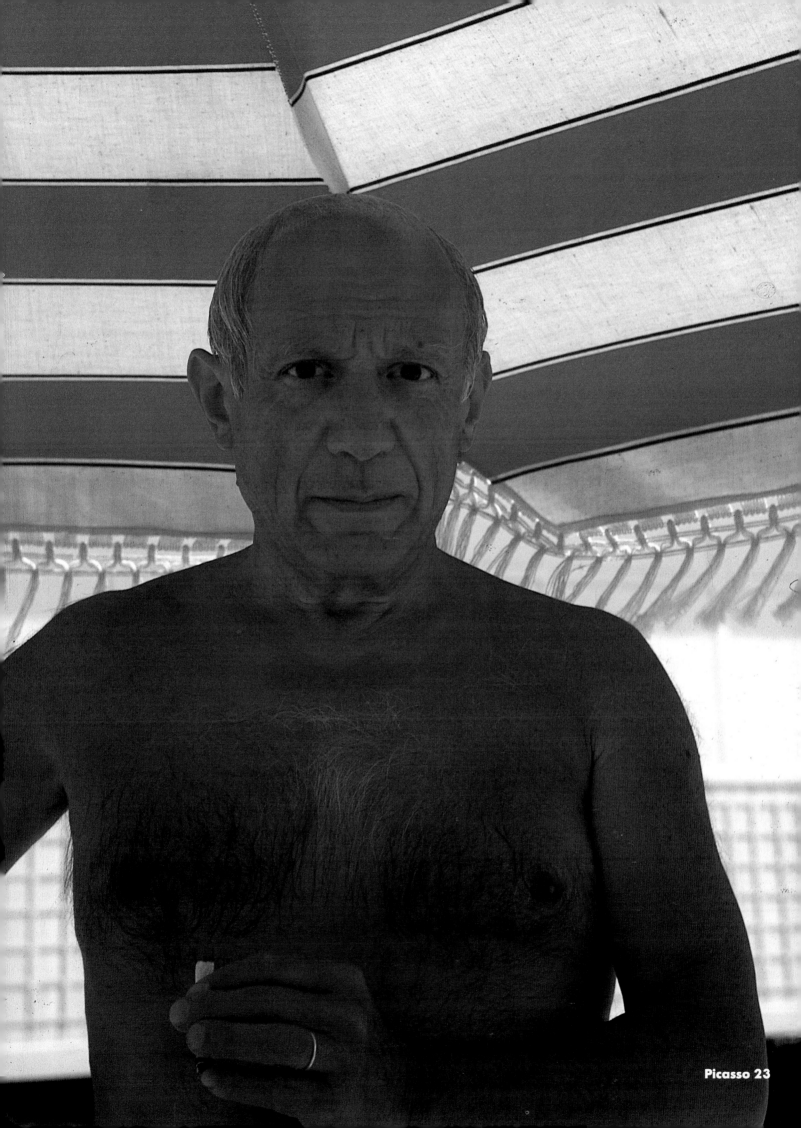

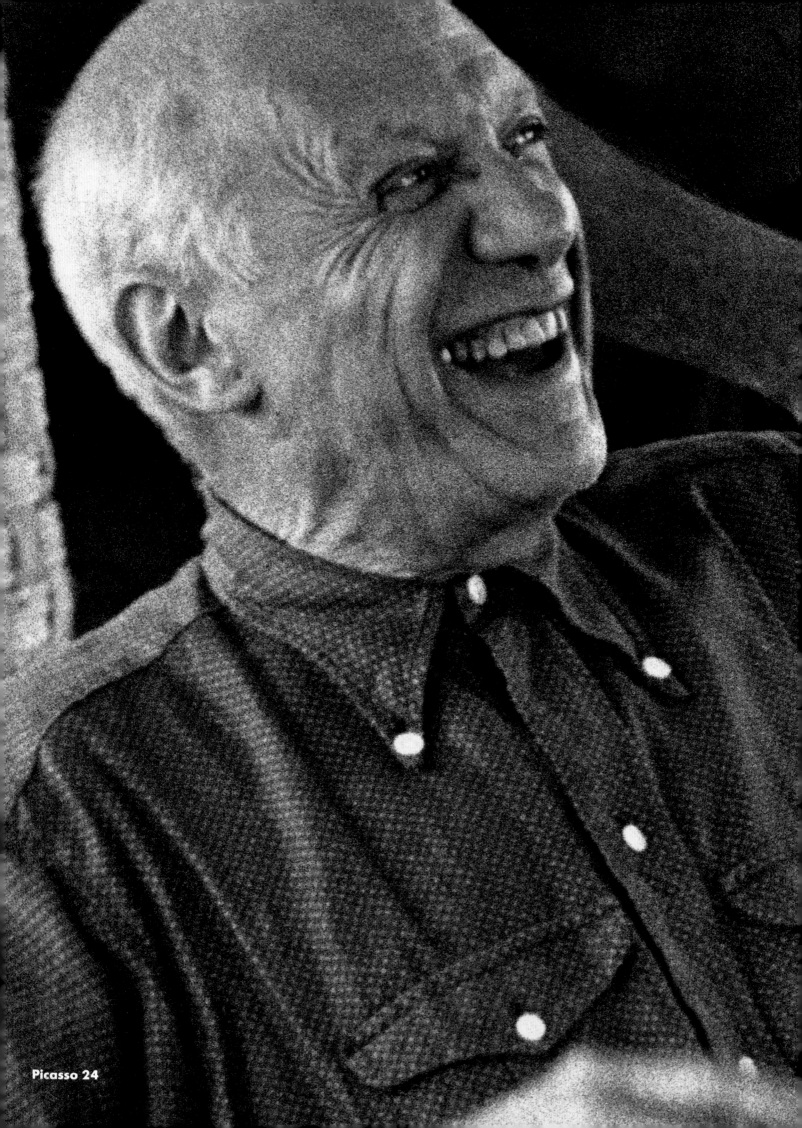

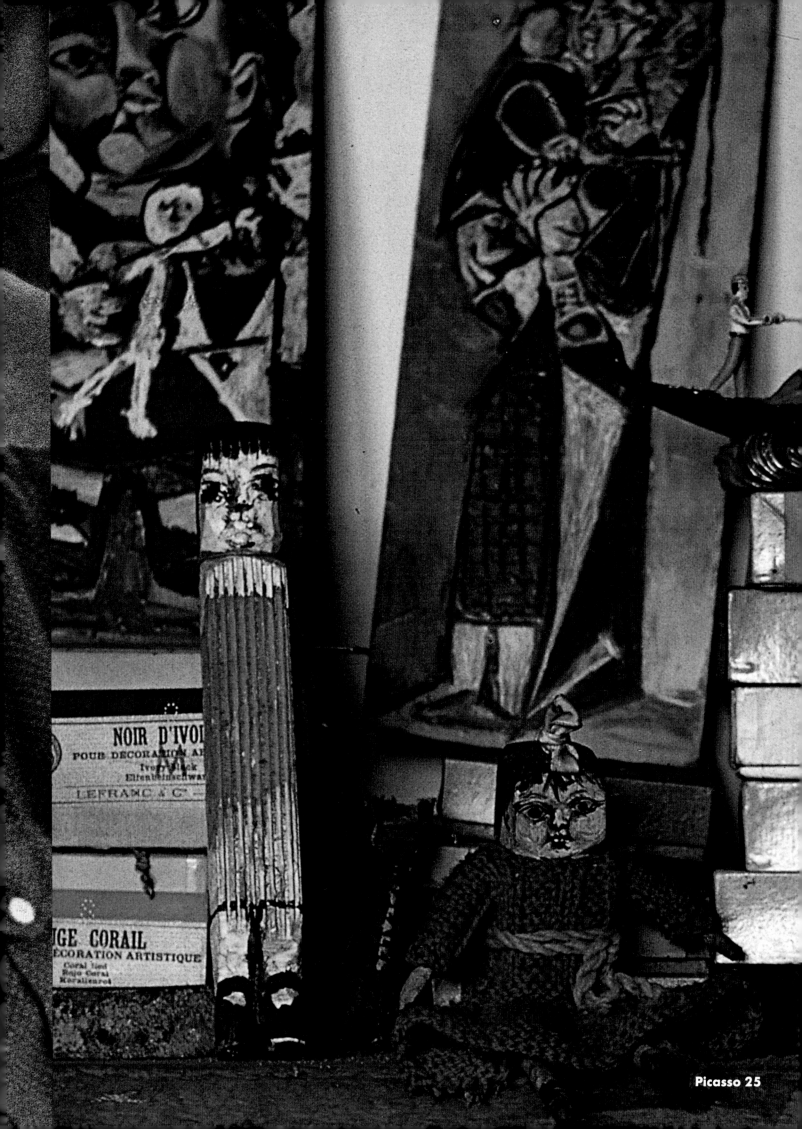

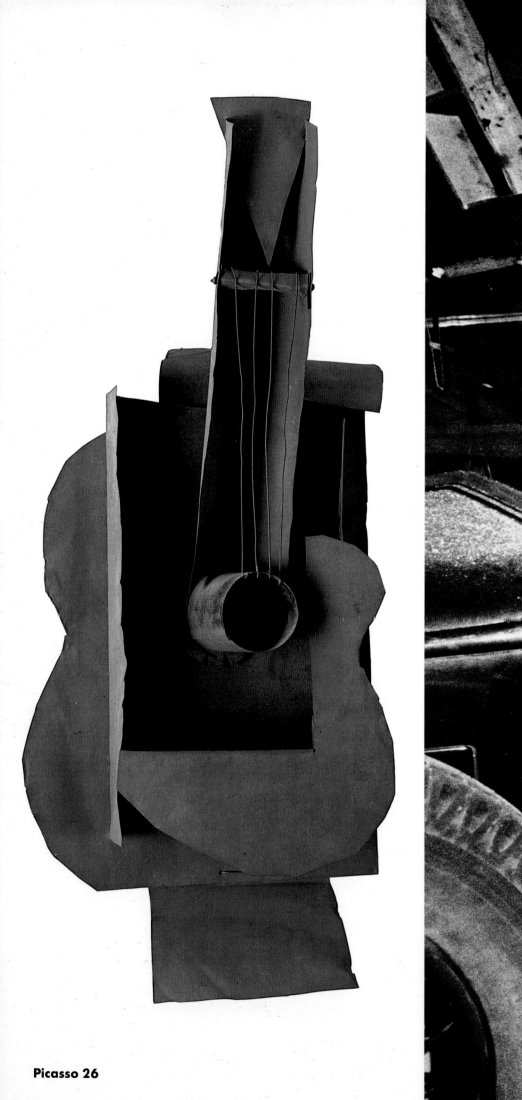

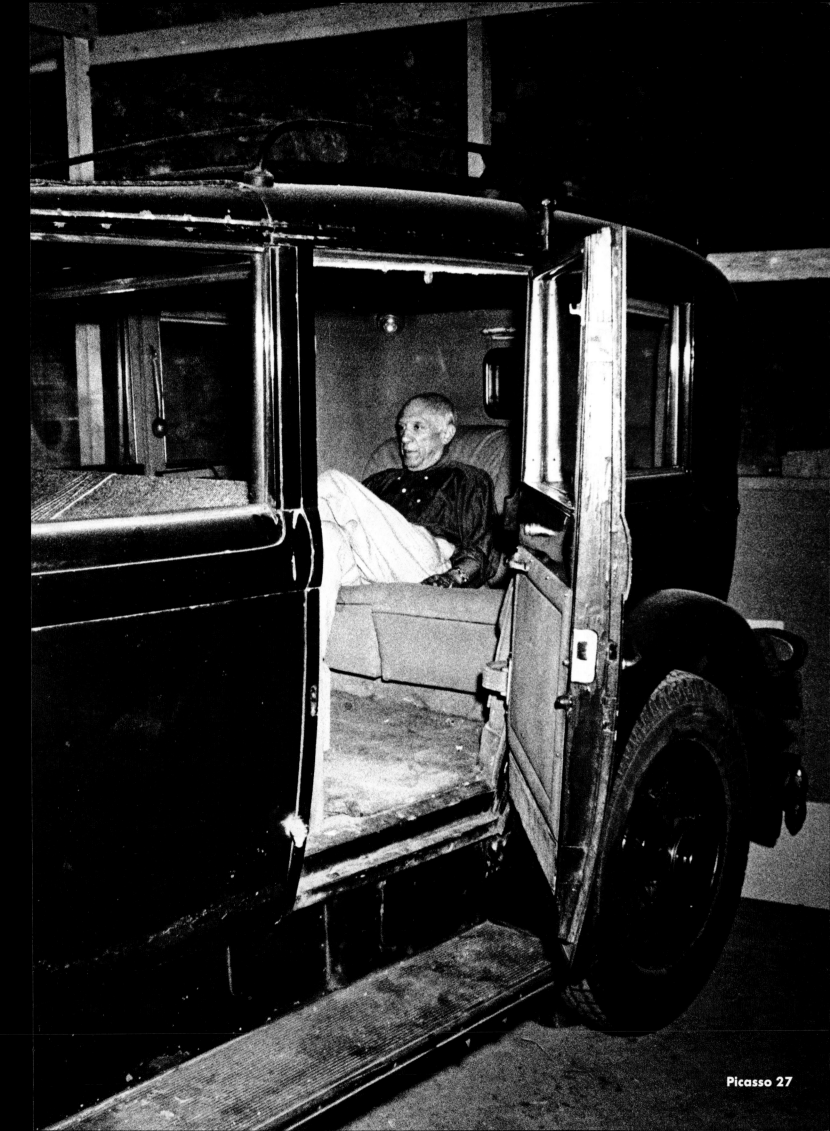

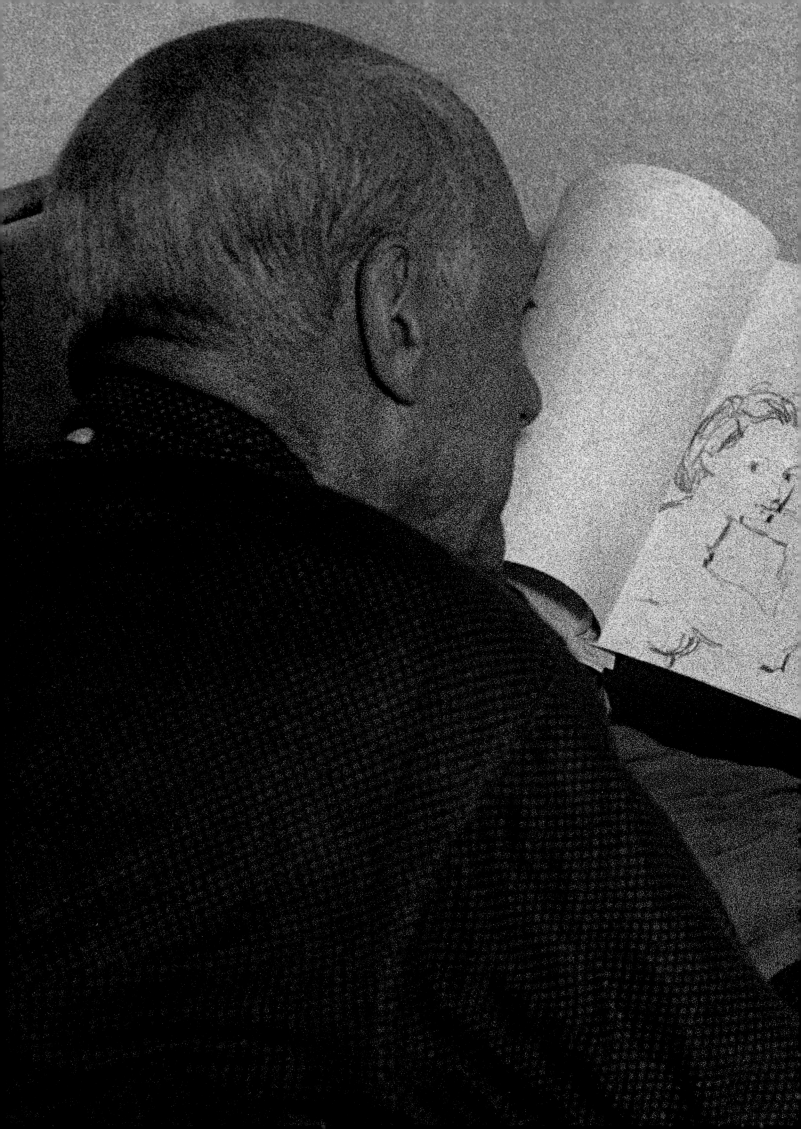

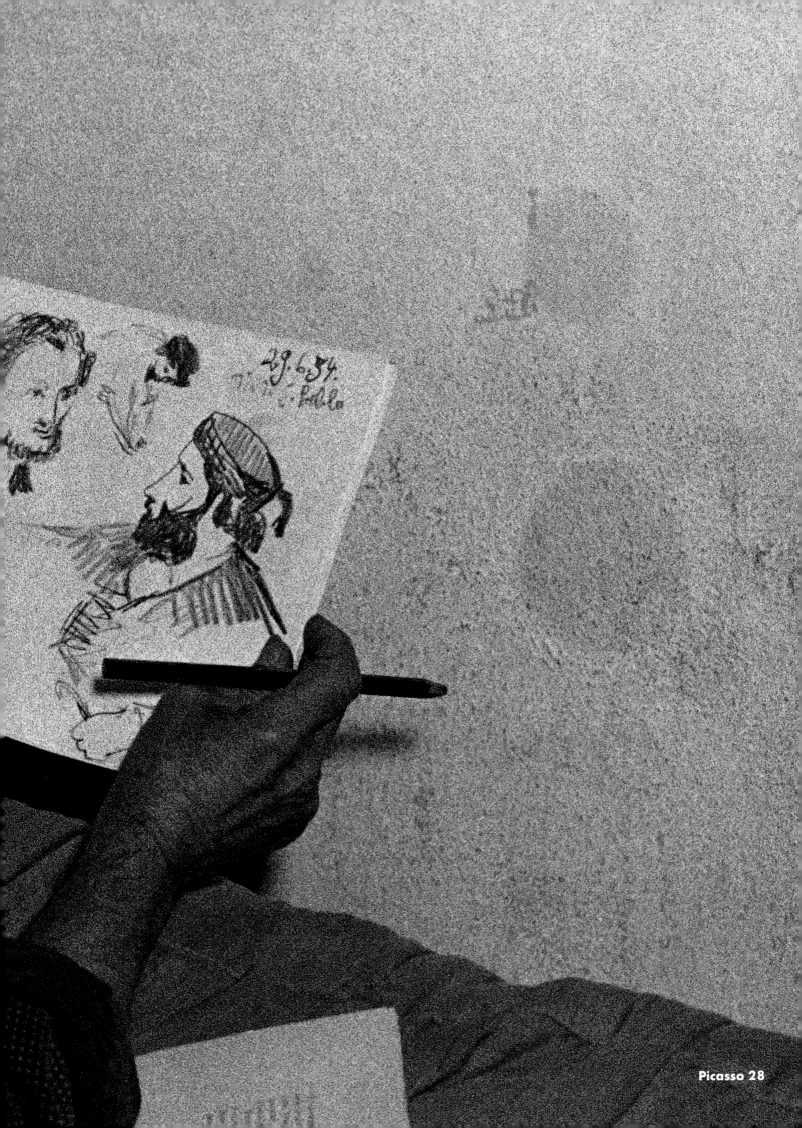

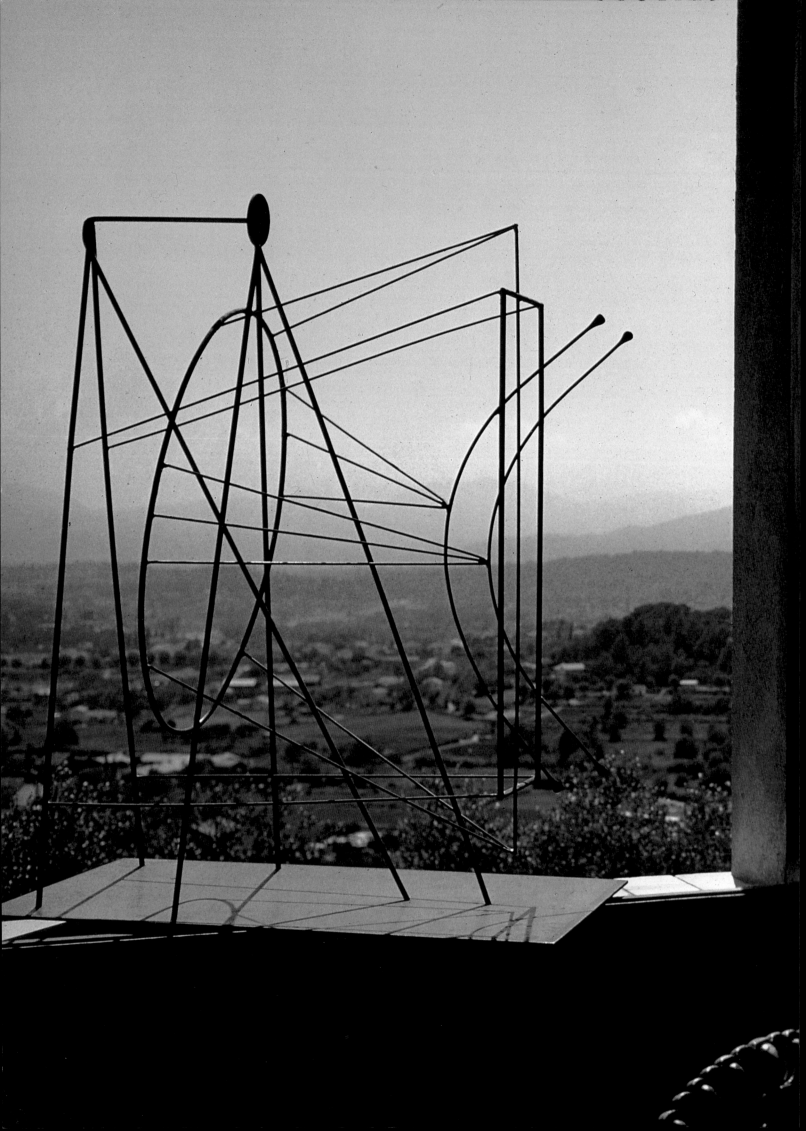

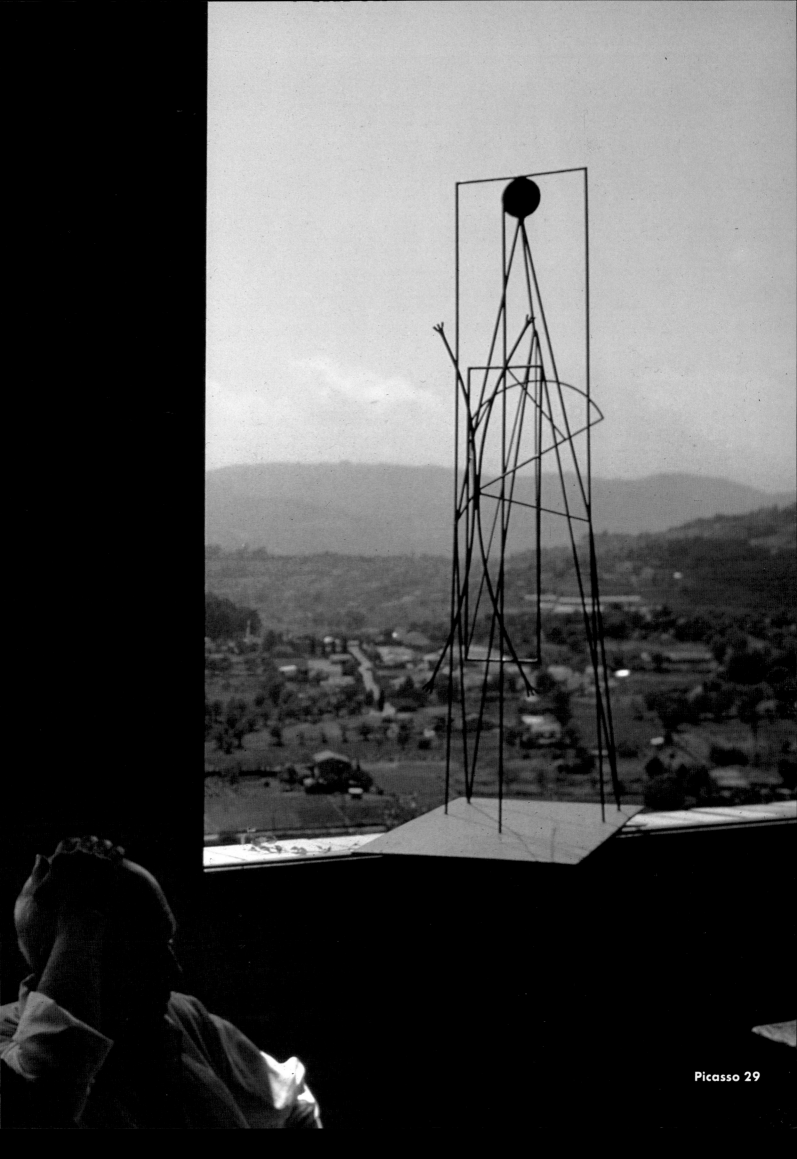

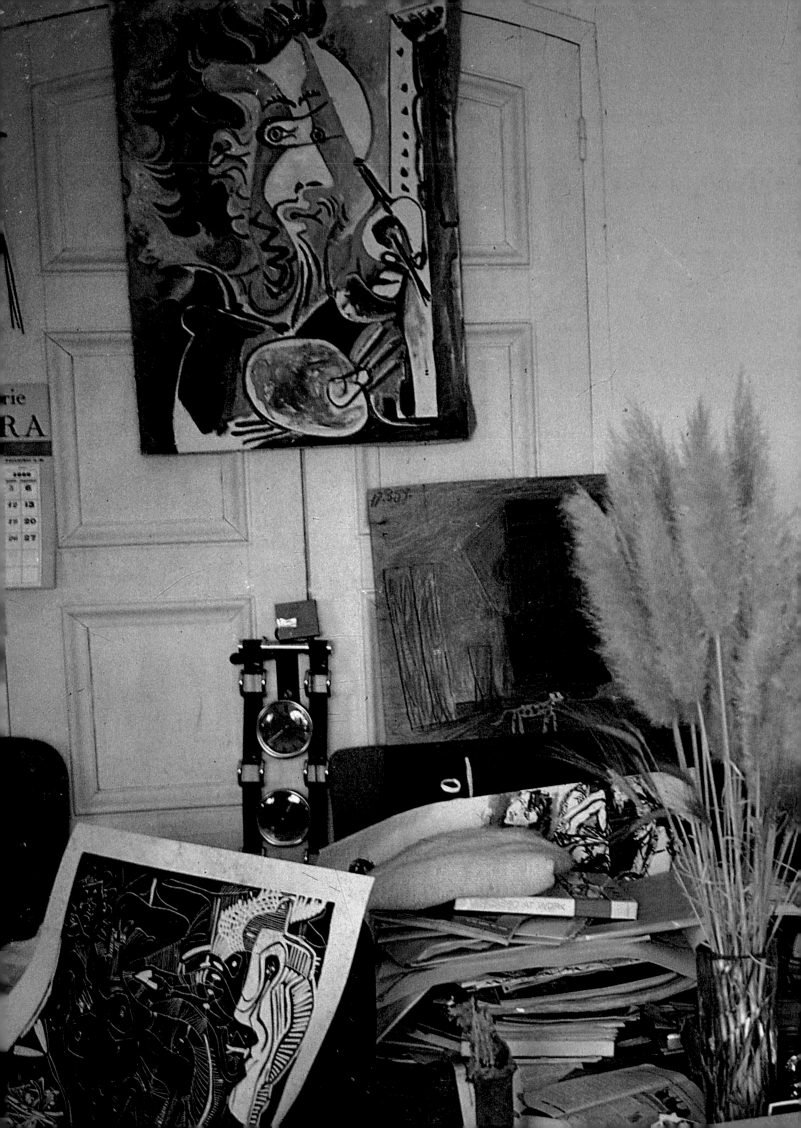

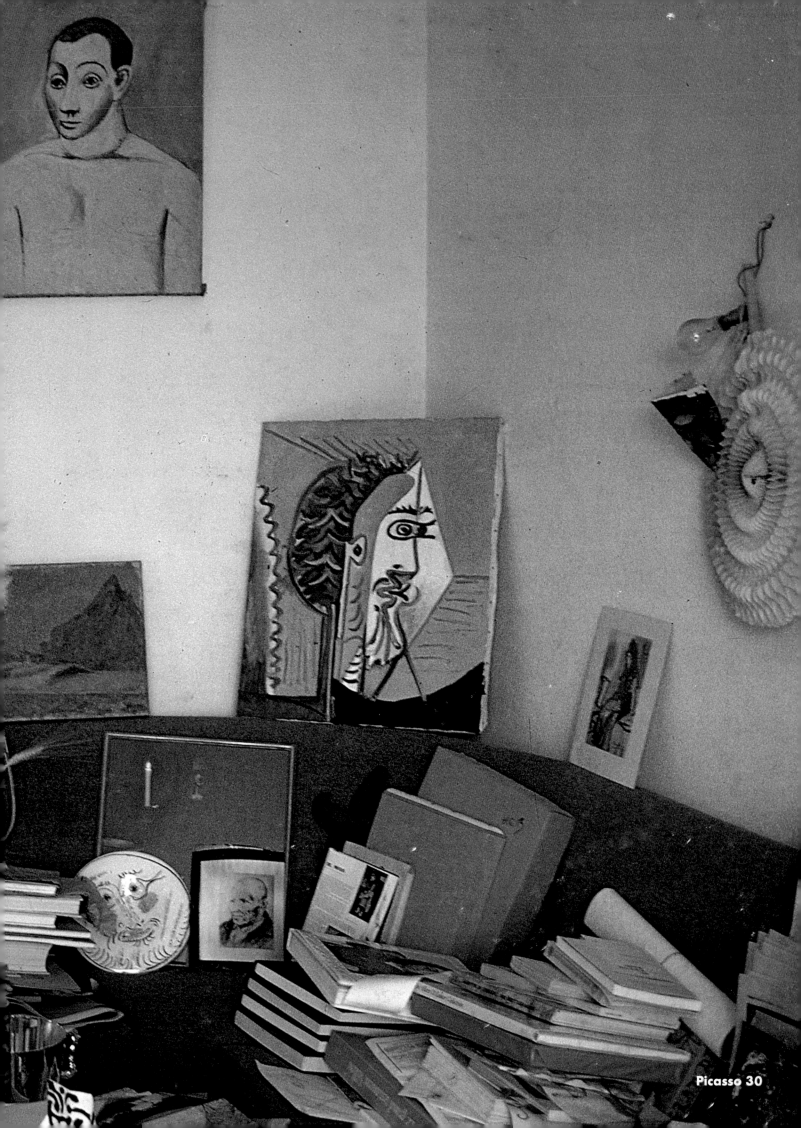

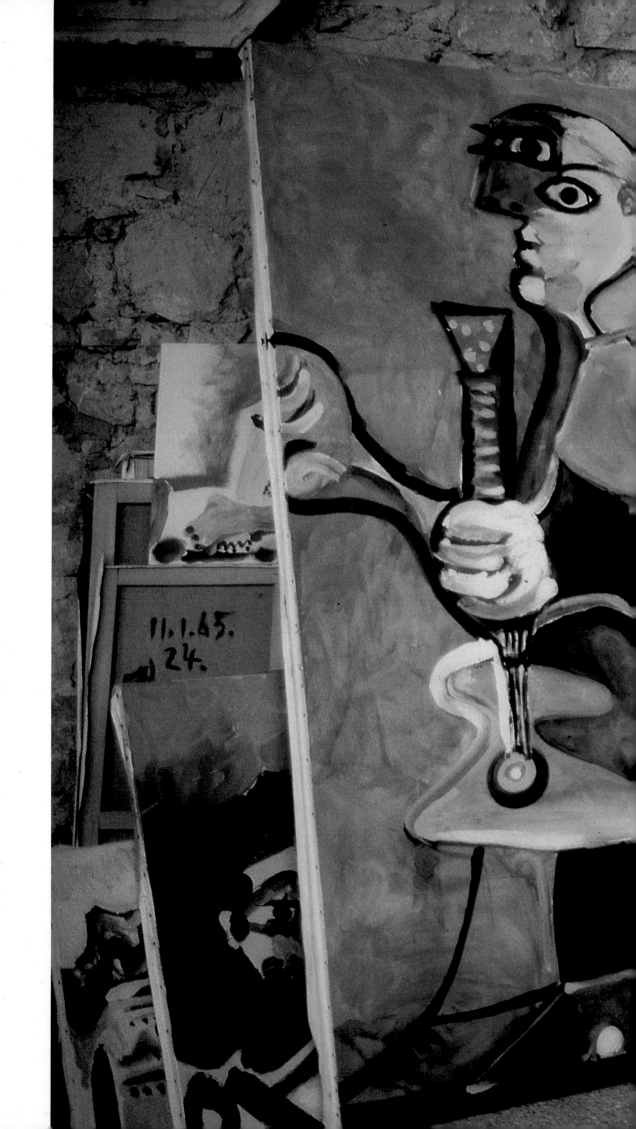

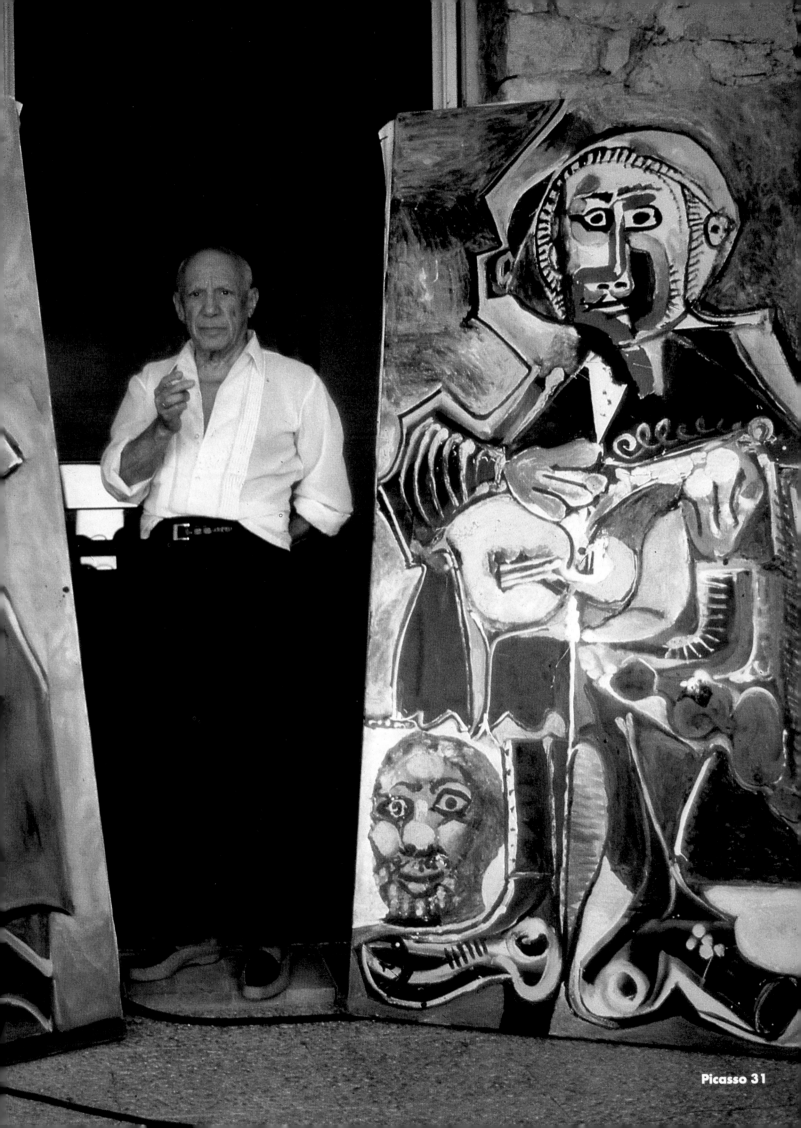

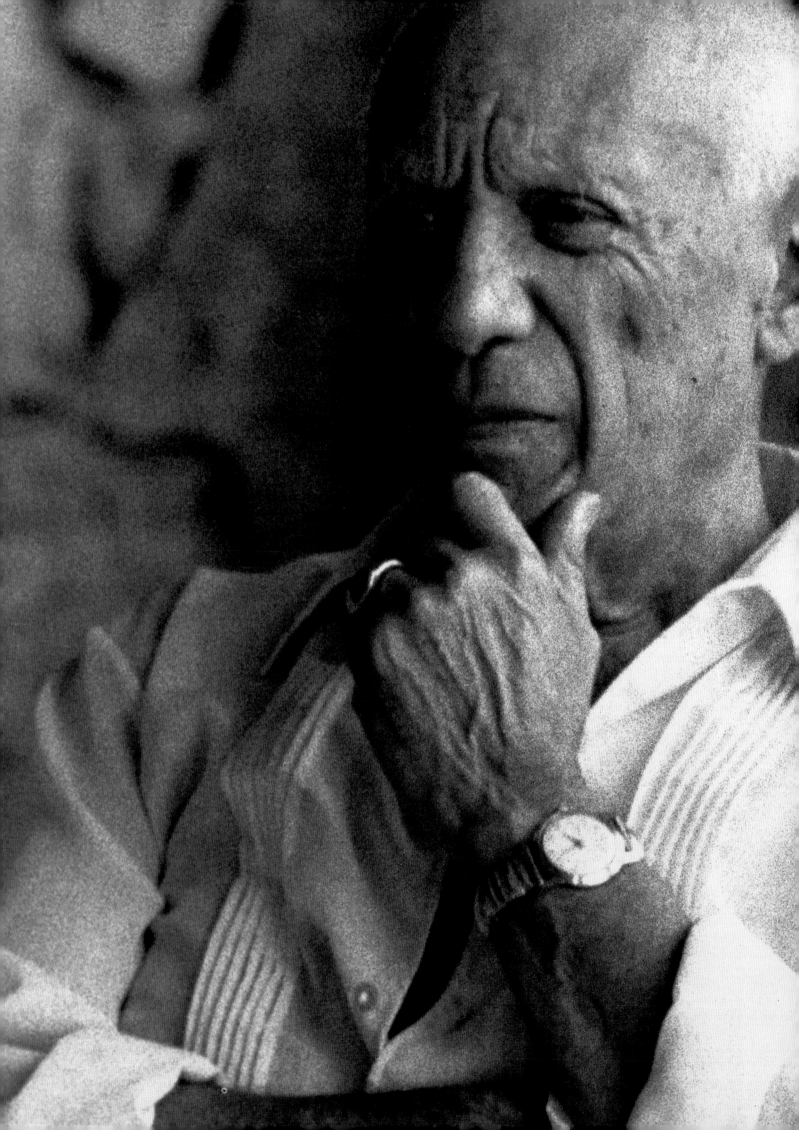

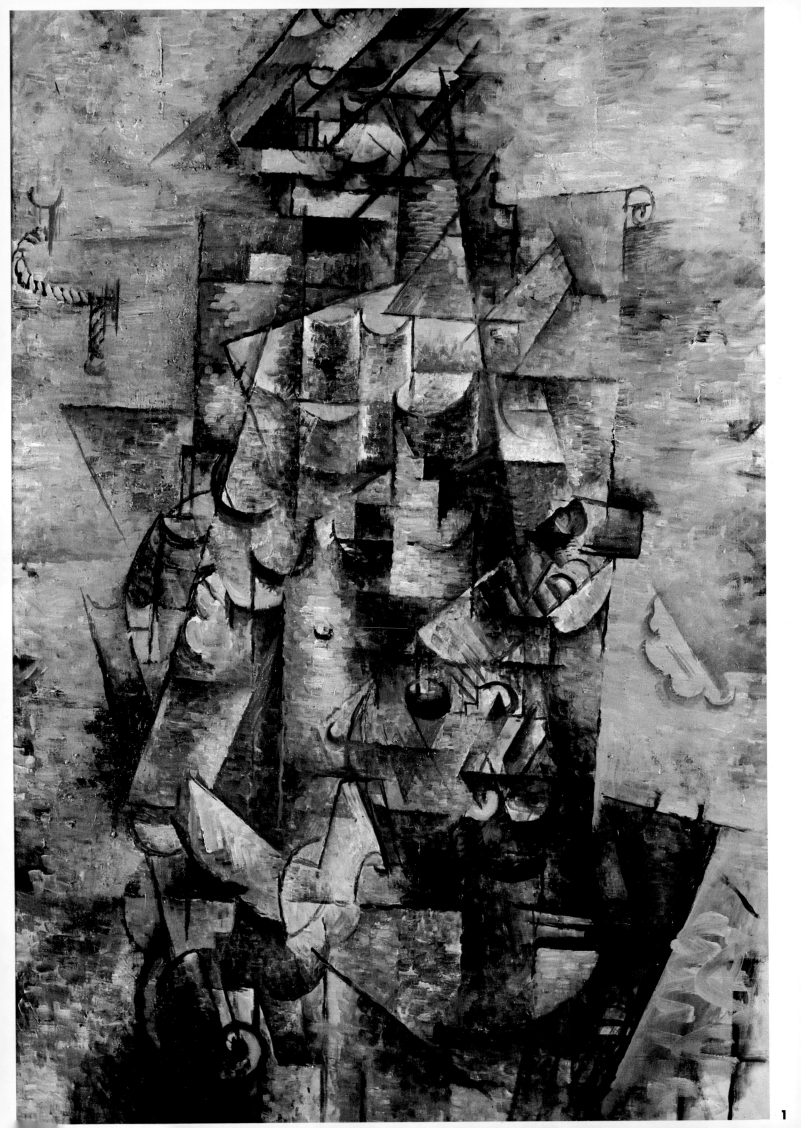

1

Braque

In Normandy, near Dieppe, the Varengeville studio of Georges Braque is an immense room with a high ceiling. It is shut off from the outside world. It is a world of its own, Braque's world. In the warm and diffused light, I found myself standing in a luminous womb.

Each ray of the sun is softened and controlled. Instead of clear glass in the windows, opaque and milky panes disperse an extraordinary glow. The traditional northern light surrenders to the warmth of the sun which penetrates the studio. The walls and curtains are white; the floor is covered with a straw mat. Everything is preconceived; each space contributes its allotted function to an organized creative factory. A visitor receives an impression of unaffected cleanliness and order.

Braque divides his studio into separate areas, like the stage of the mystery dramas in the Middle Ages: areas for engraving, for drawing and watercolor, for relaxation, and, the largest, for painting. On several easels, I saw different canvases simultaneously in progress. They looked like parts of the studio, the studio like parts of the paintings. There was no divorce.

Flat silhouettes, cut out of white paper, hung in various parts of the room, were repeated in the paintings. On one canvas posed a large bird; on the wall appeared the shape of the same bird cut out in white. In another place I saw the silhouette of a flower. Indeed, wherever I looked there were bouquets. Small, as were all the spots of color in the studio, these bouquets of flowers corresponded to the small spots of red on his otherwise monochromatic gray palette. It seemed as if Braque's visual stimulation from color became more intense in relation to the smallness of the stimulus itself. Any larger bouquets in the room were monochromatic: dried corn, dried thistles. With their intense composition and pointed design, these arrangements were already still lifes by Braque.

Many sources of visual inspiration decorate Braque's surroundings. In Paris, he has rubber plants, Polynesian shields, Etruscan sculptures. In the country, on a wall, hangs a large Indian rug of red and gold. Scattered around are small stones, pieces of wood, bits of bleached bones. Such carefully selected groups of outdoor memorabilia as starfish, pebbles, and net create harmonies which Braque quotes and translates into his paintings. Thus the picture of a bouquet of flowers and a jug assumes the hues of objects brought in from the beach. On little wire stands, built by himself, rest several of his bas-reliefs, reminiscent of early Minoan art. Next to his own sculpture lies the big pink shell of a crab on which nature has drawn its own design. There is a consonance between the two. Metamorphosis is the philosophy which underlies Braque's study of natural objects: everything made by God can be selected and transposed by the artist.

Behind his easels hang movable panels of natural sackcloth and fabrics painted brown and gray. Against these somber backdrops, the white accents of his paintings stand out vividly. Braque said, "I want my paintings to be as hard as a flint, so that when struck by eye and light sparks fly."

He is a thinker and philosopher who speaks at random: "Try to see the object, under many angles, but not through *trompe-l'oeil*. One has to try give a tactile value, first by texture, by the feeling of space." And then, in apparent contradiction to his cubist paintings, he repeated, "But always, always avoid *trompe-l'oeil*.

"We must go back to the human, not to the man. Today it's the painter who exhibits himself." Braque believes that we must go back to the universal and not stress the accidental individual. His conception is deeply rooted in the classical French tradition, which defines the ego as "hateful."

"One does not say Cézanne is 'talented'; one can say that of Manet. Cézanne's greatness is in his classical impersonality.

"One must take the object and raise it very, very high," he said. "One must have an established dimension because one needs discipline. Bonnard took the other road. Bonnard was a *symphoniste*. He painted on a huge canvas fixed on the wall. He added and added and enriched.

"There are two kinds of painting, hard and soft, with and without the discipline of an imposed dimension. Painting is very difficult. The good painting is the solution of all these difficulties and differences of space, tactile value, and color."

During one of my visits, Braque mused about the mystery of why there are certain regions, even in France, where no painting has developed. "Strange how in parts of the world where there is stone you have sculpture, and in the countries of light you have painting."

Intensive preparation goes into his work. In pencil and ink he sketches on thinly squared paper, then makes many preparatory gouaches, sometimes cutting out the principal forms in paper. He creates slowly, putting a work aside, developing another, returning again to what he has started, drawing in white chalk over the oil paint. He works close to the texture of his canvas; then he sits down, relaxes, looks at his work on the easel and, from a distance, at the subjects he is painting. Simple objects, through concentration and silence, assume additional meaning. They are divorced from their ordinary significance. There is an incantational quality in his brooding and contemplative appraisal. "The painter," Braque remarked, "must have conscience and loyalty toward his materials and himself to avoid the deterioration of painting."

There is a profound and practical craftsmanship in Braque's work. One feels this in his love of building things himself, of mixing and studying his materials as a housepainter does.

Small details are revealing: the arrangement of his studio, the meticulously studied heights of his worktables. The unique system of louvers, made of light-brown paper, suspended in vertical squares breaks the light over the areas where he is painting. He uses corrugated cardboard to hold pencils and pens—each groove storing many stubs. The stand holding the palettes are made of rough tree trunks, the bark and moss left on, with pieces of iron braced in for support. On different levels of the unique central stem are different palettes, each carrying its own harmony of colors. Braque enjoys making things out of wood and iron. He feels that the act of building something yourself, understanding how two pieces of wood dovetail, is essential to good construction in art. Another practical invention stands between two easels: his sketchbook on a lectern, as in a church, to be used as a visual dictionary of reference and inspiration. Tools are conveniently at hand for every creative need. From his easel he hangs empty tomato cans or discarded cans of any kind. In each he mixes a certain quantity of paint which is the dominant tone of a given area of canvas. In this way, work is not interrupted by the mixing and matching of colors, and a greater continuity is assured. He has an abundance of clean paintbrushes, stuck like bouquets in earthenware jars.

There is nothing in Braque of the mannered *artiste-peintre*. There is, however, the modern elegance of a practical mechanic who is not afraid to use any means. He lives in the present and with the creative stream of his time. His studio in Paris was built for him by the great modern architect Auguste Perret; in the country Braque installed, next to a French naïve painting, an armchair by Eames.

Braque is a *grand seigneur* in art. He has raised the material standard of the artist to its highest possible degree. The conception of his studios is grand and noble; they are like the throne rooms of Renaissance princes, but bare and neat and pure. There is no outward show of luxury, but luxury is everywhere: luxury is in the peace of Braque's life, in its spaciousness, quiet, and convenience. Life seems to center around him, and everything is planned to help his work. He has solved the material problems of creation.

At seventy-eight, with his pure white hair, he seems a much younger man. There is great humanity and penetration in his pale brown eyes. He weighs and compares you, the surroundings, your actions, and disappears, withdraws, into meditation. He is quiet and seems to live in a world all his own. But his exterior calm suggests a man who constantly dominates and disciplines his emotions. A sudden smile, a quick movement of his sensitive long hands, however, reveal a hidden warmth and humor.

His country house, separated by some fifty yards from his studio, was built in 1931 in the low and traditional style of a Norman peasant hut. There is a revealing difference between the modern architecture of his "work temple" and the intimacy of his home. The walls of Braque's living room are painted in different shades of warm yellow-orange; the furniture is made of dark wood. Brass and silver platters, spoons and forks, wrought metal of old design hang on the walls. Into this dark house intense light pours from small windows hung with bright yellow curtains; there is the gleam of light on silver, metal, sculpture, and the intense vibration of color from fruits and meticulously arranged bouquets. Flowers again are everywhere, in bold, unexpected arrangements made by his wife. He has been married to Marcelle Lapré for almost fifty years. Together they have lived the exciting struggle of twentieth-century art.

Madame Braque entered, a small, serious woman, with extraordinarily tender, perceptive blue eyes. Under her smart, simple hat the eyes and the nervous curve of her mouth expressed intelligence and wit. She is adored by their friends and amuses them with countless anecdotes. Music plays an important role in her life—her favorites, as well as Braque's, are Bach, Vivaldi, Mozart, and Buxtehude; she owns Erik Satie's piano.

On the lawn in front of the house, a tent had been set up. Some biscuits were brought out, and again the refinement of Braque's life was revealed. The biscuits had been warmed. We drank his favorite white wine, Muscadet, a fragrant, airy wine, innocent and easy to drink under the midday sun.

He insisted that I visit the church and sailors' cemetery at Varengeville. The small twelfth-century edifice, built right above the steep cliffs that dominate the northern beaches of France, and the cemetery with its hundred tombs and crosses are in harmony with Braque's colors. The church is gray; the cemetery crosses are of white marble. The stained-glass windows inside, and the black wrought iron and living or artificial flowers outside, contribute vivid accents. The steel-gray expanse of the northern pebbled beach, overcast with the shadows of the high cliffs, creates the dominant black of Braque's sailors. I understood how much Braque had absorbed the countryside around him.

The Norman terrain is rich and varied in inspirational substance. There is no flatness and little monotony. The shrubbery, the vales, and the trees that surround his house, the narrow, winding roads with their small cottages, contrast with the deep high cliffs of the beach, the sea color, the fog and haze over distant beaches. The pebbles, the weeds, the shells, the crabs contrast with the cows, the grass, the birds, the fruit trees of this rich Norman country; all are constant stimulation to the mind and eye of a painter.

Here life continues a timeless serenity which our civilization has overlooked. One can still eat pink, freshly caught shrimp in hotels which are reminiscent of Proust's world — where vacationing Parisians dress in blue blazers and white flannels. There is no desire to enjoy quickly, to squeeze hastily the last ounce out of life.

Away from the country, Braque manages to re-create a peaceful existence in the Paris street, the Rue du Douanier, near the park Montsouris. This steep, short dead end with rough cobblestones and small gardens simulates the tranquillity of a small provincial town rather than the capital.

The beige-brown façade of Braque's spacious house is ornamented by the black-painted ironwork of the doors and windows, and is in harmony with his predilection for sumptuous browns and blacks. In front of the tall modern windows grow rows of giant sunflowers. Inside the house, the pale gray walls of the entrance hall seem to spiral upward with the sweeping curve of the gray-carpeted stairway. As with everything associated with Braque, the subtlety of the decor, the thickness of the carpets immediately create a feeling of restrained luxury.

As in Varengeville, the living quarters have a Flemish intimacy and richness of texture. On the ground floor, off the entrance, a living room connects with the dining room. Braque's own paintings dominate the two rooms furnished with dark woods and subdued fabrics. Some of the paintings are among his earliest, as if through their presence the master can see at a glance the evolution of a lifetime.

The whole top floor, the studio, like the nave of a cathedral, symbolically crowns the architecture of Braque's everyday life. This studio is the head of his house, the summit to which he has to ascend before he can start to work. Here, as in Varengeville, the light is transformed into Braque's personal illumination by a complicated series of white curtains. I have always felt that this light is softened as if silenced; and, in the hushed luminosity, the contrast between objects ceases as they lose their individuality and fuse into their environment. This knowing manipulation of perception creates a unique universe. Air, space between things acquire tangible substance; all matter seems unified; all things in the room exchange substance — reality becomes purposely deintensified. As a scientist needs to dilute a rich substance to study it better, so Braque reduces jarring reality in order to live with it and study it better. This process of possession, the absorption and digestion of visual phenomena through the use of light, is one by which Braque's rendition of reality acquires mystery. The miracle of plant life is based on the transforma-

tion of light into energy; maybe photosynthesis is the image of Braque's creative process. First, slow contemplative assimilation is made possible by the manipulation of light; then inspiration, like chlorophyll in a plant, makes growth and expansion possible. Light is the energy behind the creative restitution that is the act of painting.

Braque was sitting in a corner of the studio on a low couch, surrounded by pillows, protected from the wall by coarse African woven mats. In this niche he could rest and observe his work, with his back to the light, his face in the dark shadows. The pure white of his soft, gently undulating hair shone like an aureole. Since he had been ill, he found that working on a very low chair with a miniature easel no higher than the chair helped his breathing. The vast expanse of floor, unobstructed by furniture, was curiously animated by many small Braque paintings. Seen from the low couch, they created a feeling of receding motion, as if a traveler glimpsed fugitive vistas.

These canvases, mostly views of beaches, were staggered around him like diminutive stage sets. They let his eye wander on the nature he loves and misses when he works in Paris. "When I long for Varengeville, I paint my postcards, these seascapes," he said with a smile. Between the carefully arranged views were old newspapers covering the floor and, on them, pots, rags, brushes, knives, palettes — the paraphernalia of the painter's art. For him, art is not only inspiration hastily transcribed; like a ritual, the actual process of execution gives to the work of art an added meaning.

When Braque in his art reaches a point where all the expected, the known, is magnificently portrayed, he is then able to go further, beyond the security of the tangible, inventing in the process a new sensuality, a sensuality of the spirit. His greatness is in his ability to explore the other reality beyond the one that is visibly lit. The unknown begins when he leaves the protection of light. He is not afraid of night, and the fathomless blacks that recur in his paintings are not shadows; they are his signals warning us of the mystery that lurks behind the surface. They are the visual evidence of the solidity of the artist's pictorial foundation and of his awareness that solid art has to dig deep to find the security hidden in the unknown, the unexplored.

I have had many conversations with Braque, who, for a painter, is particularly articulate about his art. "The painting materializes in contact with nature. Painting is a meditation. It is contemplation, for the painting is made in the head. One must regurgitate it. One must give it back. Painting is a restitution.

"Light is a delicate thing. There is a confusion made between the effect of light and light itself. Light for a painter has only one purpose — to define clearly his subject, not to make him reproduce some luminous effect.

"Take the preparation of the idea of a picture. If I am going to paint a lobster, all I like to make sure of is whether it has six or four legs. Curious, the visual memory that one has. I did not know exactly how many legs a lobster had, but in

drawing it from memory I found the correct number. I discovered that the memory of the appearance rendered the right number. Contact with nature is all the more important because it is constant. An impregnation results to which all artists submit."

I asked if nature exercised a control, a discipline upon him. He answered, "Nature acts on me practically without the slightest control. I have realized that in my whole life I have never had an act of authority. It is strange but it is true.

When I asked Braque if he didn't have to make decisions in painting, he said, "No, my painting is not premeditated. It is a need. I do not see the will appear in it. If that were the case, one might say that an alcoholic is an example of maximum willpower. But that is not willpower. Like the alcoholic who takes his little glass in the morning, I take up my brushes, just like that—without knowing. I am a little drunk. There is no will in that. It is a deep need, like hunger."

"But in your cubist period," I said, "you attempted to make nature fit into a system."

"Yes," he said, "then there was a dominant idea. An idea must be conducted, the will has an action. It was because of this that I did not sign my paintings of that period. They were not properly speaking, mine. They were my ideas; however, I always wanted something deeper."

Later, speaking about color, Braque said, "It is very complex. For me, color should not be, and is not always, attached to the object. In painting, if you find that an orange is yellow, the yellow can perfectly well be placed elsewhere than on the orange.

"It was because of color that I made my collages. In them the colors are definitely detached from the objects."

Another time Braque told me, "I do not believe in any one thing. I do not believe in this, or this [he touched an object on a small table]. I do not believe in things; I believe only in their relationship, in their circumstances. Circumstances bestow reality on things. In Zen it is said, 'Reality is not this, it is the fact of being this.' This is a paper knife, but if I use it as a shoehorn, it becomes a shoehorn. For things to exist, there must first come into being a relationship between you and the things, or between the things themselves.

"The poetic for me is to instill things with circumstantial life, to let the circumstances in which they appear serve them. One time, I explained this to a young poet. He said to me, 'I do not quite understand.' I told him, 'You will see. Once I was in my car and the brakes weren't working very well. I stopped on the top of a hill, became frightened, and then began looking around me for something to prevent the car from dashing away. I saw some stones, picked one up, and out of this stone I made a wheel block. That is a poetic transformation, a stone becomes a wheel block. I returned the stone to its place. I went away. It does not exist anymore. It becomes whatever someone else will make of it, I do not know what.'

"Everything is based on a relationship. The relationship of man and woman brings forth a child. It is the same with the artist and the motif, which together make a painting. But no one looks at the artist or the motif; they are unimportant. It is the painting that results from their relationship that counts.

"It is strange. Take Claude Monet. In the beginning he was very impressionable; his painting resembled much more the mother than the father. When one looks at an early Monet one says, 'How beautiful the atmosphere over the cliffs, et cetera.' For me, that represents the mother. But later, when he started on the cathedrals, one says, 'What a marvelous painter, what an eye!' That is the father revealing himself.

"In a male-female relationship, if there is a mating, it is an image that corresponds to the truth. What is of interest is that which is born from the encounter. Penetration, reception give a result. All nature is that, nothing escapes that. This is what I mean about Claude Monet. The feminine and the impressionable appear in his early work, when the mother is dominant. The mother—that is what I call nature."

"What part does the artist's idea have in a work of art?" I asked Braque.

"I have written," he answered, "'The painting is finished when the idea has disappeared.' The idea in a painting is like the launching cradle of a ship. It is like the scaffolding used in the building of those enormous ships. After the ship is built, it floats; it has left the cradle useless and forgotten. The idea for a painting is similar. You use the idea to build, to guide, and, when your painting is strong enough, it goes off. It floats; it no longer needs the idea to uphold it. It goes off to lead its own life, as the ship does.

"The image of reality that remains in the finished painting is not the idea. What remains is what comes from the spectator and the painting together, from the relationship between the two. As soon as the spectator looks at a thing, he makes it his own; he brings to it his desires, his needs, turning it into something altogether different. The artist does not retain control of his work in the imagination of the spectator. On the contrary, that's the beauty of it.

"The attempts of the artist should not be to convince people but to make them reflect. I do not ask them to have a definitive opinion, but if a painting of mine can make them reflect, think a little, that is very good. Something of me comes out in my paintings. Well, it is the same for the person who looks at them. The only thing that counts for him is what comes out of himself. It is in that that he must find his life."

We were discussing this when he said, "No intellectuality; one must live in reality. In our epoch, people are preoccupied with science, confused by trying to reduce everything to science. Of course science is something very good, but it does not go beyond intelligence, whereas art only begins when it does go beyond intelligence. Then art touches the soul. Science speaks only to intelligence. One needs more and more art, after all, to rediscover the true reality.

"The philosophers have greatly confused humanity. They have been seeking definitions, but there are no definitions. Happiness, like many things, ceases to exist as soon as you try to lock it up in a definition. Happiness starts where

the unknown begins. Happiness is not something promised—it is existence itself."

Braque suddenly asked if I had noticed the portrait of his grandmother in the dining room downstairs. "It is one of my first canvases. I had just finished my military training and I was twenty years old."

There were, even then, traces of Braque's inescapable stamp, I remarked. He said, "Yes, my hair has grown white, but one can recognize me. My painting has grown white, but one knows that it is mine.

"I sometimes have the impression that it is not me who did my paintings. I feel absolutely detached at first glance. It is absolutely as if they were someone else's. But when I concentrate, then I see a lot of things. I recognize my own quirks, the marks of my style. One's style—it is in a way one's inability to do otherwise. The physical is in command. Your physical constitution practically dictates the shape of the brushmarks, as it does the pen marks in writing.

"Especially in the layout of my paintings," he pointed out, "one can recognize master lines that are always in the same place. It is strange—a framing that one makes sensation fit into but that is practically defined beforehand.

"One achieves this by instinct. I have never wanted to bar a way to myself, to be closed up with principles. I accept that which comes truly out of myself.

"Personality is good if it reveals itself without the artist's becoming conscious of it. There must be no exploitation of personality. As soon as a thing becomes conscious it becomes dangerous."

"As soon as an artist becomes aware of his talent, then he is in danger. I have a horror of talent because it is a thing learned and becomes too facile if one ceaselessly refers to it. It is a facility that prevents one from being sensitive to many things. One should go beyond it.

"As a matter of fact, this search for what lies beyond talent stamps our epoch. This tendency is quite contrary to the spirit of the sixteenth and seventeenth centuries. In the Renaissance, painters did only that which they knew how to do. They studied a great deal, but they never did that which they did not know how to do. They did not go beyond the limits of their talent. In our day, though, since Cézanne, talent is not enough. There is here an aspect that could practically be called heroic. To my way of thinking, there is no master to equal Cézanne, who took risks and searched for himself all his life.

"I have always wanted to actually live things instead of representing them. It has been said by a Japanese painter that 'One must penetrate a thing in order to be able to draw it.'

"The Renaissance painters painted what they saw, but I feel that is not enough. One must paint what one feels, at a greater depth. When I am making a sculpture of a horse, when I am working on the leg, I raise mine. The Renaissance masters represented things, they did not live them, in my opinion. That is what gives the theatrical aspect to the Renaissance. The painters confused composition with staging. It was opera and stage directing. But with Cézanne composition is really painting, it is thought out."

When asked if the stamp of our epoch was on his art, Braque said, "I have never tried to trace it. I never try to define precisely. If you try to define a thing, you replace the thing with the idea you have of it, which is generally false. In my art I have said what I have said."

However, he is certain that environment subconsciously influences a work of art. "I once told a young painter who spoke to me of his search for originality, 'You are perhaps original, but you are above all a painter of the twentieth century. As soon as you have felt the influence of your epoch you will cease to worry about originality.' Then, too, the small details, the trees, the flowers that surround an artist's life are very important. But it is difficult to define their influence because, contrary to what one may think, environment does not act directly. It is noticeable only when a great deal of time has elapsed. Still, if you put side by side paintings from different countries, you can see the influence of the original surroundings.

"I would like to write on the importance of art in life, on its influences. One cannot begin to imagine the place it occupies, and its effect even on things that seem remote from painting. If nowadays you see so many people on the beaches, going swimming, it's thanks to the impressionists. They were the ones who created the cult of the outdoors. It is so true that if you look at the railway posters encouraging tourism, you'll see that many of them are impressionistic. I could cite many examples like that, a quantity of influences.

"I was very happy when, in 1914, I realized that the Army had used the principles of my cubist paintings for camouflage. 'Cubism and camouflage,' I once said to someone. He answered that it was all a coincidence, 'No, no,' I said, 'it is you who are wrong. Before cubism we had impressionism, and the Army used pale blue uniforms, horizon blue, atmospheric camouflage.'"

With a circular motion of his head, he swept his gaze across his accumulated canvases and said softly, "They populate the studio and they take so much space. I really need another studio." It was moving to hear this old master yearning for more space to fill. "I now paint larger and larger. I would like to add another story to this house."

When Braque stood up amid this multiplicity of objects, his tall figure acquired a new, gigantic stature, contrasted against the Lilliputian reductions of nature that he had compressed into each small canvas. The little paintings were principally studies, but towering above them around the walls of the studio were large finished canvases, his series of birds in flight, no particular bird, but a synthesis of different impressions.

Braque said, "The bird theme started in the thirties, and the sea gulls and the ravens of Varengeville have influenced me very much. So have the birds on the game preserve of the Camargue. There are extraordinary species of birds there, right in the midst of the black bulls. You can see the ibis, the flamingo, and the heron, a magnificent bird. The flight of the heron is beautiful."

The largest canvas of all, like an immense icon, hung in

the center of the majestic arrangement of paintings. In this great work of Braque's one gigantic bird hovers over a nest. The bird is gray-white, the background dark brown-black. There are no other colors; the somber, tragic mood is relieved only here and there by unbelievably subtle variations of paint, patina, and texture. My eyes were riveted to this haunting vision.

Braque sat silently watching his work, then said, "It goes beyond painting. Painting is something more than just decoration. There is more to it than composition. There has been too much insistence on aesthetics."

The bird itself, painted in thin layers of whites and grays, seems all the more dematerialized against the rich, sensuous background of lavishly spread paint, as if Braque wanted to emphasize that beyond *matière*, beyond the physical aspect of art, there is an imponderable. To express it he needed the minimum of substance, the minimum of paint in the area of greatest meaning. This economy of expression, this withdrawing of means, is an indication that here in the bird the artist approached the core of his art. It seems as if he feared to touch the surface even with the softest brush. For in this realm where substance is metamorphosed into idea, mystery begins.

"One cannot put this mystery into words," Braque told me. "It is beyond anything one can say. It is the *manifestation* of an indefinable feeling.

"Art tends toward *le néant*, the state of nothingness, the void. For me, perfection is a sort of nonexistence. It is a realm in which words lose their value. If a thing is perfect, one does not say it is bad or good.

"Harmony is just that state in which one can no longer say anything. It is a joy. Words are valueless, for the word destroys all."

Looking at the bird, I understood what Braque meant when he said, "Happiness starts where we cease to know." He told me, "The bird is the summing up of all my art — it is more than painting." Braque will not sell this *Grand Oiseau*. He will not even part from it for a short time. He said, "When I go to Varengeville, I take it with me."

"It has a hypnotic power," I said.

Braque quickly added, "That's it. It is as if one heard the fluttering of wings."

Plato had conceived of the soul as having wings, "The soul...when perfect and fully winged soars upward." About twenty-three hundred years after Plato, Braque, through meditation, achieved the pictorial image of the philosopher's vision. The winged flight in space is the essential preoccupation of Braque's late period.

The bird is symbol of flight. This symbolism of winged flight as a supernatural condition has been used in poetry and religion, in mythology and legend. Man tied down to earth needs wings to soar into the sky of hope.

There are inner states for which adequate words cannot be found; for a painter-poet like Braque there are moods that cannot be transcribed exactly. All the artist can do is to suggest and, by describing as much as he can of what surrounds that particular hard-to-express mood, make the spec-

tator guess at the hidden meaning. This suggesting and guessing, like the meeting of two intuitions, is the hidden language of art. When art is able to convey the unsaid, the unportrayed, by precisely guiding the spectator's mind into the artist's mystery, it attains its truest grandeur. That the great artist can be understood beyond the merely visible message is proof that he possesses the language of the soul. In our lives we are surrounded by the unsaid, the unheard, the unseen, but only the artist and the mystic can tap this fathomless reservoir. A great work of art will show traces of the exploration of the reality beyond everyday reality. Few are those who know of its existence; fewer still are those who recognize it when it is brought before them through a gift of the artist.

The theme of Braque's series of birds is the theme of solitude. The creative man is aware of his solitude, but his cries in words and sounds are heard by few ears, his image seen by few eyes. He is a prisoner caged in by the everyday reality of those who do not see and hear. But in his dungeon, through a narrow chink of hope, he glimpses a minute area of light, of sky, to which his spirit flies. Alone, he will survive through a ceaseless faith that his cry will be heard, his work understood; that his love of life expressed in his re-creation of it will be met with love.

In the brown-black dungeon of Braque's great canvas, the solitary bird flies motionless, carrying its eternal, changeless message, the passage of an inspired cry of desperate love. This cry is the artist's means of communing with the divine, the immortal. The words of Shelly on his art apply to Braque the painter —"Poetry redeems from decay the visitations of the divinity in man."

Where the material world ceases, where the unknown begins, man's faith is born. Faith is the unspoken word, the clue to "beyond painting." Now all seems clear—the white bird in its flight, like the dove of the Holy Ghost, is the symbol of man's purest aspirations, of man's eternal hope of purification through the silent breath of prayer.

Notes on the Illustrations

Georges Braque, 1882–1963. Born: France.
Photographs taken in 1948, 1953, 1957, and 1958.

1. Braque, Man with Guitar, *1911. Oil on canvas, 45¾″ x 32⅛″ (116.2 cm x 80.9 cm). Collection, The Museum of Modern Art, New York. Acquired through the Lillie P. Bliss Bequest.*
2. On the floor of Braque's studio, tin cans of media and colors—his cuisine.
3. Braque standing in front of the display wall of his vast Paris studio; behind him, two "bird paintings."
4. Braque at work in his Paris studio. There is no cold north light; instead, through a system of curtains, the artist can control the intensity of sunlight. Braque constantly rearranged the position of his own works. There are several palettes in the room, several work areas.

5. The display wall of Braque's studio. He usually worked on several paintings at a time. The studio, built in 1948 according to the artist's own unconventional plan, faces south. On this extraordinary, theatrical wall, over months and years, Braque changed the arrangement, displaying several works, creating a glorious environment.

6. Braque, in the meditation and rest corner of his Paris studio, surrounded by reproductions of the art he admired most as well as posters of his own work. Flowers are ever present.

7. The small sculpture studio in his Paris home adjoining the vast painting studio.

8. Detail of Braque ceramics and sculptures in his studio.

9. Two palettes on which Braque mixed paint with sand, gravel, or marble dust to achieve his various rich textures.

10. Because of Braque's breathing difficulties, he began to work on a very low easel.

11. On the work table, drawings of leaves.

12. Bones, whose texture and shape inspired Braque.

13. Braque's enormous number of paintbrushes, many more than most artists possess.

14. Tools, meticulously arranged in the sculpture studio.

15. A detail of a painting in progress on the studio floor.

16. Braque's Paris house, the ground-floor living room opening into the dining room. On the left, an early fauve landscape, a magnificent analytical cubist work, and a bronze horse head.

17. Hanging on a door, black and white enlargements of two Corot portraits. In the sculpture studio at left, a plaster horse that will be cast in bronze.

18. Braque, In Studio VIII, 1952-55. Private Collection.

19. The cliffs and beach at Varengeville.

20. Braque caught in a relaxed mood at a lunch in the country.

21. Braque's Varengeville house, built in 1930, in the style of the Norman peasant cottages familiar to him from childhood. Each wall of the living room is a different color: ocher, yellow, orange. On an antique Norman chest stands a head, Hesperis, which Braque chiseled out of stone from nearby cliffs; a pewter teapot that often appears in his lithographs; and an oil and vinegar set he made of two mineral-water bottles. On the wall, Spanish roasting forks.

22. Detail of Braque's Grand Oiseau.

23. Braque in contemplation in Paris.

Braque 2

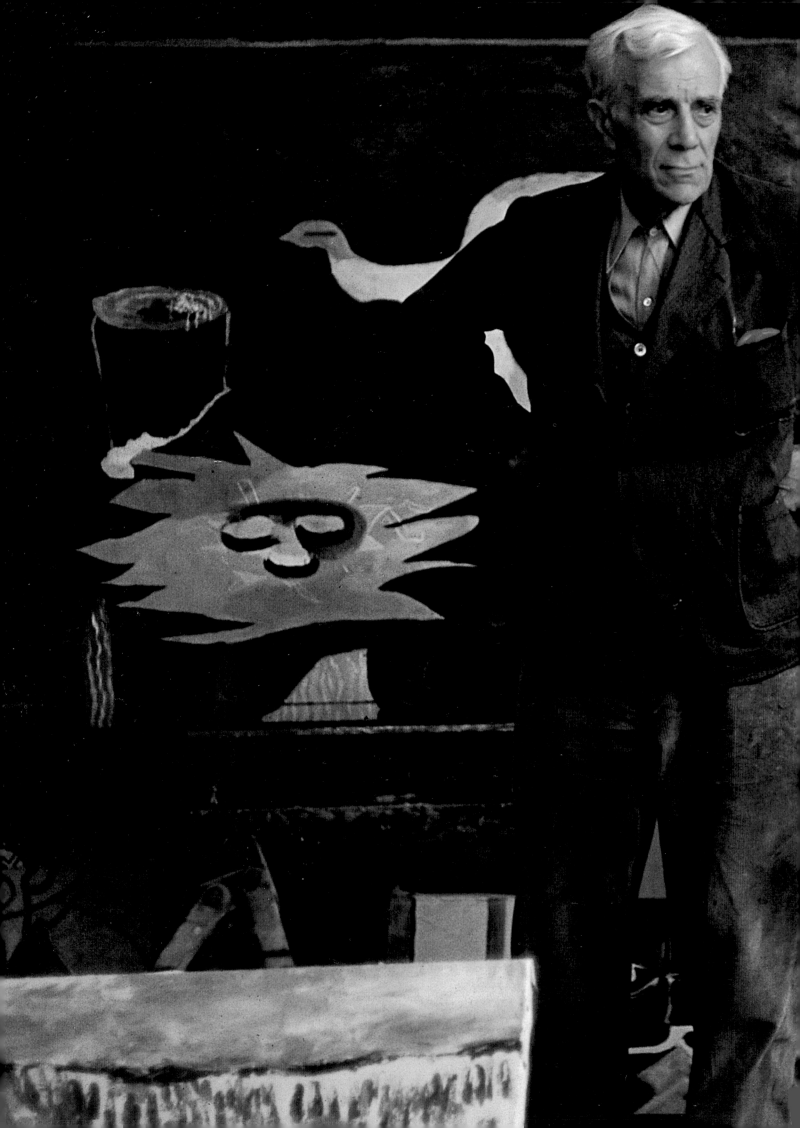

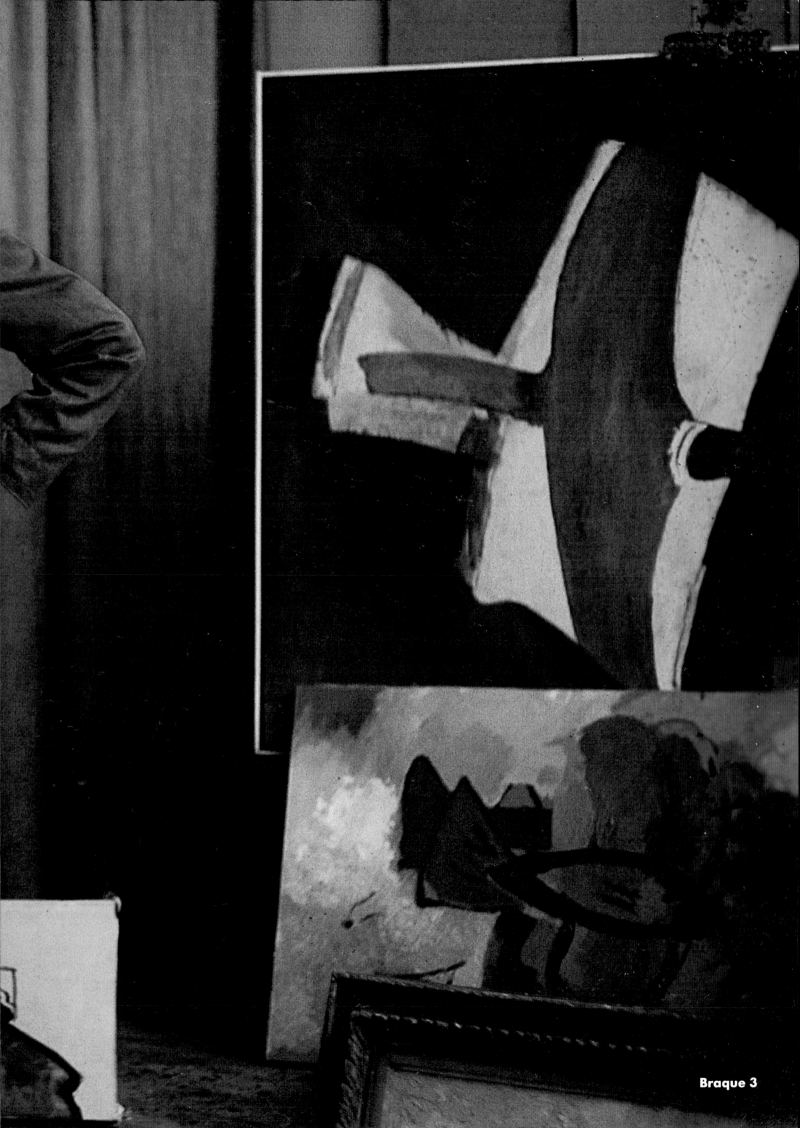

Braque 3

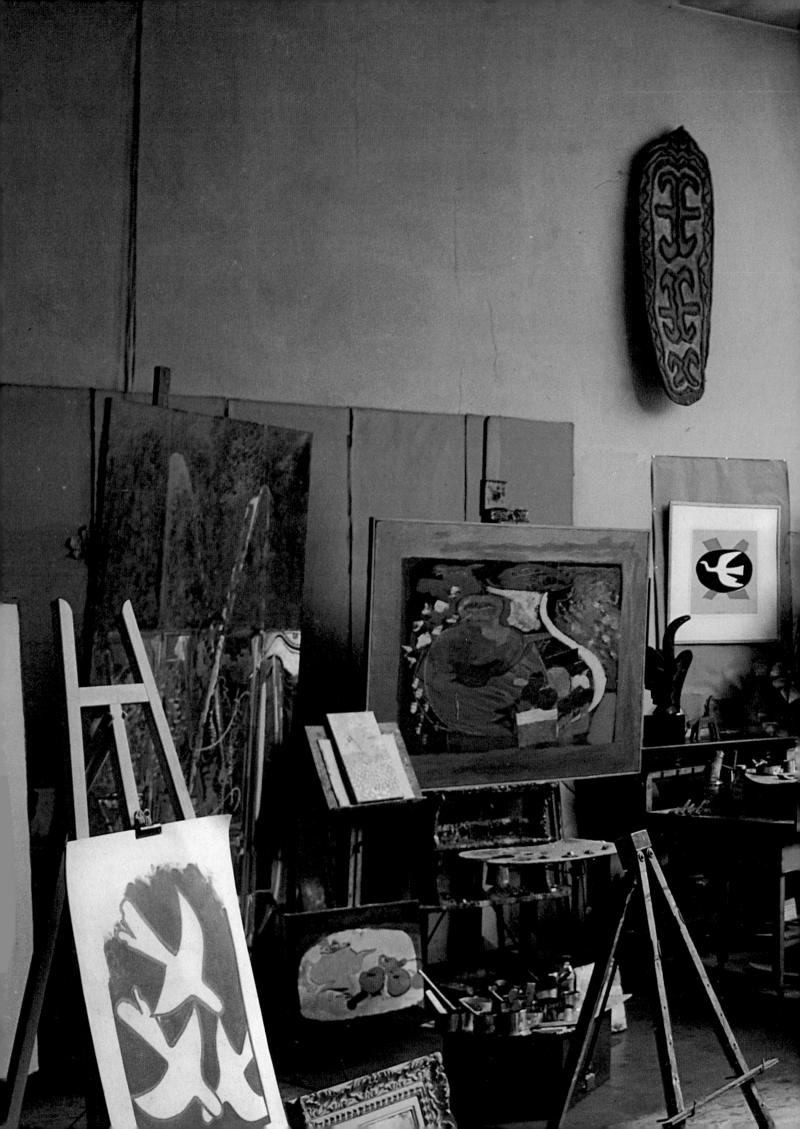

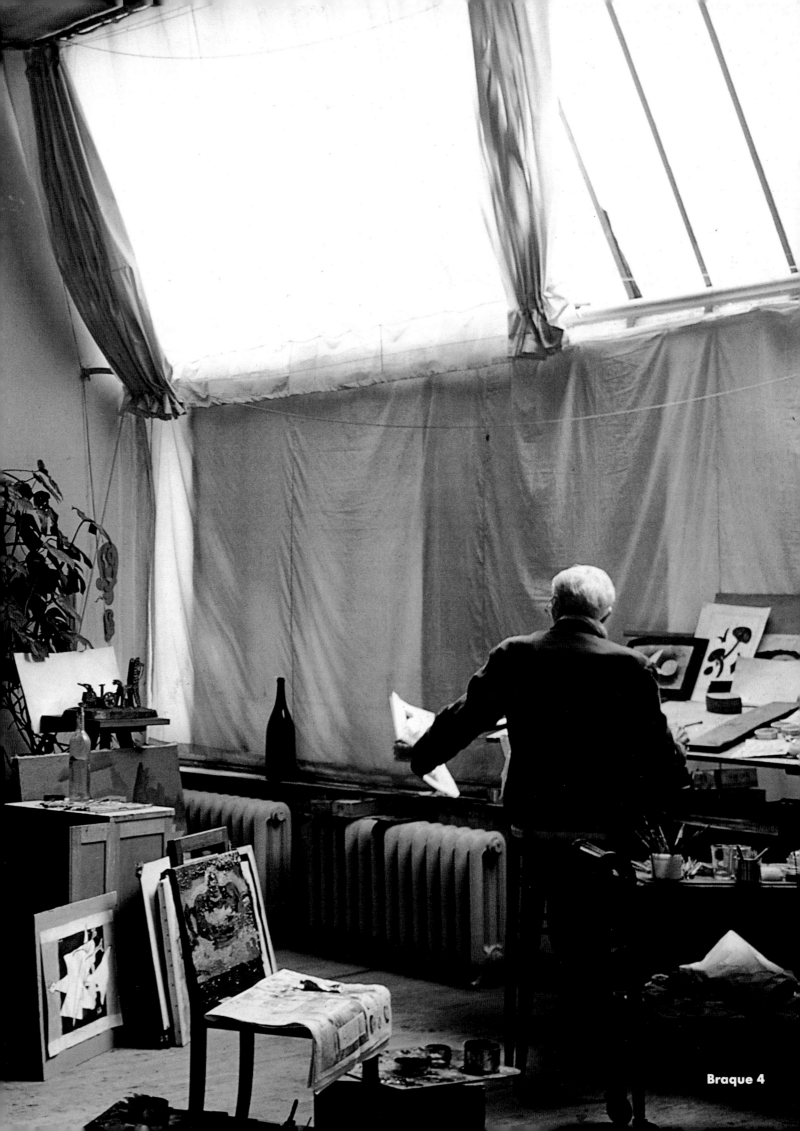

Braque 4

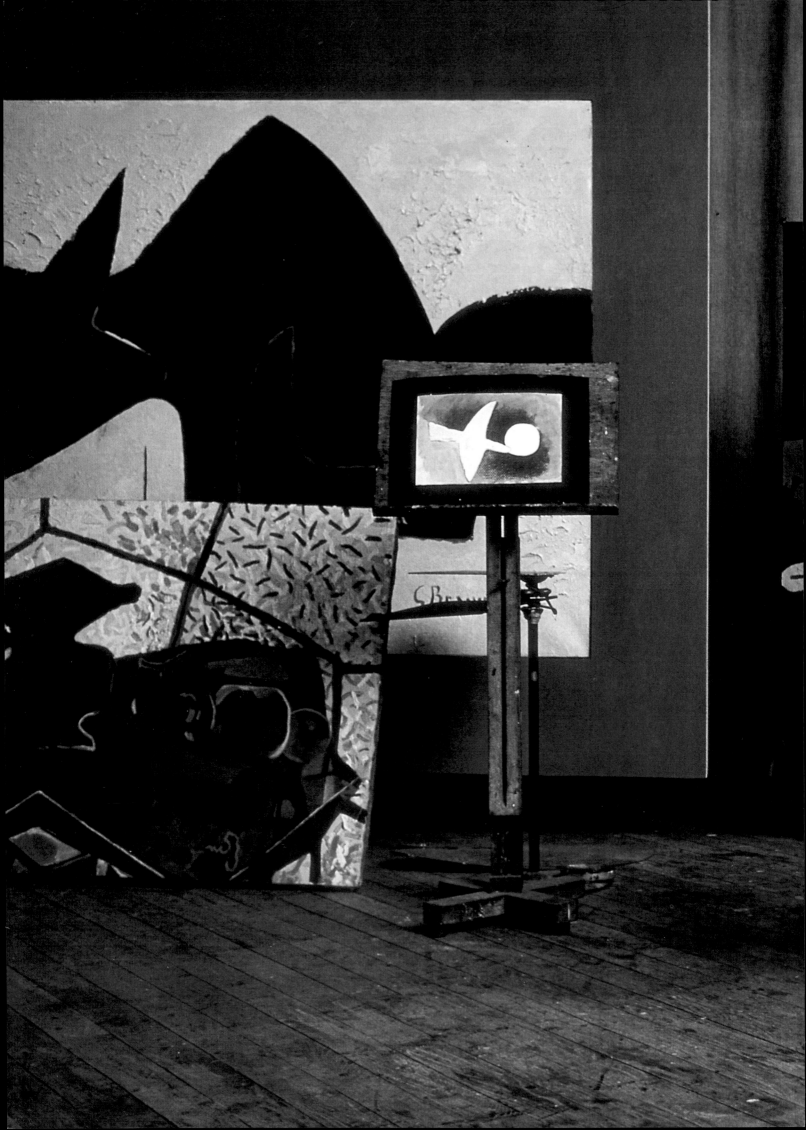

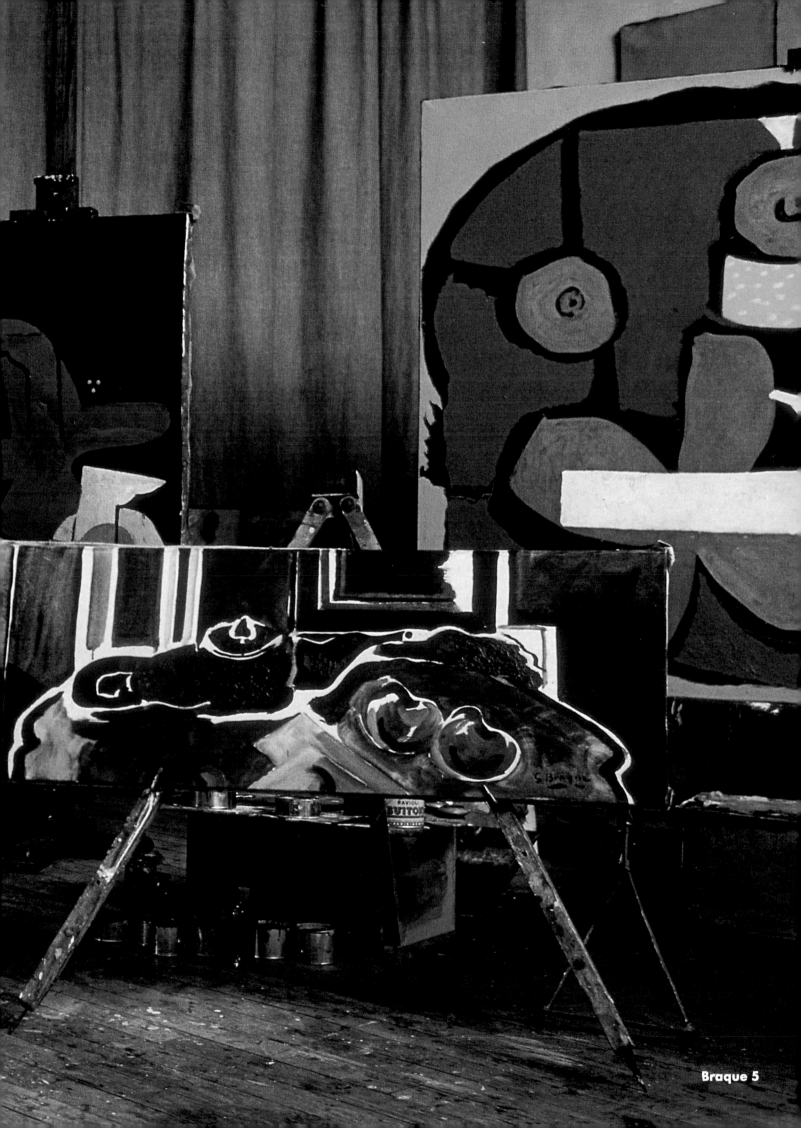

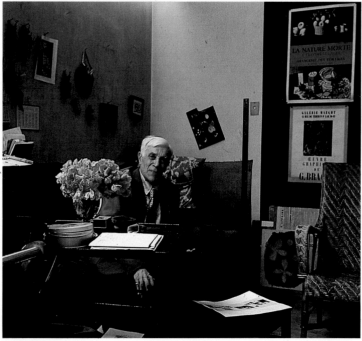

Braque 6

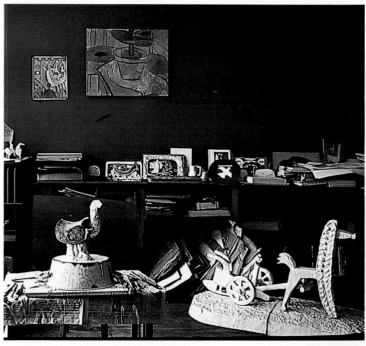

Braque 7

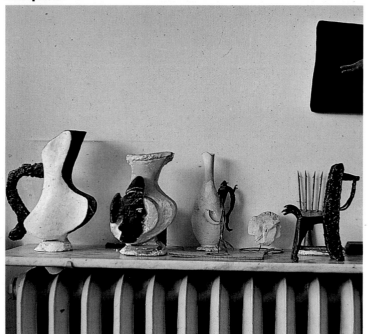

Braque 8

Braque 9

Braque 10

Braque 11

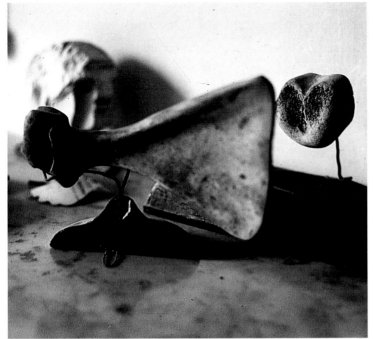

Braque 12

Braque 13

Braque 14

Braque 15

Braque 16

Braque 17

Braque 19

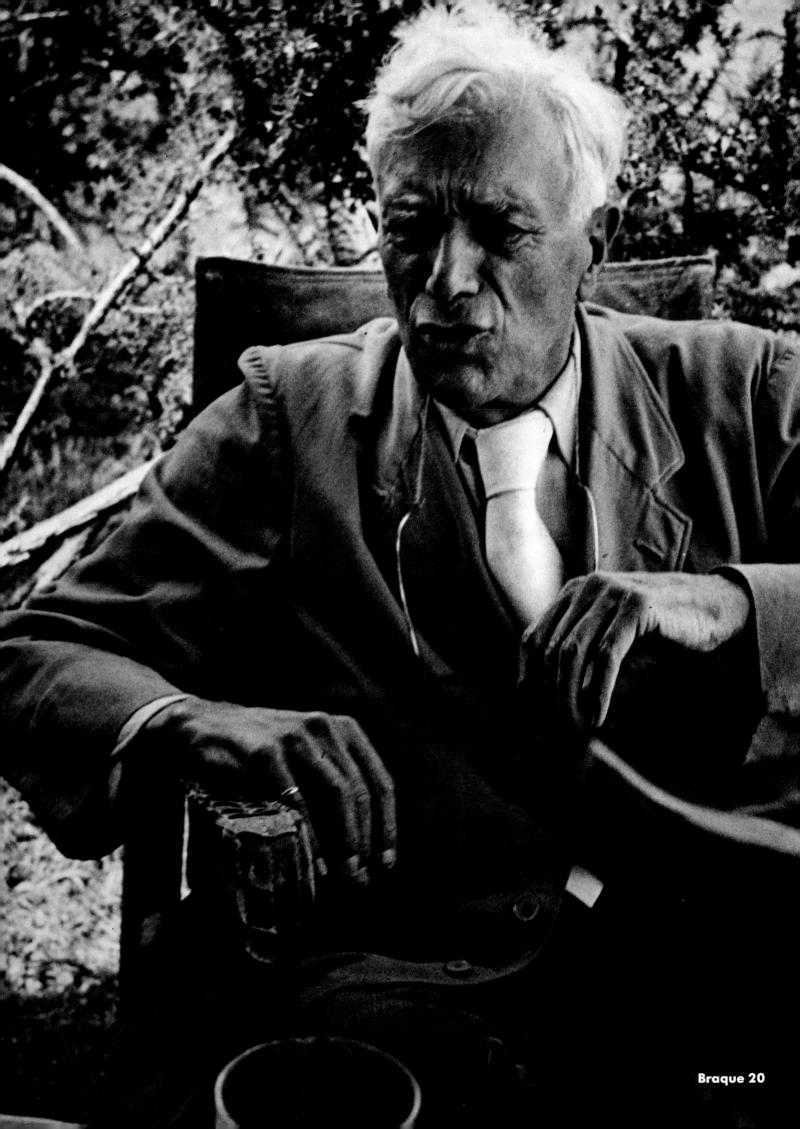

Braque 20

Braque 21

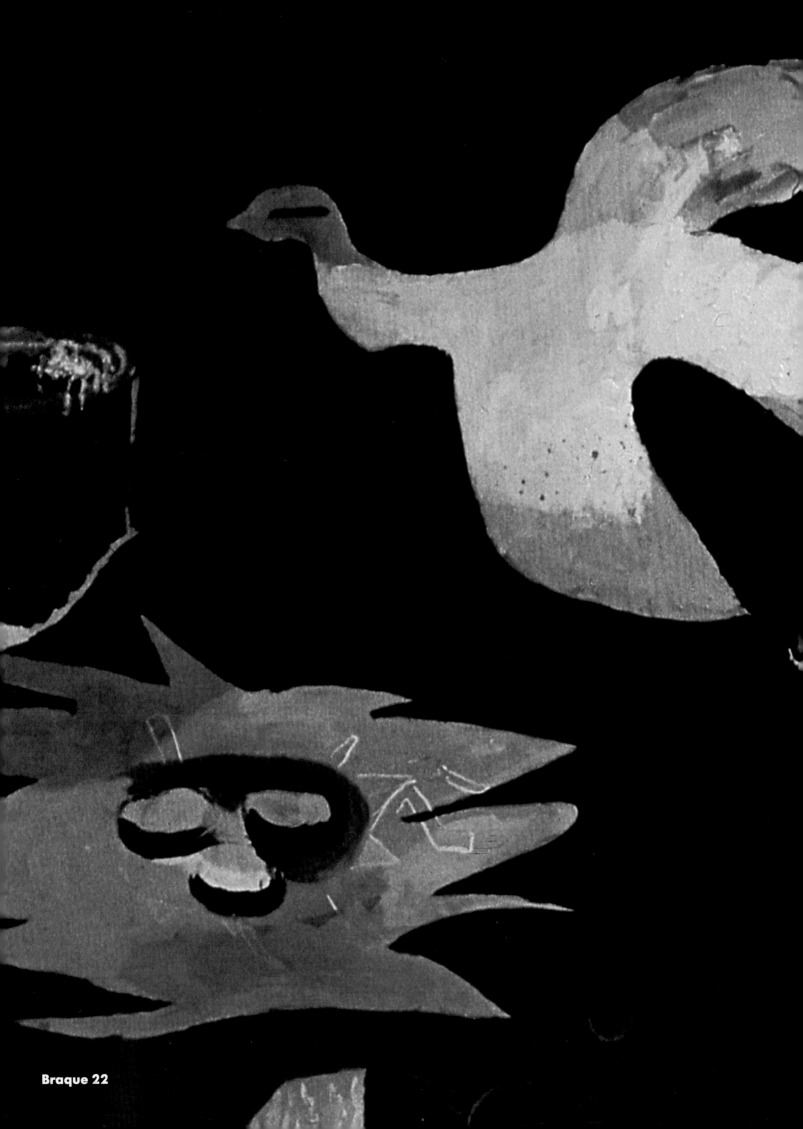

Braque 22

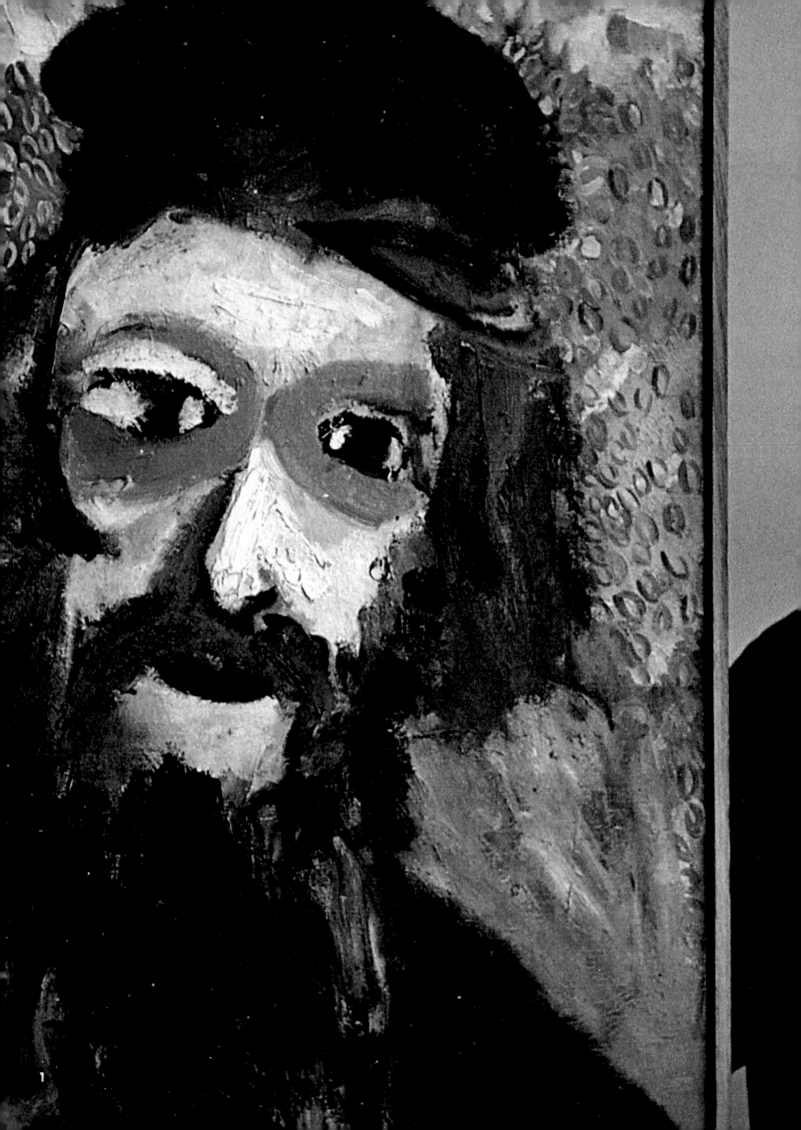

Chagall

Vence, a tiny walled hilltop village in the south of France, became in the postwar years a center of intense artistic life, attracting artists, dealers, collectors, students, and snobs. Matisse's white and blue chapel is the temple of this new Athens. Vence seems the undisputed capital of that small stretch of Mediterranean coast between Cannes and Nice. Like a rival city-state of the Italian Renaissance, only Vallauris, where Picasso once lived, disputed its dominance.

To visit the Midi has become a fashionable requisite for anyone interested in today's art. The names of Picasso, Braque, Chagall, Léger, and Matisse are heard from the lips of countless tourists disporting themselves on the promenades and beaches. The evocation of these prestigious names confers a stamp of cultural approval upon the lazy, carefree holiday life of the Riviera. A tourist may feel that he has participated in a creative adventure merely by swimming next to Picasso or Chagall. In the Midi these artists have become the nobles of the land. Their wishes are respected, their activities reported; they are a new royalty.

Marc Chagall, an *émigré* from Russia, who has lived in Germany and America as well as in France, is a relative newcomer; he bought his white villa at Vence in 1949. Marcel Proust once stayed in it, and the studio, a garage-like building next to the house proper, was once used by Paul Valéry, the great poet, when he painted. The two buildings are on the side of a steep hill, and the magnificent well-kept garden is like a gigantic green staircase descending to the entrance gate.

On a large stone terrace in front of the house a garden table was set for tea. I sat with his wife and waited for Chagall to come from his studio. Intense sunlight streaked through the bitter-clean-smelling leaves of the eucalyptus trees. We were surrounded by flowers; the spottiness of their colors combined with the broken-up patterns of light and shadow created a sensation of visually enclosed space.

Valentine, or "Vava," Chagall's second wife, sat at the table ready to pour the tea. She is Russian; her jet-black hair, her black eyes, black blouse, and black slacks accentuated

her Oriental beauty. Her regular, rounded features and sub-dued, flowing gestures expressed a tender, shy gentleness. There was a weary worldliness in her speech, an understand-ing feminine intelligence supplementing her alert sense of humor. In her Chagall has found the tact and wisdom that he needs to organize and protect his creative life.

His first wife, Bella, was the companion, the inspiration, and the tender protector of his life. Through her and with her he became Chagall, the great artist. They were married from 1915 until her death in New York in 1944. They had one child, a daughter, Ida, a painter who is a passionate admirer of her father.

The short, stocky man who descended the long flight of steps that joined the studio with the terrace was Chagall. He was dressed all in blue; a thin crisscross of red checkered his blue shirt; a thick, rough leather belt held his baggy blue linen trousers.

Chagall's face was tanned and weatherbeaten, his strong, marked features surrounded by thinning unruly locks of gray hair. His well-muscled, compact body gave a sense of youth-ful, dynamic vitality, of earthy male vigor. The intimate weld-ing of the extremes, the physical roughness with the spiritual, contributed stature and dimension to his presence.

He smiled when he saw us, a quick, self-conscious smile, his head slightly tilted to one side, like a bird examining a new object from all angles. The sadness of his eyes added, by contrast, intensity to his smile.

His voice, very soft and husky, had the dim hoarseness of many Russian voices. He seemed to speak with the tips of his lips. In whatever language he uses—French, English, German—a strong indestructible Russian accent colors and modifies the sound of each word. He sat down with a sigh. Vava poured the tea. Often during our conversation I noticed the sighs that seemed momentarily to ease some inner pain.

He laughed often; he laughed as though he enjoyed laughter. He seemed to find it, as in the sigh, a physical release. He has an acute sense of humor, a curious ability to extract fun out of the incongruities of life, like a protective device quickly interposed in order to avoid the underlying sadness. Perhaps, like Figaro, he makes "haste to laugh…for fear of being obliged to weep."

As I watched, the rich texture, the variety, the complexi-ty of this man's nature became apparent. He is intensely alert, curious about people and places. Curiosity, the desire to find out, is a sign of interest in life, and interest in life is a sign of youth. He punctuated and interrupted the conversation with direct, down-to-earth questions. Having asked, he awaited the reply with a preformed expression, as though in advance he knew the answer.

The most mobile, revealing lines on his face are the wrinkles on his brow. A high forehead is plowed by five or six sinuous furrows that undulate simultaneously. His emotions may be measured by the intensity and the direction of these exterior ripples. Surprise, interest, suffering, joy, all have their stylized counterparts in the movements of his brow.

With his ability to ask, he has the parallel gift of listening. Few people listen; an artist must. As Chagall listened, his face took on a sad, medita-tive expression or suddenly, as if kindled by a spark, his eyes lit up, his mouth opened slightly, as though to facilitate the penetration of meaning. His eyelids opened wide, his eyebrows pushed up, as if to clear the path of sight. At those moments his face was the face of a believing child to whom some miraculous fairy tale was being told. This ability to believe the unbelievable, to see the magical, the wonderful, and the unseen, is a gift shared only by the poet, the artist, and the child. Chagall, now seventy-one, has preciously pro-tected and sheltered the spontaneity of his perception. When the child that is within all of us grows up, then we look, think, and are our real age.

"When people tell me how young I look," Chagall said, "I say, 'Yes, yes, I am stupid.' One must be a little bit stupid and then a little bit smart to retain his original purity."

After tea we went into his studio, a long white room. In front of his own handiwork, a new Chagall appeared, a much graver, sterner man. A craftsman surrounded with the tools of his trade, he went about his work in a more matter-of-fact way.

Most artists are quiet in the act of creation. They become absorbed; they withdraw from their environment. Chagall sat down at a large drawing table by the single large, low window. From the incredible clutter of pencils, pens, brushes, paints, he selected a brush and meditatively started to draw. Drawing is the most direct expression of a painter's thought. The black line that slowly unwound on the white sheet of paper was a sinuous arabesque, an undulating expression of a sensuous and supple mind. The curve, the curl, the wound-up spring are images of pent-up vitality, of potential growth.

Slowly under my eyes the curve became a woman's body, the outline of the image that is always first in Chagall's mind. As in music, the line that he had drawn was his main theme. Around it he could play melodic variations. His face suddenly close to the paper, he added tiny dots, black galaxies on the milk-white paper. He would squint, draw back his head, add a minute mark, squint again, and with a subtle, barely percep-tible flourish contribute a final dot—half smiling, as though amused by his own subtlety.

Of some painted tiles in the studio he said, "What noble materials for the artist to create with: earth and fire. To be worthy of them one must be pure, simple." There is a yearn-ing in Chagall for deeper values, away from the pleasing. He finds that taste is playing a much too important role in art. "Too often art equals taste. Cheese has taste," he added. He spoke of painters whose refined and subdued color harmonies are in good taste, adding contemptuously, "A woman dressed in the colors of their paintings would look smart."

Above all, he admires the great colorists. Monet: "I adore him, he is the greatest." Bonnard: "Now here was a great painter, and *du sérieux*." He passed short judgments on his contemporaries. Braque: "Great painter, very French." Mondrian: "Good taste, charming." Klee: "I adore him." Modigliani, Soutine: "Great painters." Matisse: "He doesn't give a damn for anything or anybody. He is so sure of

himself." Giacometti: "He feels the profound forces of nature. He counts."

Two large canvases stood on easels along the greater length of the main studio. The paintings loomed even larger under the low ceiling; enormous, fantastic scenes swirled kaleidoscopically in oceans of solid color, yellow and blue; floating, dancing figures ignored the laws of gravity.

The bouquets of flowers in his paintings resemble gay fireworks in the star-studded sky; the little upside-down huts reel away from our vision as we are projected into space away from the earth. Man and animal inhabit this eerie landscape. But man looks like man only when he loves. Chagall's lovers lie in tender embrace, wrapped in a deep ultramarine shadow, while a fish with a man's hand screechingly fiddles. The violin, the instrument that most easily touches our emotions and nerves, is usually present; this is a man-made sound, pathetic against the "music of the spheres."

Chagall, practically alone among artists, has painted love. He said, "Love is all; it is the beginning." He has tried to represent love as the original creative impulse, and the great consolation of existence. He translates into visual terms the yearning of lovers.

Artists have generally been satisfied in presenting woman as the object of man's desire in a realistic analysis of her naked form. The nude in painting is treated no differently from any other existing thing and, like a tree or an apple, is studied and transformed by aesthetic laws of form, color, composition. Chagall's figures of women are symbols of purity and love, unadorned by the trickeries of costumed sex appeal. His conception of woman has nothing of the naughtiness of such eighteenth-century French painters as Boucher or Fragonard, nor of the perverse sentimentality of Greuze, nor of the matter-of-fact realism of Courbet and Manet, nor of Renoir's glorification of flesh in texture and form, nor of the linear distortion of Matisse and Modigliani.

His concept of life, art, and love is sentimental. He appeals directly to emotion, bypassing reason, but by his humility, conscientiousness, and knowledge of his craft, Chagall bestows pictorial nobility to the banal. The vision of the artist has always raised and transformed the commonplace. The chair of Van Gogh, the apples of Cézanne, the teapot of Braque are the familiars of our everyday reality. Chagall, in re-emphasizing the existence of love, tenderness, sorrow, and joy, denies the trend away from the spiritual in modern art.

The lovers in Chagall paintings, closely, magnetically, protectively tied to each other, create a new entity and live oblivious to the surrounding hostile tumult of the outside world. This privacy demands its own landscape, and in his paintings bouquets are the couches and bowers for his lovers.

"Love is the strongest possible illumination," Chagall said.

"Love is poetry, too.... We are love, we are made of love. How can we live otherwise? That is why I now speak of color-love and no longer color-light. Color-love without

theories—it does not deceive."

In his simple, direct way he knows wherein lies his delight and through himself knows what pleases humanity in general. The arabesques of his drawing, the gay colors, the flowers, the angels, the funny animals, the fiddlers, the sky, the stars, and the moon are the elements with which he seeks to touch us. They evoke attractive, gay, poetic, happy associations. We are disarmed, and we open to the inner power of his art. In front of a Chagall painting we can participate, we can experience.

In his youth Chagall retouched photographs; his figures, floating through space, illogically juxtaposed, may stem from the double influence of photomontage and poetic fantasy. Perhaps more clearly revealed are the lasting influences of the time he spent as an assistant to a sign painter. Signs are paintings on a mural scale. Signs are also signals. Their purpose is to arrest, stop, interest, direct, and inform. The visual representation of an object always gives a quicker image than the word. A boot hanging outside a shop affords quicker communication than the word "Bootmaker." We grasp the meaning of a Chagall painting faster than we would a poem. For a man represented upside down is immediately recognizable, but we have difficulty understanding MAN.

Whatever image he uses, Chagall coats it with the splendor of color. His paintings have the lavish richness of icons, the Oriental gift of illumination; nothing is too precious to adorn the object of devotion. As one watches him paint, one realizes that his technique is a slow process of enrichment. The thin layers of paint rubbed, scratched, smoothed onto the canvas with brush, rag, hand, or knife interplay and create an iridescence that only a sensual delight in the act of painting can achieve. For Chagall, *matière* is important. His symbols if carelessly painted would lose their reality, they would stand for generalities; the mark of the artist would be absent.

Chagall said, "Color is all. When color is right, form is right. Color is everything, color is vibration like music; everything is vibration."

His palette of pale yellow wood is one of the richest, gayest, juiciest palettes of any painter. All the colors, the rarest hues, are squeezed out in lavish mounds; one feels the pleasure of squeezing paint.

Like a human being, a Chagall painting reveals its rich complexity only if one has lived with it and in it, in somewhat the way the artist has during its creation. One must look at his paintings closely to experience their full power. After the impact of the overall effect, there is the joy of the close-up discovery. In this intimate scrutiny, the slightest variation takes on immense importance. We cannot concentrate for a long time; our senses tire quickly and we need, after moments of intense stimulation, periods of rest. Chagall understands this visual secret better than most painters; he draws our interest into a corner where minute details hold it, and when we tire of that, we rest, floating on a calm space of color, until the eye lands on a new small island of quivering life.

This ability to concentrate on a small area is particular to Chagall. The minute scratching of the needle on the copper when he etches, the deposits of ink from the thinnest nib

when he draws, the slight variations of brushstrokes when he paints, are all one pattern. In anything that Chagall creates, the smallest touch, mark, stroke, scratch have meaning.

We left the studio to go back to the house. It is like a Chagall museum. In every room, on every wall, hang rare early Chagalls, miraculously saved from Russia, direct contacts with his youth and the sources of his art. If memory fades, if intensity weakens, he has only to look at his early canvases to be recharged with his own emotional energy.

The most cosmopolitan of all painters, Chagall left Russia in 1910 for France, later went to Germany, back to Russia, back to Germany, back to France, from France to America, and back to France. He is the expatriate who has had to carry his inspiration with him.

Throughout his life Chagall's art has changed little. His subject matter has remained, with very slight variations, the same; his manner of applying paint, of drawing, of etching, his way of expressing himself have been strikingly consistent. There seems to be only one way for him to paint.

"Color is in the blood. I think of the blood as the chemical package that nature through your parents has given you. I do not see blood as purely physical.

"Color is a problem that is practically fated, inescapable, it is unsolvable. It has more to do with the birth of a person, with the atmosphere around him, than with culture and environment. There is something psychic in the problem of color.

"An artist has a born-color that is in him, in the chemistry of his blood. In certain cases, at certain times, sociological environment, if it resembles the atmospheric environment, may influence a man's born-color, give it a certain illumination. Some of the dramas, the tragedies, the joys in one's home add their little hue to one's born-color. And so on throughout life, changes of residence, of age light up differently the born-color, the way a stage set is lit. But the fundamental does not change.

Later Chagall said to me, "Poetry is your life, the state of your soul. We won't speak of those who have no poetry in them. God gives you poetry, your parents give it to you, but it is not something final. It must be developed. Poetry at first is like a diamond that you have in your pocket, that you found covered with dirt somewhere. You must make it shine. It is dirty and has to be washed, as every child when he is born. This diamond, this poetry that I speak of can be chemical, or plastic, or musical if you were Mozart, or poetic if you were Verlaine or Shakespeare."

The vast spaces of Russia had not been enlightened by culture when Chagall was born in 1889. Vitebsk was a small provincial town where the animal world was never far remved or separated from peasant life.

Even the élite in Russia at that time, the writers, the musicians, the painters who had been exposed to Western civilization, were still a part of a culture not far above the level of the Middle Ages. If Wagner, Cézanne, Proust had lived several centuries earlier, imagine what their art would have been. Something of the contact with Russian art with the primitive forces of nature was felt when Stravinsky's "Sacré du Printemps" rocked civilized Paris.

Chagall has kept the primitive vision of his childhood throughout his life. He was immersed at the crucial, formative age in the intensely naïve and haunting visual world of his Russian-Jewish origin. A sensitive child's mind and imagination were developed and shaped for life by the pictorial drama of religious ritual, the ageless beauty of ceremony, the revelations of the Bible, and the ever-present Russian sense of the fantastic and magical.

Naïve art, folk art, children's art are all expressions of our desire for the supernatural. There is a need in us for make-believe, for illusion. Theater is make-believe; art is make-believe. A sense of the theatrical, of the magic of the theater is one of the principal elements of art. Chagall has designed many theater and ballet sets. His costumes and décor for *Aleko*, for *The Firebird* were his paintings transposed into a three-dimensional world, and his paintings are stages for the play of his imagination.

After my visit to Vence, I met Chagall again at his daughter's house in Paris. He told me that he was still working on his monumental task of illustrating the Bible, which in 1923 Vollard had asked him to do.

One of the major creative efforts of our time, this illustrated Bible, when finally published in 1956, placed Chagall among the greatest etchers. He has etched more than three hundred plates. By a miracle, a conscientious craftsman hid the Bible plates during the German occupation. Chagall, at sixty-nine, finished the work he had started over thirty years ago. For over thirty years he lived constantly with the Bible. He was like a tree, his roots underground in this then unseen, unpublished work; the leaves, the fruit, the branches were the color-drenched canvases that the world knew as Chagall.

These unseen roots of the creative man explain so much in Chagall's art. Until the publication of his Bible it was as though the world saw a play in which the actors spoke but their voices could not be heard. The meaning of Chagall is in the Bible. And again his history proves there is no great art without faith.

Because of his background, Chagall could feel emotionally and physically a part of the Bible. His Moses is not the elderly Italian noble of Michelangelo or the athletic Greek statue by Blake, but a familiar to Chagall, a patriarch of the Jews. It is a curious plan of fate that, after all his wanderings, Chagall should have settled in Vence. For the landscapes that he saw in his mind as a child, through readings of the Bible, are the landscapes of the Mediterranean land where he now lives. Chagall in his essence belongs to this Mediterranean, the sea of our culture, the sea of the Bible. He has been to Israel, he has been to Italy, to Greece, bringing back from each voyage precise drawings, notations that confirm and revivify the visions of his memory.

That day in Paris, when we left Ida's house, we drove through the streets on our way to the engraver's. Chagall kept exclaiming, "Look at the light. Look at the light of Paris; a stone from Connecticut would be beautiful to paint in the light of Paris.

"Countries have their own colors, which are pre-

ordained. There are countries where there is an absence of color; others have just a trace of color; in others still, the color is completely photographic. No one knows why. It is an unsolved problem."

The engraver's atelier was a small two-storied building in a narrow street, far from the vibrations of traffic. Inside, the walls were covered with the prized works that had been produced there. Next to etchings by Léger, Segonzac, and Chagall hung second-rate works. It seems as though without second-rate art there would be no great art; the abundance of art in Paris, regardless of quality, is a fertilizer to art in general.

Only in Paris can one still find a few craftsmen with manual ability equal to that of the artist. One of the reasons why Paris has attracted artists is because at some moment in the execution of their works of art they need that skilled manual help. Painters, sculptors, etchers, designers can still find assistance among that élite of the working classes, the master craftsmen.

We went upstairs to a little room where a window opened onto a sunny garden. On a small table, white gauze stretched on a frame screened the distracting view and equalized the light. Chagall took off his vest. In a workman's shirt, he attacked the dull copper plate lying flat on the table. He picked up a proof and pointed out, using musical terms, "There must be the same black accents everywhere; 're-echoes,' that's the word.

"Black and white is a color. If you do not see color in a black and white picture, it is dead. In Rembrandt, Goya, and Daumier you can see the color in black and white, less so in the others. Matisse has a beautiful black and white because he was a colorist."

To be able to see the barely visible scratches, he put on thin-rimmed glasses, quickly hiding them with the vanity of a man refusing to submit to the image of age. Again, as in his studio in Vence, the subtlest nuances acquired meaning. The eye and the mind must learn to concentrate fixedly on minute detail, while constantly retaining the grand overall conception. This mental gymnastic is part of the infinite difficulty of art, the system of checks and balances where the tedium of execution slows down the impetuous flight of creation.

In the presence of his *chef-d'oeuvre*, the real Chagall emerged, a great and profound religious painter, in the tradition of Rembrandt. When Chagall finished his morning's work, his last fervent plea, his passionate cue to the engraver, gave the key to his conception: "It must sing, it must cry; it is the Bible."

Chagall's great gift is literally the power of imagination, the ability to summon and exteriorize on canvas, or other mediums, the substance of dreams, the intangible mirages of the mind. The visions of this one man's night, exposed but undissolved by the light of day, are poised as though ready to lodge themselves and live in the dreams of those who set eyes upon them. And see them we must, for the artist knows the human hunger for color, and the intense jarring colors in a Chagall painting are illuminated signs that arrest our attention. Like a psychologist con-

ducting visual tests, he knows the power of surprise; our senses routinely scanning an expected image are suddenly awakened by the unexpected.

He also knows the power of curiosity, the pleasure of investigating for oneself, and the self-confirming, egotistical urge to correct mistakes. The green woman with blue hair is an apparent, flagrant error in representing reality, but it is also a visual trap set for us by the wily artist. For while the mind is busily analyzing, transposing, correcting, our interest is held on the canvas, and all the while we are experiencing, we are involved.

Chagall's paintings obey only the laws of his own emotion. Chagall explained, "The presence of real objects is a nightmare for me. I have always overturned objects. A chair or table turned upside down gives me peace and satisfaction. A man or figure overturned gives me pleasure....

"I had the need not to destroy but to shift things. So I cut off heads, for example, and put them in impossible places. I upset in order to find, at all cost, another reality."

But the structure of Chagall's mind is against all constraint. As opposed to the logical, he establishes the equal rights of the illogical. The ordinary man's reason, presented with the illogical, protectively dismisses it as unimportant; only logic seems a solid base on which to build. Logical reasoning is a step-by-step process; it is a continuity of thought. On the other hand, the illogical is a discontinuity, a break, a jump, as though the cogs of thinking have skipped a notch. That gap, that opening in the solid wall of reason that protects and at the same time imprisons us, is the hatch of escape into another world.

The flight from the solid, reasonable ground of reality, the belief that there is something beyond the known, is creative intuition. The poet, the artist make us leave the ground, and only if we put our faith in them will we experience their vision. We must sometimes act contrary to reason. The great explorers were poets who were sustained by their belief in the existence of the unseen. They had faith, and we, in the presence of art that shocks our reason, must have faith. We must have faith in the sincerity of the artist, and in order to experience fully we must let ourselves go, not resist and puncture the images of a poetic world with the pinpricks of doubt. The miracle of art is to destroy doubt.

Part of the secret power of Chagall's art is in the artist's struggle against all the forces that shackle the flight of inspiration and pull man downward. The soaring, floating, running, jumping images in his paintings are symbols of liberation.

The profound lyricism of Chagall's art is in his dynamic conception; for him the image of motion is an image of life. And in motion there is the atavistic, childish desire to re-experience pleasure. Chagall tends toward a goal which is no longer the static ideal of form and beauty that for centuries has been the principal object of art. His purpose is to express the longing for the ideal in life. Since man is an idealist, he strives to surpass, to transcend himself. He needs in his striving love, faith, religion. In the visionary art of Chagall lies the tangible proof of one man's struggle with this longing. The

artist taps the deepest memory of humanity, where there linger, left from the whole long life of mankind, the forgotten and consciously unknown blissful images. When an artist tries to bring to the surface these memories, one can judge the man and the artist by the grandeur of his attempt. Without art, without artistic creation man would have no material trace of his idealism. An artist is a man who can express this so that all men in their hearts, souls, and minds feel, know, and see that sublime instant of creation when

"God saw everything that he had made, and, behold, it was very good."

Notes on the Illustrations

Marc Chagall, 1887–1985. Born: Russia.
Photographs taken in 1952, 1954, 1957, and 1958.

1. Chagall, in Paris, with an early portrait of his father—Papatchka, or "Little Father."
2. Chagall, I and the Village, *1911. Oil on canvas, 6' 3⅝" X 59' 5⅝" (192.1 cm X 151.4 cm). Collection, The Museum of Modern Art, New York. Mrs. Simon Guggenheim Fund.*
3. Chagall in his Vence studio. The illusion created by the enormous canvases transformed the studio into an unreal, poetic world, lit by overpowering color. The figures seemed to leave the canvases momentarily and to float, soar, and dance around the artist as he stood enveloped in the visions he had evoked. On the easel, Le Cirque Bleu *("The Blue Circus"), 1950–52.*
4. The Seine in front of Chagall's Paris apartment on the Quai de Bourbon.
5. In the Vence bedroom, a Russian icon, a Bonnard drawing, and one of Chagall's own early cubist gouaches.
6. A stone carving in the garden of the Vence villa.
7. Chagall's hands at rest.
8. In Paris, in front of Cantique, *1957, from his late Paris period.*
9. At work on his Bible illustrations: Chagall examining a plate.
10. One of Chagall's stone carvings.
11. Chagall in a happy mood with one of his magical early paintings.
12. The clutter of the studio desk, Vence.
13. The exterior of the Vence villa, Les Collines.
14. A studio shelf with ceramics painted by Chagall.
15. A severe craftsman checking proofs of the illustrations for his Bible.
16. Chagall laughing, at tea in his Vence garden with his wife, Vava.

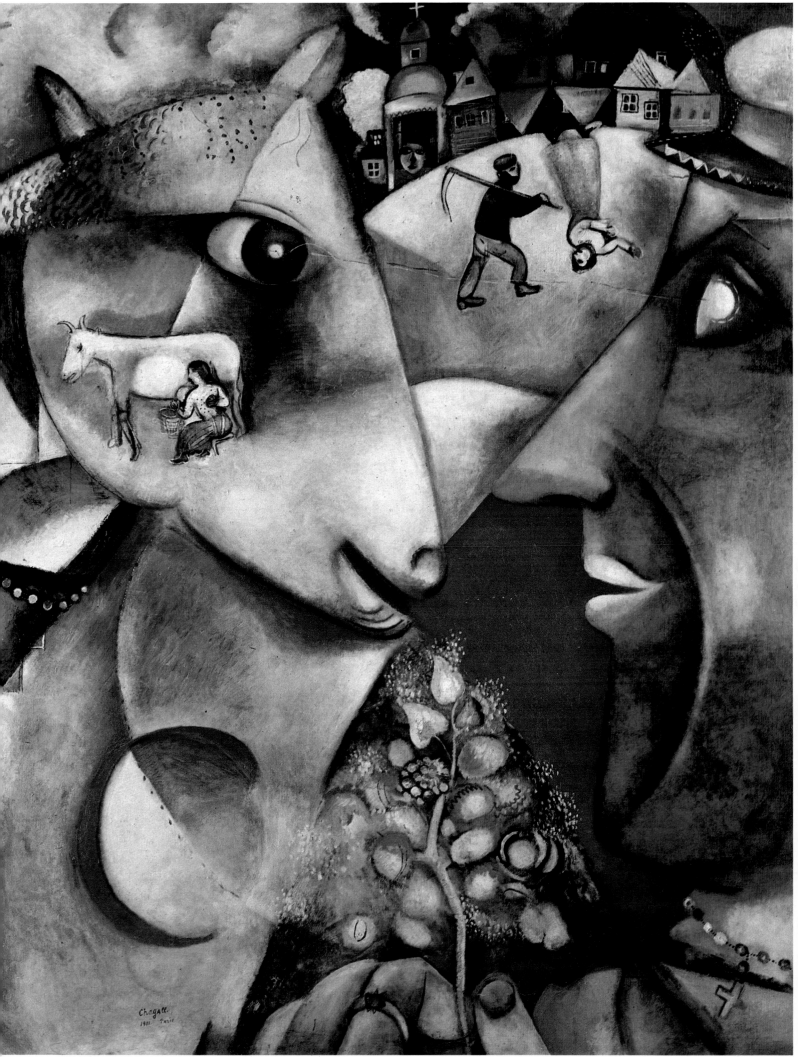

Chagall 3

Chagall 4

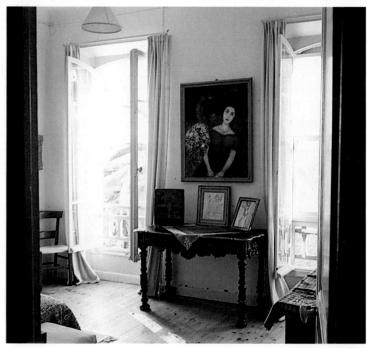

Chagall 5

Chagall 6

Chagall 7

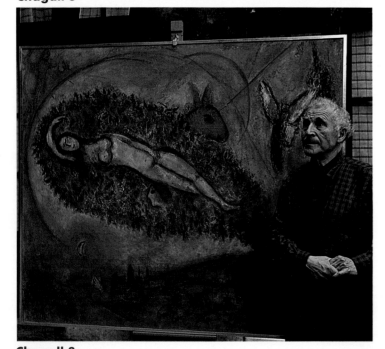

Chagall 8

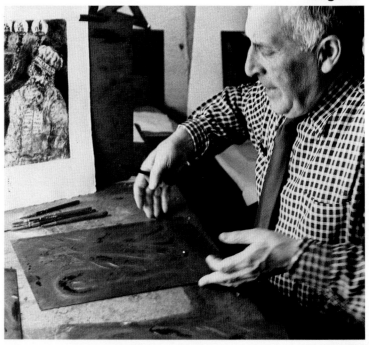

Chagall 9

Chagall 10

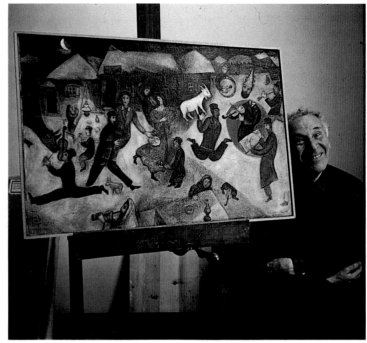

Chagall 11

Chagall 12

Chagall 13

Chagall 14

Chagall 15

Kandinsky

2

assily Kandinsky is the first man who with paint and brush painted a non-representational work of art. Until that day in 1910 painting had to represent something; the artist communicated through recognizable and usually realistic subject matter. The grandeur of Kandinsky and the other pioneers of abstract art lies not in a new way of painting but in a new meaning given to the significance of a work of art. Traditional art can be understood; at a glance one knows what the artist represents. This, truthfully, has always been but the superficial aspect of art; behind the great realistic masterpieces there always hides a higher meaning that raises the portrayal of reality into the realm of universal beauty and truth. This raising, this transposing of reality is, of course, a process of abstraction. Abstraction in art is not new; only the bad art never rose above itself and thus never achieved the dignity of a higher realm.

The revolution of Kandinsky's art is making abstraction itself the subject of the painting. In Kandinsky's memoirs he described the actual moment of the accidental discovery of non-representational or abstract art, when he was forty-four years old. Coming home at sunset from a session out of doors in 1910, his mind still absorbed by his work, he was struck as he entered his studio by an "indescribably beautiful painting, all irradiated by an interior light." In the mysterious canvas he could distinguish only "forms and colors and no meaning." Suddenly he realized that it was one of his own paintings, turned on its side. "The next day in daylight I tried to recapture my previous impression. I only succeeded halfway. Even with the painting on its side, I could always find the object, but the blue light of dusk was missing. I knew then precisely that objects were harming my painting." He wrote that he felt "a terrifying abyss opening under my feet."

The thinking man of those days was torn between the unfathomable depths of his own inner world, as revealed by Freud, and the infinity of the universe of Einstein around him. It was as if the skin were the frontier of two universes receding from each other into boundless depths.

Man has known for centuries how his world of human

beings, animals, trees, mountains, seas, rivers, and flowers has appeared to him. Suddenly one man, Kandinsky, stood up and, instead of facing outward from himself, turned and looked into himself.

Monet and the impressionists had disembodied reality by painting only its appearance as transformed through light and color. Van Gogh, the postimpressionists, Matisse and the other *fauves*, with the emotional unreality of their color transpositions had gone further in imposing over nature the artist's inner vision. Cézanne's attack on form, his rhythmic deformation of the human body, and the structural revelations of his still lifes and landscapes led directly to cubism. Picasso and Braque followed Cézanne's teachings, and their many-faceted crystalline explosions finally destroyed the myth of the sanctity of the object in art.

Each generation of painters had gone a step further than its predecessor. Once the object used as the subject of a painting was tampered with, distorted for purely pictorial reasons, it was inevitable that one day someone would throw the switch all the way over and make pictorial necessity "become the purpose of art." "The true subject of a picture is painting," said Kandinsky. His eye and mind were ready for the "accident" that was to start the abstract, non-objective, non-representational revolution that has dominated the art of our day.

Kandinsky, a Russian aristocrat with perhaps Mongol ancestors, deeply imbued with religious and cultural traditions, arrived, around 1900, in an ultra-civilized Germany where metaphysical and scientific searchings were flowering. There a combination of Russian mysticism and Western aesthetics prepared him for the great discovery of non-objective art.

Wassily Kandinsky was born in Moscow on December 5, 1866. His parents came from Siberia, that part of Russia that is in close contact with the Orient. Kandinsky studied law and political economy, and at twenty-three he went on ethnological expeditions within Russia. He ended his scientific career at thirty-four when he decided to study painting in Germany. Kandinsky is a rare case of a great painter who came to art as a formed man, without having spent his youth in the study of art.

In 1914 at the outbreak of the war he returned to Russia, there to teach at the Moscow Academy of Fine Arts. After the Russian Revolution he went back to Germany, and in 1922 he joined the Bauhaus in Weimar, that creative school whose principal purpose was to find through art and technique the answer to the aesthetic demands of the modern world. For ten years he was a vital part of that extraordinary fertile international group of painters and architects: Lyonel Feininger, American; Paul Klee, Swiss; Kandinsky, Russian; Moholy-Nagy, Hungarian; Walter Gropius, German. In 1932 Hitler closed the second, or Dessau, Bauhaus, and life for a free creative man became impossible in Germany. In 1933 Kandinsky went off to Paris to live there until his death on December 13, 1944 at the age of seventy-eight.

Throughout his life in Paris, Kandinsky and his wife,

Nina, lived in an extremely modern apartment on the banks of the Seine in Neuilly. Madame Kandinsky, a frail, serious, attractive woman, still lives there.

There is no real studio in this apartment. The largest room, formerly a living room, was made into his workroom. Its walls are a medium gray. On a large desk-table next to the window there still is a typewriter, a crucifix, a rose, and neatly aligned pencils, knives, and pens. Several icons hang on one wall; Russian mysticism prevailing alongside a stark orderliness. There are several Russian peasant sculptures next to a Tanagra figurine. In front of the desk are a gramophone and Kandinsky's armchair, covered with a sheet. No one had sat in it since his death.

Order, cleanliness, and method pervaded this room where Kandinsky worked during his ten years in Paris. Bottles, glasses, jars of colored powder are meticulously stacked and classified on shelves. Kandinsky mixed his own colors with a chemist's tools and a chemist's precision. Opaque white jars are lined up on their particular shelf, transparent jars on another shelf, next to glass retorts, white china crucibles, pharmaceutical flasks. Immaculate brushes are next to neatly stacked cartons of paints and columns of empty cigar and cigarette boxes which he used as miniature filing cabinets. On top of a bureau stands a glass vase filled with odd pieces of string, collected throughout the years.

Two large strikingly different canvases stood, the day I was there, on traditional brown wood easels. One was a 1906 pre-abstract landscape, the brilliant irregular areas of pure color clanging, as if through pure physical contact on the canvas a sound could be heard. Next to this image of passion was a serene geometric composition, *Two Green Dots*, painted in his studio. Here the artist created beauty not through passion, as in his earlier canvas, but through serene contemplation. The melodic unfolding of the composition makes the eye travel across the surface of the painting. In front of this Kandinsky painting the eye seems to listen. Kandinsky constantly surprises, caresses, charms, intrigues, purifies the experience of the eye. In each small area of the large canvas there is enough inventiveness to be the subject of the whole painting.

A door separated Kandinsky's work from everyday life. The entrance hall and the kitchen door were near his easel. He would have heard any ringing of the bell, any movement of a servant. But these intrusions did not seem to disturb him. Kandinsky knew exactly what he wanted to do with a painting; he visualized it before the very first sketch and rarely departed from his first inspiration. It was this security, this absolute control over his vision, which permitted Kandinsky to create among disturbing realities. A great self-confidence buttressed the security and the precision of Kandinsky's work.

Nina Kandinsky has a prodigious memory and an intense consciousness of her husband's greatness; they were married in 1916 and until his death they were never separated. She shared with him his constantly uprooted life and knows firsthand the intimate history of the birth of modern art.

"Kandinsky used to say," she said with a smile, "if it were up to the painters' wives to erect monuments, there wouldn't be any space left to move." Through her admiring description, the image of Kandinsky the man and the great artist emerged. This was a unique unreeling of recollections and an intimate glimpse into the small details that make up the climate in which an artist's creative life develops.

"An aristocrat, an extremely sensitive man, always considerate of others and generous, Kandinsky could not stand anything Bohemian. For him Bohemia and all it stood for was just bad taste. He hated dirt, saying, 'I could paint in my white tie and tails.'

"He knew how to enjoy things, the way children and the pure in heart do. He could laugh until he cried. He always seemed the youngest in any group. He radiated optimism and great wisdom, but above all he knew how to communicate his strength to others. He saw the positive in everything.

"His daily timetable was leisurely. He would get up at nine, take a bath, then breakfast. This was the sacred moment of the day. From eleven A.M. to twelve-thirty P.M., work in the studio, then a walk along the Seine. He needed the constant presence of nature.

"He, the abstract painter, would say, 'Now I can love nature even more. I do not see it any longer as a model; I admire it and just enjoy it.'

"Lunch was at one o'clock; if tired by the morning's work, he read detective novels. After lunch, rest; then a Russian tea and more work in the studio until dusk. He liked to have friends for dinner, but hated unexpected guests. After dinner he would draw and read; Dickens especially calmed him.

"Sometimes he listened to the radio or played his records. Music was always his principal relaxation, especially symphonic compositions. As a youth he had studied music; he could play the piano and the cello. His favorite composers were Beethoven, Bach, Moussorgsky, Stravinsky, Prokofiev.

"When he went out he liked only the good restaurants.

"His years at the Bauhaus were happy ones. There his friendship with that other great master of modern art, Paul Klee, developed; Klee an introvert, Kandinsky an extrovert. When the press attacked the Bauhaus and Kandinsky's art, Klee came and looked at the abstract *Composition VIII* and said, 'It is a thing of genius.' Kandinsky knew that an artist should find a lesson in the public's lack of understanding. 'I am very happy that abstract art is not recognized; it is a sign of strength.'

"Deep in himself Kandinsky, who spent the major part of his life outside Russia, felt always Russian. He was stamped for life by his childhood memories of ancient Moscow with its walled Kremlin, hundreds of Byzantine churches, and the exuberant unbridled fantasy of its Oriental Slav architecture. The roots of his art are in the Russian icons, the religious images of the orthodox faith. He was religious, but he seldom went to church. 'Strange that there are people who do not believe!' he would say."

In his youth in Russia, he saw a Monet painting of a haystack. "I had the impression that here painting was, in a certain way, the subject of the painting and I asked myself if one could not go much further in the same direction. After that I looked at Russian icons with new eyes, that is to say, that I had eyes for what was abstract in art."

In his prophetic book *The Art of Spiritual Harmony*, in 1912, he wrote, "The salvation of art and of man is a spiritual one. One does not have to paint Madonnas to be a religious painter." When in 1911 the "Blue Rider" group, which included Kandinsky, Macke, and Marc, was founded in Munich, they believed in a "new Renaissance, an inner one." The only law of the artist is his "inner necessity." Kandinsky proclaimed the "absolute freedom" of the artist. He added, "Such spiritual freedom is as necessary in art as it is in life."

But abstraction, being the mirror of the artist's soul, shows up his inner quality. Abstract art demands higher standards of the artist himself. In a bad realistic picture there is always the consolation of reproduced reality; in a bad abstraction there is either the frustration of a purely decorative experience, if painted by an artist who has nothing to express, or the shocking evidence, unhidden by traces of pleasing reality, of a lack of spiritual value.

Abstract art has been, and is, misunderstood. It is condemned as a meaningless, destructive attack on all that is sacred and beautiful. The tragedy of this misconception is that abstract art in its highest form is an expression of man's desire to call upon the highest aspirations that he intuitively feels, to rise above subject matter into a higher realm which, like a prayer, will call upon his spiritual energy. Kandinsky's new vision of art was "something that appeals less to the eye and more to the soul."

He believed that music is the supreme art, that every creator, in whatever field, must learn the methods of music to apply them to his own medium. He described music as "the best teacher...the art which has devoted itself not to the reproduction of actual phenomena but to the expression of the artist's soul."

For paintings to achieve the same effect, the lessons of music had to be studied and applied. The laws of harmony, rhythm, composition, transposed into pictorial language, would lead man through painting into the highest forms of art. "Color is the keyboard, the eyes are the harmonies, the soul is the piano with many strings."

For the spectator the way to abstract art is through an emotional reaction. Between the painting and the onlooker a bond of sympathy and attraction has to exist. One must literally fall in love with a painting. This by passing of the intellect is a direct appeal to feeling. Logic, understanding, cannot prove everything, but emotion, by upsetting our contact with reality, can put us into a state where without proof we are willing to believe; intuitively we sense truth.

Abstract art is an attempt at direct communication with the spectator, a search for an instinctive response in the onlooker, unspoiled by preconceived, hard-to-dispose-of associations. To search for meaning in an abstract painting is to try to open a door with a wrong key. Meaning is there, but not a meaning that is translatable into words. Kandinsky said, "When something appears senseless, and people say, 'It does

Kandinsky 3

not mean anything,' this must not be interpreted literally. There isn't a form, there isn't a thing in the world that means nothing." There are in our lives moments of indescribable emotion; words fail us many times; this vision beyond the usually describable is the realm of non-representational art.

Those who protest against the lack of meaning in abstract art would be hard put to describe the soul in words. Our inner life is the realm of that all-powerful spirit that sometimes seems to move within us, making us intensely conscious that our body is but a shell encasing our true self. That spirit, that soul, has its own laws, its own necessities.

How can an artist find out the aesthetic demands of his soul? Only by subjecting each creative motion to the laws of his inner necessity. That necessity is the artist's own inner constant; he is what he is, he feels the way he feels because of that inner control. Too few creators dare to listen to this supreme command.

These simple words of Kandinsky's are his final summation, the lesson of his life and art, rules for the inspired creative artist: "Do not fall into a manner. Change; find by yourself and do not copy, make it your own."

Notes on the Illustrations

Wassily Kandinsky, 1866–1944. Born: Russia.
Photographs taken in 1954.

1. Wassily Kandinsky, Painting No. 201, 1914 (summer). Oil on canvas, 64¼″ X 48¼″ (163 cm X 123.6 cm). Collection, The Museum of Modern Art, New York, Nelson A. Rockefeller Fund.
2. A view of the Seine from Kandinsky's Neuilly studio-living room.
3. A detail of a room in the apartment: Asian sculptures and a Kandinsky work.
4. In Kandinsky's Paris studio, his paintbrushes and Russian wooden toy sculptures, a nostalgic link with his childhood.
5. Kandinsky's Paris studio, as he left it at his death in 1944. Beside his carefully arranged painting cabinet, which he called "my keyboard," stands a large serene composition, Two Green Dots, painted in 1935. The two oils under glass, done in 1911, are among the first abstract paintings. The photograph on the wall is of Kandinsky, taken in 1933.

Kandinsky 4

Kandinsky 5

Larionov and Gontcharova

I n Moscow in 1911, the name *rayonnism* was invented by Michael Larionov to describe his and his wife's near-abstract pictures, composed of raylike lines. These artists settled in Paris in 1914, brought there by Diaghilev, whose ballets had tremendous impact on the cultural life of the French capital. The judgment of posterity has caught up with these pioneers. They are a living lesson of the patience that sometimes the greatest artists need in order to experience recognition.

For about fifty years Nathalie Gontcharova and Michael Larionov have lived in the same apartment and studio. They preserve an extraordinary human relationship, treating each other with the ceremonial tenderness of members of some secret order. Now in their old age, they speak softly and move with difficulty. Larionov's bold sense of humor is counterpoint to the aristocratic calm of his wife.

Notes on the Illustrations

Michael Larionov, 1881–1964.
Nathalie Gontcharova, 1881–1962.
Both born: Russia.
Photographs taken in 1950 and 1952.

1. The inseparable artists in their tiny, cluttered Paris apartment with two of their own historic early works of the rayonnist (1912) period.
2. From their studio window, the unique patterns of old Paris rooftops.
3. The artists' small, two-room apartment next to the Ecole des Beaux-Arts, in the center of the Left Bank. An unbelievable accumulation of books, art documents, paintings, and drawings reaches to the ceiling, crowding and restricting movement.

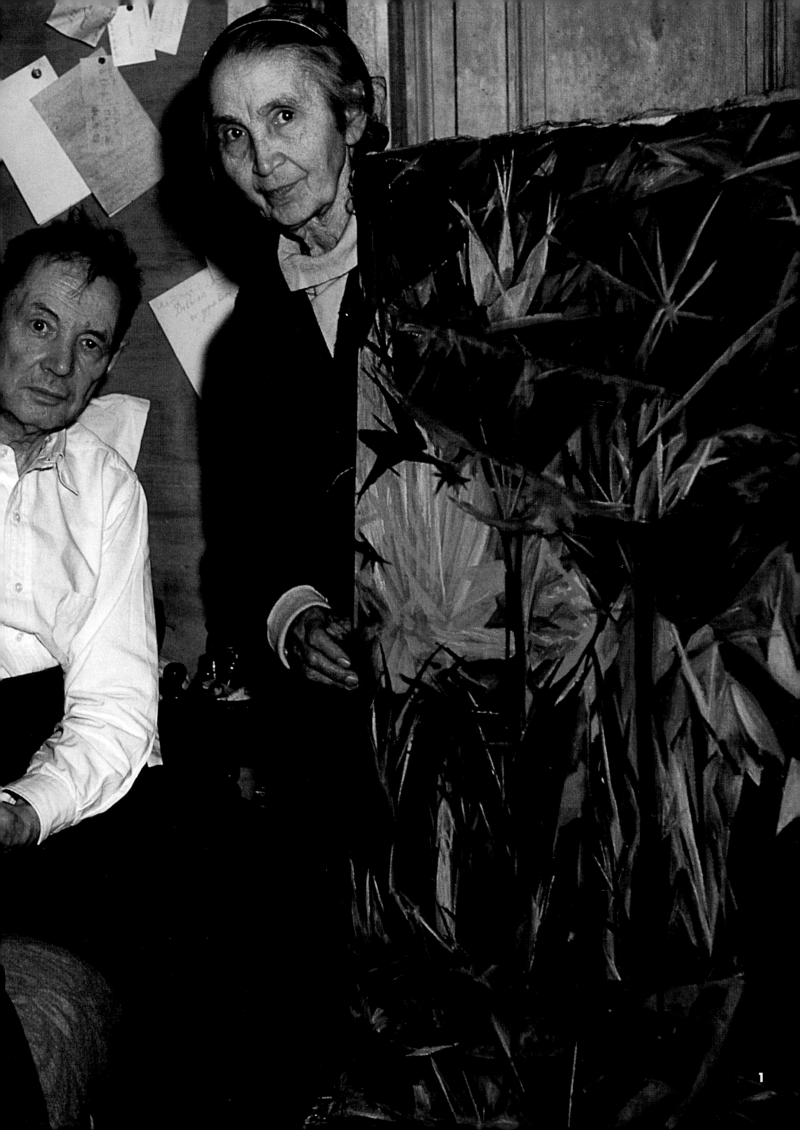

Larionov and Gontcharova 2

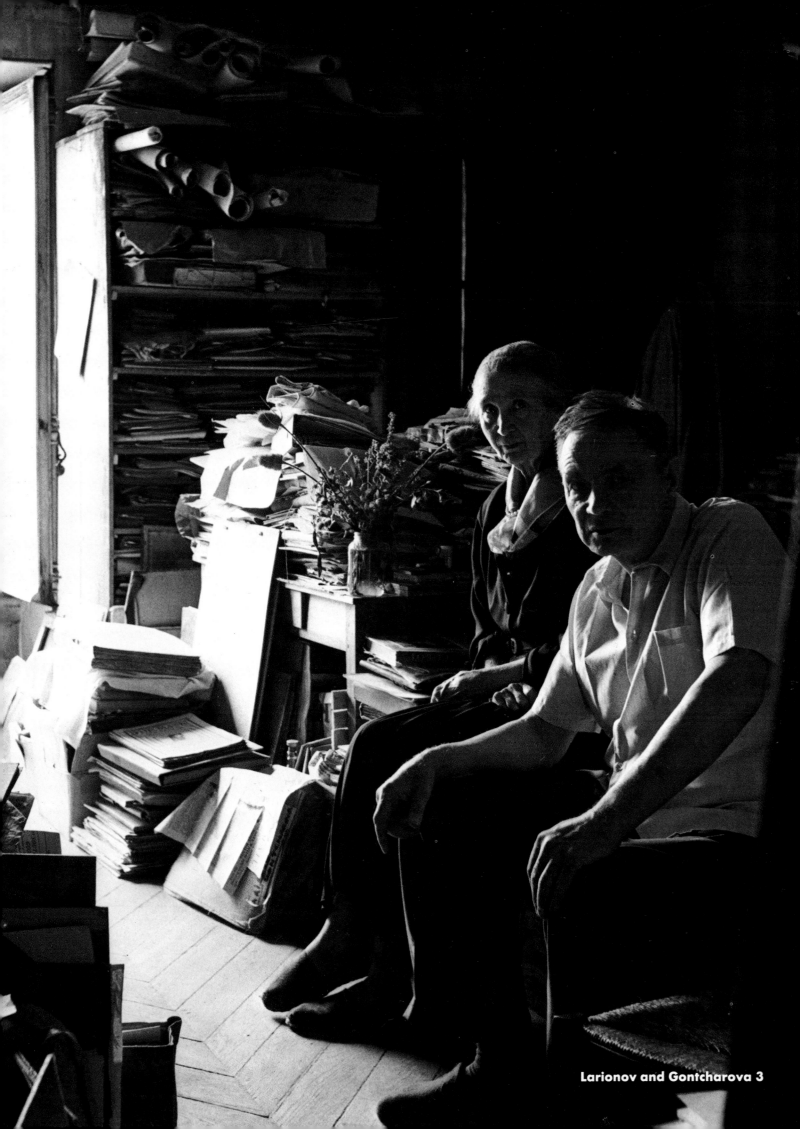

Kupka

"Renaissance. That's macaroni....
"I prefer Rodin to Michelangelo."

A slight, very thin, very wrinkled man with pale blue-gray eyes spoke. His skin, like yellow parchment, shriveled into a multitude of crisscrossed lines over sunken cheeks and protruding cheekbones. His collar hung loosely around his gaunt, birdlike neck. His gnarled hands moved quickly and, when he spoke, his eyes closed and he pursed his lips, sucking in his wasted cheeks. This Czech with the Mongol traits of Middle Europe made one think of a Buddhist priest. Against his pale eyes, his white hair, his pale blue-gray suit, the only contrasting accent was the red rosette of the Legion of Honor.

This iconoclastic, withered old man of eighty-three was Frank Kupka, one of the fathers of abstract art. His wife stood protectively near him, her massive earthy frame a contrast to his frail elongated body. In her dark peasant features traces of beauty remained. She had posed for Renoir.

The dining-room windows of their Puteaux house opened onto a curious artists' community: an overgrown suburban plot surrounded by low buildings, dark and dilapidated like abandoned pavilions, in which lived some of the most creative artistic thinkers of our day: the Duchamp-Villon brothers, and the Kupkas. This was the "Puteaux Group."

The Kupkas lived in the same house for forty-six years. When they first moved in the rent was 800 francs a year; the region was infested with bandits, and meals were safer with revolvers on the table. Madame Kupka recalls that they were so poor that the big nude Kupka exhibited in the Salon on the Champs Elysées she herself carted in a pushcart all the way from Puteaux to the Salon, a distance of about eight kilometers. When Kupka needed canvas for her portrait he had to rip the cover of her mattress. She tried to hide their poverty from her husband. When he had an attack due to alcoholism she saved him from the insane asylum because she knew that there he could not paint. She treated him tenderly like a child, and said with pride and self-pity, "He is my son."

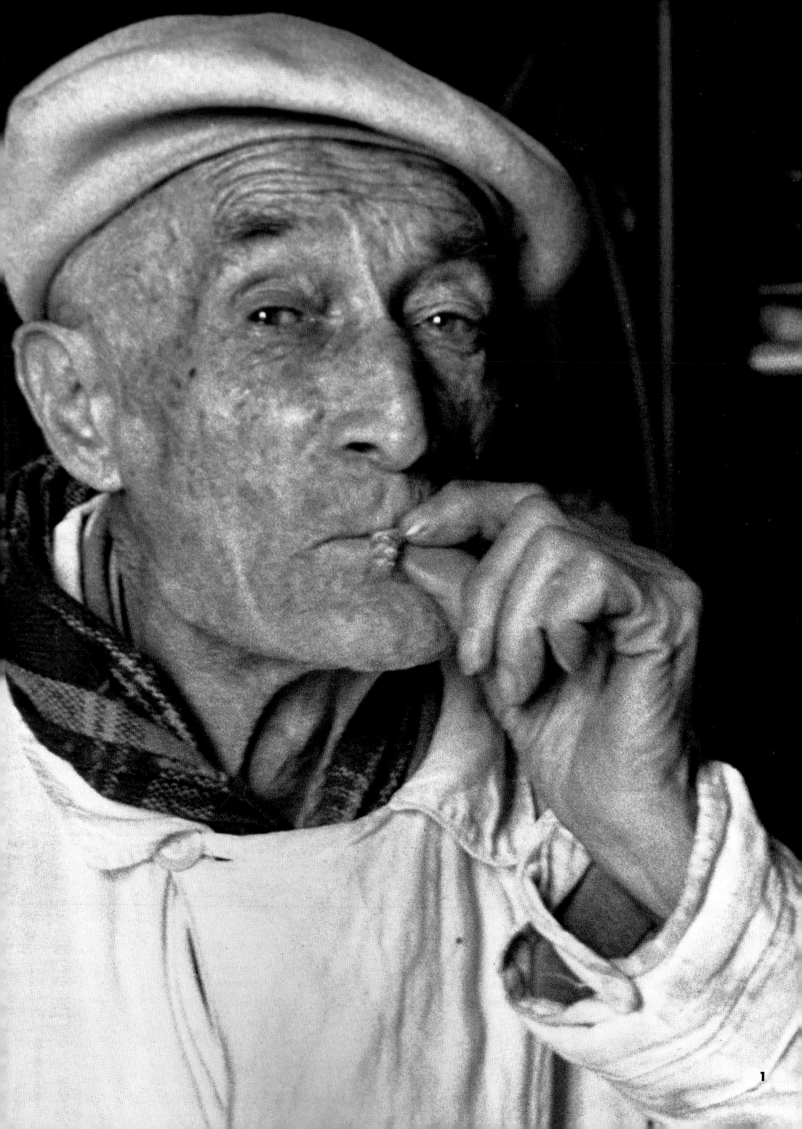

Kupka rose every morning at seven. For breakfast she cooked him pancakes with jam. He loved to eat and to drink and had fish and meat twice a day. Our luncheon, prepared by Madame herself, was typical. We had lobster, vegetable salad, eggs mayonnaise, roast chicken with new potatoes, string beans, salad, cheese, wild strawberries, chocolate mousse, fruit; and with succeeding courses white wine, Pommard, and liqueurs.

After lunch we went upstairs. Here, after the cramped, crowded smallness of the dining room, was a huge studio two stories high — as big as the whole house. As with other painters, everything seemed sacrificed for the one glorious room which was the mainstay of life.

The studio was sad. Its walls were gray. On the floor lay a rug with black and white swirling patterns of Kupka's own design. Some of the furniture was Chinese, and the whole decorative feeling of the room was a gaudy reminder of the *art nouveau* style. In his early work now hanging on the walls this painter had been a severe academic realist. He had evolved slowly away from realistic portraits, preoccupied by the mystery of the prismatic breaking of light. He abandoned impressionistic bathers with *fauve* accents for a new world of geometry and space. Rhythmic variations, themes and fugues, the harmonious movement of form and color became the basis of his art. Although dusty books and papers littered his desk, although many of the studio's furnishings seemed terribly dated, a new canvas in progress on his easel was the work of a young man. It was intense, clean, and vibrant.

Kupka spoke of painting as "the visual pleasure of a thing well organized, constructed in beautiful color.

"Color must be frank. Shading is weakening. Everything must be precision. When one crosses a street all our acts are dictated by precision. It is through our precise movements that we avoid death and accident.

"In the old days no one looked closely at painting; now it is examined very, very closely, so it must be precise. Paint cleanly.

"Mysticism in painting does not lead anywhere. Optical research does not lead anywhere. One does not have to be inspired by forms of nature. One must turn one's back on nature — everything is in the head, the mind."

Kupka was very critical of his own work; he disliked anything he painted and wanted to rework or destroy it. He painted after many, many studies, taking infinite pains, redrawing in pastels the original inspiration before putting it down on canvas.

"Goncourt has said one needs nine years to create a book, and I say one needs six years for a good painting."

About exhibitions, Kupka remarked, "To exhibit, why? So that everyone can copy you?"

His culture and memory were incredible. His favorite reading was astronomy and Plato. All philosophy fascinated him. He knew and he followed everything that happened in the world around him.

He often fell into long, deep silences; suddenly his eyes would fill with tears when some inner thought welled up. He said, "It's terrible for a painter to go blind." At eighty-three, just as the public and the museums were beginning to recognize him, his eyesight began to fail, and in the last years of his life he painted with great difficulty.

Kupka and his wife sacrificed everything in life for their belief in his art. He was a pioneer, misunderstood, unrecognized. He felt bitter that many who had come after him grew famous and wealthy and that he, one of the early innovators, had been bypassed. When visitors came to see his more famous contemporary, Villon, who lives in the house farther down in the garden, they walked by the Kupka house; and these two proud people could see famous art dealers and visiting celebrities stalk by their house, pretending that they did not know them. The art dealers were, as Kupka said, waiting for him to die. He paid the price of having been many years ahead of his time. Neglected, alone, unrecognized, these two old people strove to finish their lives with the one hope that all of their sacrifices might not have been in vain.

The Kupkas were married for over forty years. Theirs was the most striking example of a painter's ménage. The wife lived for her husband. She believed in him and would do anything to help him achieve success. She had the will to save him from any misery, she hid any suffering that might hamper his peace of mind or his creativeness. Today his success and vindication are justifications of her own life.

Kupka lived through his life sheltered and protected as though in a dream, in communion with his philosophers, his ideas, his research; like a composer he had to work logically, slowly, methodically, and he needed this peace, this divorce from the worries of everyday existence. When one saw the Kupkas one realized what it meant to devote one's life to an ideal, to brave solitude, misery, nonrecognition, and to struggle on despite them.

Many have died without ever knowing any recognition at all. Kupka died just before knowing that his name in the history of art and his place in the abstract century are secure. His was a desperate striving for a new horizon, a search to give the world a new visual experience.

Notes on the Illustrations

Frantisek Kupka. 1871–1957. Born: Czechoslovakia. Photographs taken in 1949, 1953, and 1956.

1. Frantisek Kupka.
2. The Kupkas' Puteaux house, where they shared a garden with their neighbor, Jacques Villon. This whole area of Paris was to be demolished and become the site of La Defense, a modern skyscraper complex.
3. The sideboard in the dining room of the Puteaux house. The walls were decorated by Kupka himself.
4. Kupka, a year before his death, standing before one of his great early abstract masterpieces. Dressed in soiled white, he raised his arms in an unspoken, all-embracing gesture, an unforgettable vision.

Kupka 2

Kupka 3

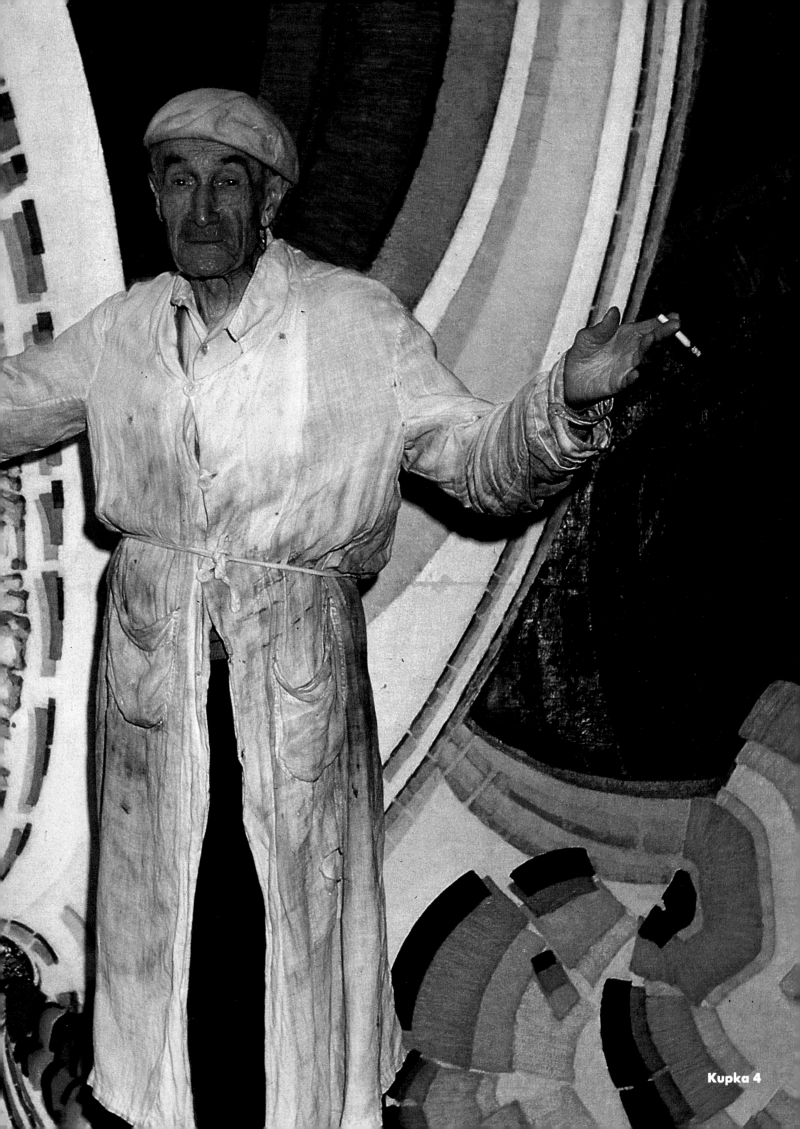

Kupka 4

Delaunay

It is interesting to speculate on the reciprocal influence in the relationship of artists who are married to one another. Sophie Taeuber-Arp and Jean Arp are but one example of a husband and wife who collaborated, sometimes on the same painting; Lee Krasner and Jackson Pollack are another. The inspirational, creative role of women in art and their influence on male artists has for too long been ignored, forgotten, or dismissed.

When the Ukrainian-born Sonia Stern married the French painter Robert Delaunay in 1910, a rare artistic relationship was born. It was a time in Paris of Bakst, of Diaghilev, when the splendor of barbaric ornament and exuberant color swept the restrained classical French sensibility into a whirlwind of enthusiasm for the innovative, the radical. A new era was born. Sonia Delaunay, who would be one of the last surviving masters of early color abstraction, brought to the marriage her childhood memories of Slavic folk embroideries with their primitive geometric patterns and strong primary color; Robert's involvement with Chevreul's discoveries concerning the structure of light had an immediate effect on both of them. She wanted to revolt against all established academic rules—even the new cubism was not daring enough; he was searching through color in order to go beyond reality, to reach the outer limits of expression. Together they brought to our world, for the first time, the visual impact of color—pure color—as a subject of art.

Sonia Delaunay was also one of the first artists to apply her imagination to the transformation of everyday life through applied art. She reinvented interior design, furniture, fabrics, and clothing. The revolution she attempted and foresaw at the time of lingering Victorian codes of behavior and of dress still has its effect today.

When I last saw her in her studio she was surrounded by the remaining paintings of her late husband, an artist who had known fame only late in life. He had been ignored through many difficult years, but Sonia had helped them both to survive financially by selling ideas for advertising, where, once again, her graphic designs pioneered.

Modern art has changed the physical aspect of everyday life. We are surrounded, indeed overwhelmed, by the modern around us. This new worldwide image is due in large part to the struggle of the few like the Delaunays, who knew that in abstraction and color lay a deeper truth than man had yet known, a universal visual language.

Notes on the Illustrations

Sonia Delaunay, 1885–1979. Born: Russia.
Photographs taken in 1954.

1. Sonia Delaunay at work in Paris.
2. Sonia Delaunay in her Paris studio, surrounded by her husband's works.
3. Sonia Delaunay, Rhythm, *1945. Grey Art Gallery and Study Center, New York University Art Collection. Gift of Mr. and Mrs. Myles Perrin, 1958.*

Delaunay 2

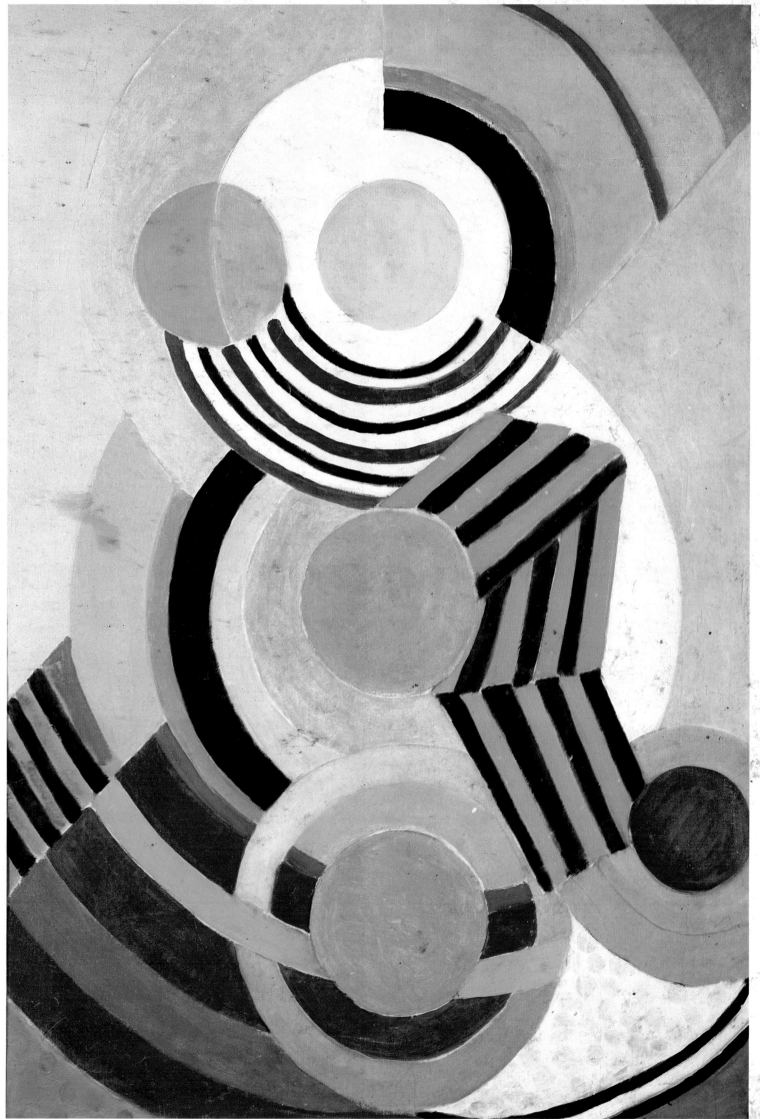

3

Brancusi

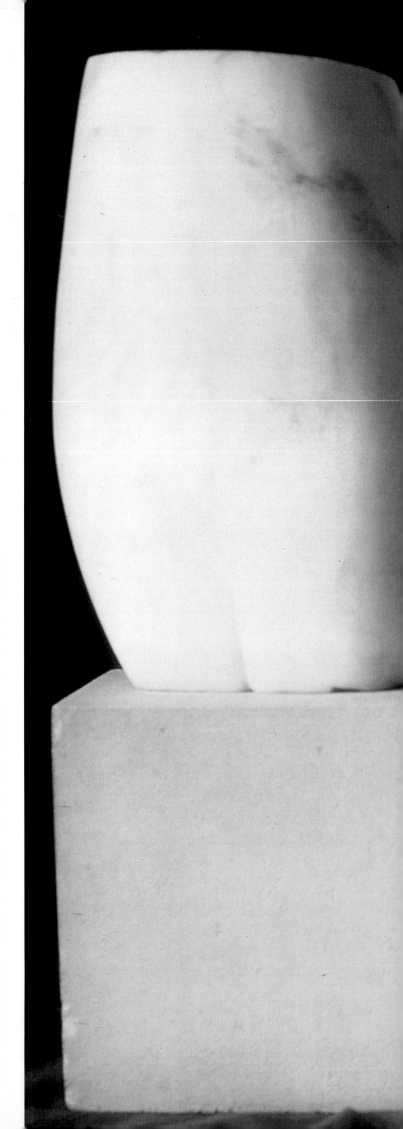

For years I tried to photograph him, but toward the end of his life he had a superstition that if his picture were taken he would die. I sat opposite him many times, my camera on my lap, not daring to transgress his command. "Why do you want to photograph me? I am old. My works are my portrait. They are my children.... Don't write down what I'm saying. I don't like fame. I have known fame. I'm sorry I'm not a bum singing near subway entrances. I love to sing; I even make up rhymes."

Brancusi's great studio was in the Impasse Ronsin not far from Montparnasse. Huddled around it was a cluster of studios, all doomed by the encroaching city. They seemed like a medieval village clinging for protection to the Brancusi castle. Only his fame kept the demolition squads away. And only a thin battered door protected him from the outside; his tiny living quarters off the studio opened directly into an unpaved alley.

There was a mattress on the bare floor; there was a two-burner gas stove; and all around, the clutter of discarded sculpture, tools, plaster cars, wood carved and uncarved, marble, and many withered bouquets of flowers kept, curiously, like love fetishes. On the whitewashed walls hung his sculpture tools, fantastic shapes, rusty, black, and ominous as the instruments of a medieval torture chamber. Pointing to them, he said, "This is my arsenal."

Even though he was ill, the room was cold. No one was around to serve or help him, but suspended over his bed was a huge brass disk that he could strike if he needed help from his neighbor friends. "The doctor told me recently to go for a useful walk. So, I go out and get my food. What could be more useful?"

As he sat up in bed, motionless, now silent but still aggressive and proud, he created a strange aura of wisdom and magic. He made me think of a Buddhist monk and of Merlin the magician. His pale yellow skin, his long, unkempt white beard, pointed knitted skull cap, and once-white bathrobe, all added to my feeling that he belonged to no definite period, that he was outside of time and history. Through the

narrow slits of his eyelids his pale, piercing eyes glistened, shrewd eyes that accented the biting intensity of his words. He spoke as if he wanted his words to cut through thought as his hands cut through marble. All the wisdom of the world seemed on the edge of his tongue. The mysteries of Egypt, of China, and of the Bible were always present in his thoughts. It was as if he had been where no one else dared go.

Once while he cooked his own lunch he said, "We live off manna. There is a layer of manna on which we feed. We think that we are warmed by the sun, but that is false. The sun is going to perish. From time to time I even see the ions when they light up. They light up when the sun is perpendicular to the Equator. The sky that men believe to be blue is not. It is black beyond."

When he relaxed, Lao-tse was spiritually near him. "Lao-tse wanted to find out why little animals seem happy. He watched them and realized that the secret was play. They play all the time. To live long, do as the little animals — play."

We had many long talks, and here are some of the things he told me at random.

"I was born in the mountains of Rumania. My father gave me tsuika to drink when I was two and a half. He used to drink and beat me and put horse dung under my nose. He wanted a daughter

"It is because of a violin that I came to sculpture. I was eleven years old, working in a cleaning and dyeing shop. I had straightened out and arranged everything so well in the shop that the owner said to me, 'I know something you will not be able to do — make a violin.' I started working and made a violin. I discovered the secret of Stradivarius. I hollowed out the wood, I boiled it. The violin made a wonderful sound. After I made the violin, the owner said, 'You must be a sculptor.' . . .

"I started school, jumped several classes, then got a scholarship to the art school. I finished at the Beaux-Arts with three diplomas. I studied anatomy and made a sculpture of the musculature of a man. It is still used by students. To do it I had to dissect more than a hundred cadavers

"Once I was asked to create a monument to a dead poet. One of the figures was a woman. All of a sudden she looked too real to me. I felt like handling her roughly. I wanted to express prayer . . . when the arms are crossed. Then the woman looked as though she was cold. I cut off the arms. I understood then that realism was not essential to expression

"I came to Paris in 1904, practically on foot. Paris was beautiful, 'La Belle Epoque.' There were no automobiles. At first I washed glasses in a café. The Queen of Rumania wanted me to study with Rodin. I said, 'Nothing ever grows under great trees. Why do you want to smother me?' . . .

"I worked with wood because it was cheaper than marble. Marble was one hundred francs a kilo. I don't like the veins in marble. I want anonymity. Then, too, marble dust penetrates all. I've tried everything, even masks, but still it penetrates into you through the pores

"The bird — I am always working on it. I have not yet found it. It is not a bird, it is the meaning of flight

"Over there is a turtle, a turtle that flies. It is the

material that dictates to us our creation. The marble did not allow for legs. In that other corner is a turtle that crawls, made of wood

"I do not follow what is happening in art movements. When one finds his own direction, he is so busy that there is no time.

"Why have pupils? One cannot teach soul. For them everything has to be prepared on a conveyor belt. Then one is not free anymore if he feels like doing something. Young artists see things from the outside. They see the surface. One must forget what one learns

"To see far is one thing, to get there is something else.

"Intelligence helps us if we give it the brakes of love and soul. Nowadays everyone is intelligent. It is a bad thing. Intelligence is fictitious. Love is spiritual, it is the Divine. Physical love means emptying oneself. Real love is God. The soul is everything. To make love gives us a glimpse of the Divine

"No religion. I was an archdeacon in my church. I took things from Jesus Christ. Love each other. Rid yourself of evil. Save your soul. If you live well, if you purify yourself, you go up into the heavens and stay there. If you live badly you come back onto this earth or another earth. Earth is a hell.

"I have been in Egypt and visited the tombs of the Pharaohs. I even went as far as Aden

"In India it has been proved that there were ten or eleven deluges, although we know of only one. We are living the beginning of a new apocalypse. The deluge is coming. Nothing will be saved. Sculpture will be lost in the sand

"If one could create as one breathes. That would be true happiness. One should arrive at that."

Once while I was with him, this very old sage, withered and seemingly weak, got up suddenly, opened an extraordinary all-wood door he had carved himself, and went into his hangar-like studio. He decided that a monumental sculpture was out of place and with incredible, unexpected power pushed it into the desired place. I will never forget the image of that small, gray, bent figure shuffling and limping through the maze of sky-reaching sculptures he had charged with the eternal energy-giving powers of art.

Notes on the Illustrations

Constantin Brancusi, 1876–1957. Born: Rumania. Photographs taken in 1955.

1. Three seminal works by Brancusi. From left to right: Torso of a Young Woman, *1918;* Torso of a Young Man, *1917, polished bronze; and a detail of* Beginning of the World, *1911, white marble. All photographed in the apartment of Brancusi's friend and dealer, Pierre-Henri Roche.*
2. In Brancusi's studio, the wooden King of Kings, *(1930) and one of the many versions of the* Bird in Space.
3. A view of one side of the immense studio, taken while Brancusi was still alive, with its fantastic accumulation of forms. On the right wall, the giant versions of The Cock; *a smaller plaster version is on a stand in front of the painted backdrop. In the left middleground, one of his early works,*

The Kiss; *in the left foreground, the Caryatid. In his will, Brancusi left the entire studio and its contents to the French government on the condition that it be reconstructed exactly as it was in his lifetime.*

4. *A corner of the studio. At the upper left, the marble head of Mlle. Pogany II, 1931; at the upper right, the wooden portrait of Agnes E. Meyer; in a frame, a charcoal study of a woman.*

5. Brancusi, Fish, *1924-26. Polished bronze on a steel disc and wooden base.*

6. *Works finished and in progress in another part of the vast Impasse Ronsin studio. From left to right: a marble* Fish, *wooden* Endless Columns, *a smaller bronze* Fish, *a polished bronze* Leda, *and a* Bird in Space. *Next to the tall wooden* Caryatid, *a* Little Bird *in colored marble and the fireplace Brancusi built himself.*

Brancusi 2

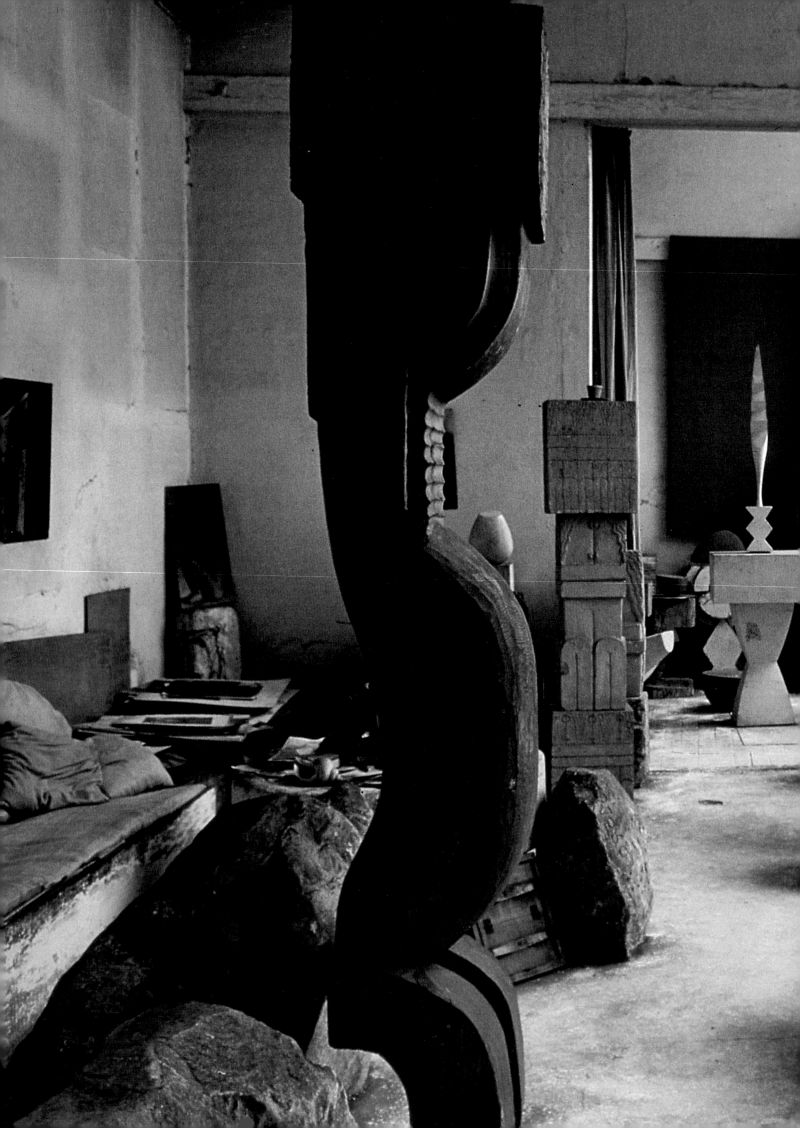

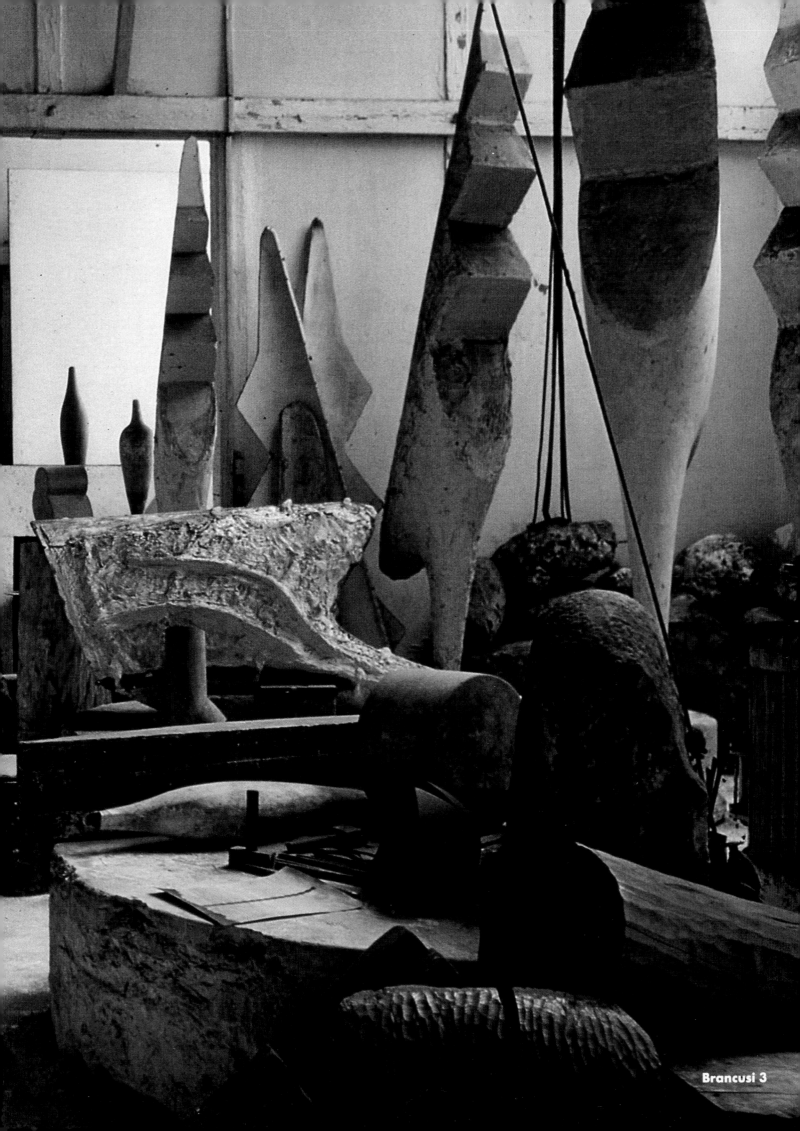

Brancusi 3

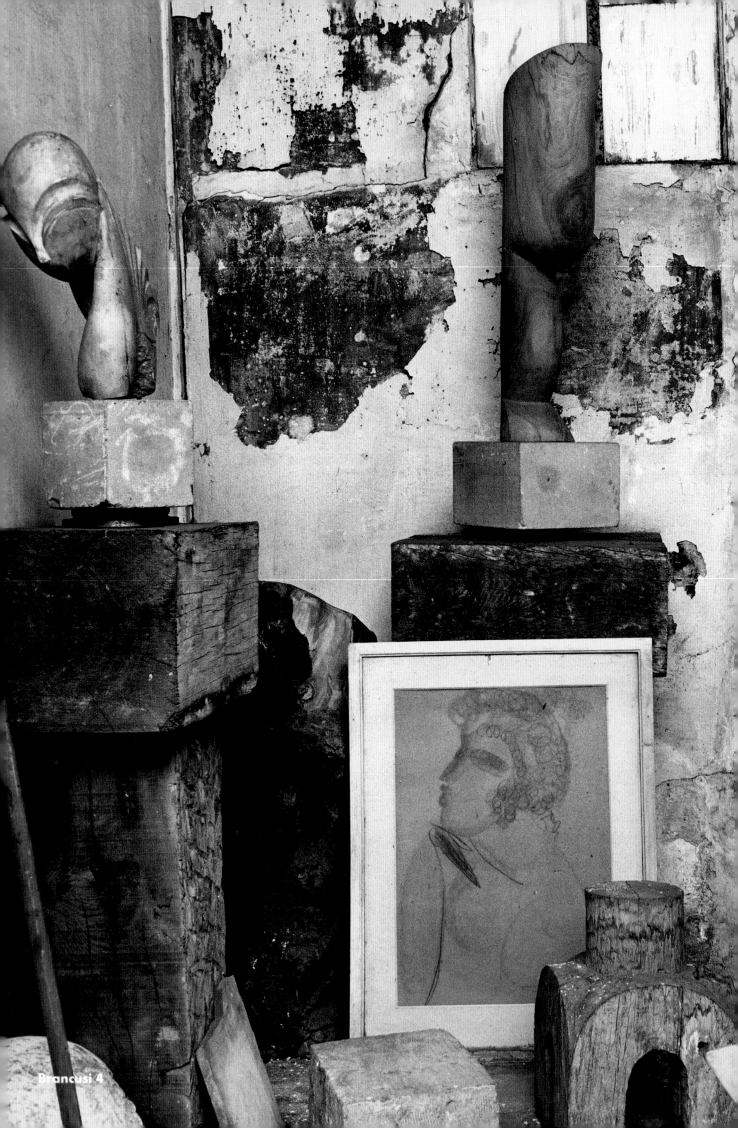

Brancusi 4

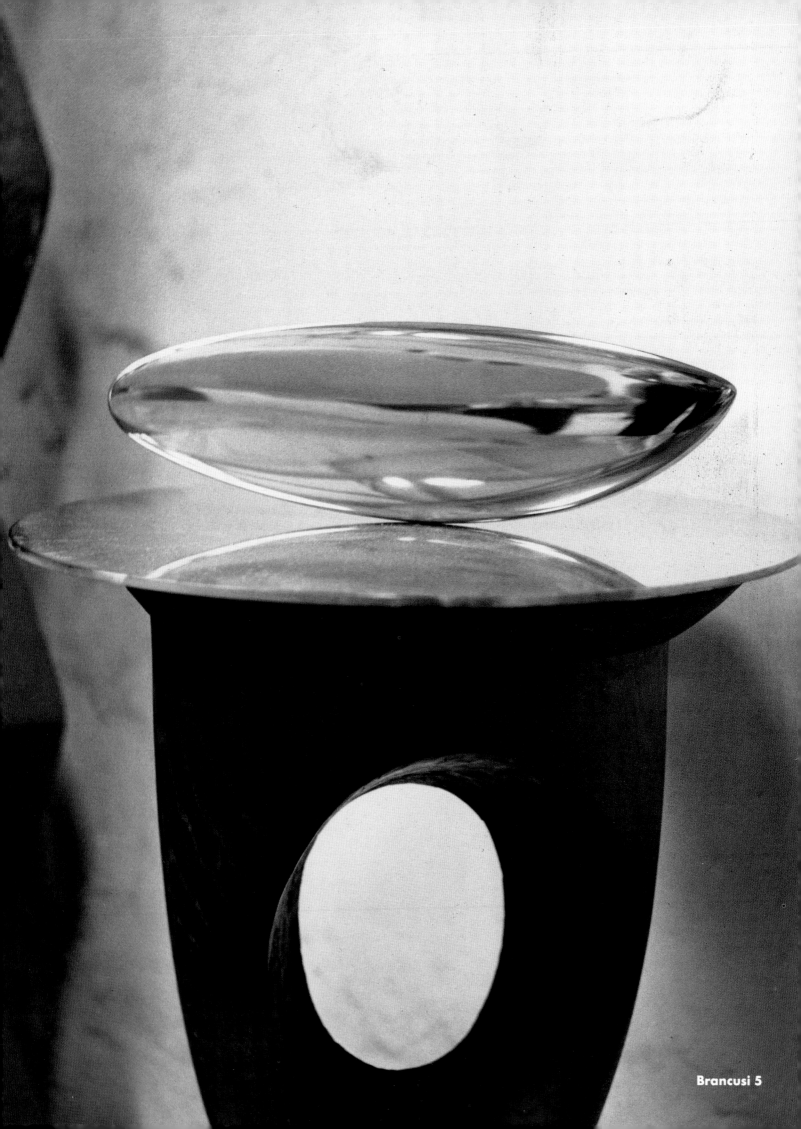

Brancusi 5

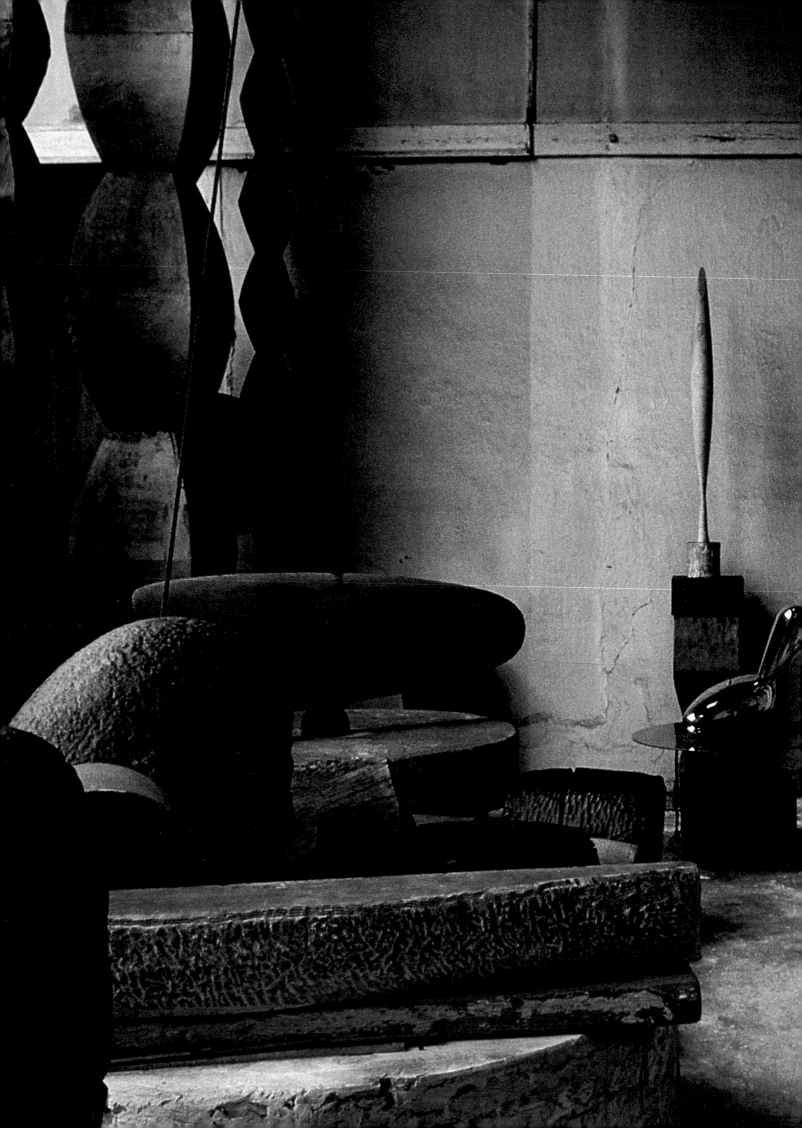

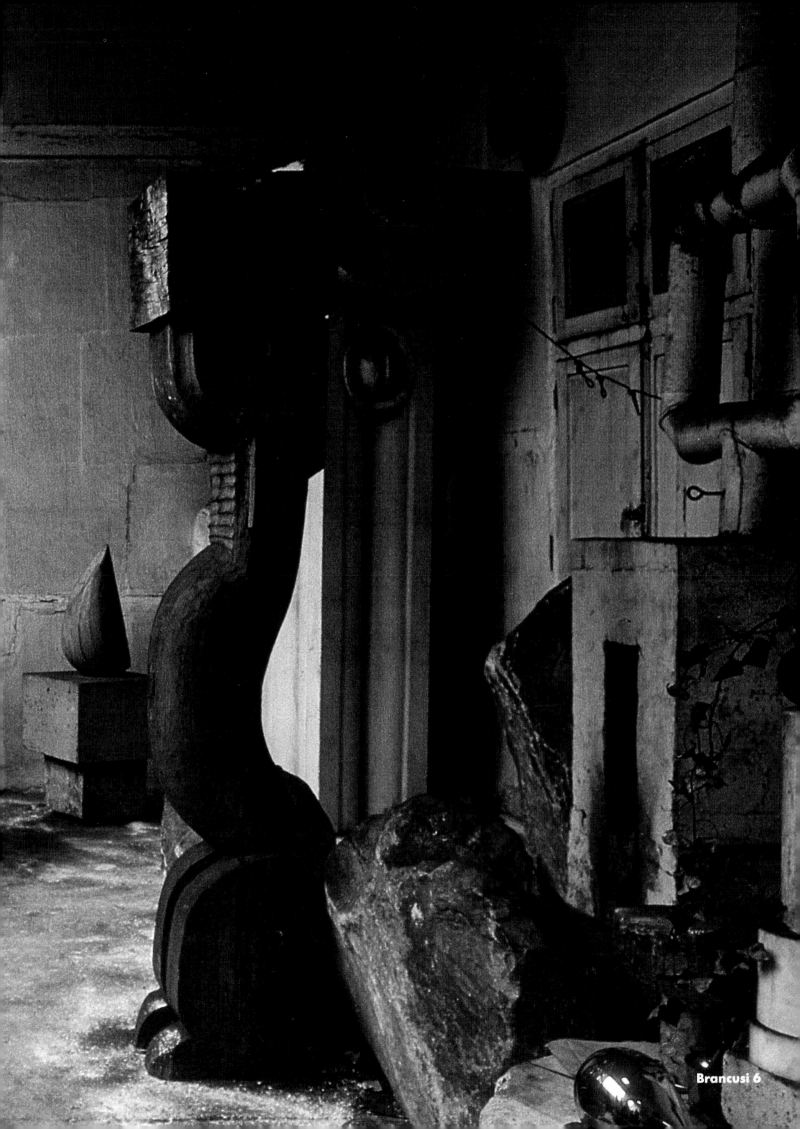

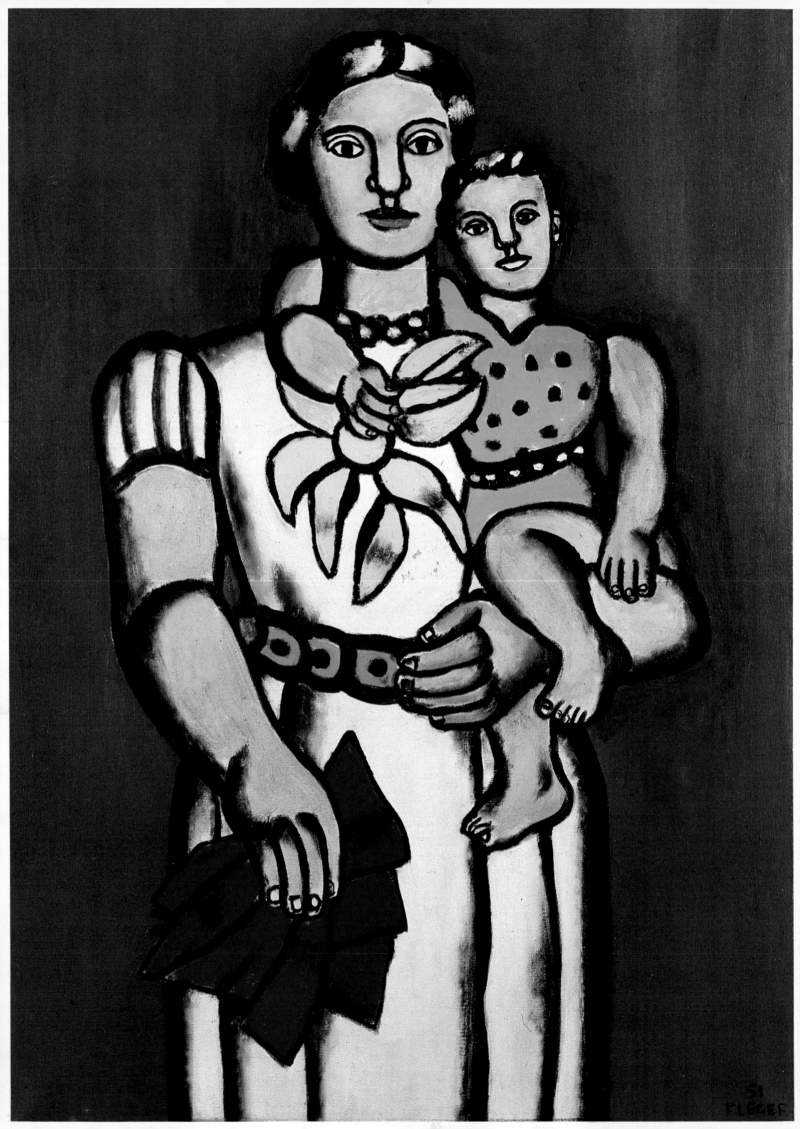

Léger

For more than thirty years Fernand Léger lived on a sunny, quiet street in Paris near the Luxembourg Gardens. A tall neoclassic portal opened onto the narrow courtyard of his house, two floors of which Léger used for his studio and another for his apartment. An incredibly narrow, winding wooden staircase led up to the first landing, where a sign announced that all appointments had to be made through the secretary of M. Léger. If, however, the visitor knew Léger, it was all right to go straight up. The fanlike development of the stair was so steep that I arrived out of breath. Léger opened the door. In a gruff voice he said, "Come in. Oh, hello. It's you."

I found myself in an immense double-storied room. With the strong light softened by sliding white curtains, a sensation of overwhelming color came from the red, paint-spattered floor and from the kaleidoscopic far wall covered from ceiling to floor with his own paintings. The intensity of colors and lines combined to create an insistent vibration. Léger wore a checked shirt, and the violent pattern of his clothes against the violent pattern of his paintings made him seem like a chameleon. This mimetic camouflage between Léger and the art that he had created was not only superficial; the forms on the canvases of nudes, acrobats, and bicyclists also resembled the massive form of their creator.

Léger was heavily built, rough-hewn. His face consisted of powerful lines and volumes, shaped like the limbs of the figures he painted. The extraordinary deep furrows, the wrinkles on his brow, the two deep-set lines on each side of his nose, the lines under his eyes, all dug deep into the massive face. One vertical line cut his forehead in two even parts. I thought of the Byzantine icons with their harshly outlined features. His eyes and mouth, like slits in a mask, seemed small in his big, mobile, symmetrical, primitive face. I thought, too, of the weather-ravaged features of peasants and laborers in the out-of-doors.

When he smiled, a tenderness softened his somewhat brutal features. There was great heartiness in his manner, his laughter, his jokes. He had a spontaneity of gesture and a need for communication with the world. The telephone rang frequently, and he had a gruff familiarity with people on the phone, with me, with visiting students. In spite of his massiveness, he had a surprising lightness in action. When he spoke, his hands darted quickly, his supple fingers bending expressively. I felt an immediate friendship for him. He picked up a drawing and said, "I will autograph it for you as a souvenir of your visit."

This feeling of spontaneity, of generosity, was visible in Léger's actual palette. On it colors were two or three inches thick. Vigorously, abundantly squeezed out, the colors formed miniature mountains. From the constant rubbing of the brush, colored peaks had been hollowed into craters, the reminders of creative eruptions.

Next to this extraordinary palette stood a folding step-ladder. On each step there were brushes—an inventive solution for the problem of storage. Behind the brush stand was a long mirror. In it Léger could look at his paintings from a distance. For him the relationship between the dimension of the work of art and the space around it was all-important. He remarked that this Paris studio was eight meters long and six meters wide, the perfect proportion, adding, "I am a victim of dimension."

The floor of his studio was unique. Most artists in their studios surround themselves with monochromatic or subdued color, but the deep red floor of Léger's studio was an intense base from which his eye received a constant shock. He needed the stimulus of pure color. The blotting papers on his writing table under the window were red, yellow, green—bright and intense.

I had expected Léger to be surrounded with elements from the modern mechanical civilization, but his studio was bare of inspirational objects. I looked at his recent canvases, filled with the memories of his childhood in Normandy, cows, roosters, countryfair musicians playing the accordion, acrobats, bicyclists, men and women enjoying life's simplest pastimes and relaxations. I realized that Léger no longer sought his chief inspiration in industrial or agricultural

machines. I sensed a reaction against the mechanical—against abstraction per se. "Abstraction, that's good for the decorative," he exclaimed. A return to the human, to nature was now foremost in his mind. He wanted to reassure through the use of the familiar.

A short while before his death, as if to satisfy this need for nature, his rediscovered source of inspiration, he bought an abandoned inn at Gif, in the Vallée de Chevreuse, the tender, undulating countryside that flanks Paris. There, surrounded by farms, but within quick reach of the city, he spent his last months. Gradually he abandoned Paris for the studio in Gif, a former ballroom which he quickly filled with the gay color beat of his last major work, *La Grande Parade*. This gigantic canvas of circus figures blocked off one whole wall, as if Léger wanted to impress upon the art of easel painting a new grandeur, a fresh concept of monumentality.

Great architecture has always tended toward the monumental, and Léger followed this trend. "When a thing is powerful it is not fragile," he said. Largeness of conception, a feeling of volume and scale, a generosity and abundance of form characterize his later work.

At the opposite end of the studio, facing this enormous circus panorama, stood a very large black and white porcelain bas-relief. Léger often sat under it when tired, in a colored deck chair to contemplate his work from a distance. While he sat in this chair, talking to me, a steady stream of recollection poured forth. As if hypnotized by his own art, he seemed to dig into the innermost layers of consciousness. "I am a Norman. I'm a primitive. My father was a cattle dealer. I went into painting instead of beef. As a child I never drew. Around sixteen or seventeen I did some caricatures, some sculptures out of chestnuts."

Suddenly, he looked around him and exclaimed with wonderment, "How could I have become a painter with all that cattle running over me? I am a child of the earth, of the Norman earth, and I am proud of it!

"To earn my living I became a photographic retoucher and did photomontage. Maybe it is true that the smooth gray shading in my paintings comes from that training. Then I became a draftsman in an architect's office, but I always painted on the side. I was in utter misery. I didn't have a cent. It is only very late that recognition came.... The French like impressionists.

"Braque and Picasso are impressionists. I, never! Their mandolins were selling when my pistons were laughed at. Impressionism is sensuality."

I asked him who were his great influences: "Cézanne, Douanier, Rousseau. Rousseau taught me the quality of finish—he used to say to me, 'Monsieur Léger, why doesn't Monsieur Matisse finish?'

"I was very fond of the Douanier. I'll tell you an amusing incident. The Douanier wanted to exhibit in the official Salon but he was refused. With some of my friends, I arranged for the Salon des Indépendants to hang his paintings. But the Douanier, being a real civil servant, wanted official recogni-

tion. So when the Minister of the Beaux-Arts came to inaugurate the Indépendants, the frustrated Douanier ran up to me and said, 'Monsieur Léger, is it the same minister as in the official Salon?'

"Wars have always had a determining influence on my life. In the First World War, I was an engineer. There and then I had contact with the reality and the solidity of life. The breech of a seventy-five-millimeter cannon has taught me more than the museums. I saw the magnitude of the machine and the antlike smallness of man.

"But I came into contact, too, with the People with a capital P, and that was the truly deciding influence on my life. I got to know them, to love them and their language, so direct, so full of imagery. The simple people have real instinct. For example"—he smiled—"an elegant woman wears a pink sash; a woman of the people would wear a red sash. Taste is the enemy of painting."

The Second World War exiled Léger to America; that was his second visit. The years spent in the most modern of civilizations stamped his work indelibly, but curiously made him seek the human element.

"I remember a man standing on Broadway," he said. "The lights kept changing and he seemed lit up, as if abstracted by the reflections of the neon lights. He would suddenly turn from red to green. There the idea of color outside of the drawn image came to me. And the idea of bodies hurling through space came to me on a crowded American beach where I saw sixty or eighty people simultaneously diving, jumping.

"You see, I earn my life on the roads. My eyes are on life. I pick up everything. I even have a television set; on it I pick up deformation.

"I make notations in contact with nature, but create from memory. I hate abstraction and those horrible abstractionists. I went through an abstract period but only to bury it better."

He stopped for a moment, then mused, "All the things that go through one's head and that one doesn't fulfill."

There was a silence. Then he added, "Cézanne did not fulfill.

"Artists are divided into two groups, the classicists and the romantics. The classicists are the men of the North. They are slower. Picasso is an example of the romantic, a precocious child of the South, for in the South men awaken to life earlier. I build, I am a Norman. I am a classicist. I am at peace with myself. My torment and suffering are purely aesthetic. I don't philosophize; I just paint, paint, paint.

"The great primitives, like Giotto, are my masters. In their art the subject is second to plastic values. They had plastic liberty. There must be plastic freedom. They used color arbitrarily. Colors in an object are imprisoned. One must not submit to the subject. My main preoccupation is with the question of color inside form or outside of it."

Around the room were several canvases, drawings, gouaches of the circus. Some of the "circus parades" were realistically colored with a three-dimensional effect like magnificent *images d'épinal;* others showed how, step by step, Léger liberated color from form.

It was an extraordinary experience to be present when a great painter struggled to make up his mind. The conflict between realism and abstraction tormented Léger to his last day. Side by side, he had two large canvases of his circus. In one the color was used realistically, filling in the forms prescribed by his black outline. It was a beautiful work. The sky was blue, the clown's nose red, all colors had their predestined place. But somehow there was no mystery; the viewer's mind rested, unstimulated by the expected; there was no surprise to free one's imagination by disconnecting it from its habitual manner of thinking.

The mystery of the unexpected, the surprise of incongruous juxtaposition generate a friction in our brains, giving off the spark that imagination yearns for. Léger, as he contemplated his realistic circus parade, felt the lack of this vital stimulation. He made up his mind then that form and color must be free of each other, and painted his final *Grande Parade* with the liberated color playing over the interweaving images of dancers, acrobats, clowns, and horses. This, his last work, was his masterpiece and his testament. He had solved his conflict. "This way, with the color outside, there is a double play and a double effect."

There can never be an exact return to the past. Art, like civilization, is indelibly marked by the progress of time. Changes in the artist's vision are the means of checking on the distance he has covered.

In his painting Léger attempted to satisfy the visual needs of human beings just as modern architects seek to solve their physical demands. The great architects of the past consciously created sensory effects on the spectator by leading him, for example, from a narrow passage into a vast hall. Léger created the same spatial feeling of mental expansion or contraction by juxtaposing seemingly contradictory scales. As I looked at the canvases around me, I realized that a painting by Léger was fundamentally an imaginary architectural rendering. Objects and people were studied like the elevation and plans of buildings.

On the immense canvas in front of us, the bold, black, sinuous outlines of the figures were independent of the circles, squares, and triangles of pure color. Simplified areas of color clarified the whole pictorial concept, as an architectural master plan clearly expresses its dominant themes. Léger's color was seen as if hovering above the surface of the painting and looking down. But the figures drawn in black lines over this color were seen from a different point of view—from the side, in elevation, the way we normally see buildings and human beings. This double play on our senses creates an unexpected sensation. We never stop to think that we live and walk over vast plans of cities, of buildings; in fact, we forget the existence of such plans and are conscious only of verticals.

The big, gruff man covered his eyes with his hands and leaned back in the deck chair. Then, after a pause, he summed up, "My purpose is to give certitude in art." After a few moments' silence, he got up with an effort, and we went into the sunlit countryside. The garden furniture had been painted bright red, yellow, blue; it stood out against the whitewashed walls. Under a widespread tree hung a mobile and a plastic acid-green watering hose which added a completely contemporary accent. But the roof was of centuries-old tile. Léger, in a green-belted hunter's vest, touched the low-hanging tiles lovingly. For an instant he seemed transported into his childhood. Proud of his tiles, he looked at me, shrugged his shoulders, and smiled, saying, "I am a Norman." He had just married his second wife, a Russian who had worked with him twenty-five years in his art school. "I said to myself, 'What will become of me, old and alone?'" Léger continued, "Love and painting are two very different things. To make love tires one. The artist is an egoist. No woman has had a hold on me. Only painting has counted in my life."

The key to his art was the audience he sought. "Everyday people...I love them...their language, so direct...."

Of all the modern masters, he was the one most conscious of the present world of machines, industry, speed, the world of advertising, of the quick, direct appeal to the spectators' senses. Magazines, newspapers, television, movies, posters use attention-getting devices that are part of our everyday life. They have been carefully separated from so-called fine art. But basically there is no division. A poster can be art. Many people, forgetting the long history of art, often think, carelessly, that only a framed object with three-dimensional shading and perspective is a painting, and that a bright-colored flat surface is decoration or advertising.

Advertising, the graphic arts, considered apart from painting, have the secret of mass appeal. Toulouse-Lautrec, the impressonists, Bonnard, and others enriched their paintings from the art of the poster. Scientific investigation of human reactions, the probing of psychological research into human vision, and the investigation of the subconscious by psychoanalysis have given to the graphic artist invaluable data. Traditional art relied on intuition to achieve universal appeal and ignored the revolution in our knowledge about ourselves, our likes, our dislikes. It ignored the scientific discoveries of perception. Art became really modern art when all this accumulation of knowledge became part of the creative artists' means of expression. Modern art is the visible acknowledgment of mankind's awakening to itself. Cubism, surrealism, abstraction are not manners or ways of painting; they are signs of artistic maturity, the affirmation of artistic freedom from the superstitious worship of tradition.

One of the discoveries of modern psychology is that for intensification of vision our eyes demand contrast. Contrast is the basic law of advertising. Léger more than others used this knowledge of contrast in his art to achieve a direct, deep physical reaction. He re-established the value of the sign, the essential timesaving symbol of communication.

It is rewarding to think of art as primarily communication between the artist and the spectator. One of the purposes of cybernetics, the science of communication, is that there be no loss, waste, confusion, or distortion in the message conveyed. In his use of thick, bold, precise outline, Léger sought to reduce the area of misinterpretation or error. Speaking of

213

line, he said, "Line is everything. What would my art be without that black line?" His line is not the refined, sensuous, vibrating line of the traditional master draftsman. It is the line which, like writing, defines precise vision and thought. Directness of response to his work was one of his goals. "I believe in painting that hooks one!" he said.

Until modern art, paintings had to be penetrated by the spectator. Léger paintings reach out to the observer. In our day one sees so many visual images that their individual impression can be easily dulled. Léger's aggressive conception has given art a commanding new voice. His paintings do not require a participation and response that our distracted minds cannot give.

If you enter a room in which there are several paintings by different artists, a Léger will probably attract your eye first. This bombardment of our sensitivity is in harmony with contemporary visual thinking. His is not an art in which the spectator tries to escape and forget reality in a dream world of pleasant images. His is an art that aggressively knocks on our senses, forcing us to recognize it. If it does bring joy and beauty, it is not through escape.

Léger was squarely planted in the midst of our civilization. He was not preoccupied with the Etruscans or with African sculpture. His was the world of today and of tomorrow. And his influence may be the greatest on the generations to come, because he was not afraid to make art without art. Our century is obsessed with the idea of work. Léger faced the aesthetic problem of the workingman in his series of builders; his men at work are great odes to human progress. He respected human beings who build. Of himself he said, "I build." There was nothing destructive in Léger's art. On the contrary, there was a constant glorification of the means and materials through which creativeness is made possible: the hands of the workers, their gloves, trousers, caps, their tools, the scaffolding, the girders, the rivets, the machines.

He wanted to stop the ever-increasing division between art and life. He wanted to bridge this gulf by the use of permanent symbols. His was a dual return to the human, in the subject matter of his art and in the methods he used to act on the spectator. In his subject matter he rediscovered for himself the human form. In his methods he used the lessons taught by modern psychology. Léger's art may seem crude to the sophisticated; it is a warning to return to the basic instincts that motivate the human race. He believed in art for the many, not art for the few. Like the great religious primitive, Giotto, he wanted to satisfy the humble and the great, the peasant, and the intellectual.

Maybe art in its preoccupation with aesthetics and ornamentation has lost contact with its primeval impetus. Returning to the human form, Léger had perhaps reasoned, was one of the surest ways to re-establish art's universal appeal.

In seeking to reach other men, the artist must rediscover the man in himself. He must establish a direct transmission of his inner feelings. This undefiled purity of exteriorization is the privilege of the great so-called primitive artists. With civilization the task of the artist has become more difficult. The original inspiration, before it reaches the spectator, is coated with layers of convention. Léger preserved his immediacy of perception, his directness of vision. In that sense he was a twentieth-century primitive. Many painters spend their lifetimes trying to free themselves from the binding conventions; to wipe from their memory the obsessive, clinging academic teachings. Léger learned to forget, to be himself. Whatever struck his unprejudiced vision was worthy of striking the vision of others. He was his own testing ground. He knew that only in being true to himself does an artist have a chance of being true to others.

The way of reaching out of oneself, of communicating is, at first, mysteriously, by an inward path, as if the creative soul had to turn itself inside out before it could be free. This double movement, first inward before becoming outward, is the necessary safeguard of true art. An idea, a vision, needs to be tempered in the crucible of the creative soul. Only then will it acquire the immortal power to survive the corroding flow of time.

Notes on the Illustrations

Fernand Léger, 1881–1955. Born: France.
Photographs taken in 1952, 1953, and 1954.

1. Fernand Léger, La mère et l'enfant *("Mother and Child"), 1951. Courtesy of the Menil Collection, Houston.*
2. Léger looking out of the window of his Paris studio, Rue Notre Dame des Champs.
3. In the Paris studio, the magnificent display wall. Hanging upper left, Le Grand Remorqueur, *1923.*
4. Léger's palette, in the Paris studio. He used it for over forty years, until it became a color moonscape.
5. Léger, photographed in 1952, in his Paris studio, wearing his favorite "casquette," or workman's cap.
6. The Gif studio. Léger liked to throw sketches on the floor. On the far wall, his two contrasting styles: left, a version of Le Grande Parade *with the colors painted within the form; right,* La Partie de Campagne *("The Party in the Country") with the color used independently.*
7. In the Gif studio, Léger's colors.
8. On the wall of his Paris studio, an artist's inspirations.
9. Léger's house in Gif, outside Paris.
10. On the table in the Gif studio, Léger's experiments in sculpture.
11. La Grand Parade, *the final version of Léger's last great masterpiece. He made an extraordinary number of preliminary sketches in black and white and in color, then a great many smaller versions in oil, always seeking a solution that would satisfy him. After this great aesthetic conflict, he decided to free color from line. He stands, solidly planted, a rugged, earthy part of the visual parade behind him.*

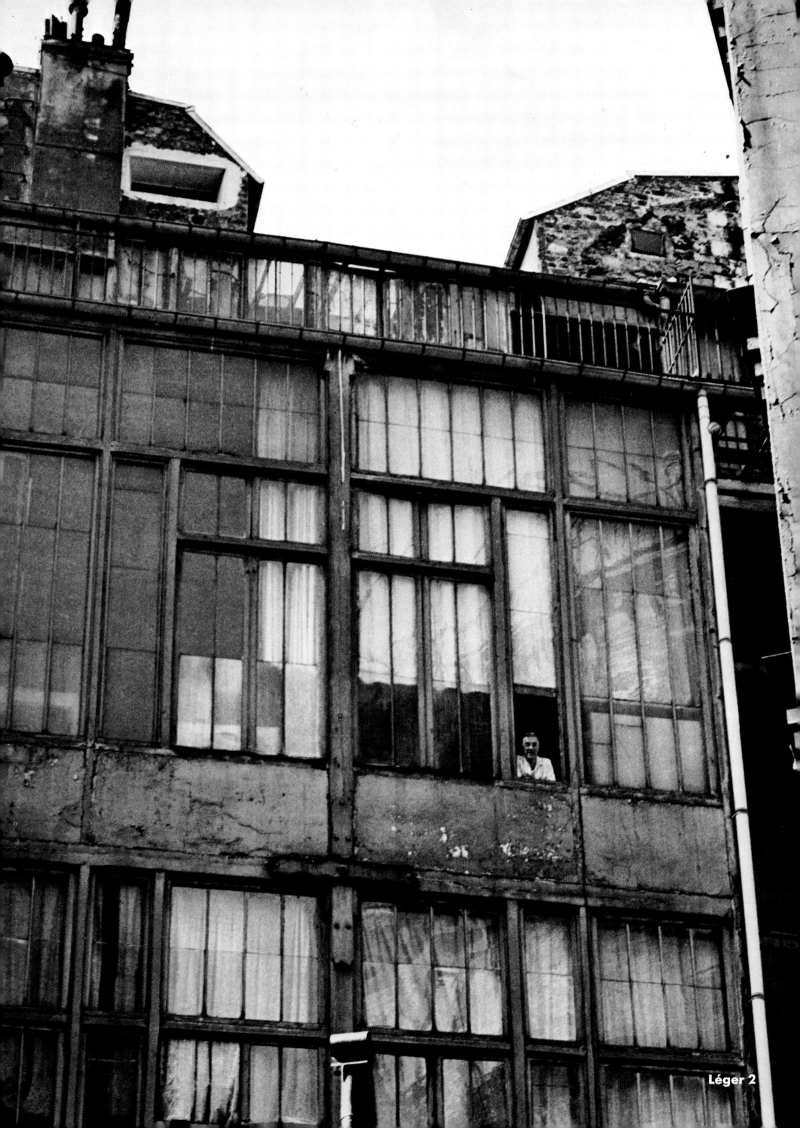

Léger 2

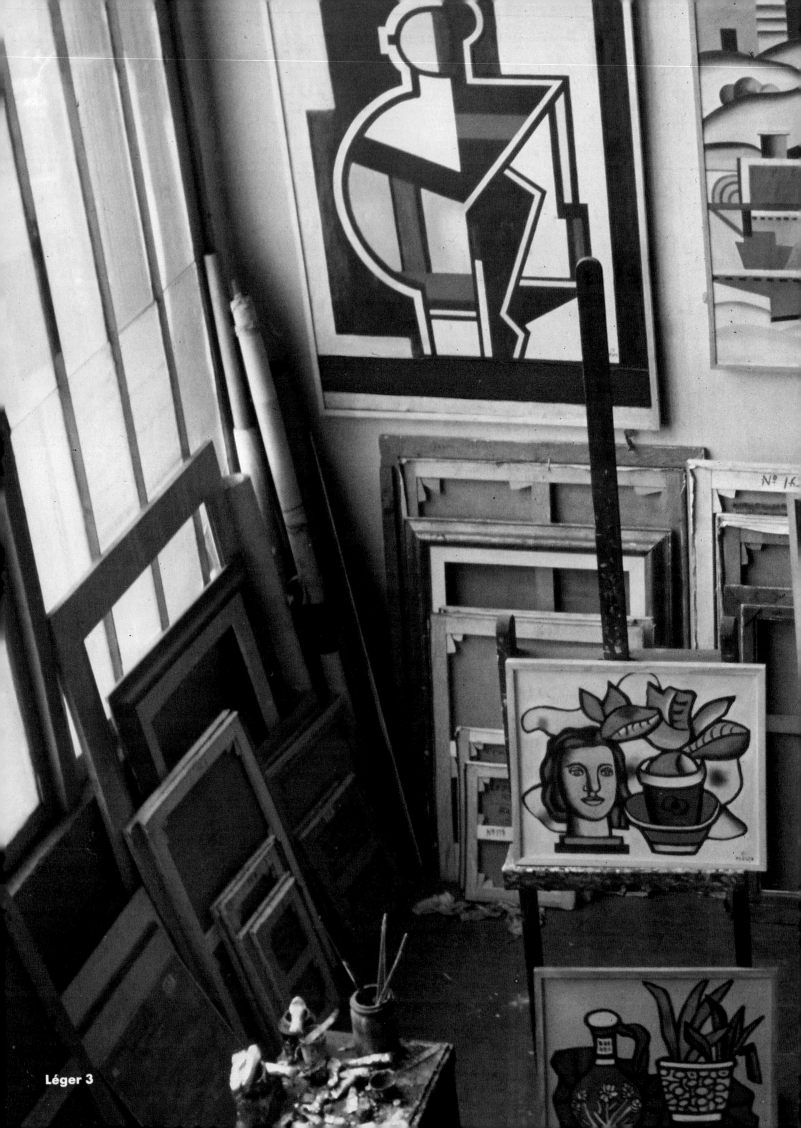

Léger 3

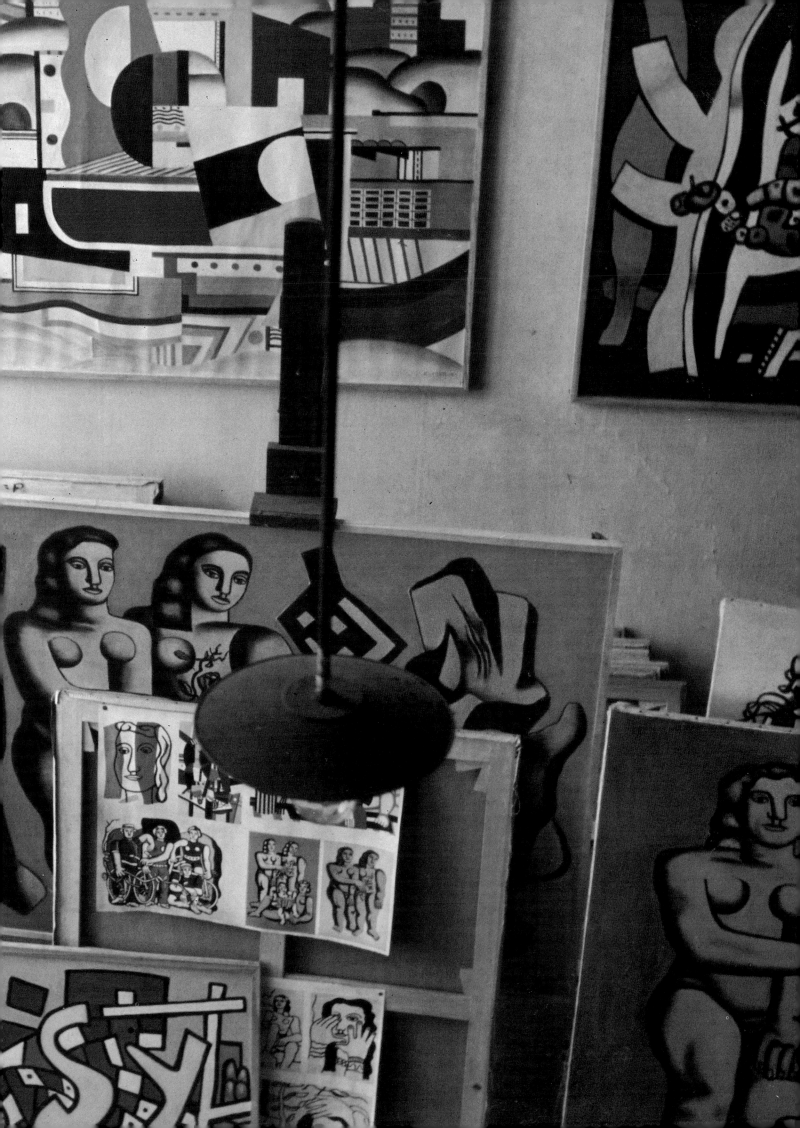

Léger 4

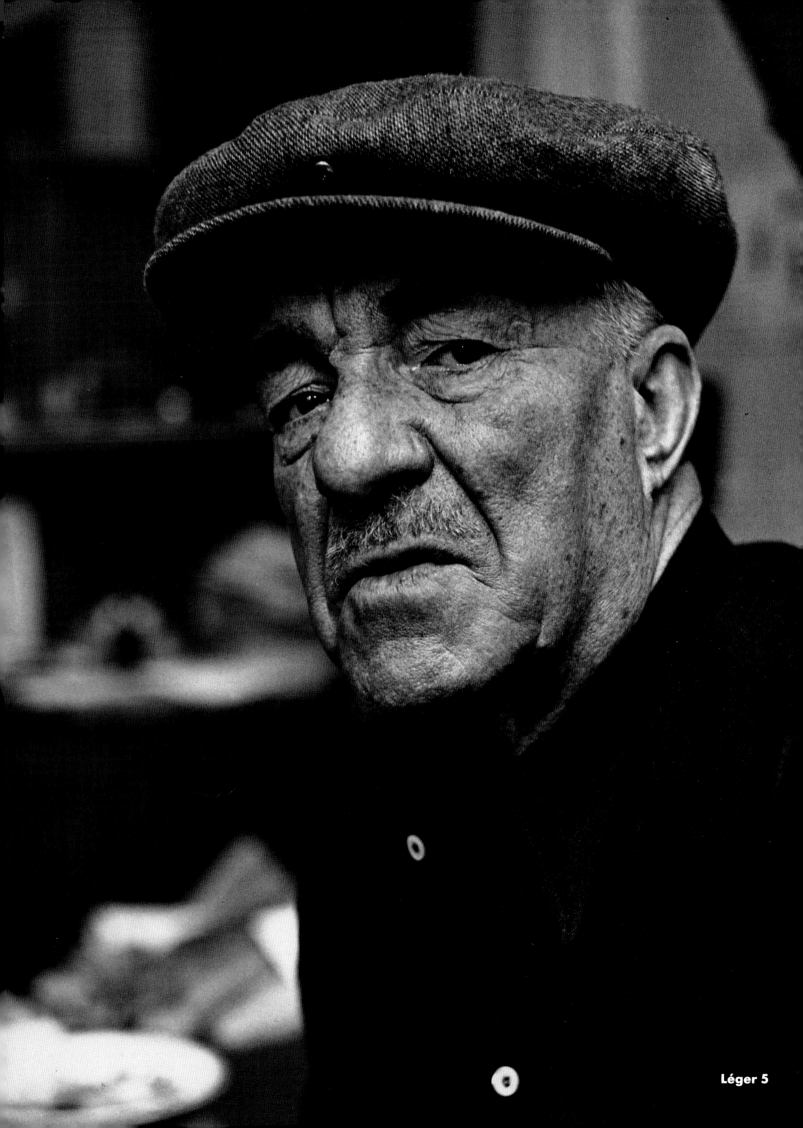

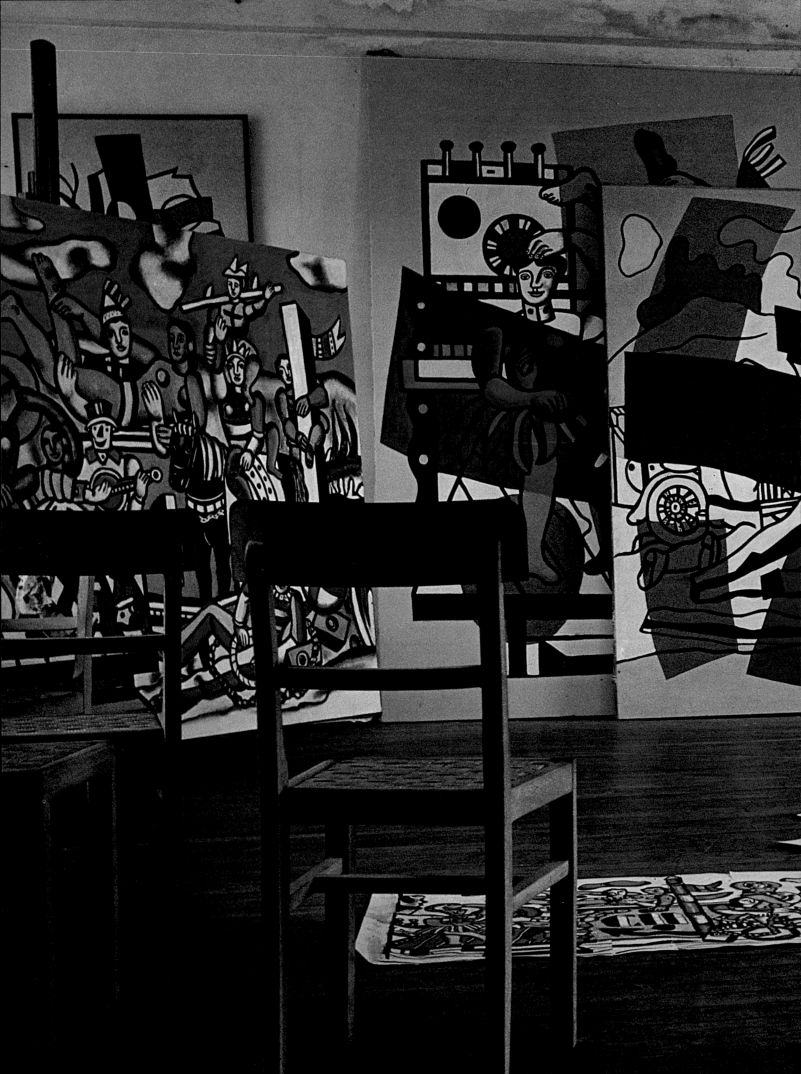

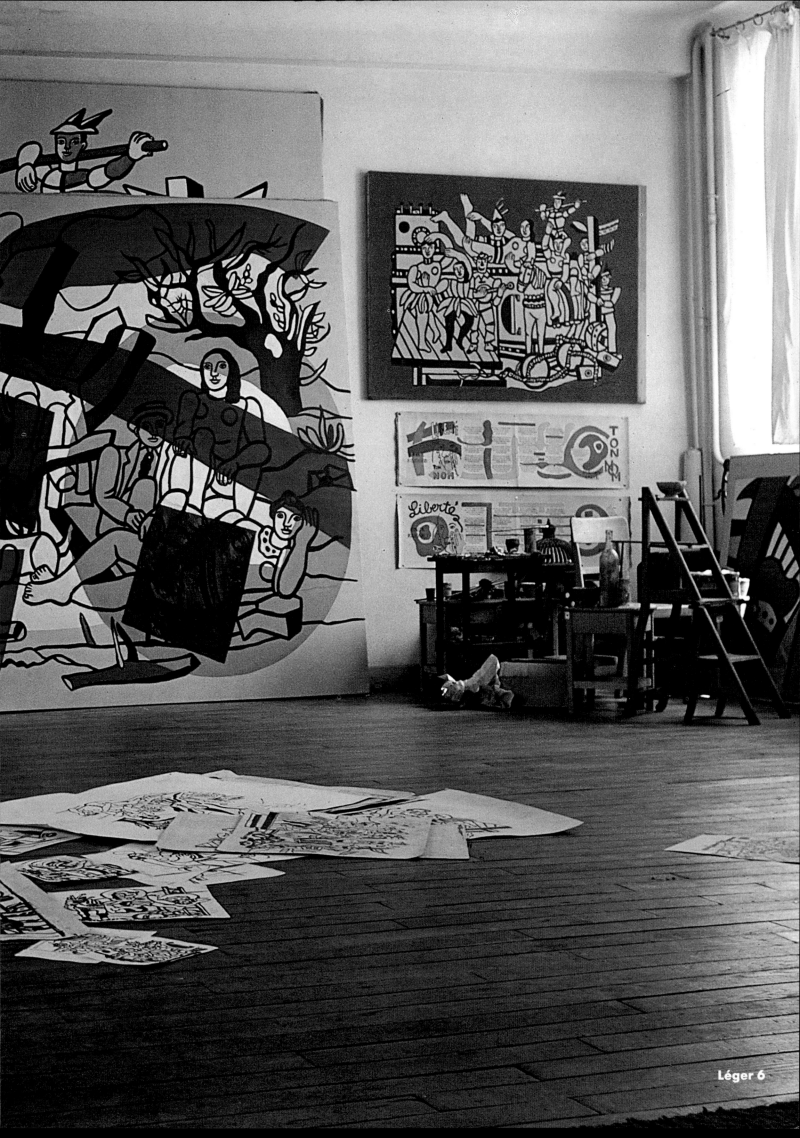

Léger 7

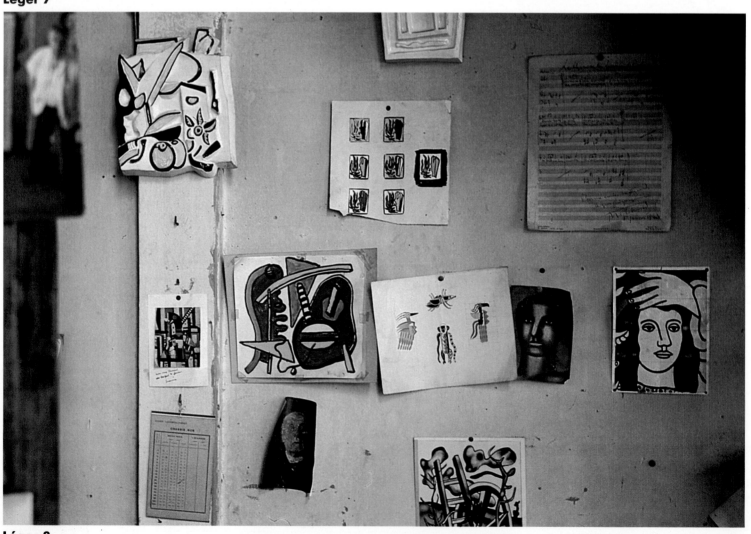

Léger 8

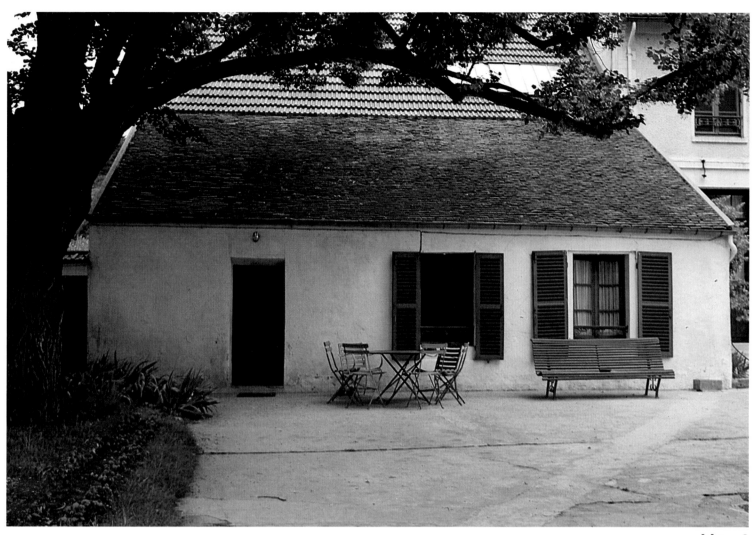

Léger 9

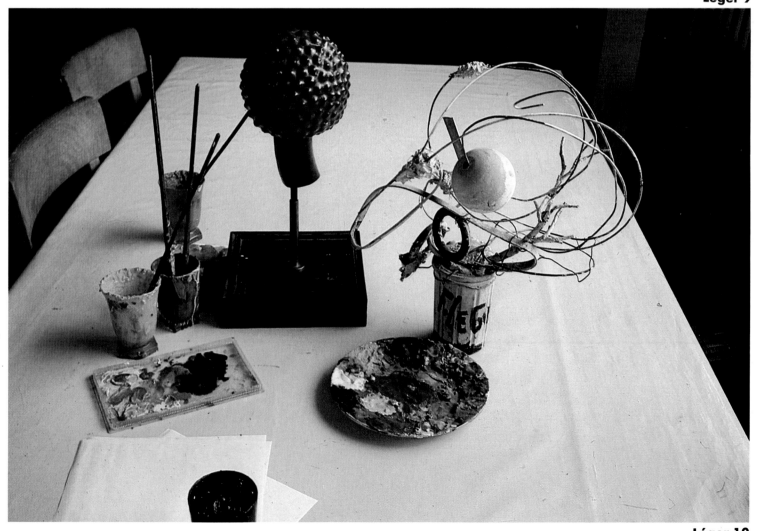

Léger 10

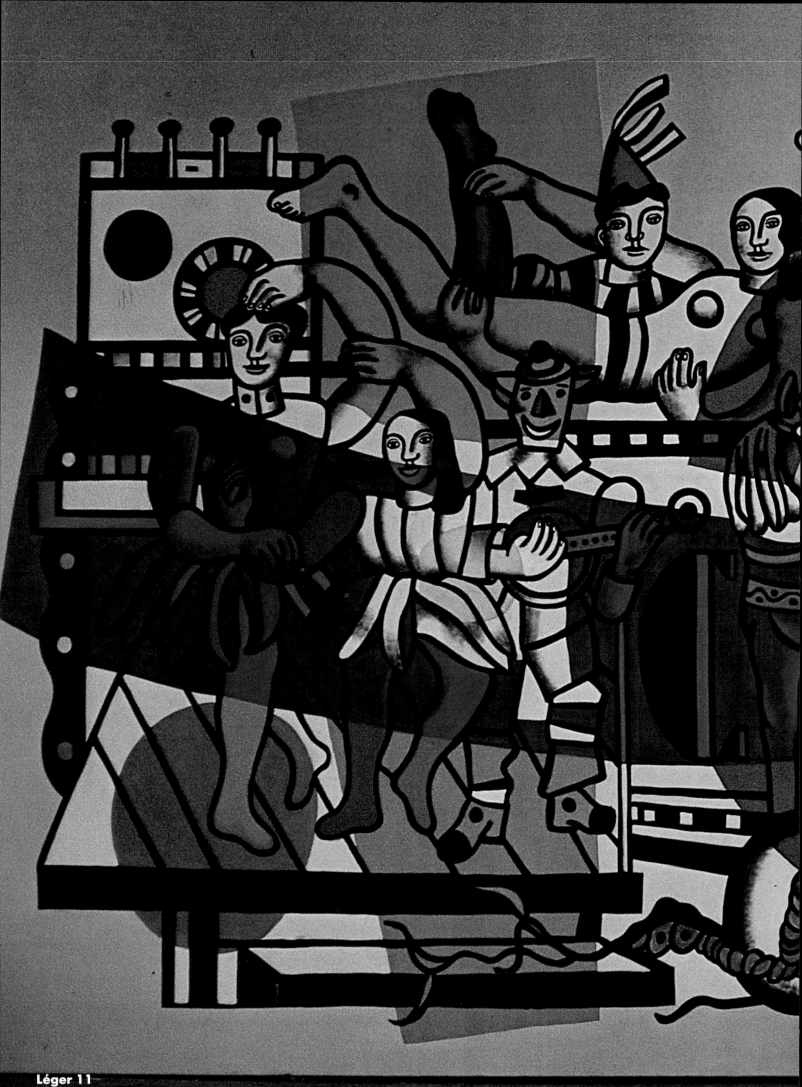

Léger 11

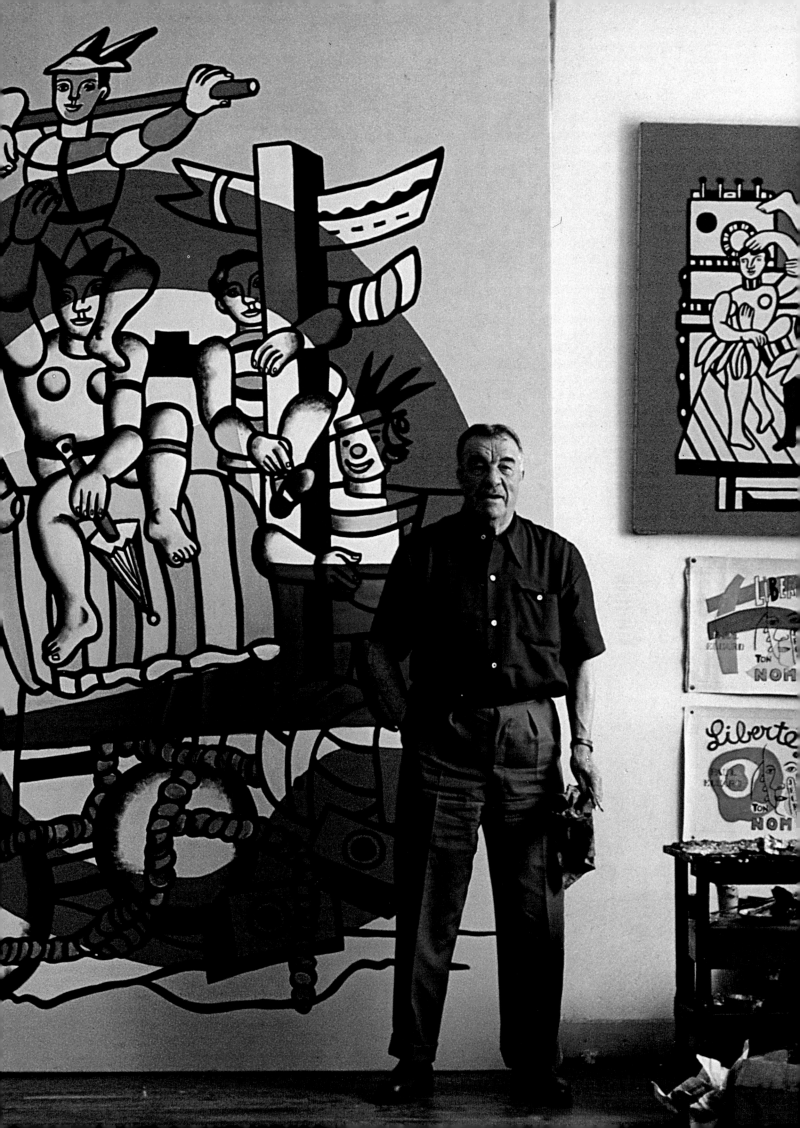

1

Le Corbusier

L e Corbusier lives and works on the top floor of one of the first ultra-modern apartment houses that he designed in Paris. His studio, with the main wall of rough-textured stone and the ceiling vaulted, gives the feeling of an unfinished chapel. The large paintings with their bright yet strangely soft colors contrast startlingly with the monastic cement and stone. Le Corbusier himself is a man of contrasts. The formal bow tie he was wearing was out of place with his shortsleeved shirt. He is businesslike, distant, and severe. He creates on as grand a scale as any artist in history, yet there in his studio the sketches and paintings seem small, like initial images in his mind, fertile cells ready for growth. In contrast to them were hundreds of paint cans arranged subconsciously by the great architect-painter in front of his easel on the floor to resemble a visionary city as if seen from the air. To this austere master all form and space seem to be rough, disorganized materials which are in need of discipline.

Notes on the Illustrations

Le Corbusier (Charles-Edouard Jeanneret), 1887–1965.
Born: Switzerland.
Photographs taken in 1954.

1. Le Corbusier next to one of his sculptured forms.
2. Le Corbusier at work. Painting was always a secret backbone of his art. A founder, with Ozenfant, of purism in the early twenties, he continued to paint and sculpt while erecting the dominant architectural visions of our time. Throughout history, some of the greatest architects have been painters and sculptors, and some of the great painters and sculptors have been architects: Giotto, Michelangelo, Da Vinci, and Le Corbusier.

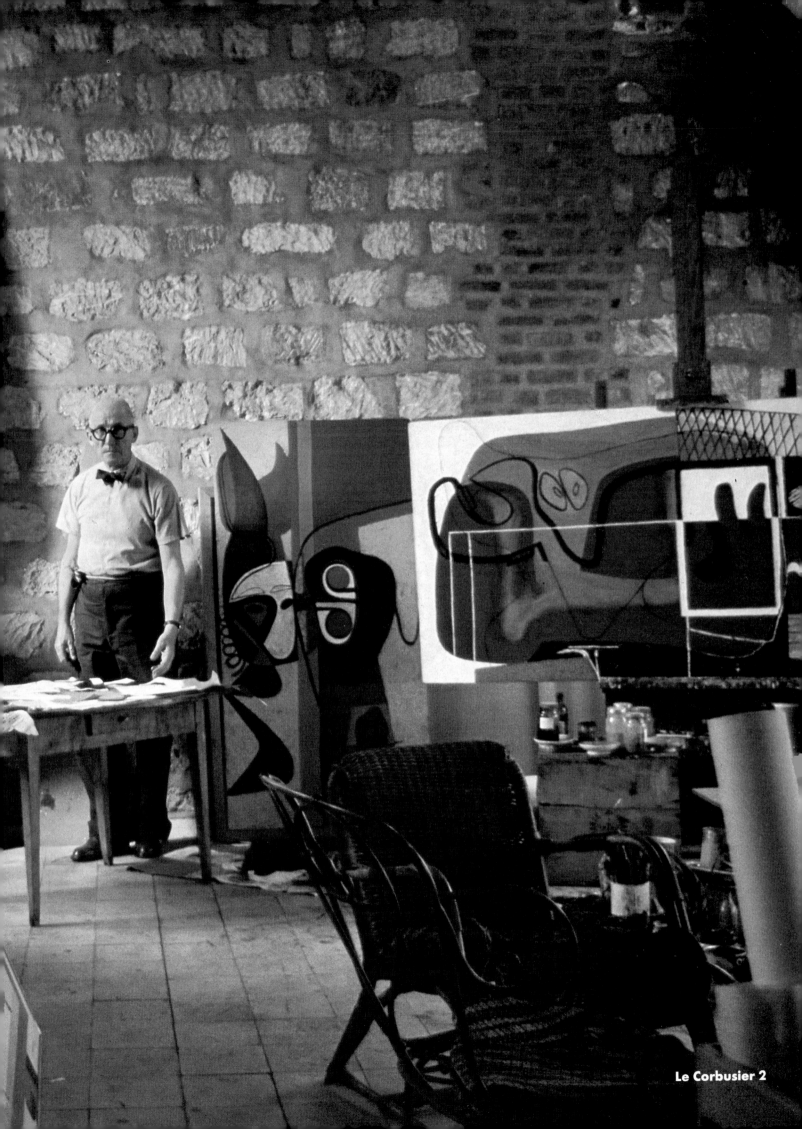

Le Corbusier 2

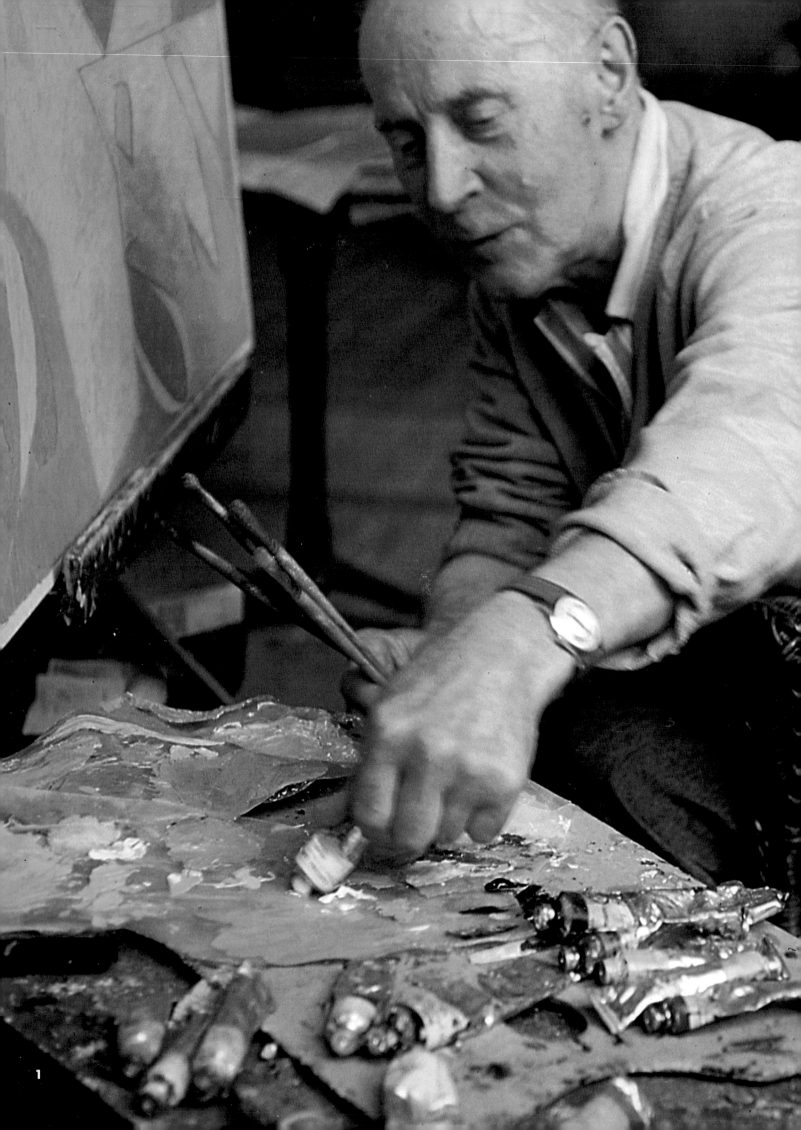

Villon

"What is inspiration? It is essentially a love of life that makes me conscious of the air I breathe. I am hooked by life as by a woman." The man speaking, Jacques Villon, is now eighty-five. His thin white hair seems blond; his cheeks are pink and smooth. A slight build and an ease of movement contribute to him an aspect of youth. The illusion is emphasized by an open shirt and soft sweater, slacks, tennis socks, and sandals.

His is an ageless face. Centuries of culture, of intellectual refinement, of breeding can be traced in the subtle proportions of his features and bone structure, the thin lips, the long nose, the high and rounded forehead. I thought of a scholar finely drawn by Holbein or a portrait of some nobleman by Clouet.

On his cheek appear two small warts. How often such accidents have had a tactile fascination for portrait painters, especially those of the Renaissance, and how often such "defects" graft themselves on one's memory whereas perfect, smooth, monotonous form is soon forgotten.

In the presence of Villon one is inescapably conscious of France—*la douce France*, gentle and charming. The very name Villon conjures up the image of François Villon, the great ribald and tender poet of the fifteenth century.

The French intellectual is seldom a dry non-sensual man. To Jacques Villon, the abstract artist, nature is woman. "I am not tempted to philosophize about nature. I'd rather possess her," he said. Villon speaks of his art and his relations with nature as a man of his mistress—a healthy desire to possess, uncomplicated by complexes.

Since 1906, for more than half a century, Jacques Villon has lived in the same studio in Puteaux, a Paris suburb, built on a hill that slopes gently down to the Seine. (Continuity of surroundings seems to have played an important role in many creative lives.) His studio, off a quiet provincial street that seems very far from Paris, is part of what was once an extraordinary community—the "School of Puteaux," of which Villon is now the only living master. One cannot get to Villon's house without passing an old suburban villa once occupied by Frank Kupka, one of the pioneers of abstract art. Villon's studio is a sad gray stucco pavilion. Farther down in the shaded garden stands another building where Villon's brother, Raymond Duchamp-Villon, lived.

Kupka is dead. Villon is eighty-five. Recognition came slowly to these artists, and they symbolically stood aloof, as Cézanne in Aix, from the Paris where for so long they were not appreciated. There is no view from Villon's studio. Instead there is the quiet sadness of a garden overgrown with grass and unweeded paths. All the houses on this street seem to exist on borrowed time; the city is encroaching, and soon they will be torn down and replaced by apartment houses that will use up this wasted space where a few sensitive creative men found their haven.

Villon is a Nordic, born in Rouen, Normandy—that extraordinary nursery of such great French artists as Poussin, Courbet, Léger, Dufy, and Braque. The rich northern province with its fields and seashore has for centuries mothered and inspired artists. One must hear the pride with which Léger or Villon says, "I am Norman," implying in that short phrase heraldic deeds and peasant humbleness—the spirit of the sailor and the shrewd cunning of a poacher. To be a Norman implies the ability to act and to execute, to put one's ideas into practical form, to change with one's own hands dreams into concrete reality.

But above all there is the light of Normandy, that magic medium that transforms nature into an eye-stimulating color impulse. The haze from the North Sea reveals all the hues that the harsh sun of the south bleaches. The great schools of colorists have flourished near areas of water—the Venetians, the Dutch, the English, the impressionists near their rivers and seas, and then the Normans of contemporary art.

"I was born in 1875. My mother was a Norman. She used to draw when she saw me paint as a child. My grandfather Emile Nicolle was an artist, an etcher who also sold marine insurance. I studied law, but at eighteen I failed in my exams."

Recalling life in Rouen, Villon said, "An artists' supply shop there had drawings by Lautrec and Steinlen. A friend of mine wrote news articles about painters. An eighty-three-year-old aunt, or cousin, contributed notices on art to the newspapers and magazines of Rouen. She even wrote a play, and at a time when Rodin was hated she defended his art and him. There was a current of modernism, a stirring

"It made me want to leave Rouen and go toward the modern movement. I wanted fresh air. I went to Paris, to Montmartre. There I was surrounded by the *avant-garde*—no *pompiers*. I was a *petit révolté*." He added, "That was 1894. I adopted a pseudonym, Villon; our real name was Duchamp." He paused a moment and said, "You see my father was a fine man. He was a notary; I was a *révolté*, but I did not want to hurt him. Now that I am successful, I am sorry to have changed my family name. How my conscience troubles me because of him!" As he spoke the stream of recollection brought animation to his gestures; his lips moved quickly in staccato, each word precisely formed. There was warmth, tenderness, and an exceptional humanity in what he said—the words of a man who knew what family love meant.

"We've always been a tightly knit family. I was particularly close to my middle brother, Duchamp-Villon. He had studied medicine, but during an illness he tried sculpting and became a sculptor. He lived in a studio next to mine for twelve years, until his death in 1918. At that time our younger brother, Marcel Duchamp, the painter, was always nearby. Marcel made a point of honor of being brighter and stronger than we were." Villon's eyes twinkled. "We taught Marcel to play chess; he learned so well that I could never beat him. We tried billiards; we used to play in a place called La Poule au Gibier. He beat us at that, too. I like games, but not money games. I don't gamble."

It is rare in the history of art for three brothers to achieve greatness. Those of the Duchamp-Villon family have. Duchamp-Villon, an early cubist, was one of the great sculptors of modern art. Marcel Duchamp, the painter, has had a profound and lasting influence on contemporary art.

Villon remembered. "Marcel went into abstract art because he could not stand all those people who raved about 'beautiful sunsets.'

"Marcel classified everything, even chance," Villon said. Duchamp's obsession with chance, his sense of irony, made him his own victim. He abandoned painting for chess, finding in the limitless speculation of mathematical laws of probability the answer to his hunger for speculation.

Although Duchamp gambled on the mysterious creativeness of accident, his older brother Jacques Villon believes that "One must avoid the accidental present. I want my art to be more general." In spite of their differences, these two have much in common: their sense of humor and, beyond it, irony, acute intelligence, and love of scientific speculation. Villon is the classicist who has repressed much in order to achieve modernism within tradition. Duchamp is the romantic who broke with tradition, and too late realized that he had destroyed what he loved.

Villon then talked about himself. "In the early days, to earn a living, I illustrated newspapers. I would draw all night; it was a way of making money, and then most of my friends were doing it. A painter must have difficulties to surmount." His index finger pointed in emphasis. "But I won't say anything bad about newspapers! Journalism has not harmed literature. For an artist to illustrate newspapers is a contact with reality. He comes to grips with life. But when I think back on the fifteen years I worked for newspapers—in a way they were wasted. I could have painted that much longer.

"You see, my father had six children. He could send me only a little money and I wanted to make more. I should have contented myself with what he sent me and painted instead of wasting so much time. It was all a matter of pride—my desire to prove to my parents that I could manage on my own. If only I had been less proud." Apologetically he added, "I could have done so much better, but luckily, because of my long life, time has been given back to me.

"After I started painting I was always in a hurry. When I was on vacation, I tried to get back a week earlier. I had the feeling that I had to recapture the time lost. There is so little left to live. If I had died twenty years ago, there would not have been a painter Villon."

In the peace of his later life, in the protection of his marriage, Villon works. He said, "My wife watches over my health." Madame Villon, to whom he has been married since 1904, is a frail elderly woman. She has large, warm brown eyes, contrasting with the sharp, pale, cool eyes of Villon. Whereas his features are pointed, hers are round. Her slippered feet made no noise on the wooden floor. In the gentleness of their relationship there is a serenity that provides a calm and ideal climate for creative work. Their voices were never raised. I was struck by the tranquillity of their life, the quietness of the studio. Here in the remote suburb, with its tree-cast shadows, was the peace of surroundings and of mind that allows quiet meditation and the cutting of the visual world into the facets of Villon's vision.

My first impression of his studio was of gray austerity. The cold north light carefully equalized by white cheesecloth seemed to transfix every object as though caught and suspended in a white crystal. Light there seemed to have a density of its own. I thought of Vermeer's figures eternally preserved for posterity in their hunks of light-crystal. Light as an object seemed to exist all the more because of the white plaster walls, the dust-gray wood floor. On the dark end of the gray scale were the black wicker armchairs, the black-painted staircase that led to the second floor of the studio. Light seemed even more luminous against this monochromatic backdrop. There was not a single colored object to distract the spell. There were never two paintings visible at the same time; Villon always turned one against the wall if he wanted to show a second. In that sad, eye-resting room the lone vibrant canvas became an explosion of color, as though all passion, all effort were concentrated into that one intensely burning spot. The canvas was a prism breaking up the white light of the studio into the rainbow of the spectrum.

When, after long hours of meditation and work, Villon puts a painting back on one of the neatly built storage shelves, the studio seems momentarily plunged in darkness, as though the artist-scientist, after putting away his laboratory equipment, switched off the light. As I looked at the painting he was showing me, there seemed no immediate connection between it and its surroundings. There was no continuity, no obvious link between the pure bright colors, the geometric shapes, and the seemingly indifferent studio. On a high shelf, a few plaster sculptures by his brother Duchamp-Villon caught light and dust. Nothing seems more melancholy than abandoned bas-reliefs.

On a dark wood provincial chest, curiously out of place in the austere surroundings, were some small toys, painted naked dolls next to brown cows and white sheep, all intermingled as though abandoned by a careless child. Like Poussin, the severe classicist who re-created his compositions in miniature theaters, studying light on draped terra-cotta figures, Villon works out his compositions with these toys. The accidental reality is eliminated, and the artist can work in the peace and security of his studio on the involved problems of composition and execution that art requires. "Art is a translation of nature that has more grandeur," he said.

On a table were several toy models of airplanes. With them this artist-scientist was experimenting, as the aeronautical engineer who tests his theories on miniature plane models in a wind tunnel. But here the more sensitive instruments —the human eye and brain—were testing in the wind tunnel of light that is Villon's studio. Here where objects could be manipulated, seen, and analyzed from all sides in a flow of vision, the artist could discover secrets that simple sketching from actual reality would never disclose. The crude simplification of these objects reduced them to rough essences of the things they represented. The airplanes and other toys were stand-ins for generalizations—human, animal, machine. Villon assigned to each its place in a seemingly new nature, not the one of everyday surroundings, but the one behind superficial appearances, the essential nature where the hidden structure of the universe is revealed.

One by one he picked up the toys and haphazardly placed them on a chessboard; it seemed as though the mathematical laws that govern chess suddenly governed these playful symbols. Villon with his toys and his chessboard was re-creating life in microcosm and, as in his art, rendering perceivable that which is too vast for us to perceive. As an artist who is also a man of science, he continues the tradition of the Renaissance. Leonardo da Vinci could well have been his master. The sketches of airplanes by Villon reminded me of the notebooks of Leonardo, where the first flying machines were prefigured.

On a small drawing table next to his canvas were several torn sheets of tracing paper—his palettes. On them he can mix his colors without one color's intruding on the other; the pure mixtures thus isolated permit methodical, precise work.

"I work with pure colors…straight from the tube. I don't add oil or turpentine. I don't worry what will happen. I am working only for the present!" he said.

The bright canvas on the easel seemed to obey some hidden law of color harmony. Villon, the great colorist, explained. "My purpose is to reduce all colors to a unity, to give each color the same value, and to fill the gulf between them with white or maybe even black." From the large table littered with drawings he picked up a small book lovingly covered with neatly folded brown paper. It was the French edition of O. N. Rood's *Modern Chromatics*, published in 1881 in New York. "My system of the use of color is based on the study of this American scientist. I want to achieve harmony between all colors. The master craftsmen who worked with stained glass always took into consideration a unifying theory of colors." Rood in his book compares the luminosity of colors to white paper, and if white equals one hundred, each color will have its relative number.

Villon said, "Colors have different vibrations. If white, considered as a base, stands for one hundred, then yellow in relation to white will be eighty, vermilion twenty, ultramarine-blue seven, et cetera."

To achieve this harmony between all the colors in a painting, Villon has worked out his own rule of thumb. "I want to equalize the whole painting. To do that I must equalize all colors toward white. Suppose I have a yellow. To establish the quantity of white that I will add to it, I take the yellow, squeeze out some. With my palette knife I then divide my little mass of yellow in two equal parts. I say, I have fifty-fifty. I divide again—each one of the fifty parts into two, and get twenty-five-twenty-five. Now I have to add white. I have to add nearly seventy-five, or three parts of white equal in size to the twenty-five quantity of yellow, in order to get seventy-five plus twenty-five equals one hundred. If I have a blue, which stands for seven, I have to add about ninety, or nine times the amount of blue in white paint.

"There need be no relationship between the sizes of white added to the yellow or the blue. The small quantity of white I added to the yellow is sufficient to give the yellow an equal value with the blue to which I had to add ninety. It is not complicated; I do it now instinctively." After many years Villon just squeezes his white tube, matching and measuring with the eye the correct amount of paint.

By this use of white in his colors, the white paint acting as a built-in light, Villon achieves a strange and personal color harmony. The colors of a Villon seem deceptively pale, as though bleached by an inner intense light, but this subtle gentle color sensation slowly grows more intense, insinuating, marking on the mind a permanent afterimage. Whoever has looked at the sun and then closed his eyes knows the miraculous complementary color of the afterimage, paler but so intense. A Villon painting is an afterimage that one sees with open eyes.

Villon continued. "If I have made a colored study for a painting—I do this sometimes—the colored study is made from the colors of reality. But I do not leave them just as they are. I influence them. I intensify the original sensation. The original sensation is altered, influenced by the colors I have chosen on the chromatic circle. After I have finished a painting, I sometimes rework it and influence the whole with

a yellow, for example. It unifies the canvas. It is not a bad thing to do.

"There is a division in my work: color gives the sumptuousness, the richness of the opera; and the explaining is done by drawing.

"First, I make notations from nature; then I redo them, making a more complete drawing, stressing the main values. These main values I use as a base for the division of the subject into planes.

"There can be a rear plane, a middle plane, and a forward plane. There can be subdivisions of these planes, but, as much as possible, I limit myself to three planes. Each of these planes is colored, after I have chosen a scale on the chromatic circle. With three planes the chromatic harmony is usually of three colors. Each plane is influenced by one of the colors. For instance, if I am painting a face, the particular planes of the nose, the cheeks, et cetera, will be indicated in the color of their plane in general. I try to have, between the planes of color, neutral planes. These are the planes of rest. I express myself principally through planes."

Later Villon and I went into the living quarters. The small rooms contrasted with the gray but luminous vastness of the studio. Madame Villon was in the dining room, patiently reading a newspaper—the wife who knows what patience means, for to be the wife of a painter is to have the ability to wait. As she sat in the dark room, she seemed to blend with the surroundings, as though she were in an interior painted by Vuillard. Leafy shadows added a green dominant to the weak light that bathed the simple white wicker furniture. Near the window a table was set for a frugal lunch; these two would calmly break their bread together, undisturbed, and in this interlude the artist would find strength to resume where he left off. Nothing would jar him or tear the continuity of his creative thoughts. "I get up at eight in the morning and paint from nine till lunchtime," he told me. "After lunch, around three o'clock, I paint again. I take a two-week vacation every year."

Absorbing the austere surroundings, I realized that this was not a picture-making interior; this was the house of Monsieur and Madame Villon and it was apart from his art. It could not, in its neutral simplicity, interfere and intrude into his paintings.

Villon is exceptionally articulate; his intelligence, the quickness, the precise analytical quality of his mind permit a revealing study of the artist. Through Villon one can grasp the thought behind the creative act of the modern artist.

"Painting is a form of the *élan vital*, the vital impulse," he said. "It is one of the forms of love. I am always attempting to join the two—love and painting—they are Siamese twins." He has found happiness in painting; but he said, "One suffers to produce it. It is not a happiness exposed in bright sunlight. It is a happiness that one must gain piece by piece. If a canvas 'rings,' if it is successful, then there is restitution." After a pause—"There is no immediate happiness," he added.

I asked him why he painted. "One has to pass one's time on the earth!" he answered, smiling his shy smile. "It is not necessary to paint. I don't believe in the modern artists' justifying their blobs of paint as instinctive. Only those who have studied have a right to modern expression. Probably the discipline, the moderation of my art comes from my bourgeois wisdom. Art for me is an opportunity to be happy. The tragedy of some painters is that they have an aspiration for beauty but don't attain it. We are not gods! Some painters look at themselves in a mirror and say, 'I am going to surpass my vision.' They cannot, and rage."

This French *bon sens*, which warns when to admit the impossible, is typical of Villon. His method of work, his life are a calm, serene flow; the wisdom of the French philosophers is in him.

"Art," he said, "is a distillation of emotional and physical origin in which intelligence wins over intuition."

During the First World War Villon worked as a cartographer for the army. Many painters bear the mysterious, lasting influence of some early craft: stained glass for Rouault, photo retouching for Chagall, architecture for Léger, house painting for Braque, perhaps mapmaking for Villon. He said, "I decompose the subject into planes and my painting is a working drawing by which to read reality." Then, too, there are the years Villon spent working on etchings. "Maybe the differences of bite of the acids made me realize strongly the differences of planes," he explained.

Whoever has seen military staff maps with cross-sections indicating the changes of level in the ridges, the hills, and the mountains knows the importance of variations of levels. The slopes and ridges, translated pictorially, show a world of surfaces and edges. The thin line of the edges in a Villon painting is the clash of two color surfaces, the frontier where their color maximums meet. Any line drawn on any surface gives a new meaning; it is a ridge of the imaginary levels that surround it, and all flatness seems to disappear from our perception as we become familiar with this notion. Then we see lines in paintings with new eyes.

The scientific study of vision undertaken during the Second World War to teach pilots safe landing methods has proved the importance of gradients (the gradient of a hill is its change of altitude with distance) and the importance of edges that cause changes of light energy, which in turn stimulate the eye.

As I write about these findings, a Villon painting comes to mind, its surfaces, edges, conflicts of light stimulation, those essential requirements for maximum perception. If Villon's art is difficult it is because it is so advanced. Twentieth-century art is much less developed than twentieth-century science. But our understanding of new signs is rapidly increasing, and the seemingly incomprehensible but daring vision of the artist is a new facet of reality that the artist detects and reveals ahead of his time.

Villon finds geometry useful for the organization of his paintings. "I am constantly preoccupied with the pyramid of Da Vinci," he said. "We perceive things in a pyramidal way. Let's say the apex is in the eye and the base is in the object seen, or vice versa. As a matter of fact, both can coexist—a sort of going and coming between the eye and the object. This

interpenetration of double pyramids gives movement to a painting and at the same time ties it together.

"Then if one draws the diagonals of a canvas, the intersection is the summit of four pyramids. The extremes of value will be, let's say, on the opposite sides of the pyramid. A painting has its own light not connected with the light of reality. The choice of what my painting is going to be is made before the execution begins. I do not like to repaint."

Villon paused, then said, "All these systems, I use them roughly, but their great advantage in creative work is that they force me to reflect. This way I do not start working at random.

"Study is very important, study should be used to make plans. I like to collect evidence for my paintings, to make studies from nature before I start working. Study is to me what scales are to a pianist. Little by little, I discover harmonies in my study, harmonies that are to be brought out so that the painting can have a personality that it owes to itself and to its source without being merely a copy.

"My paintings always have their origin in reality. I stir the source around in every direction, but I always need contact with the earth."

"What is the relationship between the artist and the outside world?" I asked. "Is there a correspondence that starts the creative act?"

"There is an appeal, a call," he answered. "One's mind recognizes certain forms. The subject is, perhaps, not very important. I became interested in airplanes because of their general rhythm. Rhythm has great importance. An airplane is in the air, it flies; one can see it as a whole, which is effective. I choose my drawings by their rhythm."

Villon went on. "I haven't a good visual memory; I remember poorly; I must lean on nature. I do not flee reality. In my most extreme paintings I like to hold on to reality."

More than any other modern artist, Villon has reconciled the two opposing movements of contemporary art—abstraction and realism. This synthesis may well be the solution to many of the dead ends of art.

Villon has been called the Cézanne of modern art. Like the classicists, Cézanne believed that great art must be based on a theory and a system and not rely on the accidental, intuitive handling of paint. "To re-create Poussin from nature" meant to Cézanne to superimpose on our vision of reality the laws of composition, geometry, the laws of number which since Plato have governed all great art. Cézanne, however, lived on the threshold of the twentieth century. The Scientific Age was to him a vision of the future. He felt that he was the "first marker on the new path; others will come." But Cézanne, perhaps, was too human and too passionate to realize fully the severe vision of his mind. It is as though Cézanne proceeded with intuitive logic, and Villon with scientific method. A man of thirty when Cézanne died, Villon has benefited fully from the great development of science. He is the painter-scientist who with infinite patience and discipline pursues his research.

He told me, "I have a difficulty in speaking about art. All that I have done all my life is search. When one seeks, one cannot put precisely into words what he has not yet found."

Never in any other artist's work have I seen a clearer manifestation of the sum of the mentally torturing, physically exhausting actions that go into the creation of a truly thought-out work of art. Yet Villon's art is not cold, for where Poussin, in his severe seventeenth-century French classicism, re-created the chilling, gray-shaded stillness of antique marble, Villon has used the vitalizing energy of pure color to express his severe compositions. He is fortunate to have inherited his intense palette from Seurat and the impressionists, but above all from such daring visual scientists as Chevreul.

When Villon sat down to paint, he picked up his brushes, and among them stuck out a ruler. With this restraint in hand he works. "There must be a discipline. One must sit down in front of the easel without waiting for inspiration. Inspiration has its place, but at a different moment. Inspiration in painting must be reduced rather than increased. If one increases it, one arrives at a false inspiration.

"Cennino Cennini orders artists to pray before they start working. That is so that they do not rush to their canvases and start putting down colors by accident. A preliminary meditation is necessary. It predisposes and forces one to concentrate and not to let oneself go at random.

"For a long time, I painted very freely," Villon said, "but I felt the need to meditate, reflect, organize. Now I submit to the laws of color and of the chromatic scale. This submission allows me to get ready; it is a preparation. Chance notation is good in a study, but after that one must bring order. Laws of color are not absolute, but important. Now I bring my work back to the laws of color—chromatic circle. I believe that the division of the canvas by the golden section helps a great deal.

"There is an inner discipline too that, in a way, controls everything. Even in the work of the abstractionists, where chance seems to dominate, there is a play of memory.

"I like to concentrate on a drawing without having other preoccupations and then to organize it into a painting. Above all, I am conscious of organization. I seek to avoid confusion. A work of art is more than just a conversation, it is a discourse. One must strengthen the thought behind a painting. Organization gives a rhythm on which drawing can lean. The drawing is not confined but rather held together by the laws of organization, instead of being governed simply by taste.

"Taste is a dangerous thing, especially for painting. After I have made a study drawing, I transform it by stressing rhythm. I avoid transforming because of taste, just to have it look good. If one paints just to record a bouquet of flowers, then taste is enough. But if one wants to magnify the bouquet of flowers, one must make a cathedral out of it, transform it. In art one must erect, one must go beyond the painting.

"My ambition is to explode the object and to make it, in exploding, reach the edges of the canvas, thus creating a new object."

Later he said, "Painting has changed and will change again, given new mechanical means of self-expression. The painting of today is a tributary of the painting of the past. I do not feel the need to redo *Sardanapale*, or the great sub-

jects of the nineteenth-century painters. The painting of the future will not have to express all that we were obliged or wanted to express.

"In ten thousand years will there still be painting? Will there be a need to paint? One wonders if maybe art, beauty, and truth are not as absolute as one believes. I wonder if they are not relative, relative to the times, to manners, and customs. Yet there is something more than taste."

On a large worktable in his studio were many sketchbooks and loose sheets of drawing paper. He said, "When I was young I made many sketches, now very few, but I have found that when I now feel the necessity to sketch there is a real significance."

This statement revealed a curious ability of his mind to take with a grain of salt whatever happened to him. Certain sentences reveal graphically the structure of the inner mental process and permit the study of a man's mind.

Villon is *un homme d'esprit*. In the French language the one word *esprit* stands for humor but also soul, mind, sense, understanding, intellect, wit, fancy, temper, character. The dignity of man is his mind. Intelligence is the weapon he uses in his struggle with the universe; with it, man is slowly unlocking the many closed doors that bar progress toward understanding. The mystic, the philosopher, the scientist, the artist are but names given to men of the mind, who seek in their own chosen ways the answers to their questions. Their search for the truth is a measure of man's faith.

When I watched Villon work and live, listened to Villon speak, the great aged artist seemed to be "the portrait of the artist as a young man." It seemed as if James Joyce had prefigured Villon's existence and thoughts—as if the painter ahead of his time confirmed the vision of the writer who wrote of art: "To speak of…things and to try to understand their nature, and, having understood it, to try slowly and humbly and constantly to express, to press out again, from the gross earth or what it brings forth, from sound and shape and color, which are the prison gates of our soul, an image of the beauty we have come to understand—that is art."

Notes on the Illustrations

Jacques Villon (Gaston Duchamp), 1875–1963. Born: France. Photographs taken in 1950, 1954, 1957, and 1959.

1. Villon at work. The white paint that is the artist's light was added in measured amounts to all colors, bringing them into luminous balance. The paper palettes, which he discarded, are collected by Villon admirers.
2. The famous bust of Baudelaire by Villon's brother, Raymond Duchamp-Villon, is a dominant presence in the studio.
3. Jacques Villon at seventy-nine. The model of an airplane in his hand expresses his vision of space.
4. The interior of Villon's Puteaux studio. His easel nearly always stood in front of the same wall. Through the years very little changed in the things surrounding him; only the new paintings reflected the variation in the vision of the artist. The two canvases are in his late manner (1958). The sculptures are all the work of Raymond Duchamp-Villon, one of the great sculptors of the cubist generation.
5. An intimate moment: Villon, with his wife Gaby, at lunch.

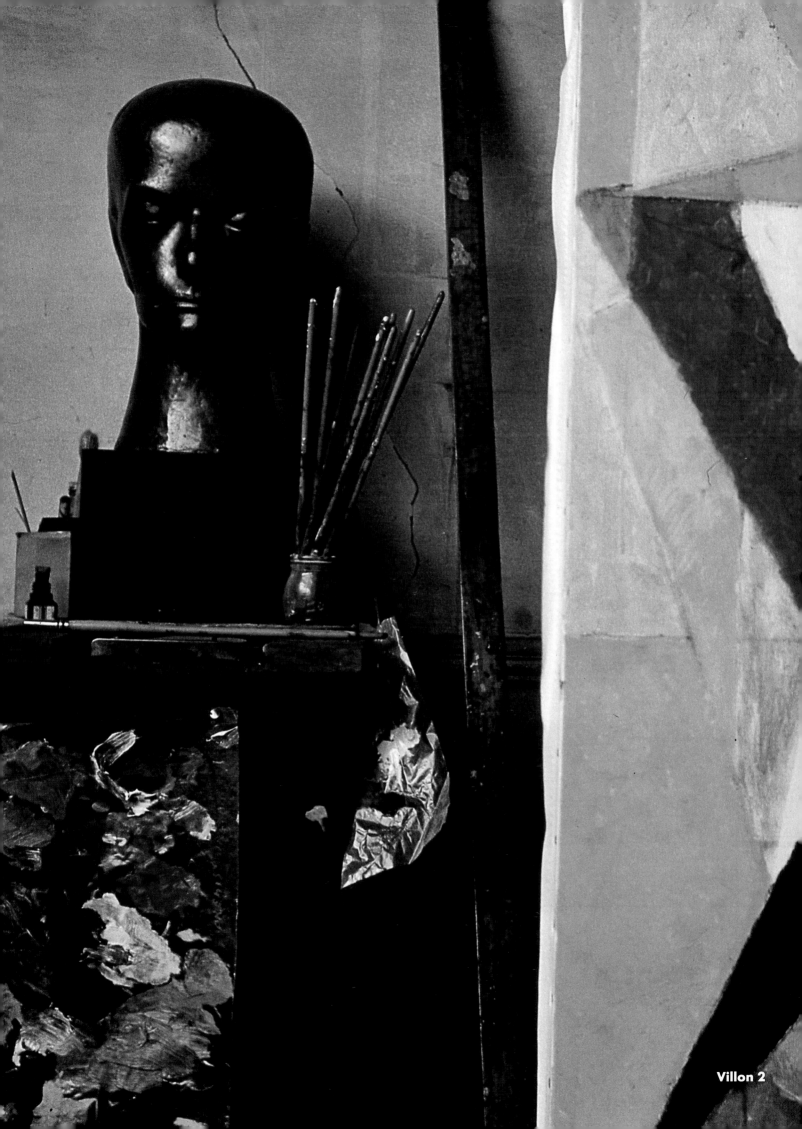

Villon 2

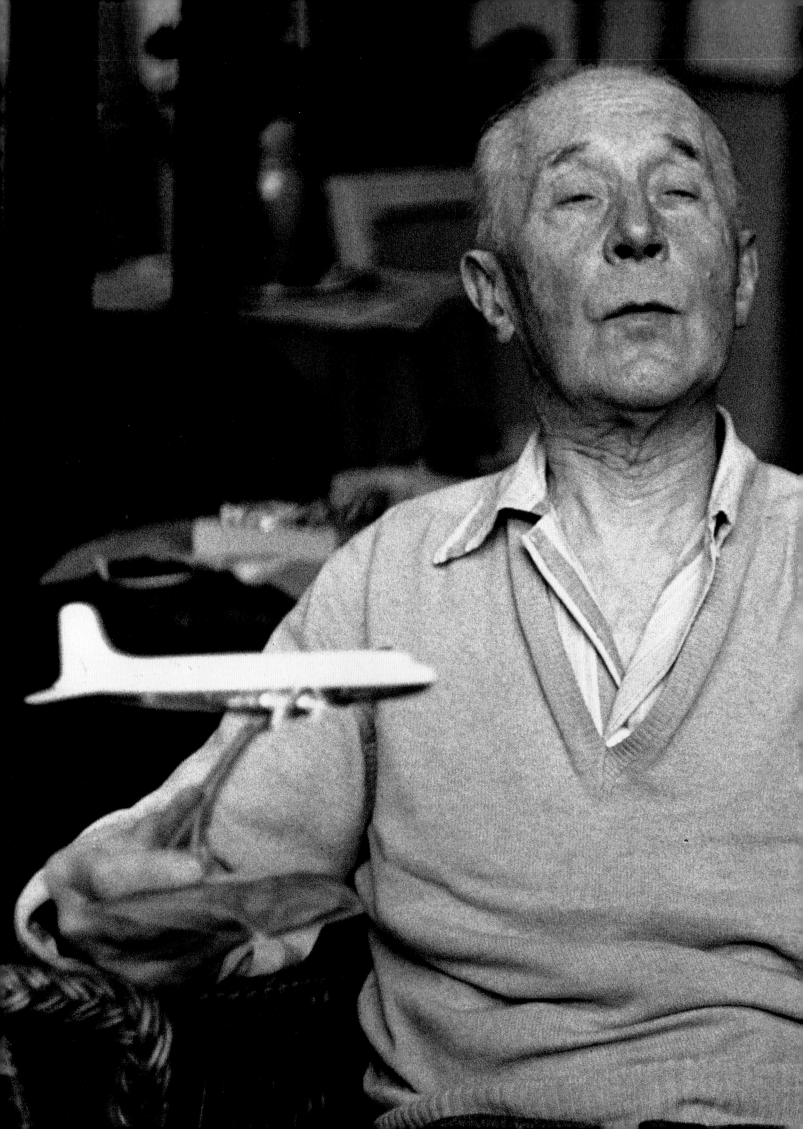

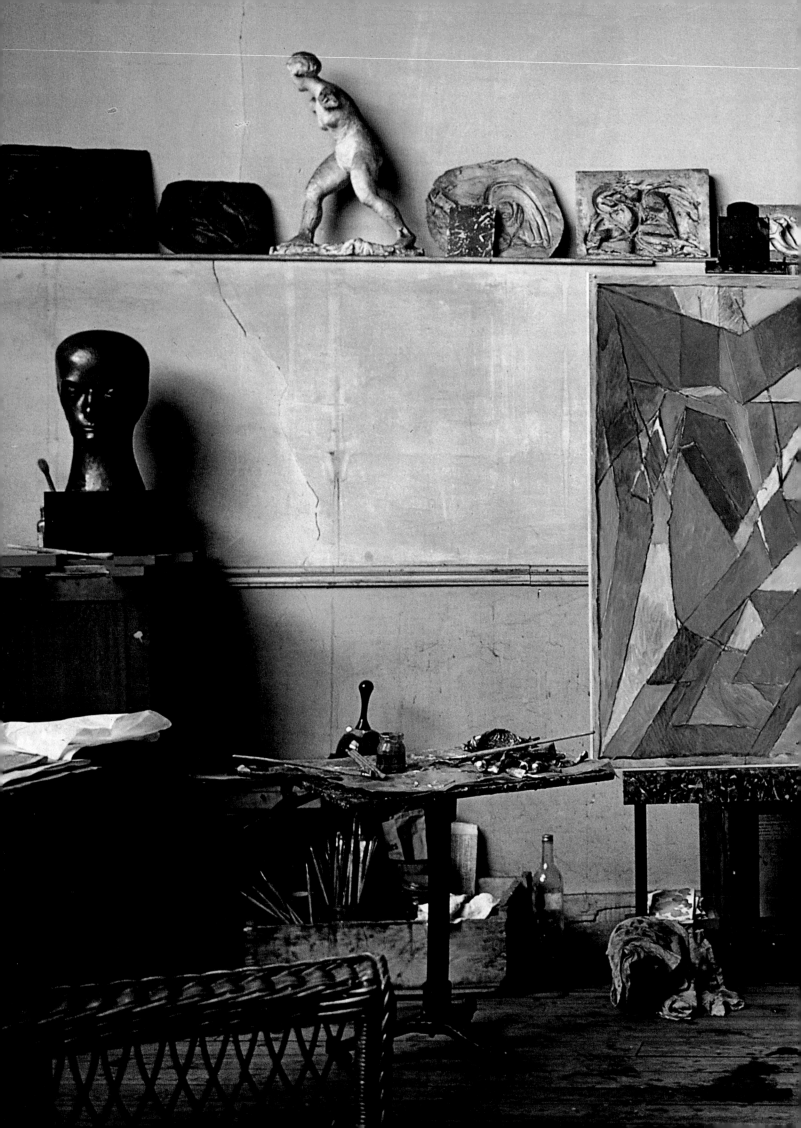

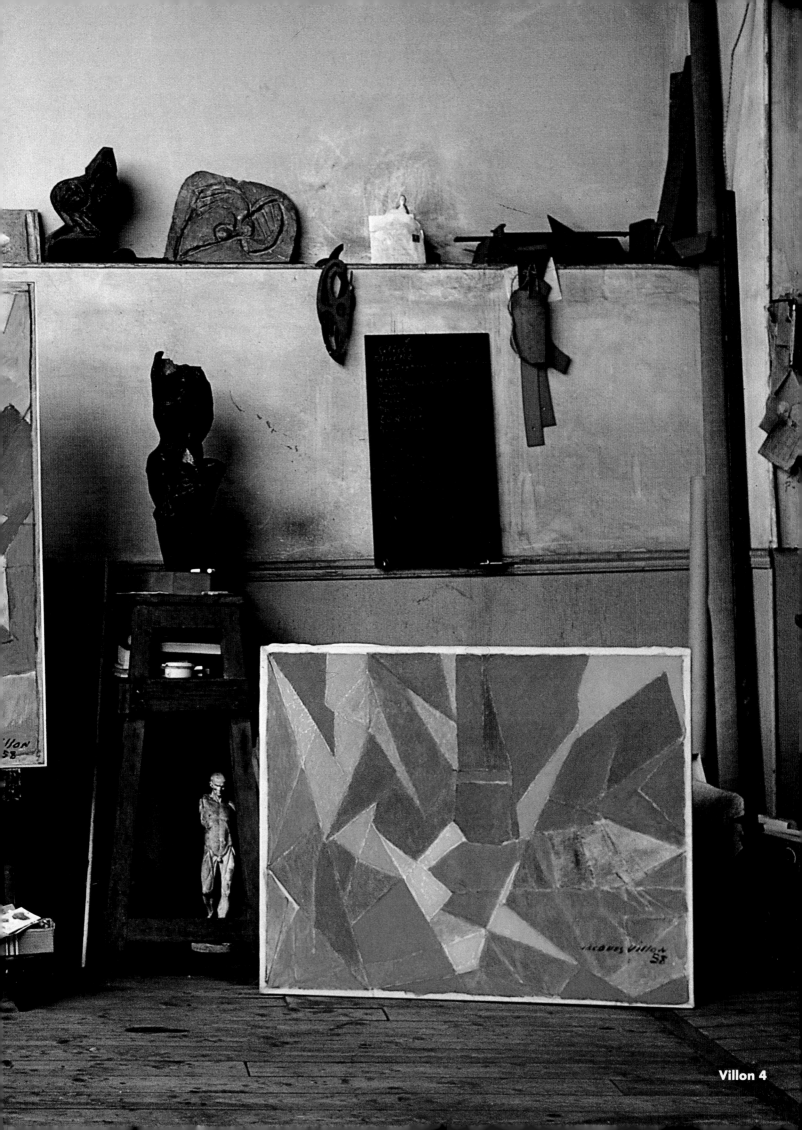

Villon 4

Villon 5

Duchamp

His face tortured with subtleties, his hands moving in a courtly ballet, Marcel Duchamp has a strange, regal presence, an ecclesiastical authority. Only the prelate's robes are missing. He is a truly Renaissance man, a curious mixture of poetry, earthiness, and cunning. In his New York apartment are many sets of chess, the game with which he is obsessed, perhaps because in it he finds a sublimation for power. Duchamp is a professional chess-player. "I never abandoned painting for chess," he said. "That is a legend. It is always that way. Just because a man starts to paint does not mean he has to go on painting. He isn't even obliged to abandon it. He just doesn't do it any more, just as one doesn't make omelets if he prefers meat. I do not see the need to classify people, and, above all, to treat painting as a profession. I don't see why people try to make civil servants out of painters, officials of the Ministry of Fine Arts. There are those who obtain medals and those who make paintings."

Duchamp is the aristocrat of modern art. He has the haughtiness that comes with the dismissal of creative torment. He has put an end to his creative suffering; but even before this his hands did not have to be sullied for him to create. He had the arrogant vision to see and to confer art upon what he deigned to see.

Marcel Duchamp, the man who painted a mustache on the Mona Lisa to show his contempt and irreverence for the sacrosanct attitudes that he felt were stifling the creativeness of young artists, shocked America with his *Nude Descending a Staircase*, in the 1913 New York Armory Show. He was one of the first dadaists, the group which started out in 1916 as a revolt against traditional art. His was a revolt against academic aesthetics; he wanted art without art. Marcel Duchamp was one of the first to discover the "ready-made"; he realized that the everyday object could be transformed by artistic selection into an object with aesthetic qualities.

During our conversation he said, "There are too many artists. When there are so many artists, all possible, all good, then nothing is good. In each century there are no more than one or two geniuses. Otherwise art becomes a profession, a handicraft, and a painter makes a good painting just as a cabinetmaker makes a good piece of furniture.

"Today the artist is free, free to die of hunger. An artist should have no social obligations. If he marries, has children, he very soon becomes a victim. He must earn money to feed his family. Only one person who does not have to be fed is easier than three or four. To increase the number of people around an artist is a calamity. By forty or fifty he can earn his living comfortably, but thirty years have gone by during which he had to compromise to do it. An artist must be an egotist. He must be completely blind to other human beings—egocentric in the grand manner. It is unavoidable, one cannot create great things if he is only half involved and in doubt.

"The life of an artist is like the life of a monk, a lewd monk if you like, very Rabelaisian. It is an ordination."

Notes on the Illustrations

Marcel Duchamp. 1887-1968. Born: France.
Photographs taken in 1959.

1. Duchamp in the living room of his New York apartment, standing before his work on glass, Nine Malic Molds, *1914-15, a study for his great* The Bride Stripped Bare by Her Bachelors, Even ("The Large Glass").
2. The hands of the artist playing chess, his great obsession.
3. Duchamp, The Bride Stripped Bare by Her Bachelors, Even ("The Large Glass"), *1915-23. Oil and lead wire on glass. Philadelphia Museum of Art: Bequest of Katherine S. Dreier.*
4. A typical gesture of ironic mystery.

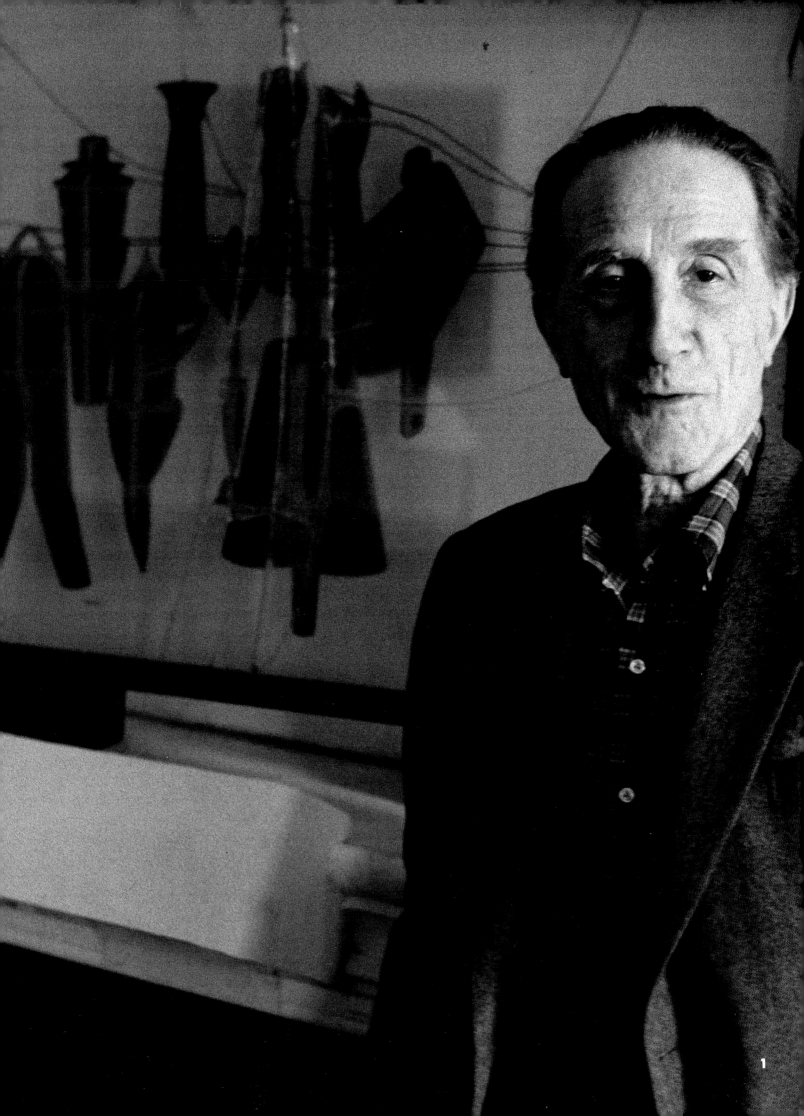

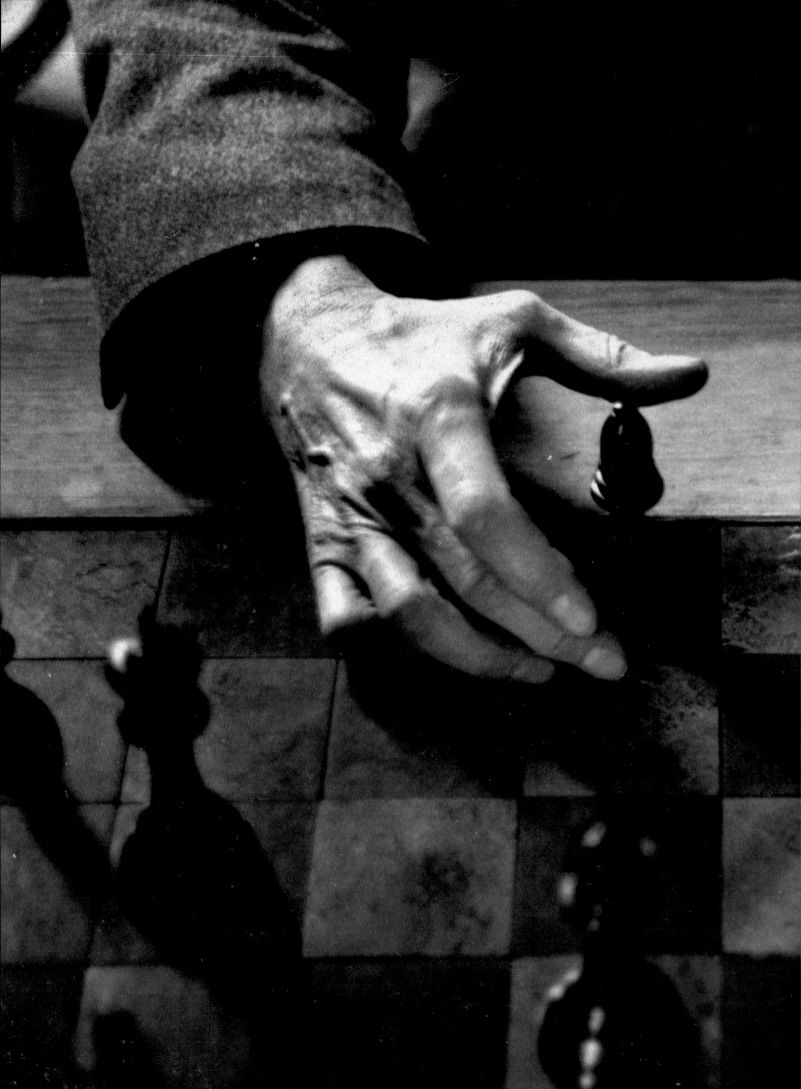

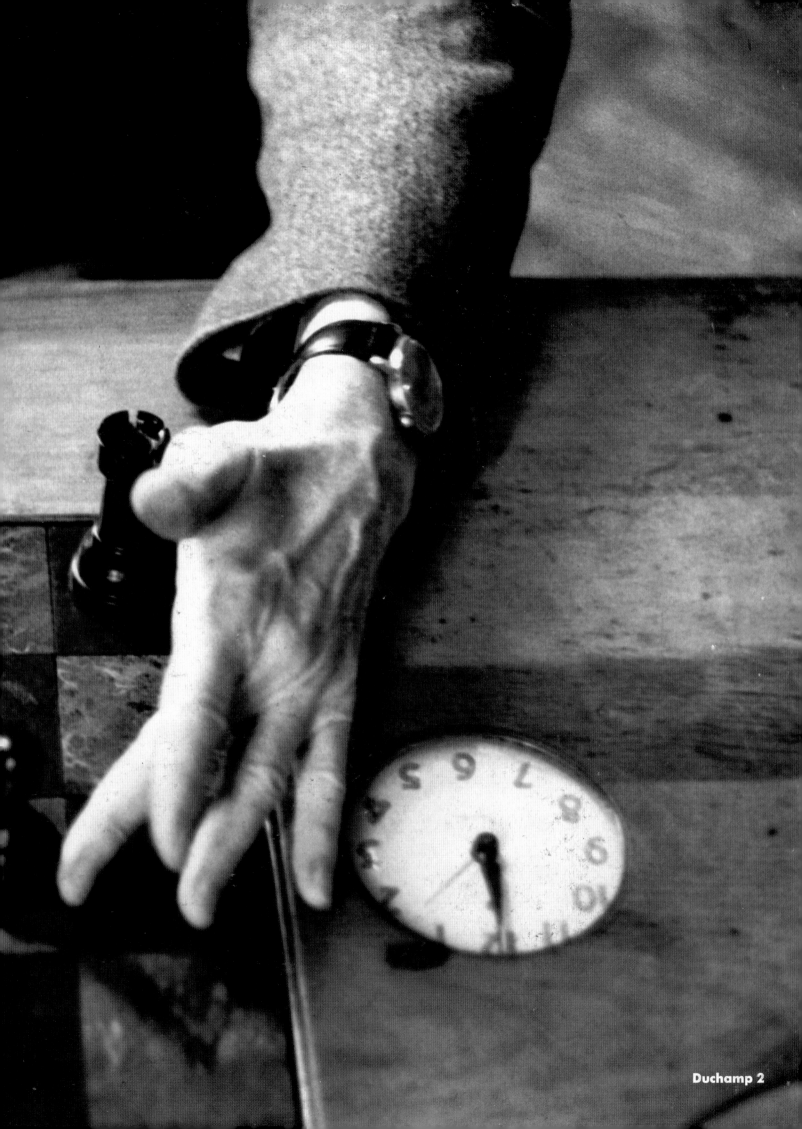

Duchamp 2

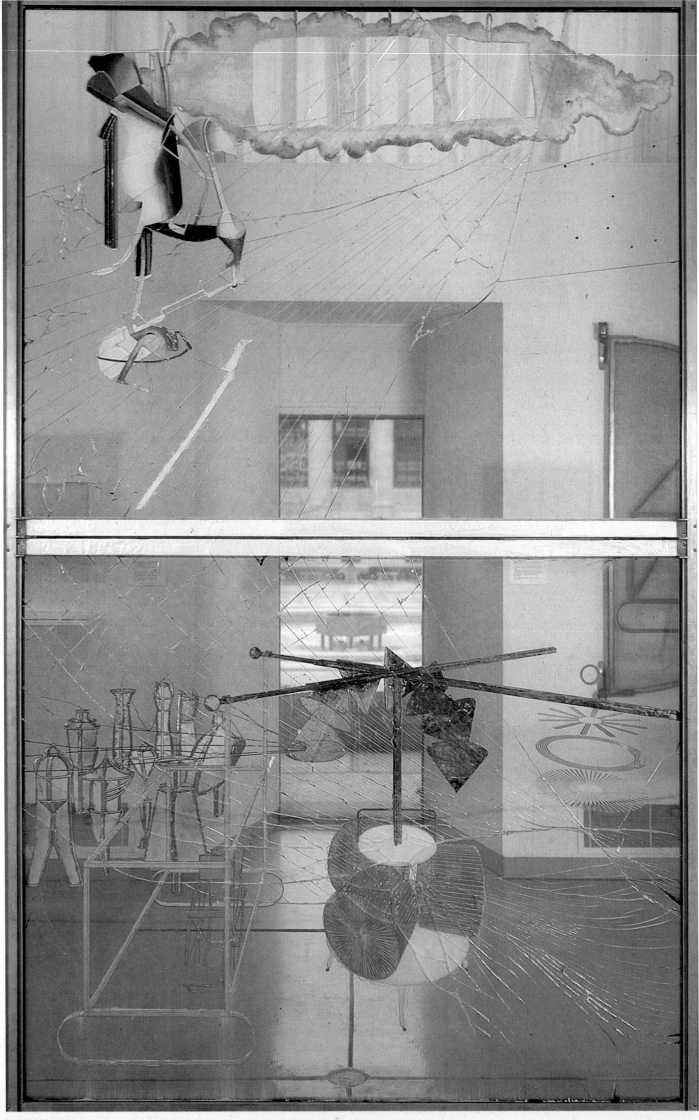

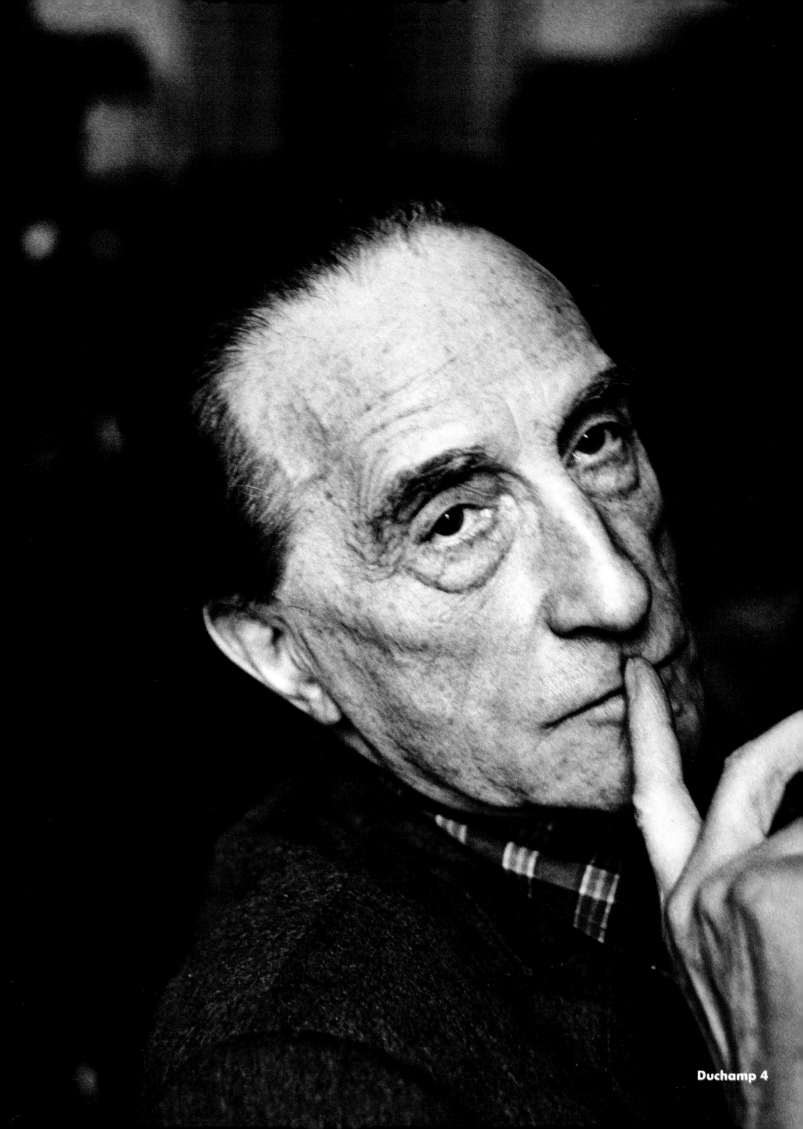

Duchamp 4

Arp

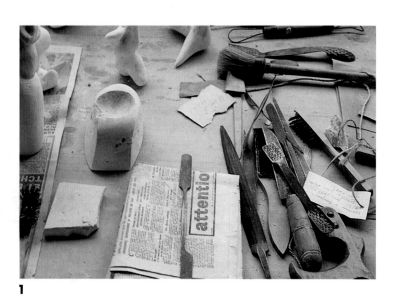

1

Jean Arp is one of the giants of modern art. His share in the shaping of the new image of the world around us is, and has been for a long time, dominant. One of the founders of dadaism as far back as 1916, he pursues his iconoclastic creation with a serenity that only supreme self-confidence can give. After years of being left in relative peace, now that the abstract century has begun, he emerges as the shape maker of things present and to come.

When I last saw him, he stood in the long narrow studio as if hemmed in by the inventiveness of his all-white perfect forms. He remained motionless, deep in thought; then, an unexpected gesture of his hands, a movement of expression across his face made me sense that behind his deceptive scholarly calm lurked a wit destructive yet essentially kind. A quick, shy smile broke the Olympian mask to reveal for an instant that the most serious creative act can have its roots in humor and in a sense of play. The source of his adventure is perhaps the release that laughter gives to inspiration.

Notes on the Illustrations

Jean Arp, 1887–1966. Born: Alsace.
Photographs taken in 1959.

1. The sculptor's tools.
2. Jean Arp in a playful moment in his sculpture studio.
3. The study on the second floor of the Arp home. On the walls, works by his first wife, Sophie Taeuber-Arp, an important artist in her own right, hung with his own. At times the couple worked together on paintings and collages.
4. Arp, Enak's Tears (Terrestrial Forms), 1917. Painted wood relief, 34" x 23⅛" x 2⅜" (86.2 cm x 58.5 cm x 6 cm). Collection, The Museum of Modern Art, New York. Benjamin Scharps and David Scharps Fund and Purchase.
5. Arp in the studio with his assistant, surrounded by works in plaster.

Arp 4

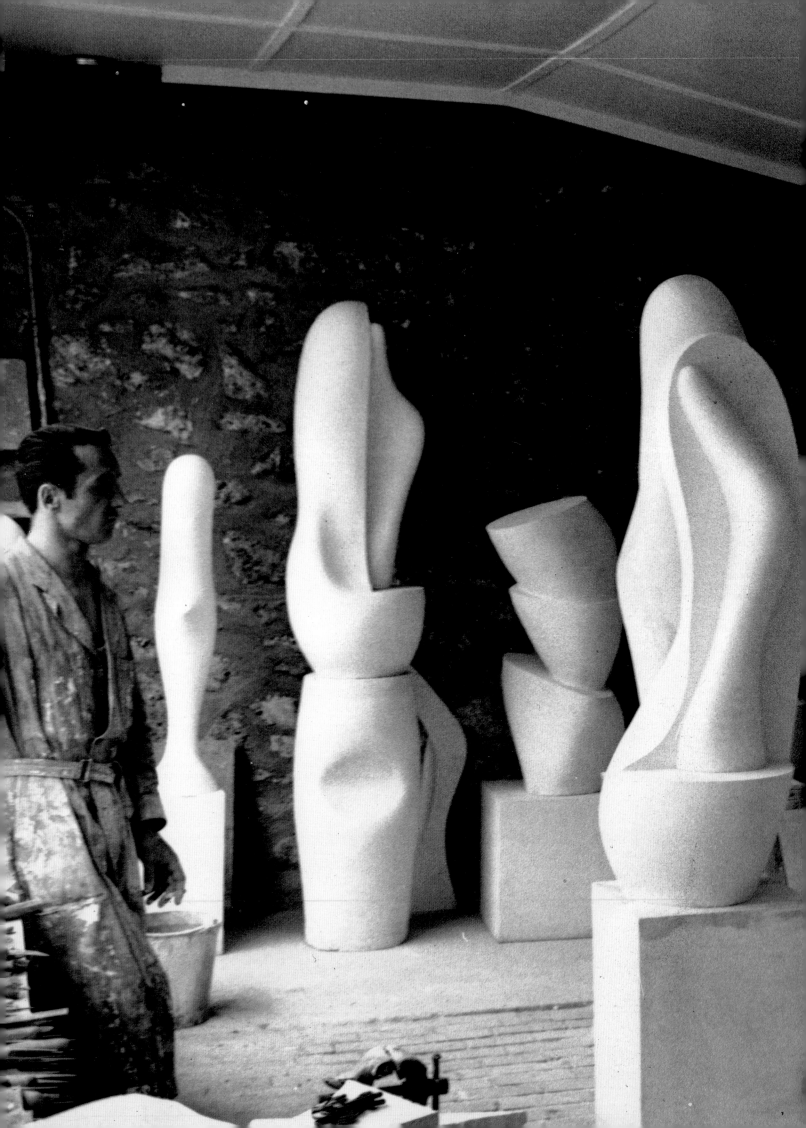

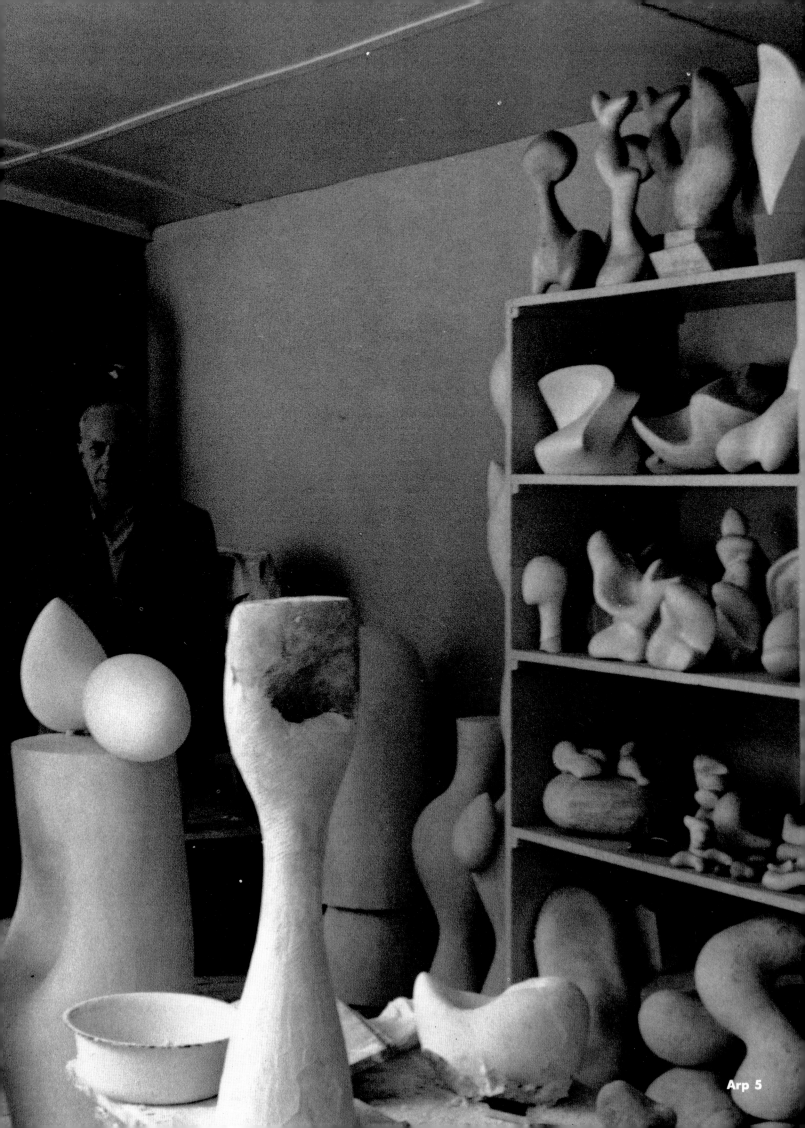

Masson

The studio of André Masson in Aix-en-Provence has the bareness, the intimacy of a Provençal farmhouse. The view from this studio is dominated by Cézanne's Mont Sainte-Victoire. "Since Cézanne," Masson said, "one feels too much in painting the obsession with volume and monumentality. Oil painting is too heavy. I want to deliver the world from gravity."

The son of rich peasants, Masson is rugged, yet gentle. Somehow, the peace of country life has slowly stripped him of defenses. He seems to be a quivering receiving center for the translation of visual impulses. He uses this state to pursue his research, constantly trying to find better means and newer mediums. When I saw him last, he was experimenting with throwing sand and fixing the obtained design.

"I want to create a cosmogony, to remove objects from their familiar and useful situations. In this painting [of nudes] I wanted to represent the effort of taking off into flight —beings who are rooted, but have wings and want to fly away. I wanted to project the nudes into a space in which they could live freely. Cosmogony! If I could explain it in words, I would write instead of painting. I want to paint the birth of things, to represent the act, the effort of creation. It is more important than the painting. The painting—it is up to the spectator to make it. The artist must work with the thought that the spectator can understand things half said, not completely described. Just because a spectator is slow, the artist does not have to be slow. One must be understood, but not at any cost. I must hope that the spectator will understand the seed I have offered him."

Notes on the Illustrations

André Masson, 1896–1987. Born: France.
Photographs taken in 1956.

1. Masson in his Aix-en-Provence studio. Masson was one of the first French artists to investigate the action of chance — through the throwing of paint.

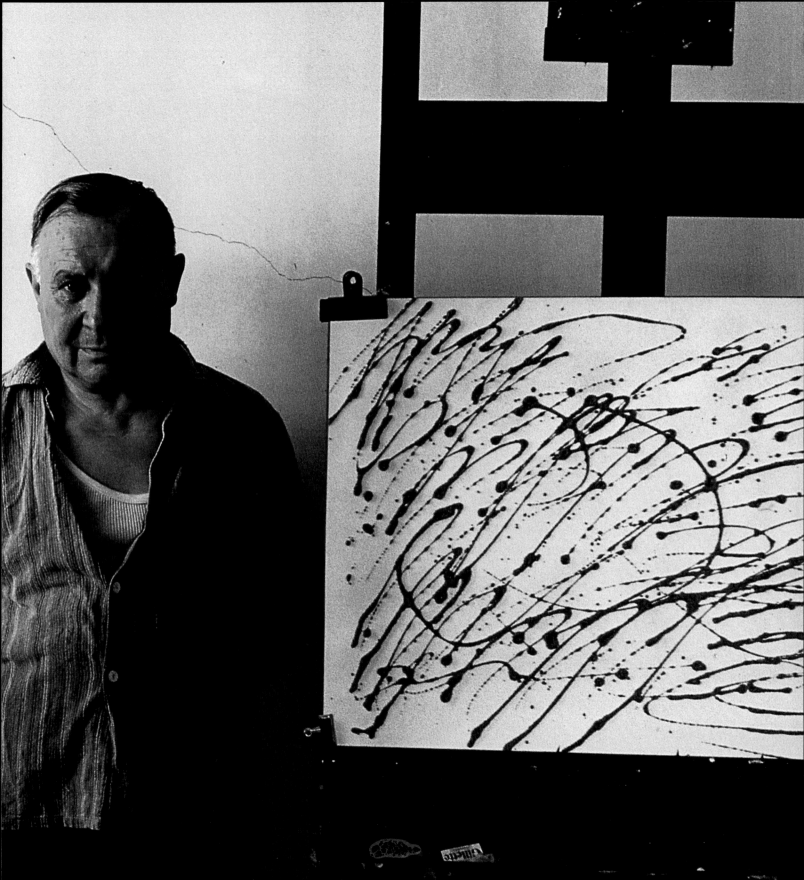

Dali

Salvador Dali's incredible gestures in art and in life are extensions into space of his inner being. To him the incredible is always possible, and he is sure to try to make it happen. This brilliant intelligence is ready at any time to jolt the conventional and the complacent. Art to him is a tool for opening new horizons to man's imagination. He is a sum of contradictions held together by aesthetic passion. Mysticism, anarchism, surrealism, classicism, expressionism are all reduced to one simple result, Daliism. He surrounds himself with an air of mystery. His long hair "à la Velásquez," his gold-tipped cane, his aggressive mustache pointing to his piercing, steely eyes, his purposely difficult to comprehend speech—all contribute to the spectacle of what he believes the image of an artist caught in life should be. His wife Gala, ever present in his art and in his life, is the approving and inspiring partner in this unique collaboration between husband and wife on the art stage of the world.

Notes on the Illustrations

Salvador Dali, 1940-. Born: Spain.
Photograph taken in 1959.

1. Salvador Dali, the extravagant surrealist, who acted out his paroxysms throughout his public life.

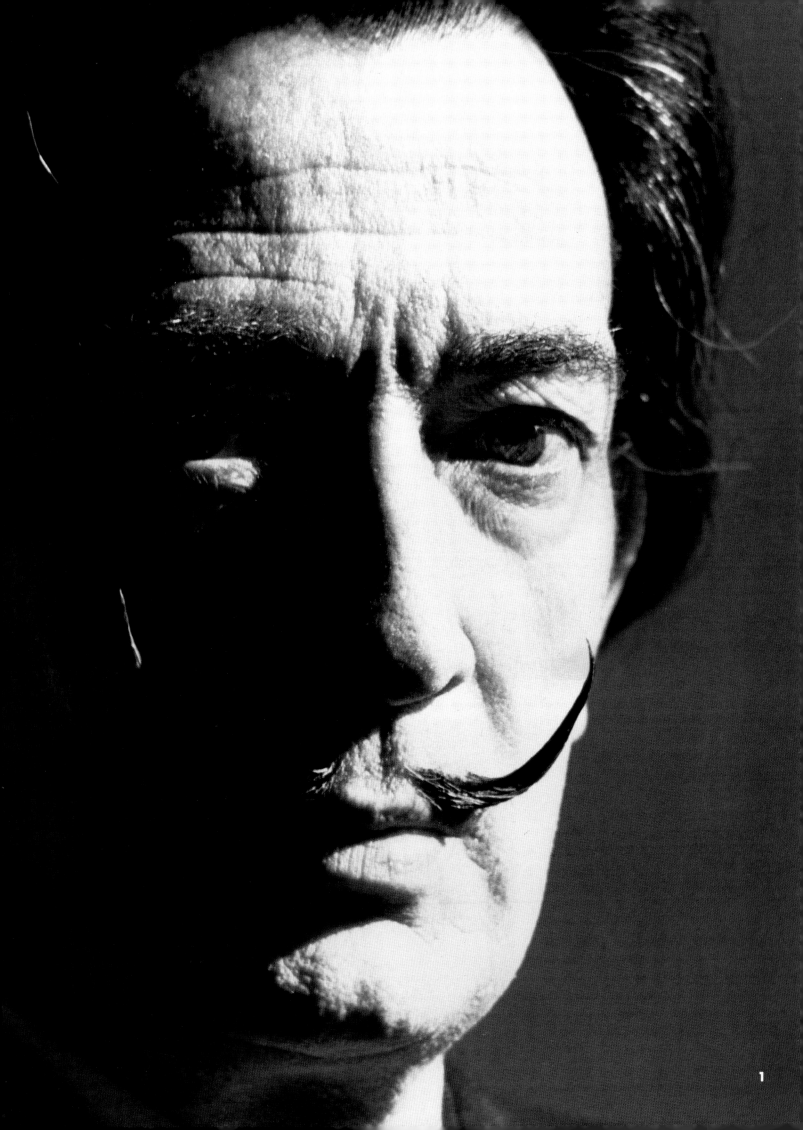

Ernst

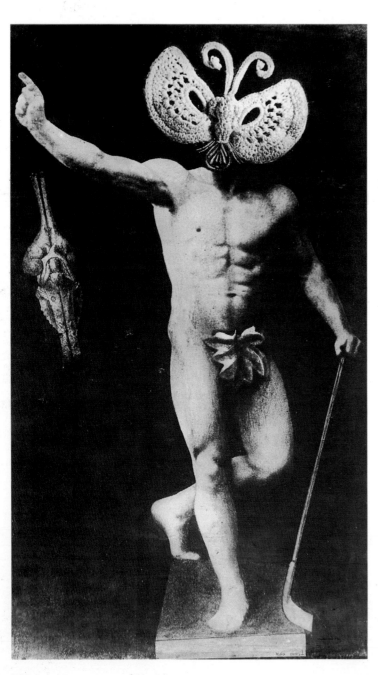

Max Ernst brings to painting a mind trained in philosophy. From the earliest days of dada and surrealism, he has juxtaposed images as intricately as thinkers juxtapose thoughts. His inventiveness opens new visual horizons. His experiments with technical means lead to a hitherto unknown language of textures.

His studio is in Huismes, about three hundred kilometers from Paris. The Loire countryside is the true image of *douce France*. Flowers surround the studio in a remodeled farmhouse. In this idyllic, tender scene of nature, Ernst's creations seem the materializations of an alchemist's search. his Gothic features, the white, silky long hair, his self-conscious and studied manner all increase the impression of a visual link with the medieval past. The paintings and the still expression of his eyes made me feel that he had studied the cabala.

Notes on the Illustrations

Max Ernst, 1891–1976. Born: Germany.
Photographs taken in 1959.

*1. Max Ernst, La santé par le sport ("Health Through Sports"), 1920. Courtesy of the Menil Collection, Houston.
2. Max Ernst in his Huismes studio in 1959.
3. Ernst, Euclid, 1945. Courtesy of the Menil Collection, Houston.
4. In his studio. Beside a painting on the easel, a stand with paper palettes. Ernst pioneered in the research of textural surfaces and graphic surrealist collage, his inventive mind constantly ready to find and exploit the undiscovered.*

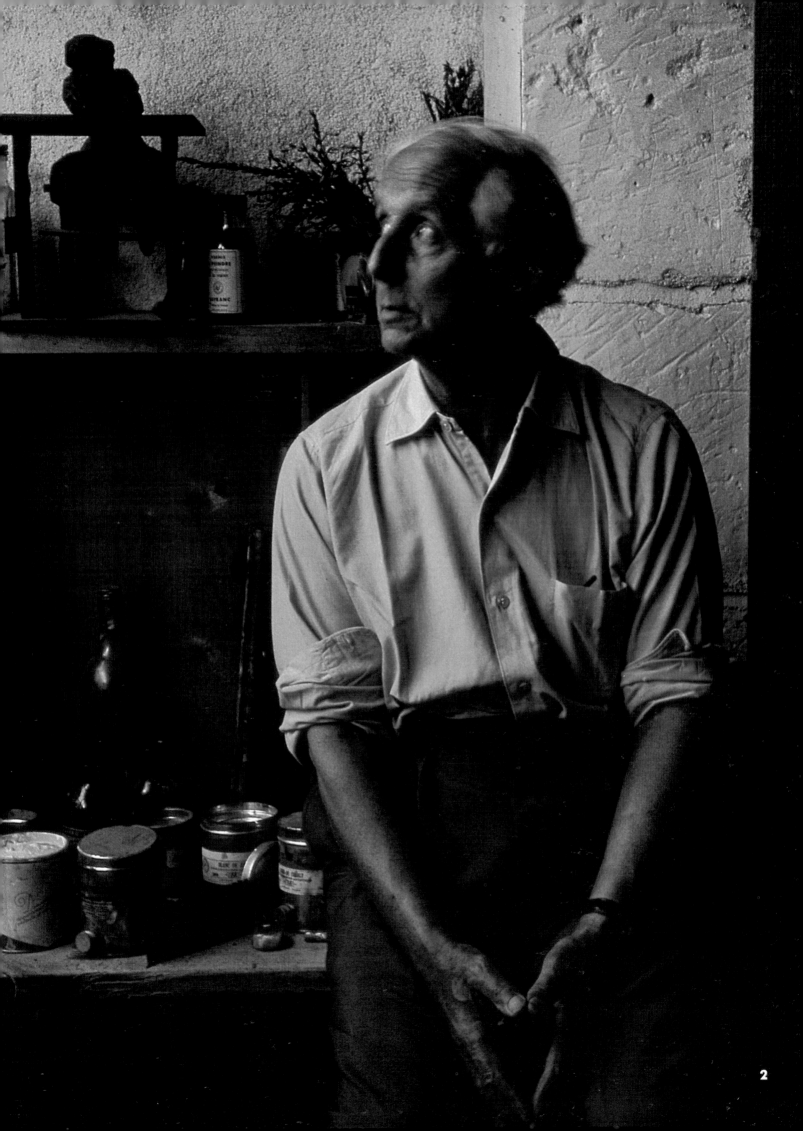

Ernst 3

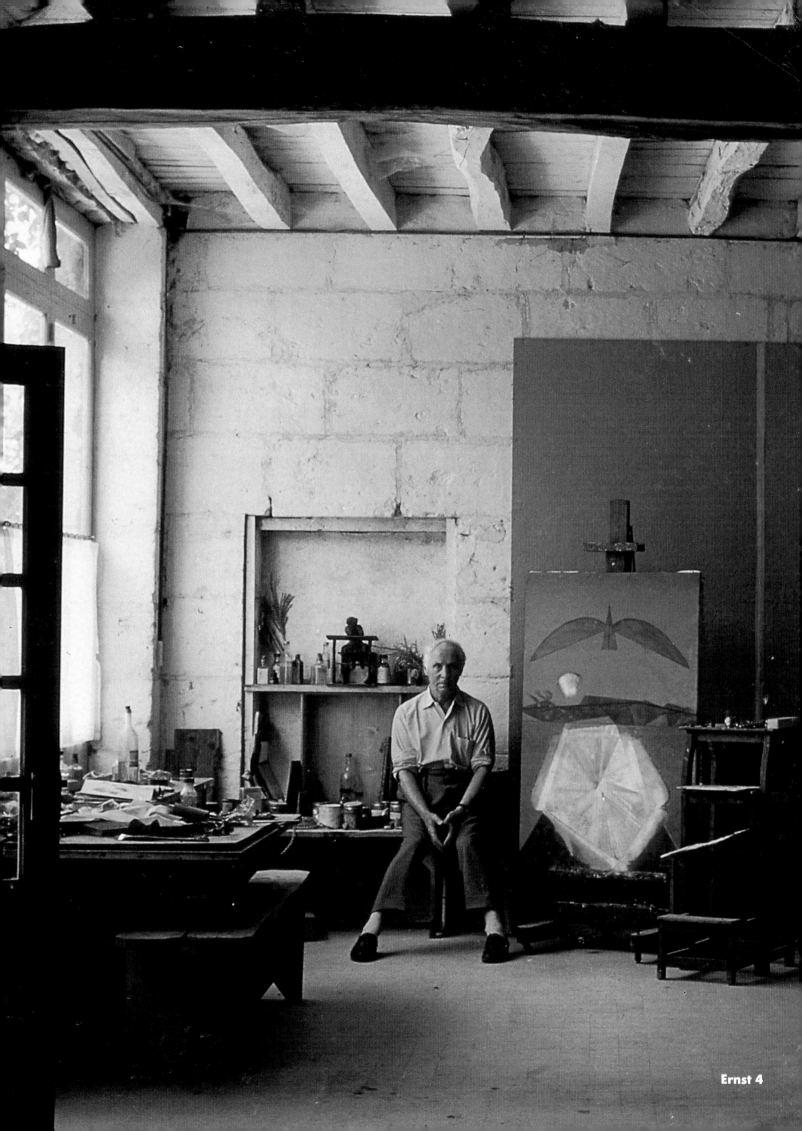

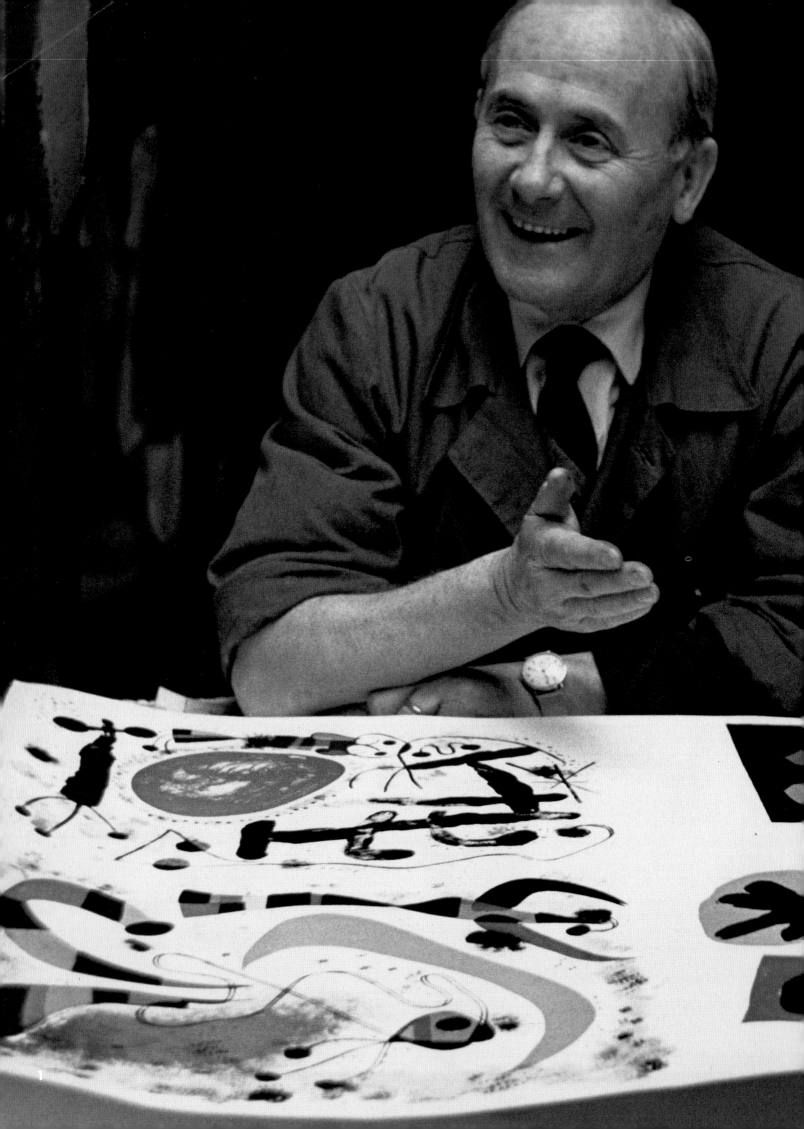

Miró

J oan Miró has no studio in Paris. The closest he comes
to one is the Mourlot lithographic atelier, where he
creates his unique language of signs. His lithographs
belong in the hierarchy of Miró's work and are a major
achievement. A few years ago he won the Grand Prix at the
Venice Biennale for his graphic work. When I saw him in
1953, he sat framed in an alcove and surrounded with first
proofs of some new lithographs fresh off the presses. Rotund,
short, he easily breaks out into a kind, witty, innocent smile,
but his gestures are formal and stylized, as if he were in a
Guignol show. This stylized approach to spontaneous humor
is the essence of Miró the man, the artist. He seems to be
smiling at imaginary puns. The pun is a reviving somersault of
humor, and Miró's drawings themselves are visual puns. His
smile, as suddenly as it comes, disappears, and he withdraws
from the reality around him into a haughty absence. His face
and body take on the forbidding stiffness and severity that
only the Spanish can achieve, a mixture of arrogance and
humility, arrogance toward life, humility toward death. Miró's
humor, like a ray from the sun, fights off the ever-encroaching
darkness and sadness in his Spanish temperament.

Notes on the Illustrations

Joan Miró, 1893–1983. Born: Spain.
Photographs taken in 1953.

*1. Joan Miró working on a series of lithographs in the Paris
atelier, Mourlot, where Matisse and most of the greats
created their graphic oeuvre. Miró's printed works are one of
his most vital contributions to the modern visual life.
2. Miró, Hirondelle/Amour, 1933-34. Oil on canvas,
6' 6 ½" X 8' 1 ½" (199.3 cm X 247.6 cm). Collection,
The Museum of Modern Art, New York. Gift of Nelson
A. Rockefeller.*

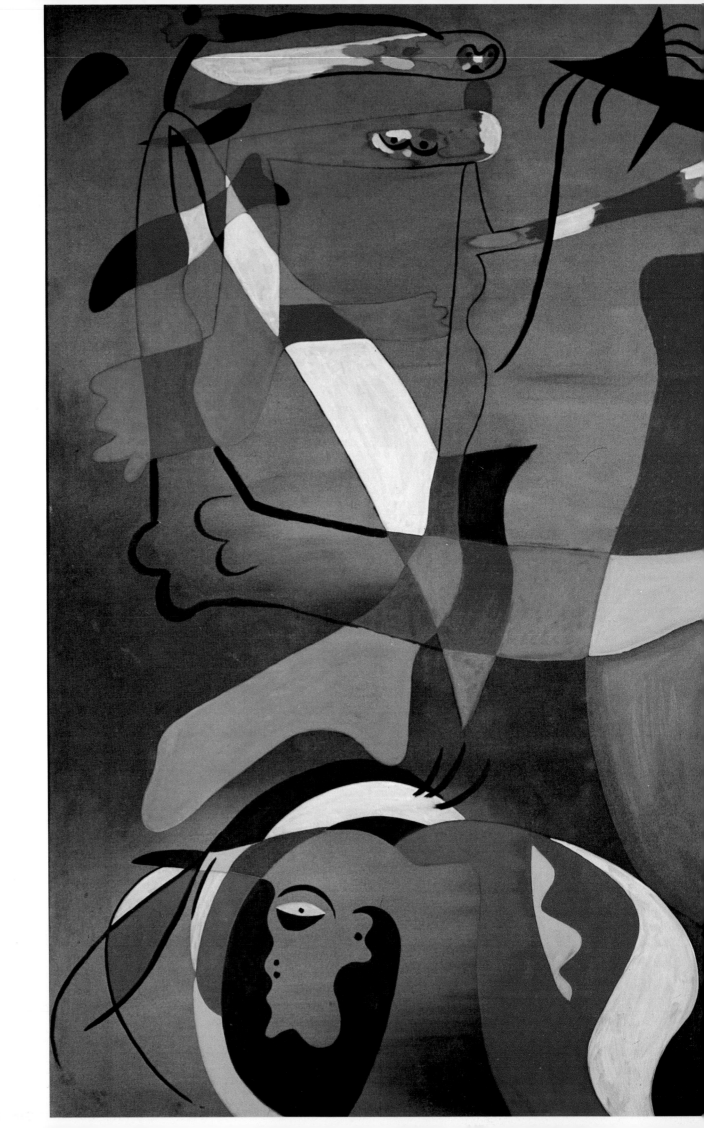

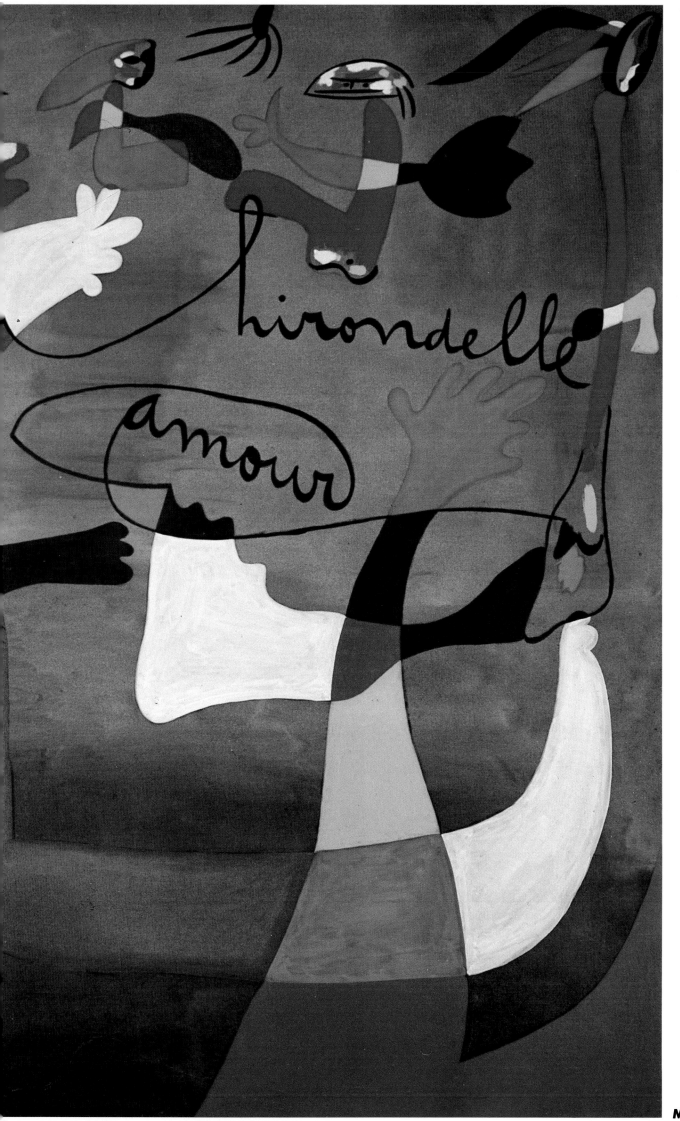

Miró 2

Dubuffet

The origin of pictorial vocations is mysterious and varied. Jean Dubuffet was a wine dealer, then a maker of theatrical masks. He assaults the concept of beauty with the violence of a primitive. A compulsive belief that truth can be found in untrained vision makes him investigate the arts of the innocent—children, savages, madmen, and the unconscious everyday artists who scribble on walls. These outpourings of instinct, however distorted, are the undecoded messages from man's inner yearnings.

It is hard to penetrate Dubuffet's shell of self-protection from everyday life; he knowingly shelters his inner dreams. He looks like a being who could have lived untold years ago. With something of a medium's power Dubuffet links in his art the far-distant past with the unseen—to all but him—future. He has broken more violently with the conventions of traditional easel painting than any painter I have photographed. I watched him throw sand, or gravel, into amorphous mixtures smeared over a plaster board. With a knife, trowel, rag, or his hand, he shaped the lavalike flows of earth color until he finally brought them to a stop. I marveled at the amount of stored-up skill he summoned to fix the fleeting images that seemed to well up like volcanic eruptions.

Notes on the Illustrations

Jean Dubuffet, 1909–1985. Born: France.
Photographs taken in 1952.

1. Jean Dubuffet in 1952 on a working visit to New York.
2. The painter in action, using plastics on wood. Dubuffet abandoned traditional tools and made movement and speed participate in the creation of his paintings.
3. Dubuffet, Corps de Dame: La Juive, *1950. Oil on canvas, 45¾" X 35" (116.2 cm X 88.7 cm). Collection, The Museum of Modern Art, New York. Gift of Pierre Matisse.*

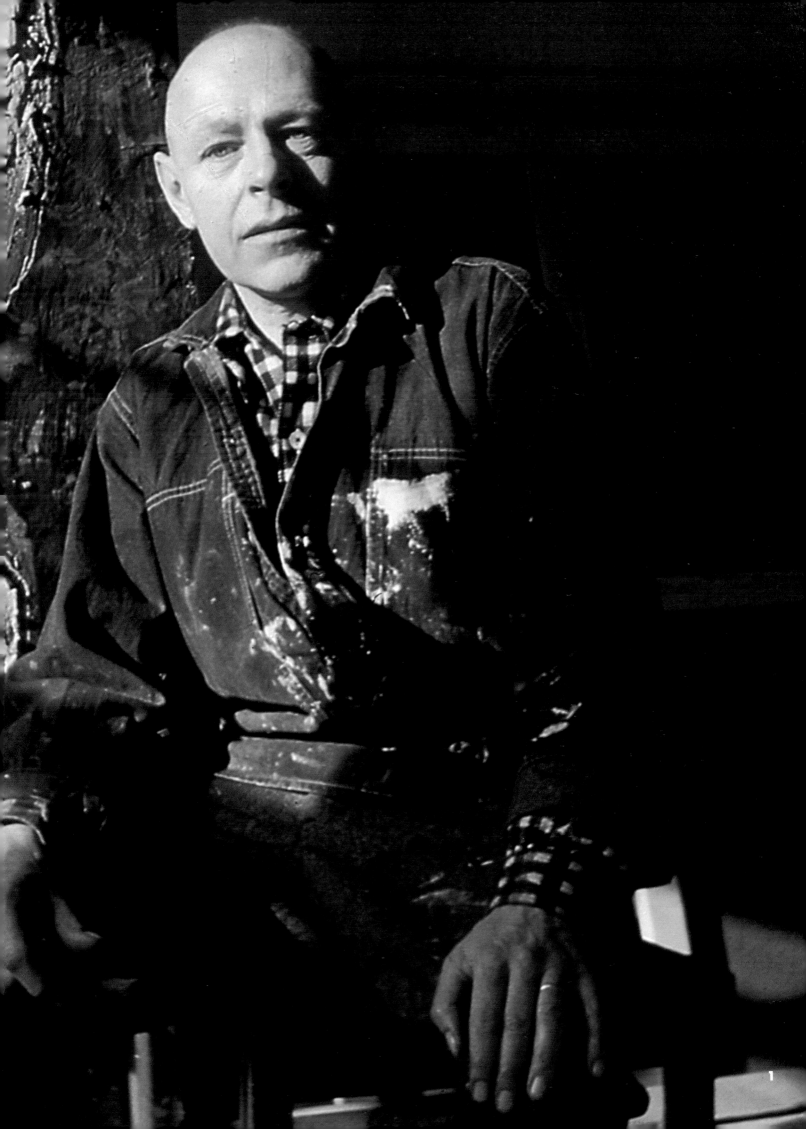

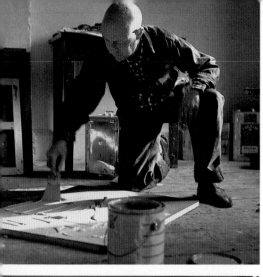
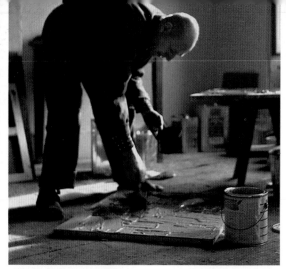
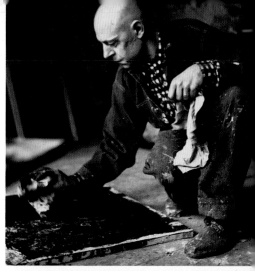
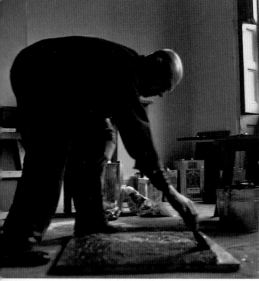
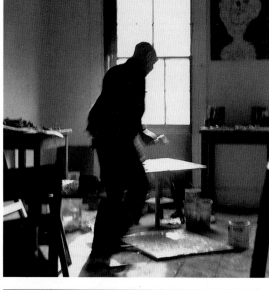
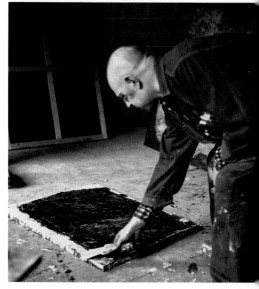
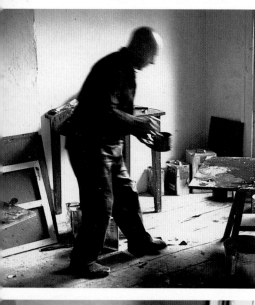
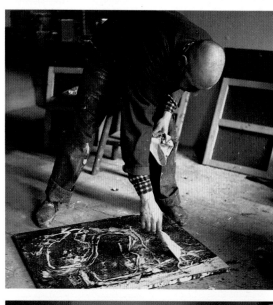
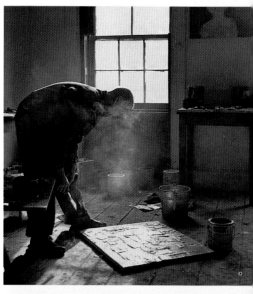
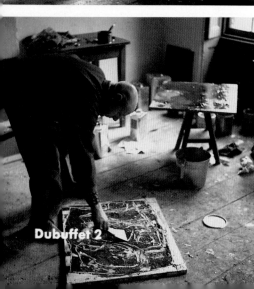
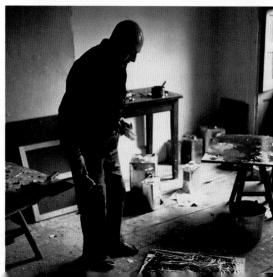

Dubuffet 2

Dubuffet 3

Balthus

Balthasar Klossowski de Rola, known as Balthus, is a mysterious and reclusive painter. I met him in the late forties at an intimate dinner with his great friends Derain and Giacometti. Balthus, a witty, civilized, attractive young man with a rare charm born, one senses, of generations of sophisticated ancestors, was already famous in a small circle of admirers, an artist who painted against the current trends. Although he was influenced by the surrealists, his work bears the structural rigor of Cézanne, Poussin, and Piero della Francesca. Its classical restraint created a link with the research of his contemporaries, the development of the cubists' discoveries, and an as-yet-unseen link with future abstraction. He was a modern artist within the cover of traditional, realistic subject matter.

1

Balthus 3

Above all, Balthus was a noble painter. His mastery of technique, of a frescolike texture and a strict composition, give a monumentality to his work. He was also a man of the Freudian era, and in his preoccupation with the secrets of repressed sexuality and his obsession with pubescent young women, he has created a counterpart to the public's visually unexpressed longings. As one absorbs a Balthus composition, the influence of photography with its daring vision of animation frozen in time is inescapable. The ability of the candid camera to seize intimate instants — as if the observer were not present — is similar to his own voyeuristic instincts.

Balthus's mind was imprinted by Anglo-Saxon culture when, as a child, he visited England. In fact, among his major works are the drawings illustrating Charlotte Brontë's *Wuthering Heights*, which were born in his reliving and understanding the juvenile erotic passion of Heathcliff for the adolescent Cathy. They express the similarly murky, undefinable yearnings of Nabokov's *Lolita*. It is curious, this strange effect of Anglo-Saxon culture on the psyches of those two uprooted Slavs. It is as if Balthus were the reincarnation of Humbert Humbert as a painter. But Balthus is able — and that is one of his secrets — to instill in the viewer a sense of terror, of Hitchcockian suspense as if violence was in the air. It is as if within the charm of Fragonard's erotic titillations one sensed the powers of de Sade and Freud, or even the matter-of-factness of police documentation of the scene of a crime.

I visited Balthus again in Rome in the early sixties where he had been named by Malraux to direct the Villa Medici, France's official residence for winners of the Beaux Arts Prize. There Balthus had transformed the musty palace interiors, having all the rooms lovingly repainted with his own subtle colors and textures. He lived there as if within one of his own paintings.

He was once quoted as saying, "Bonnard was the first to teach me what it means to be an artist — he showed that an aesthetic was not necessary. He could create art with the radiators of central heating or with any other thing." In his own paintings, Balthus proves that he, too, can create art out of the seemingly ordinary, the intimate moments of life. He is an artist who fixes for eternity the fleeting — he enriches the world with the stillness of the yet to happen, of time suspended.

Notes on the Illustrations

Balthus (Klowosski de Rola Balthus), 1908–. Born: France. Photographs taken in 1954.

1. Balthus, Cathy Dressing, *1933. Musée National d'Art Moderne, Paris, France.*
2. Balthus and a friend at a dinner for Derain and Giacometti at a Chatou restaurant on the banks of the Seine.
3. Balthus, The Room, *1952-54. Private collection.*

Giacometti

Alberto Giacometti is a wiry man, about five feet ten. His face is that of a *condottieri*; thick, curly brown hair encases his head like medieval headgear. The long, straight, noble nose, the deep creases from cheek to thick-lipped mouth, engrave his portrait sharply in my memory.

In the movement of his body there is the weight of gravity. He stands with courage and boldness in front of his easel, in front of his sculpture. His legs, like those of a fighter in a ring, are astride and firmly planted. As he works he springs forward, steps back, scratches his hair.

In his painting everything is reduced to the simplest means of expression: the heads are so small, the nudes and figures so narrow, the brushes so thin. With two fingers he holds a long sable brush at its farthest extremity. He digs it into a tiny layer of gray and white paint. Then, with circular, groping movements, as though in a trance, he shapes a small layer of paint into the suggestion of a face in its minuscule form. His eyes are half closed, his movements rapid. He smokes incessantly. Hundreds of cigarette butts litter the floor. When he sculpts, there is more movement and abandon. He seems to dance around the emerging form. His arms sway wide to add by touch the substance that will be form.

Giacometti lives in an artists' community in one of the sadder parts of Paris. Into a narrow courtyard, some six feet wide and forty feet long, open the doors and windows of various studios. Several garbage cans stand just behind the entrance to the court. On the soot-covered gray stucco walls hang classic bas-reliefs of angels dancing in a frieze, leftovers from more academic inhabitants. Giacometti has the four small studios on each side of the entrance. On the left is the room in which he works, and, next to it, his one-room apartment; across the narrow gap are his brother's workshops, where the processing of Giacometti's sculpture is done. He has lived here since 1927.

His studio is a small room, about fifteen feet by twelve. One window takes up a whole wall. Since the studio is on the ground floor and the courtyard is only six feet wide, the light

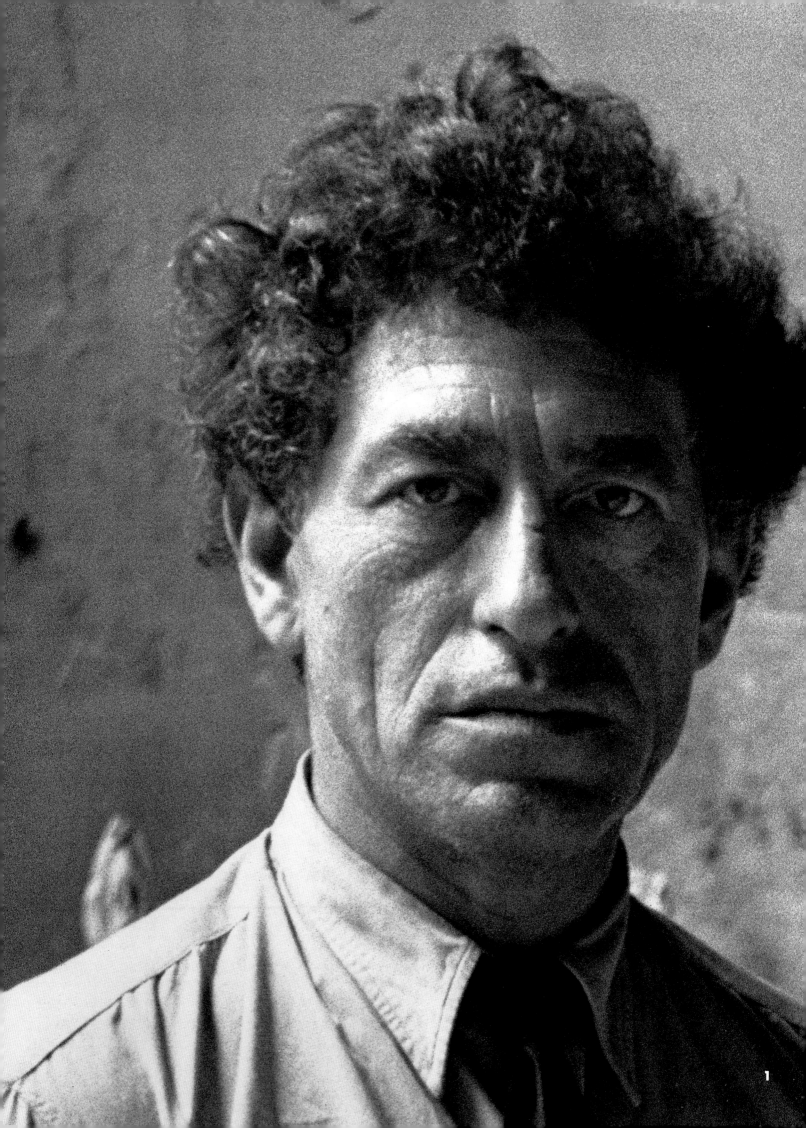

that streams in is gray and dull. The overall impression is of monochromatic grayness. The street outside, the whole quarter is gray. The walls are gray; the sculpture gray and white, interspersed with the sepia accent of wood or the dull glint of bronze. The walls are scratched and scribbled on as though some cave painter had tried to capture images in this cavern. Under the big window is a long table entirely covered with squeezed tubes of paint, palettes, paintbrushes, rags, bottles of turpentine. Like figures, the bottles stand shrouded in layers of dust chipped away from Giacometti's sculpture. Here sculpture and painting mix intimately. He has painted his recent sculpture in the manner of the ancient Greeks, and on his worktable the two mediums intermingle—turpentine, oil paint, color-soaked plaster, with clay, wire, stone, and bronze.

In the darker corners of the room his long, narrow life-size figures of white plaster seem like apparitions from another planet. One is surrounded by beings never encountered before. In other statues he has shriveled the human form to its smallest visible image. Men and women one-quarter of an inch tall stand on monumental pedestals. This ability to suggest dimension is one of Giacometti's chief preoccupations.

Giacometti is obsessed with the unattainable. "One does that which escapes one most," he said. How thin, how without substance can the human body be? How small, how infinitesimal? How to express in art an idea, the idea, the concept of man? An idea is something immaterial; one must use the minimum of material substance, reduce the quantity of substance needed to express an idea to the limit. This fantastic economy of means is at the heart of Giacometti's work: the minimum of color, the minimum of texture, the minimum of substance. It's as though the structure inside his sculpture were the idea of the sculpture itself. And when there is so little, every accident, every grain of matter on his long bodies take on a profound meaning.

"Why does one paint or sculpt?" he said. "It's the need to dominate things, and one can only dominate by understanding. I make a head to understand how I see, not to make a work of art. One must understand through intuition what moves one, and arrive at domination through logic, not through science. Art is not a science." As Giacometti talked, he worked on a clay torso and head. It seemed to take on the shape of the many portraits he has done of his brother Diego, as though his brother's head were an ever-present form in his mind. As usual he worked on doubtfully, complainingly, as if unable to predict the result of his work. He suddenly stopped and said with despair, "It looks like an object—a dead object."

Obsessed with line, he is also obsessed with jotting down and capturing images wherever and whenever he can. In the corners of his studios lie many portfolios of paper on which he draws with charcoal, pencil, oil, ink, any medium. His walls are covered with drawings, his sketchbooks full. He said, "I've been fifty thousand times to the Louvre. I have copied everything in drawing, trying to understand. Art is more what one sees than what one reads."

He spoke of the duality of precision-imprecision. "Look at an Egyptian head. It's precise, but its effect is mysterious. Venus de Milo means nothing to me, but I like Phidias and the archaic Greeks. *Laocoön* fascinates me."

About the creative impulse he said, "No one decides 'I'm going to do sculpture,' or 'I'm going to do painting.' One just does it. It's an absurd activity. One does things through mania, obsession, through an automatic need that escapes the understanding."

On the walls of his bedroom are drawings, and the cracked paint on the cupboards reminds one of damaged frescoes. In this room there is a bed with no back, just a mattress with an eiderdown, two pillows, and white sheets. An ordinary painted chair, the paint all cracked on its rounded, bent back, serves as a bed table. On it were three or four torn books of poems: Apollinaire's *Alcools* and the poetry of Rimbaud. Like Matisse, Braque, and Picasso, Giacometti is a great reader of poetry. But unlike many artists, he reads innumerable newspapers. Behind the bed are an old wireless set, a small lamp, a large, badly printed closet. Next to two jars of instant coffee stand empty jars of yogurt. Diagonally across one corner of the room hangs a string on which clothes and kitchen towels dry. Under the window is a sink, a small two-plate burner, a basin, a pitcher of flowers. The small bouquet that his wife places in their sad, grim bedroom is a spark of emotional relief. Without it this room would seem unbearable.

Giacometti's wife, Annette, is about five feet four, like a slender girl of fourteen. She is not fourteen, she is much older, but her youth, her beauty, a poetic quality of mood are a contrast to Giacometti's somber brooding. She has the naïve and innocent expression of a child, and laughs often with a girl's laughter. This girl-wife seems made to be the companion who does not distract the artist from his work. They met in 1949. She always says the formal *vous* to Giacometti. He sometimes teases her. Then the wrinkles, the two deep furrows in Giacometti's face crease even deeper, and he beams like a mountaineer enjoying a good joke.

He is a man possessed. Time has no meaning in his daily life; he eats and sleeps as he needs to. There is no specific hour for any activity, only the time to speak, to create. He creates best at night. He has been known to work through forty-eight hours without sleep or meals. His best work, he believes, is done after hours and hours of work, when he is so tired that his intelligence has lost control. This is a familiar feeling of many artists, this extraordinary state of trance that can be obtained only through extreme physical fatigue. Then, exhausted, Giacometti lies on his bed and says, "I don't know. What am I going to do? The work is not coming as it should. I will soon have to look for another métier if it goes on like this." To get away from his self-torture, Giacometti often visits his mother in southern Switzerland, near the Italian border. (His father was a famous Swiss postimpressionist painter who had studied with Bouguereau.) There, for several weeks or months, in a small village, he stays immersed in nature, sketching endlessly.

It is strange that this famous man, one of the great sculptors and painters of our day, lives the way he does. This misery is not materially necessary, but perhaps there is a superstitious need to prolong the mood of his creative inspiration. Looking at his small, crowded studio, Giacometti said, "I've never had the time to move. The more I work the bigger this studio seems." To relocate and adjust physically and suddenly to improved quarters might cut the thread, alter the radioactive effect of the surroundings that have produced so many masterpieces. Here Giacometti has found his own world, a world of stone, a world of dust—everything is dust. This dust is the substance out of which God fashioned the universe and out of which Giacometti fashions his own universe. To move a bottle, to clean up the studio, might be sacrilege.

Cézanne toward the end of his life expressed the anguish of the truly creative artist. "I have not realized," he wrote. Giacometti is such an artist. He is obsessed with the pursuit of the ideal. Never satisfied, he smashes or discards much of his work. "I have always failed...but I am sure no one can realize that for which he strives!...Oh, to be able to say, 'That's it, I cannot do more.'"

Notes on the Illustrations

Alberto Giacometti, 1901-1966. Born: Switzerland.
Photographs taken in 1951, 1953, 1954, and 1955.

1. Alberto Giacometti.
2. A haunting detail in the studio: a plaster in progress leans against a wall map of Europe.
3. Bottles of turpentine, covered with dust, stand beside Giacometti's palette and small figures; outside, a cast of Donatello's Cantoria.
4. The Giacomettis—Alberto, his brother Diego, and his wife Anette—both his favorite subjects of sculptures and paintings.
5. In an alley that separates the main studio, right, from his casting studio, left, Giacometti speaks with his brother Diego, also a sculptor.
6. The finishing of a work in bronze; the final patina applied to sculptures including a bust of Diego.
7. The sculptor at work, a cigarette in hand.
8. Anette reading a tender feminine romance in the cluttered, austere studio.
9. A world of imagination. The walls of Giacometti's studio are covered with his drawings and meaningful scratches. On a shelf, small sculptures in progress.
10. A pause in the usually busy studio: an exhausted Giacometti meditates.

Giacometti 2

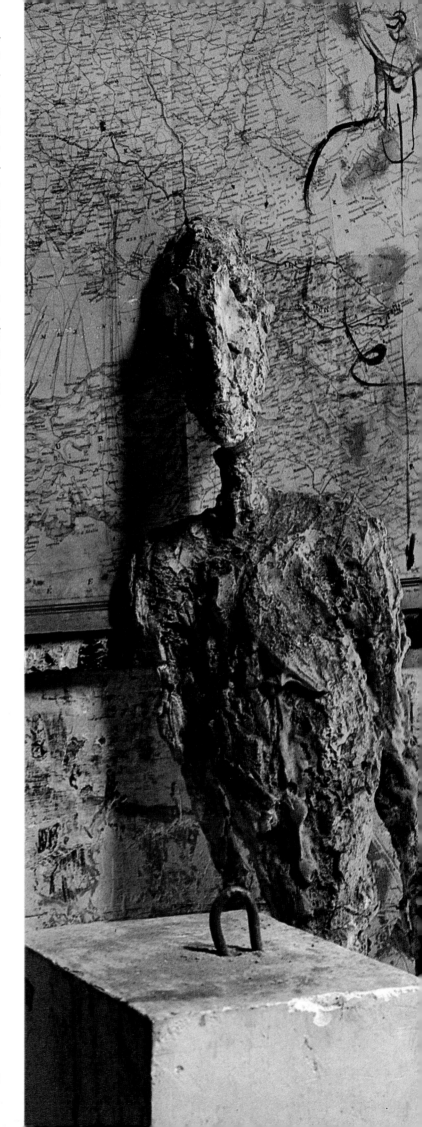

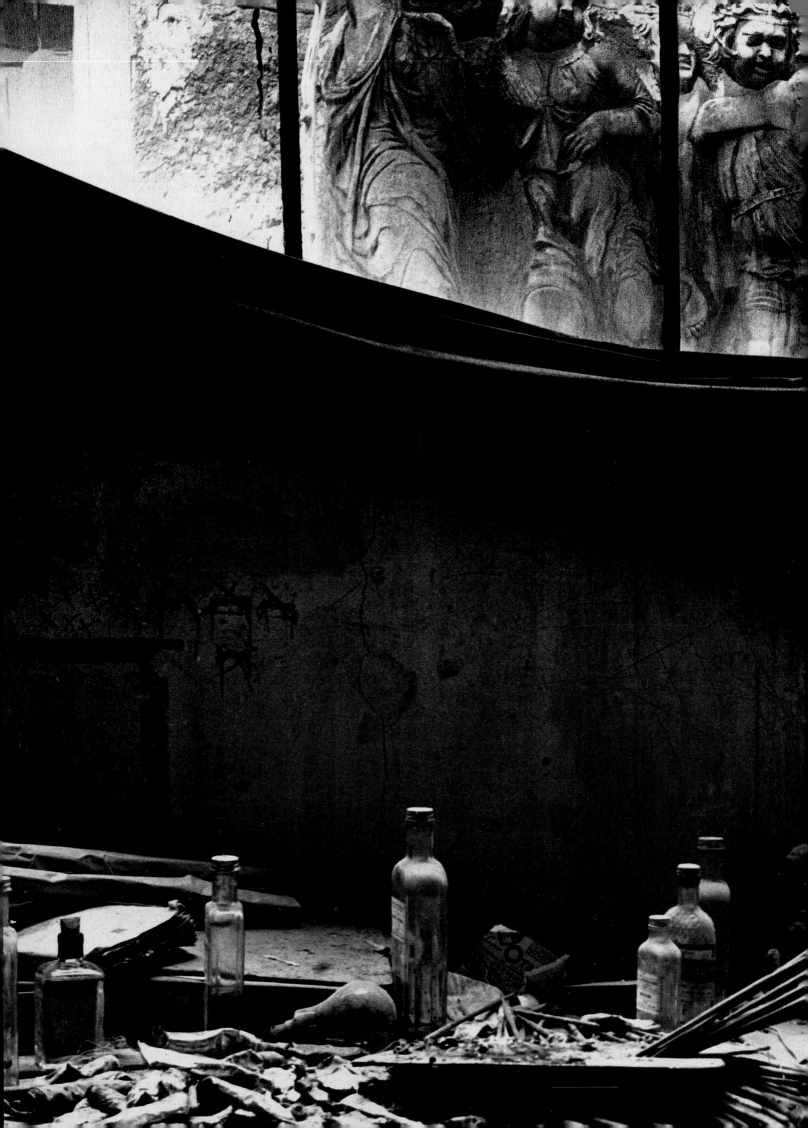

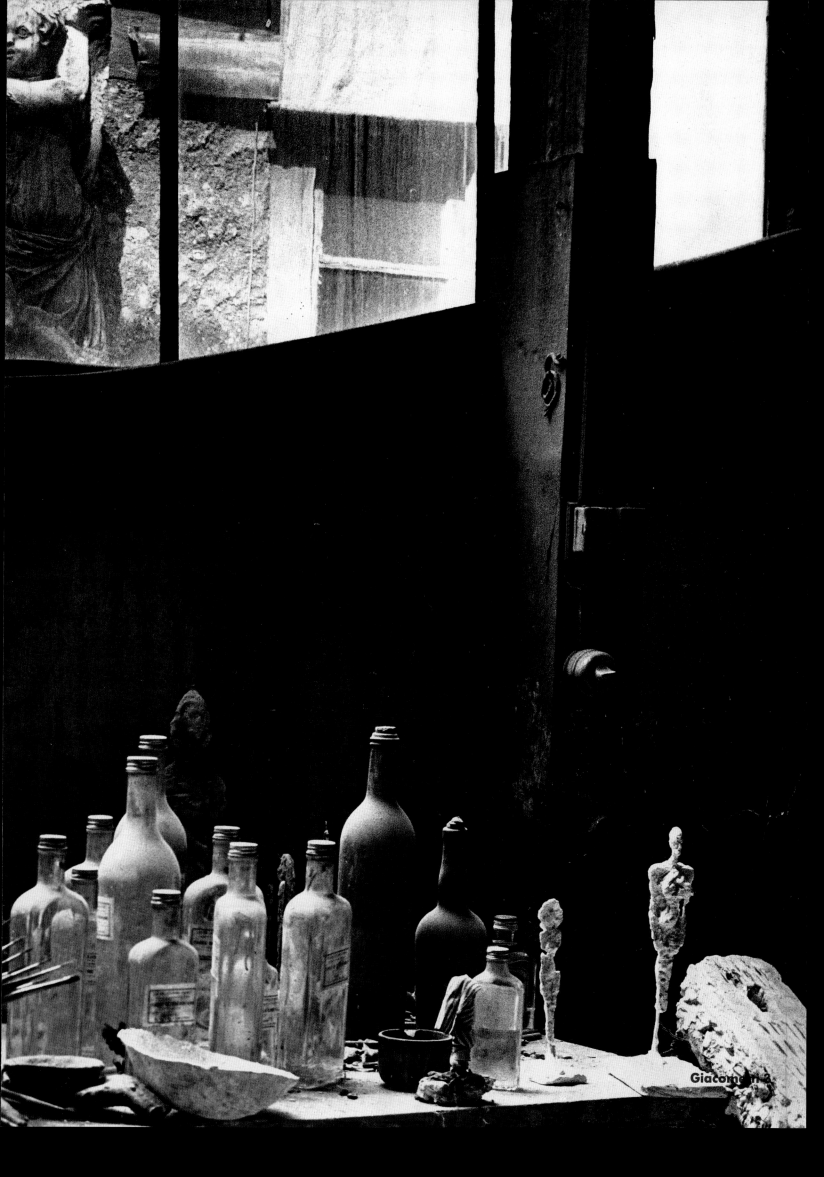

Giacometti 2

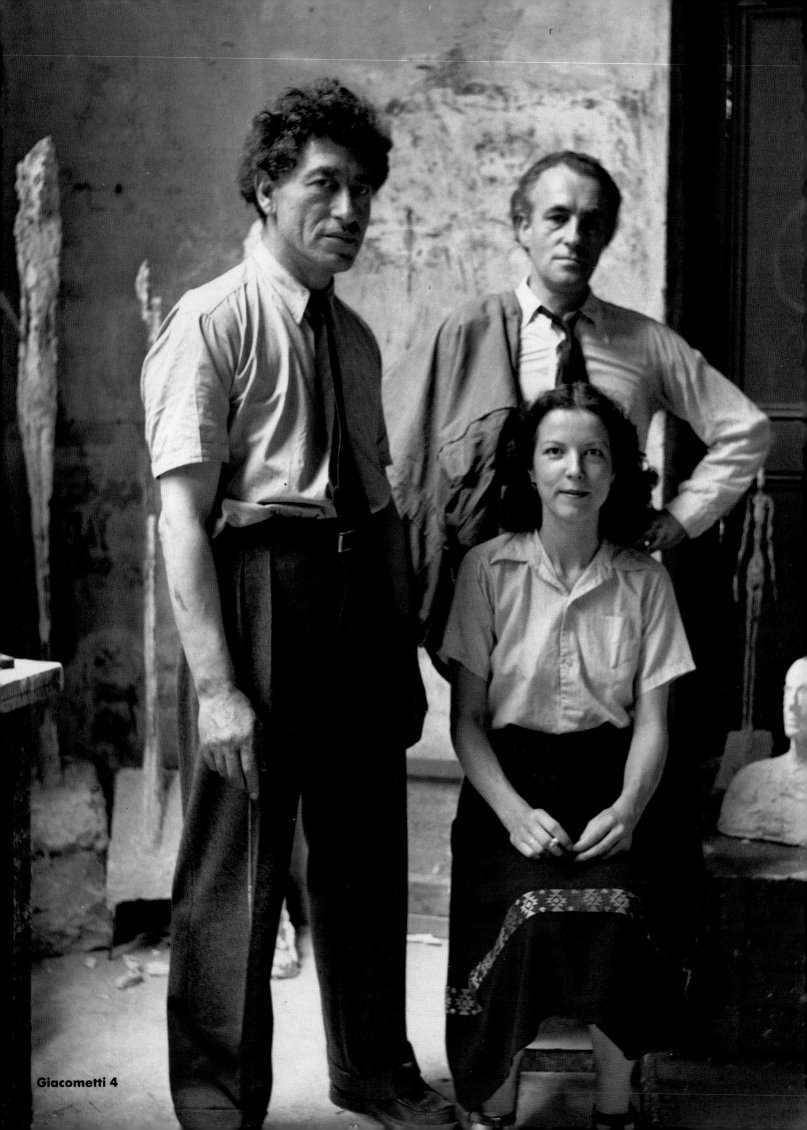

Giacometti 4

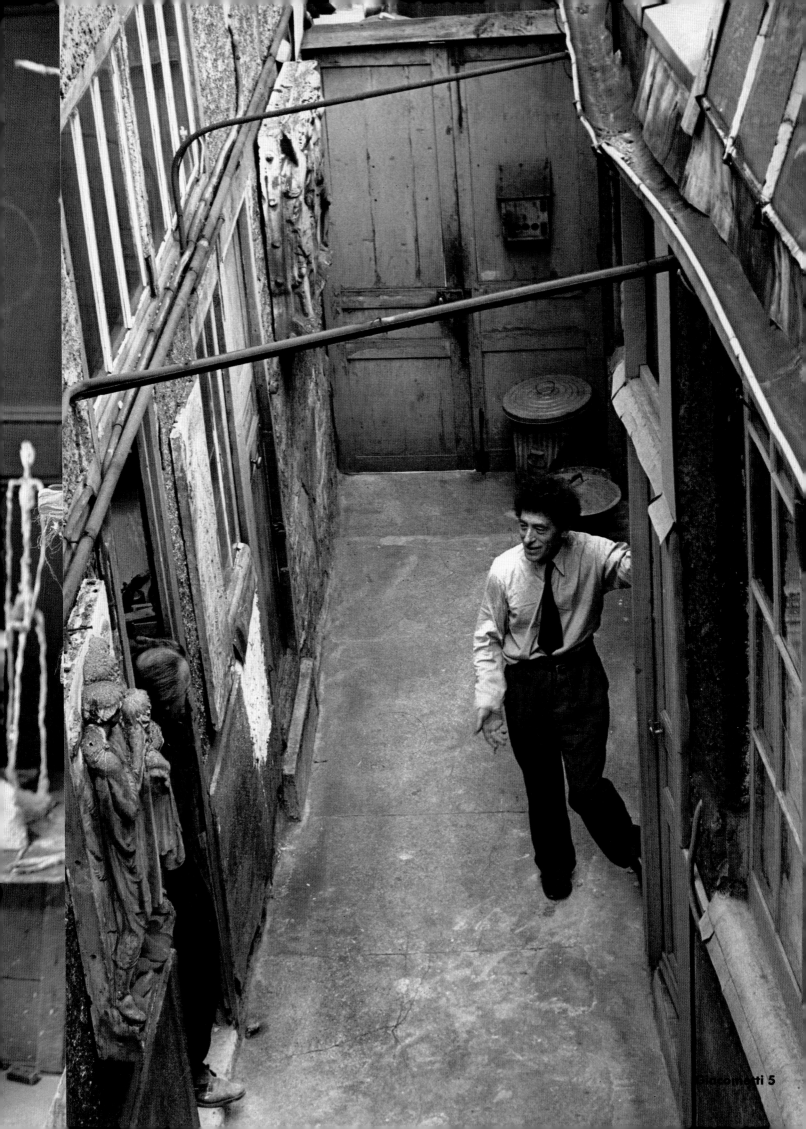

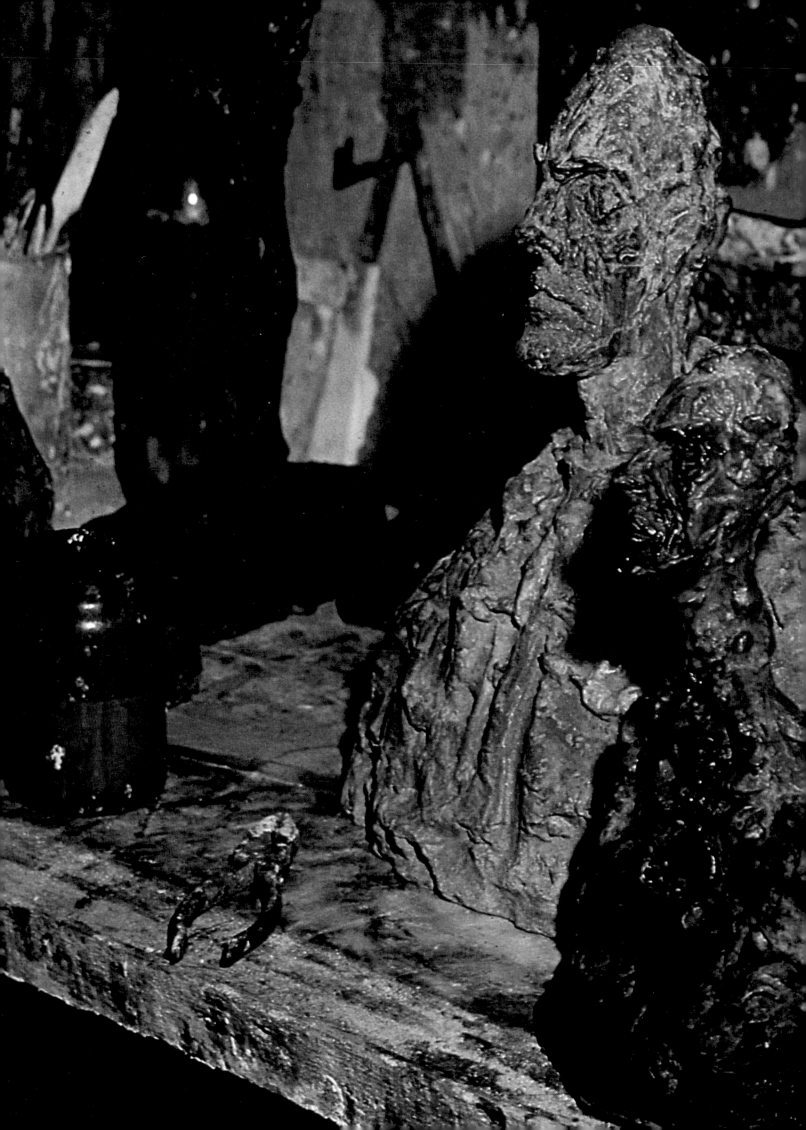

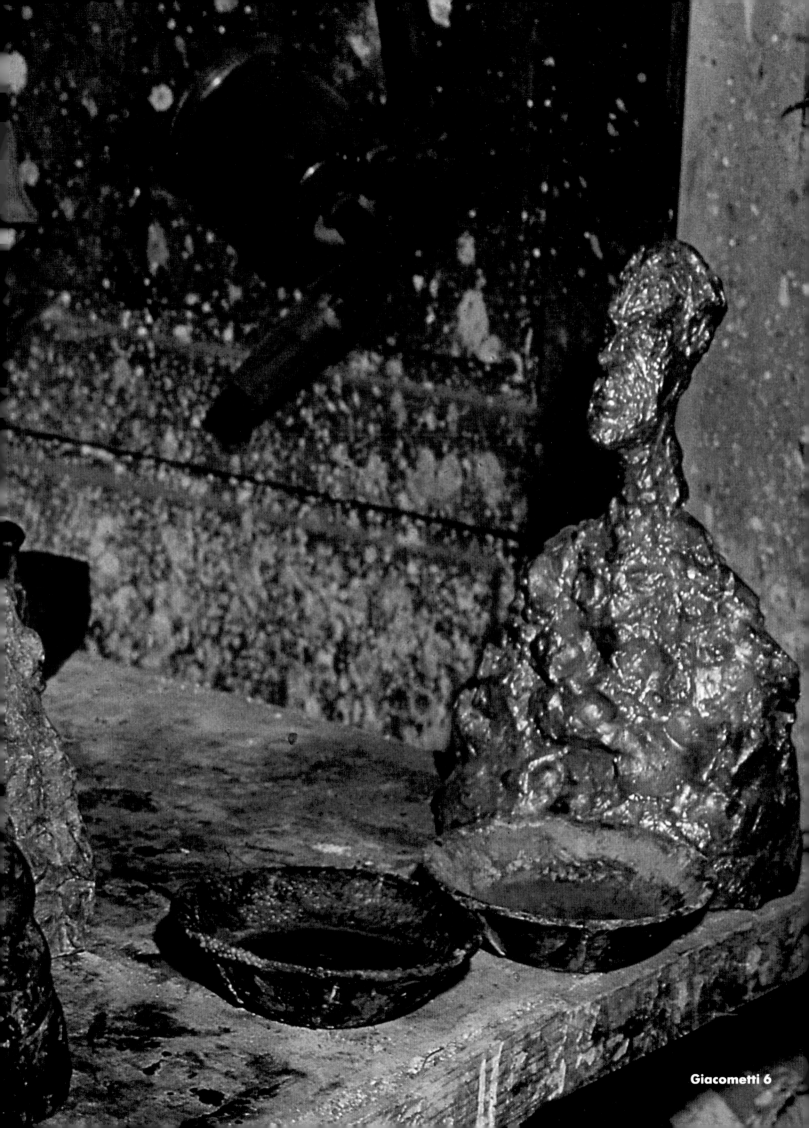

Giacometti 6

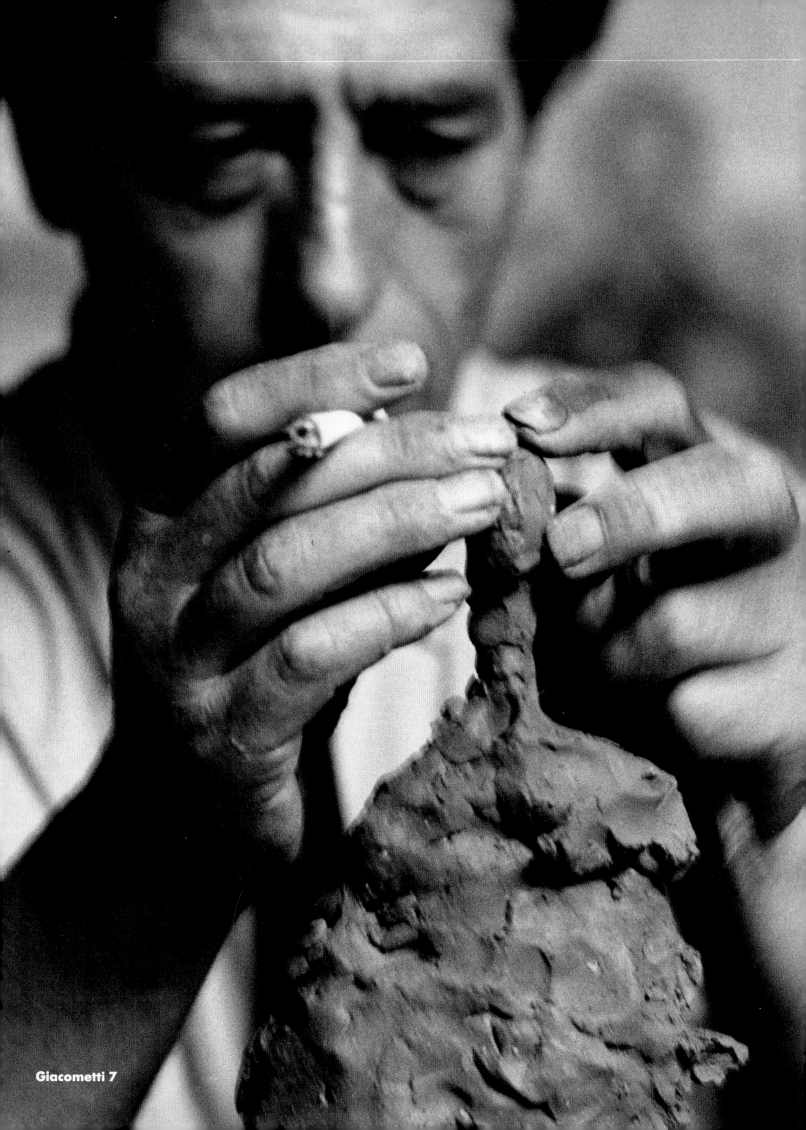

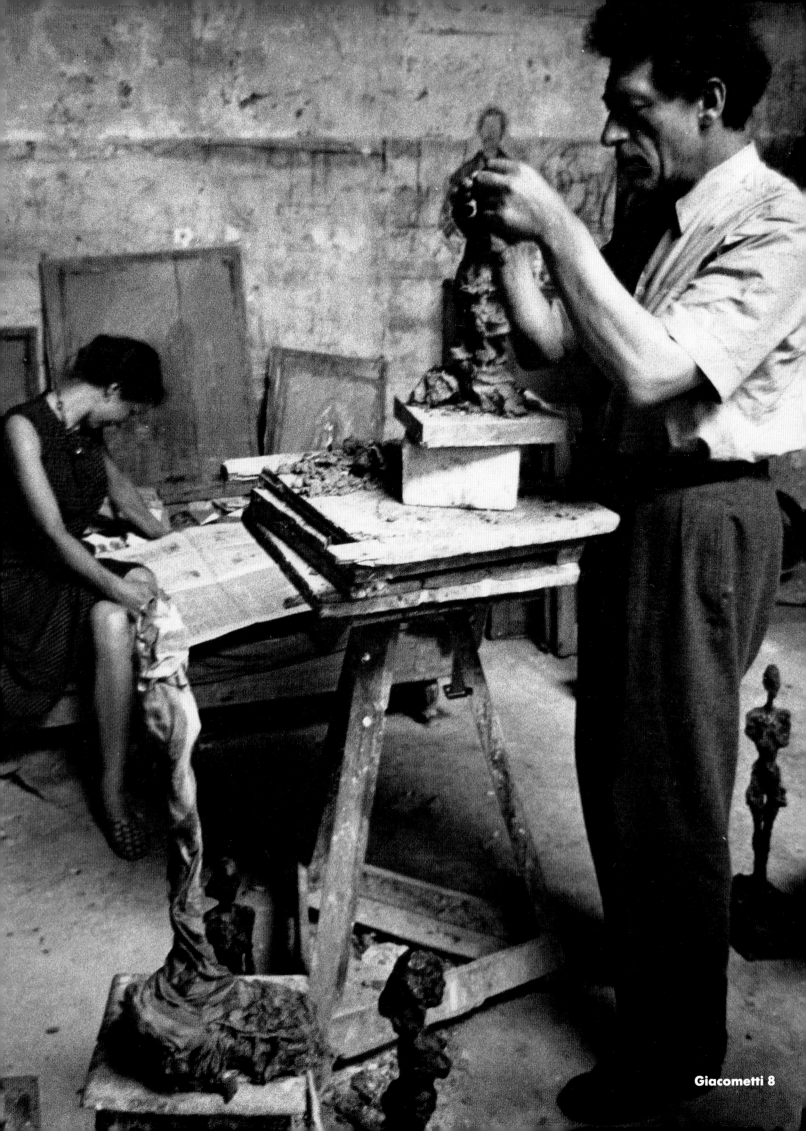

Giacometti 8

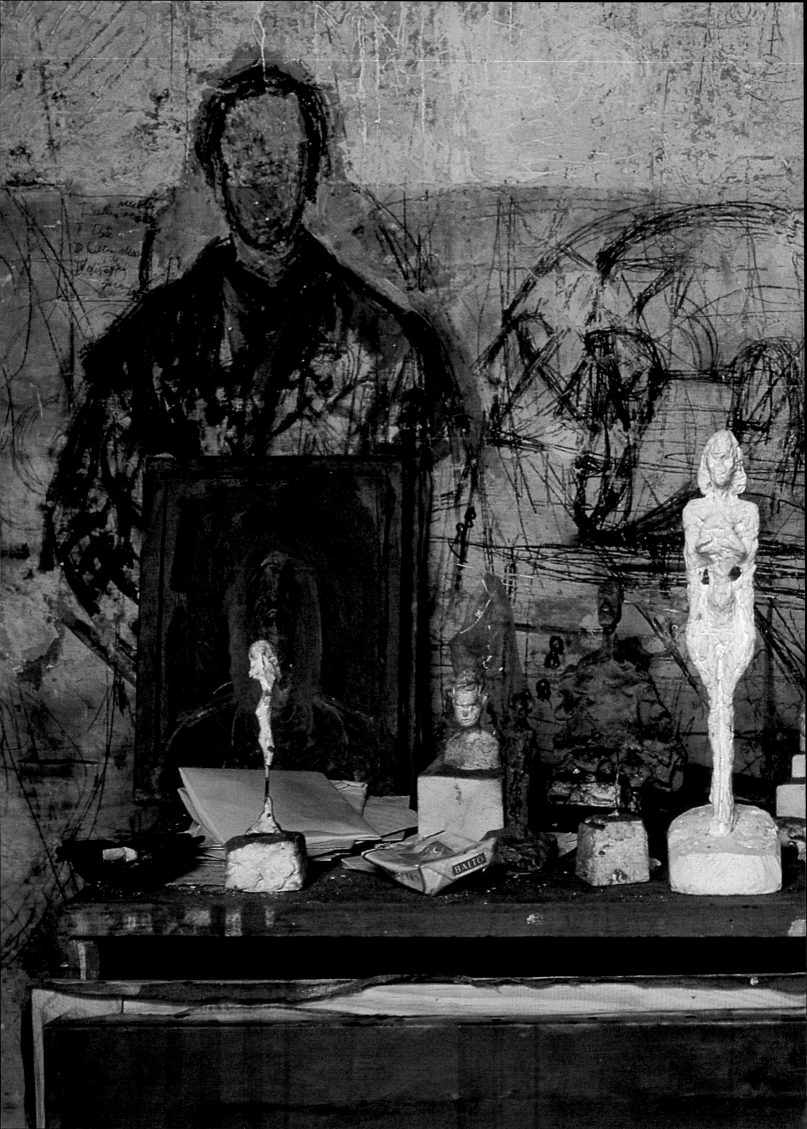

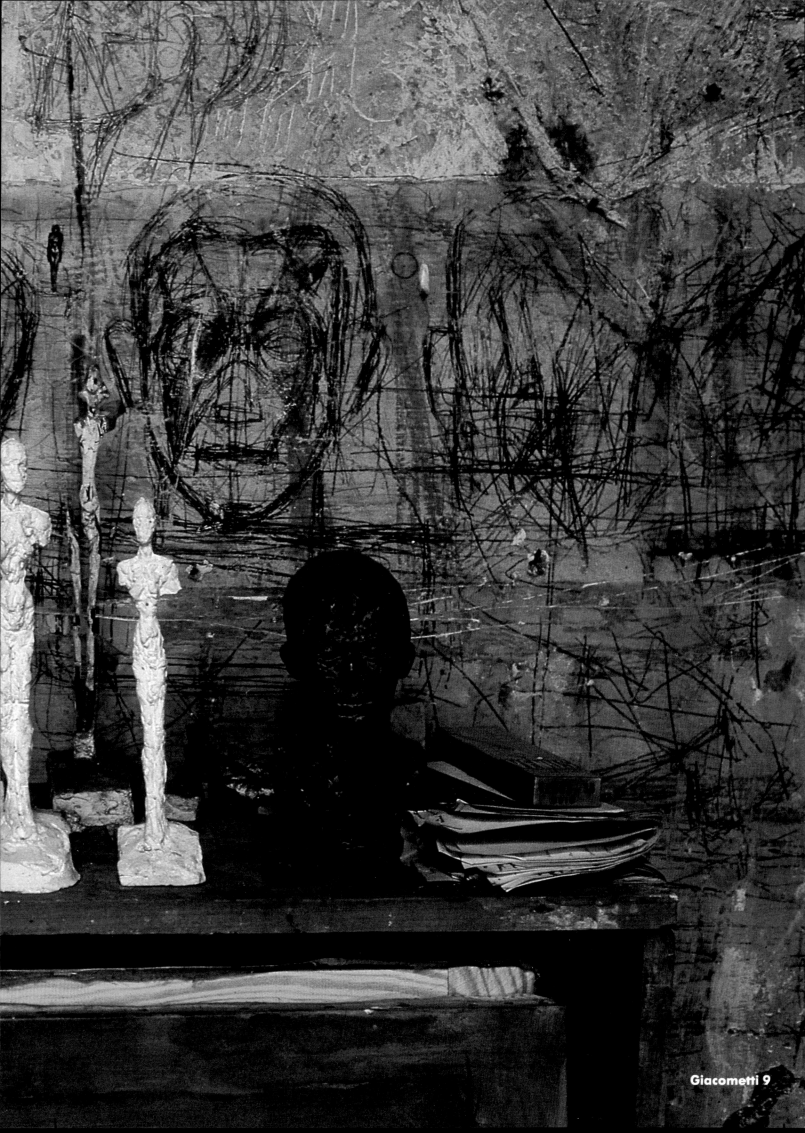

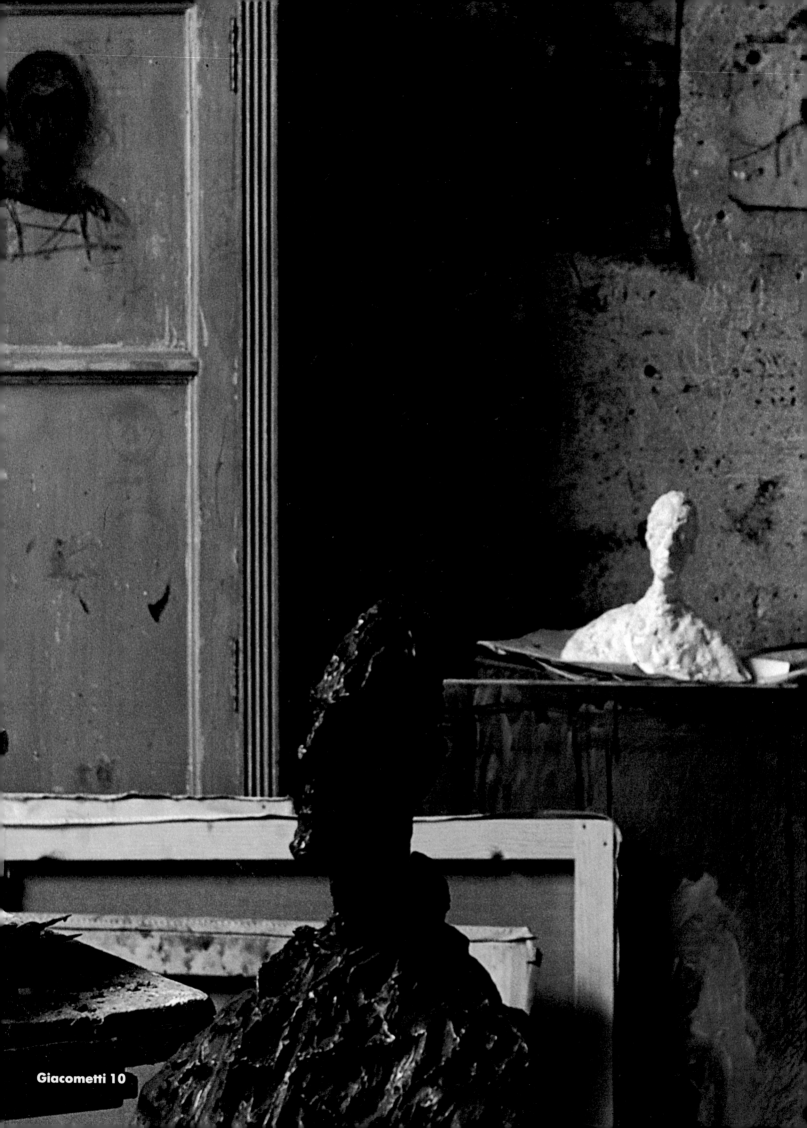

Afterword

While it is difficult to compare the individual achievements of these masters, it is Picasso, more than any other, who then, today, and for all time stands as the archetypal artist of the twentieth century. His genius originated, developed, and summarized the great art movements of his time. During his long life, his art continually evolved and dramatically changed. Of all the artists I met, he left on me the strongest spell, a memory that is as vivid today as it was a quarter of a century ago.

Picasso's sensitivity, in his life and in his work, to the struggles of the world beyond the studio was a revelation to me. His art, more than that of any of the others, dared to face the frightening reality of his terrible time. He experienced revolutions, insurrections, international and civil wars, and the violence, cruelty, and hatred of fascist oppression. Indeed, his Spanish affinity for the drama and spectacle of cruelty, inseparable from the consciousness of death, infuses nearly all his art with tragedy.

Picasso also was aware of the torture of the creative struggle—a fact revealed in his obsession with the well-known novella by Honoré de Balzac. *The Unknown Masterpiece*, written in 1832, is the tale of a great painter living in the Rue des Grands-Augustins in seventeenth-century Paris—a story of an all-destroying quest for absolute perfection. Balzac's old artist has slaved for ten years on a portrait of a beautiful woman, which he keeps hidden. When finally he consents to show it to his friends, they see only the meaningless tangle of the countless corrections and revisions. One of them remarks, "I can see nothing but confused masses of color and fantastical lines that go to make a dead wall of paint." Here Balzac struck a deep chord in Picasso, who drew many etchings based on this shattering experience in an artist's life, coincidentally, many years before he, himself, moved to the same small street near the Seine. The theme of the artist and his model engrossed Picasso to the very end of his life. He took the image of the painter on many subconscious transformations from young virile cavalier to old bearded dwarf and shriveled monkey. And, like Balzac's hero, Picasso would wrestle with each canvas, endlessly repainting. But Picasso, the greatest of artists, dominated his fear of failure by yielding to its challenge, creating masterpieces in spite of the changes left visible; the apparent drama, in fact, enriching the work in its own way.

I remember Picasso speaking of the finished as being like death. All great artists know that sometimes, in spite of themselves, in the so-called unfinished is the mystery of resurrection, rejuvenation, and rebirth, and that the end of one work is but the beginning of another, that as long as life lasts and strength allows, the struggle will continue. In their faith and hope in the lasting life of their art, they may be rewarded by the immortality of their creations in the visual memory of the world. We, in turn, facing each work, marvel at the mystery, the glory, and the life-giving miracle that true art embodies in itself.

Opposite: Picasso, The Painter and His Model, *1927.*
Etching for Balzac's Chef d'Oeuvre Inconnu.
Musée Picasso, Paris.
Back endpaper: Paris: the rue des Grands-Augustins; at the upper right, the windows of Picasso's studio.